Matsuri!

MATS

UCLA FOWLER MUSEUM OF CULTURAL HISTORY
LOS ANGELES

UCLA Fowler Museum of Cultural History
Textile Series, No. 6

Textile Series Editorial Board
Marla C. Berns
Patricia Rieff Anawalt
Roy W. Hamilton
Betsy D. Quick
Lynne Kostman
Daniel R. Brauer

URI!

Japanese Festival Arts

GLORIA GRANZ GONICK

With contributions by Yo-ichiro Hakomori
Hiroyuki Nagahara
Herbert Plutschow

UCLA
FMCH
Textile Series

The Fowler Museum is part of
UCLA's School of the Arts and Architecture

Lynne Kostman, *Managing Editor*
Michelle Ghaffari, *Editor*
Danny Brauer, *Designer and Production Manager*
Don Cole, *Principal Photographer*
David L. Fuller, *Cartographer*
Paulette Fontanez, *Photography Assistant*
Christina Yu, *Photography Department Volunteer*

UCLA Fowler Museum of Cultural History
Box 951549
Los Angeles, California 90095-1549

Requests for permission to reproduce material from
this volume should be sent to the UCLA Fowler Museum
Publications Department at the above address.

Printed and bound in Hong Kong
by South Sea International Press, Ltd.

Library of Congress Cataloging-in-Publication Data

Gonick, Gloria.
 Matsuri! Japanese festival arts / Gloria Granz Gonick ;
with contributions by Yo-ichiro Hakomori, Hiroyuki Nagahara,
Herbert Plutschow.
 p. cm.
 Includes bibliographical references.
ISBN 0-930741-91-9 — ISBN 0-930741-92-7 (soft cover)
1. Shinto arts. 2. Fasts and feasts in art. 3. Fasts and feasts—
Shinto. I. Title: Japanese festival arts. II. Title

NX692.S56 J365 2002
704'.9'4899561—dc21

 2002028793

Cover: Detail of fig. 4.63.
Title pages: Detail of fig. 4.47 (background),
 detail of fig. 4.100c (inside "*Matsuri!*" letters),
 details of fig. 4.49 (top and bottom).
Contents page: Detail of fig. 4.88.
Page 6: Detail of fig. 4.89.
Page 11: Detail of fig. 4.86.
Page 14: Detail of fig. 4.106.
Page 246: Detail of fig. 2.6.

**Funding for the publication and the exhibition
has been provided by:**

Anonymous
The Nikkei Bruin Committee
The Christensen Fund
Mr. and Mrs. Lloyd Cotsen
The Blakemore Foundation
City of Los Angeles—Cultural Affairs Department
UCLA Center for Japanese Studies
San Francisco Bay Area Rug Society
Manus, the support group of the UCLA Fowler Museum

Contents

Forewords

THE SPECTACULAR JAPANESE COMMUNITY FESTIVALS KNOWN AS MATSURI ARE CENTURIES old. Even today, in a society driven by technological advancement, these annual rites continue to function as a mechanism for purification and renewal and also to ensure all aspects of communal productivity. The pageantry of these events—their extraordinary dress, performance, and Shinto-Buddhist ritual enactment—brings communities together in an act of worship that is, as well, an extravagant artistic celebration. Dominated by the gorgeous textiles worn by troupes of participants, *matsuri* also boldly incorporate decorated banners, exquisitely "dressed" festival wagons, dramatic masks, and elaborate portable shrines. The historical importance of *matsuri* within the cycle of annual religious events in Japan is also reflected in the representation of these festivals in several pictorial forms, from lavish screen paintings to elegant woodblock prints.

Despite the diversity of elements that combine to create the astonishing *matsuri*, textiles dominate in numbers as well as in visual impact. The UCLA Fowler Museum of Cultural History has published eight books dealing with Asian textile subjects in the past fourteen years. This sustained effort has been predicated primarily on the great breadth and depth of the Museum's Asian textile holdings, which now total approximately twenty-five hundred items. *Matsuri! Japanese Festival Arts* is no exception. We are deeply indebted to visiting curator Gloria Granz Gonick for her efforts over the past eleven years to collect and document Japanese festival textiles. These textiles became the basis for the development of a major exhibition that presents, for the first time, the panoply and complexity of *matsuri*. Additionally, as this book demonstrates, the festival textiles are a remarkable resource for an investigation of *matsuri* themselves and the Shinto-Buddhist religious framework that surrounds and informs them.

The Asian textiles featured in previous Fowler publications serve a wide range of functions in their communities of origin. The ikat cloths of Borneo, for example, bear intimate connections with the former practices of head-taking, while those of the island of Flores are exchanged in great numbers to bind extended kin groups together in marriage alliances. None of our projects, however, has involved a more dramatic usage of textiles than the Japanese *matsuri*, where they are displayed quite explicitly to astonish and delight the deities (*kami*). Their bold colors and patterning seem anomalous in Japan, where so much else in the aesthetic domain is characterized by restraint. Whether they are worn as costumes, flown as banners, or wheeled through the thronged streets on huge carts, the purpose of their vibrant and often eccentric style is to attract the attention of the *kami*. These spirits are called upon to come and reside in the community during the festival and impart their blessings. Thus the textiles themselves are a key element in promoting community well-being from one annual festival to the next.

This dramatic use of textiles attracted Gloria Gonick's attention and set her on a path of discovery that ultimately resulted in this book and the exhibition it accompanies. She has documented the use of textiles in more than twenty-five different festivals scattered over the length and breadth of Japan. This book interweaves these textiles with the other arts that constitute *matsuri* as well as with their symbolic meanings and the history of textile making in Japan. While many of our American readers may have some familiarity with Japanese textile traditions, they will probably be surprised that Gloria's research path also led her to western China, a source for some of the most prized textiles used in *matsuri*, especially in the famous Gion Festival held in Kyoto.

This project has been years in the making and has involved the participation of many individuals and institutions. The book has been an ambitious undertaking, exploring several aspects of *matsuri* from an interdisciplinary perspective. While Gloria Gonick has done the primary research on the rich and complex subject of festival textiles—indigenous and imported—we are indebted to several other scholars: Herbert Plutschow, Professor of East Asian Languages and Cultures at UCLA, who addresses both the political underpinnings and theatrical aspects of *matsuri*; Yo-ichiro Hakomori, Adjunct Assistant Professor, School of Architecture, University of Southern California, who deals with spatial aspects of *matsuri*, including the actual context for the events, as well as with the various religious and secular structures that are part of the festivities; and Hiroyuki Nagahara, Assistant Professor of Japanese, Department of East Asian Languages and Literature, University of Hawai'i at Manoa, who explores the fascinating world of inscriptions and calligraphy related to *matsuri*. Together these essays represent the most comprehensive treatment of these Shinto-Buddhist festivals to date.

As indicated above, many of the works in the exhibition are part of the Fowler Museum's permanent collections. We have also borrowed crucial works from many lenders whom we thank for so generously assisting us in presenting a full picture of the diverse artworks that comprise *matsuri* (please see the list of Lenders to the Exhibition, p. 4). Some of the pieces have required special loan arrangements due to their age and fragility, and we would like to acknowledge the cooperation of Joe and Etsuko Price and Cynthia Burlingham, Deputy Director of Collections, UCLA Hammer Museum and Grunwald Center for the Graphic Arts.

Matsuri! Japanese Festival Arts would not have been possible without generous financial support. Major funding for the exhibition/publication project has come from the Nikkei Bruin Committee, a group dedicated to supporting Japanese and Japanese American related programs at UCLA; the Christensen Fund; Lloyd and Margit Cotsen; and the Blakemore Foundation. Support for educational programming has been provided by the City of Los Angeles—Cultural Affairs Department, and the UCLA Center for Japanese Studies. Thanks also go to the San Francisco Bay Area Rug Society; Manus, the support group of the UCLA Fowler Museum; and an anonymous donor.

As always, a project of this scope and complexity could not have been realized without the dedication of the entire Fowler Museum staff. Given challenging time constraints, many staff members have worked tirelessly to produce the exhibition and book. Roy Hamilton, Curator of Asian and Pacific Collections, has overseen all aspects of the project's development and has worked very closely with Gloria Gonick on both the exhibition and the publication. Planning for the exhibition has been deftly managed by Director of Exhibitions David Mayo, who accompanied Gloria to Japan and took both still photographs and video footage of festivals at several locations. His exposure to *matsuri* in Japan has given him perfect inspiration for the exhibition design, which captures so well the spirit and pageantry of the festivals. He and his installation team have done a wonderful job of creating a sense of the event itself and its dramatic arts. Betsy Quick, Director of Education, has produced accessible and lively texts to narrate the exhibition's stories, and Martha Crawford has designed an equally sympathetic graphic package to present them. The detailed process of securing loans for the exhibition has been ably overseen by Sarah Kennington, Registrar, and Farida Sunada, Associate Registrar. They worked closely with Fran Krystock, Collections Manager, and Anna Sanchez, Associate Collections Manager, in coordinating the complex retrieval of Fowler collections from storage and the transportation of loaned materials to the Museum. Jo Hill, Director of Conservation, did a meticulous job of

preparing objects for photography and installation, which is especially challenging with textile arts. A roster of educational programs and family events to extend the project's interpretive range has been developed by Betsy Quick, Director of Education, with Alicia Katano, Assistant Director of Education, and Ilana Gatti, Program and Events Coordinator. Publicity and promotion has been creatively managed by Stacey Ravel Abarbanel, Director of Communications. Lynne Brodhead, Director of Development, and Leslie Denk, Assistant Director of Development, undertook with great success the weighty task of fundraising. Other administrative and financial aspects of the project were skillfully managed by David Blair, Assistant Director, with the assistance of Allison Railo, Accounting Administrator, and Betsy Escandor, Executive Assistant.

Assembling a book with several authors and with a multitude of photographic sources has demanded the coordinated efforts of a highly talented, professional team. Lynne Kostman, Managing Editor, has done a masterful job overseeing the final stages of editing the volume and integrating its constituent parts. The essays were edited with a sure hand by Michelle Ghaffari. The beautiful book design was managed and executed by Danny Brauer, Director of Publications, who captured so elegantly the vibrancy of *matsuri*. Don Cole is to be commended for his gorgeous photography, which has brought the festival textiles vividly to life.

Finally, our sincere thanks go to Gloria Granz Gonick, for the enormous task she has undertaken to curate the exhibition and author the publication. It has surely been a labor of love, and we are grateful to her for her passionate commitment to Japanese textiles. We are pleased to be the first museum to mount a major exhibition on this particular subject, which we couldn't have accomplished without her. Once rare and misunderstood, *matsuri* textiles are herewith unveiled as part of the mystique that delights the deities, and, we are sure, will delight our readers as well.

Marla C. Berns, *Director,* UCLA *Fowler Museum of Cultural History*

IN JAPAN, FESTIVALS (MATSURI) ARE NOT LIMITED TO THE SAIREI *HELD AT SHINTO SHRINES.* There are also the festivals held to propitiate the souls of ancestors and other deceased people during Obon (Festival of the Dead) and Ohigan (the equinoctial weeks); festivals for the gods of rice fields, supplicating them for an abundant harvest; festivals for the gods of mountains, asking for success in hunting; festivals for gods that protect land and homes; and countless other festivals as well. Festivals are held wherever people live.

Etymologically, the word *matsuri* means "to be beside and serve someone." More specifically, it means to sanctify and serve a transcendent being who exists above and beyond people. Thus, for Japanese, who have traditionally believed that such transcendent beings are everywhere in the real world, festivals have long been a deeply rooted part of life.

Being group events, festivals initially arose among communities of people who lived and worked together. Repeating their daily routines of going out to work at daybreak and returning home at sunset for the night, people lived a life that changed with the cycle of the seasons. In so doing, they surely felt gratitude for the blessings of nature, as well as a reverence for nature itself; and as an expression of this, seasonal festivals— spring festivals, summer festivals, autumn festivals, winter festivals—came to be held.

At the center of Japanese festivals are *ujigami* and *chinju*, local guardian deities predicated on the thinking in Shinto, a religion unique to Japan. It is thought, however,

that these deities were originally gods of mountains, rivers, rice fields, and farms who existed long before Shinto took clear form. Japan's traditional festivals have, of course, changed with the times. Long after its establishment, Shinto became mixed with Buddhism, and the influence of this amalgamation (known in Japanese as *shinbutsu shugo*) can be seen in festivals. An even bigger change, however, was a separation of *shinji* (Shinto rituals) and *sairei* (festival, celebration), which became especially pronounced in the Meiji era.

Originally, festivals were composed of these two elements, *shinji* and *sairei*. In the Meiji era, however, a Shinto priesthood was established, and *shinji* became its exclusive province and at the same time grew more formalized. Only the *sairei* element was entrusted to the *ujiko* (communities under the protection of, and devoted to, a particular deity). That ordinary Japanese now think of festivals as merrymaking events is due to this fact.

Another and perhaps even more significant change in the history of festivals is currently ongoing. Since the end of World War II, the cohesion of communities, whether in towns, villages, or cities, has been weakening due to changes in the society at large. As a result, a situation has arisen in which festivals themselves are disappearing. Nowadays, to see a traditional festival, Japanese must betake themselves at certain limited times of the year to certain limited regions where such festivals are still being held.

While this is the situation in Japan, in the United States efforts are under way not only to research and record Japanese festivals but also to introduce them to the American people as an important aspect of traditional Japanese culture. This is an extremely significant project, and to the UCLA Fowler Museum of Cultural History and Ms. Gloria Gonick, who have planned it, I as a Japanese would like to express my deepest admiration and gratitude.

With festivals having had a relationship to the divine since their beginning, a nonquotidian type of space is produced in their rituals, which comprise actions seen as sacred. The implements used in festivals could even be said to have been fashioned for purposes of producing such space and such actions. The *shimenawa* (sacred braided rope) and other festival articles perform the role of transforming ordinary space into extraordinary sacred space, while the headgear, especially the masks, and the clothing have the function of temporarily changing people into gods themselves or into intermediaries between the divine and the human. By putting these on, people are converted from beings helpless before natural forces and evil spirits into beings that have the power to foresee the future, guarantee property and livelihoods, dispel evil spirits and epidemics, and ensure the prosperity and safety of the community. And while these ritual implements and garments include items that appear to be just like or modified versions of examples used in daily life, there are others that have completely unique forms. The exhibition being held at the Fowler Museum of Cultural History not only elucidates the cultural history and ethnological aspects of Japanese festivals, it also allows visitors to see many of the diverse forms that festivals have created. Garments used in festivals are another of its features.

I have great hopes that, spurred by this endeavor, additional and varied research into Japanese culture will be conducted in the United States and that the fruits of this research will benefit research into Japanese culture conducted in Japan.

Nagasaki Iwao, *Professor, Kiyoritsu Women's University, Tokyo*

Preface

A LONG-STANDING INTEREST IN HISTORIC TEXTILES AND DRESS LED TO THE CREATION
of this book. As the "close arts"—daily in our line of vision, underfoot, and next to
our bodies—textiles seem to me to best reflect how cultural history influences the
appearance of society.[1] Although in the beginning my absorption was international in
scope, gradually I found the designs and textures of Japan to be the most intriguing.
My sequence of discovery began with kimono designs and evolved into a fascination
with the sober beauty of Japan's everyday work textiles (*mingei*). Later, a distinct group
of textiles related to *mingei* and intended for the Shinto-Buddhist shrine festivals
called *matsuri* beckoned to me. *Matsuri* textiles, however, seemed to deny everything
I had learned of Japanese aesthetics.

The tasteful restraint, elegance of line, and attention to surface textures that have
come to be associated with Japanese arts were nowhere to be found in *matsuri* textiles.
They were instead shockingly bold and unrestrained in hue, featuring large-scale designs
that directly assaulted the eye and communicated their messages forcefully. I began
to search for an explanation of these startling aesthetics and their acceptance in a social
environment usually thought of as remarkably reserved. As an essential component
of my inquiry, I began to travel to Japan on a regular basis to observe the Shinto-
Buddhist shrine festivals in which the textiles and costumes make their appearance.

Matsuri are held in every corner of the Japanese archipelago, and each summer
over a period of eleven years, I visited as many events as possible, documenting
them through notes, photographs, sound recordings, and videotapes. Although
extant English-language accounts of *matsuri* proved enlightening early in my endeavor,
I was nonetheless initially handicapped by being a foreigner with an incomplete
understanding of what I was seeing. Much more instructive were the interviews I
secured and recorded with festival organizers, priests, performers, textile and costume
craftspeople, and scholars in the related areas of Japanese folklore, history, religion,
and the performing arts. It should be noted, however, that the clear and specific
answers I yearned for as an American were not forthcoming. Instead information
was offered reluctantly, with hesitation and abundant Japanese-language qualifiers:
"maybe," "perhaps" (*deshō*), and "I guess" (*to omoimasu*). Although rejecting absolutes
may be a reflection of Buddhist mores regarding the absence of infinite truth, there
appeared to be some justification for uncertainty and qualification. The facts about
matsuri and its trappings do indeed differ from one locale to another. Tremendous
variations exist in virtually every aspect of the rites, including ritual costumes or
draperies. All festivals, however, are perceived as expressions of an almost universally
respected need to demonstrate awe of the Shinto-Buddhist deities.

Concurrent with my field research on *matsuri*, I completed a masters degree in
the Department of Art History at UCLA, taking a number of courses in the Department
of East Asian Studies. I focused on the history of Japanese design and culture, as well
as the study of the Japanese language. The myriad examples of weaving and dyeing I
have encountered in my formal studies as well as in the field provide abundant evidence
of the long tradition of high standards for cloth worn and used in Japan. Before the
twentieth century, Japan was a nation of handweavers and textile artisans creating
superb textiles of bast fiber, silk, and cotton from handlooms and backyard dye pots.
It remains a nation in which both genders carefully discriminate regarding details of
fabrics and attire. Reflecting taste through dress has also enjoyed a high priority, and
concern with being suitably attired and demonstrating awareness of fashion has been a
notable preoccupation of Japanese society. Unlike many other nations where it is the
affluent in particular who demonstrate great concern regarding details of wardrobe,

in Japan ordinary working men and women, office ladies and salarymen, housewives and farmwives, as well as the advantaged, tend to be selective about cloth and design, and seemingly ready to stretch budgets in order to display their sense of taste.

In Japanese literature and drama, references to dress abound. The *Kojiki,* annals of the lives of the Japanese deities completed in 712 c.e., records the parting song of Opo-kuni-nusi, consort of the Japanese queen Suseri-bime. As Opo-kuni-nusi is about to depart on a trip, it is suggested in the Philippi translation (1968, 108), that his leave-taking was not entirely loving and that an abundant display of jealousy on the part of the queen may have motivated his decision to go. In the song below he appears to be either strenuously attempting to charm or distract her, changing his attire three times while he sings:

> All dressed up
>> In my jet-black clothes
> When I look down at my breast,
>> Like a bird of the sea,
> Flapping its wings,
>> This garment will not do;
> I throw it off
>> By the wave-swept beach.

> All dressed up
>> In my blue clothes
> Blue like the kingfisher,
>> When I look down at my breast,
> Like a bird of the sea,
>> Flapping its wings,
> This garment will not do;
> I throw it off
>> By the wave-swept beach

> All dressed up
>> In my clothes dyed
> With the juice
>> Of pounded atane[2] plants
>> Grown in the mountain fields,
> Now when I look down at my breast,
>> Like a bird of the sea,
> Flapping its wings,
>> This garment will do. [Philippi 1968, 108–9]

This volume seeks to identify and describe the exuberant textiles and costumes of *matsuri* and to consider their significance within their cultural context. Many of the examples illustrated date from the Meiji period (1868–1912), the last time when handwork was produced by individual artisans for their own use or that of their neighbors. The textiles and articles of attire were collected from sources throughout Japan between 1979 and 2000. They are preserved today in the collections of the UCLA Fowler Museum of Cultural History and have been supplemented with examples drawn from other public and private collections. The unique focus on festival arts in

this publication allows us to identify the special aesthetics that differentiate the textiles worn and used on Japan's holy days.

At *matsuri* a cascade of beautifully crafted garments in vibrant hues meets the eyes, foregrounded distinctly against the hushed simplicity of the Shinto shrine. As the festival gets underway, the costumes and textiles seem to become an independent organic form, floating and expanding in shape and shade, assembling into a linear procession, then disintegrating into dance forms of circles and rows. Ultimately these swell into dynamic pulsating clusters in rhythm with the big *taiko* drums that summon performers to makeshift stages. It is an incredibly vital spectacle of human artistry at the service of a sacred occasion. Watching a *matsuri*, I realize that my long fascination with the "close arts" of individuals has expanded into a quest to understand the spiritual roots of an entire people.

Gloria Granz Gonick

Acknowledgments

THIS PROJECT COULD NEVER HAVE COME TO FRUITION WITHOUT THE HELP OF THE MANY generous individuals who have given unstintingly of their time and knowledge. In Japan, inspiration over the entire eleven-year period of my research was provided by Professor Yamanobe Tomoyuki—a tireless teacher, who consistently responded to queries with kindness, patience, and clarity. Others also readily made their scholarly expertise available. These include Professor Nagasaki Iwao, Kiyoritsu Women's University, Tokyo, to whom I am grateful for writing an insightful foreword to this volume, and Professor Sugimura Toh, the former director of the National Museum of Ethnology, Osaka, who has graciously helped me over the years, as well as Professor Tanno Kaoru of the International Association of Costume, Tokyo, and Professor Inoue Nobutaka of Kokugakuin University, Tokyo. Professor Fukuhara Toshio of the National History Museum in Sakura clarified several concepts for me, including that of *furyū*, when he showed me his institution's *chōchō odori* screens. Wada Mitsuo, the director of the Ōtsu City Museum, graciously opened the museum's vaults, permitting me to document the imported artworks preserved there.

Morita Tadashi proved an unfailing source of connoisseurship regarding *mingei* artworks and graciously provided hospitality in Tokyo. Akatsuka Noriko made my first terrifying encounter with Japanese characters and grammar as painless and enjoyable as possible. Kazuko Kotsugi Stearns illuminated not only the Japanese language but also Japan's culture. As a gesture of friendship, she and Professor Nakanishi Hisae both altered their busy schedules more than once to travel with me around Japan in the heat of the summer. Each year Sasaki Kohachi has extended warm hospitality in Osaka. In Tokyo and Kyoto, Toyota Mitsuo introduced me to the charm of *tenugui* design. The help of excellent translators has been invaluable throughout the project. These have included: Ueno Yumiko and Ito Sayuri and her parents in Kyoto; Kitazono Yuka and her parents; Nabeshima Nobuko; Iwata Atsuka; Saito Yoko; and Ono Saori. All have been not only helpmates but also enthusiastic and congenial companions. Gratitude is due the Japan National Tourist Organization for facilitating research travel in 2000. The Tokyo Bruins and Eric Rutledge are also deserving of thanks.

My joyous initiation into the world of *matsuri* took place in Sendai, an experience made memorable by the Amae Shin-rokuro family of that city—including Dr. Amae Shin-taro and Amae Setsuko (née Kobata Setsuko)—as well as by Hakomori Mitsuko of Sendai and Seattle and her sister, the esteemed weaver, Hayasaka Yoshiko. The preparation in Japan for material on imported *matsuri* textiles in chapter 5 was made possible by a generous grant from the Japan Foundation in 1994. The pioneering study of imported artworks in the Gion Festival published by Kajitani Nobuko and Kojiro Yoshida (1992) formed the basis of my research on that collection, as did personal communication with the authors. In 1994 I also benefited from access to the facilities of the International Research Center for Japanese Studies in Kyoto and particularly from insights provided by Professor Yoneyama Toshinao, then also of Kyoto University. The staff at the Kyoto Cultural Exhibition Room, Sakura Bank, were consistently helpful as was Ito Munehiro, the director of the Library of Historical Documents, Kyoto. I am grateful to the San Francisco Bay Area Rug Society for funding acquisition of the Gion Matsuri Yamaboko Rengokai transparencies, which were indispensable to my research. Many thanks are due as well to Alan Marcuson and Nicholas Purdon and to *Hali Magazine* for their participation in the study in 1994.

Sessions with Professor Ohtsuka Kazuyoshi, of the National Museum of Ethnology, Osaka, crystallized my understanding of the Northern Silk Route, and Professor Serizawa Chosuke of Serizawa Keisuke Art and Craft Museum, Tohoku Fukushi

University, Sendai, provided materials that furthered my investigation. In China, Professor Kevin Stuart of Xining Teachers College, Qinghai Province, kindly illuminated the ways of the peoples of western China. Wang Mian-hou, director of the Liaoning Provincial Museum, and his staff provided insight into the role of China's northeast as did Professor Yang Yang, the director of the Ming Qing History Department, Social Science Academy, Jilin Province. Important assistance was received as well from Professor Chen Bingying, Director, and Zhang Pengchuan, Vice-Director, Gansu Provincial Museum. Zheng Lan Sheng, Deputy Division Chief, proved a tireless guide in that region. Gratitude is due to Professor Hao Sumin, Northwest Minorities University, who interrupted his schedule to help uncover links between the wool weavings and the peoples of Gansu. Li Jinzeng, Director, Ningxia Relics Research Institute, Yinchuan, provided assistance during my visit to Ningxia. In Shanghai, Professor Gao Hanyu, Vice Director, Shanghai Textile Research Institute, provided valuable historical and technical information about silks and was equally knowledgeable on the topic of wool weavings. In Palos Verdes, California, during the course of two lengthy visits, Lee Yu-kuan described the market towns of western China that he had known in the early decades of his long life.

From the beginning, this study was undertaken and formulated with the guidance, continuing friendship, and inspiration of Professor Bernard Kester, formerly acting dean of the UCLA College of fine Arts, who has continued to provide insight and encouragement. I am grateful that Professor Kester and Professor James Bassler were willing to permit enough flexibility in my Master's Degree program to enable me to initiate my studies of Japan's *matsuri* arts. Enormous thanks are due as well to professors in the Department of East Asian Languages and Literatures at UCLA, particularly Professor Herbert Plutschow, who has acted continuously as a mentor and who guided my diffuse observations of *matsuri* textiles into a meaningful construct. Professor William Bodiford has provided help with the Buddhist aspects of Japan's syncretic Shinto-Buddhist religion. Throughout the years, the resources of the UCLA East Asian Library and its staff have been indispensable, as has the help of librarian Toshie Marra and her predecessor, Toshiko McCallum. In Claremont, Professor Leonard Pronko, chairman of the Drama Department at Pomona College, and Tomono Takao have been rich sources of friendship and of insight into theater costuming.

At the UCLA Fowler Museum of Cultural History, I am indebtded to former director Doran Ross for his help with early proposals and overseeing the initial stages of the development of the project. Marla Berns, the Museum's current director, has seen this volume and the accompanying exhibition through to their culmination. I am extremely grateful for her support and her vision. I wish also to thank Roy Hamilton, the Museum's curator of Asian and Pacific Collections, for his involvement in the development of both the text of the book and the exhibition.

Throughout my long involvement in this project the inspiring, visionary, multitalented Sandy Bleifer has proven a stalwart friend and traveling companion. This is true as well of my textile comrade Dr. Brenda Focht, curator at the Riverside Municipal Museum. I thank them both for their enthusiasm and efforts on my behalf. Dr. Jean Krag has been a source of encouragement and unfailing support.

Finally, I wish to express my gratitude to my husband, Dr. Harvey Gonick, for serving as an example of excellence and dedication, and for his continued acceptance of my devotion and commitment to this project over many years. Throughout everything, he and our children have provided strength, comfort, and affection, and I am grateful for their sacrifice of my time and attention.

Gloria Granz Gonick

MAP OF SELECTED *MATSURI* SITES THROUGHOUT JAPAN

YELLOW SEA

KOREA

EAST CHINA

SEA

Ōda-shi
Kumano Taisha
Izumo

Kokura
Karatsu
Miyajima
Hakata
Saga
Okayama
Nagasaki
Himej
Ariake-cho
Takamatsu
Kobe
Kotohira
Osak
KYŪSHŪ
Tokushima
Sa
Uwajima
Kochi
Wak
Hitoyoshi
SHIKOKU

Kagoshima

Naha
OKINAWA

0 150 mi
0 300 km

HOKKAIDŌ

Sapporo

Abashiri

Kushiro

Mutsu

Aomori

Hirosaki

Hachinohe

Akita

Morioka

Yokote

Hanamaki

Sakata

Tono

Mizusawa

Yamagata

Shiogama

Yonezawa

Sendai

azawa

Takaoka

Ojiya

Aizu-Wakamatsu

Soma

Yatsuo

hirakawa-mura

HONSHŪ

ıga

Takayama

Nikko

hama

Suwa

Utsunomiya

Inuyama

Ena

Chichibu

Nagoya

Kofu

Kawagoe

Hamamatsu

Tokyo

Yokohama

Narita

Enoshima

Kamakura

Yokosuka

Katsuura

ASIA

PACIFIC OCEAN

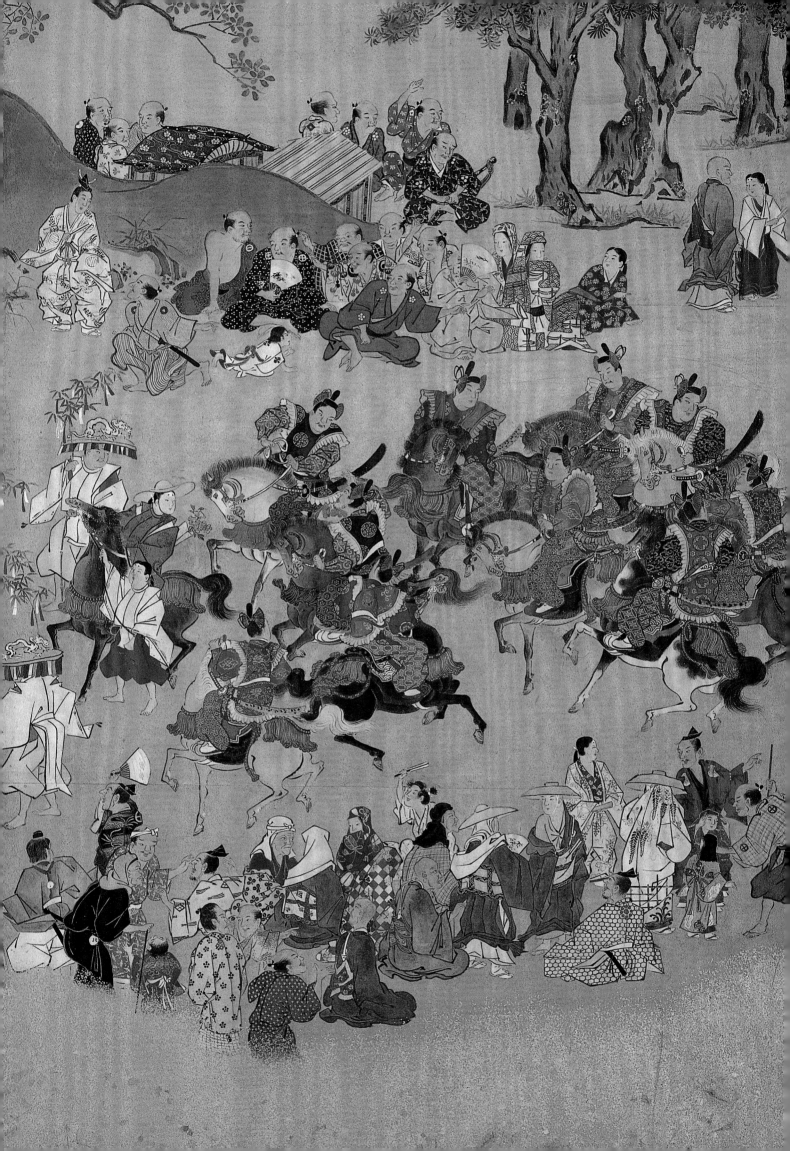

ONE Introduction to Shinto Festivals

GLORIA GRANZ GONICK

LATE ONE SUMMER AFTERNOON, HEARING LAUGHTER RISING FROM THE BUSY TOKYO sidewalk below my hotel, I peered down in the direction of the voices. A cluster of animated young men, identically dressed in white cotton kimono with bold blue designs, seemed to be heading gaily down the street. The day was an ordinary workday in Japan, which would typically call for sobriety and conservative business attire, so the lighthearted and playful attitude of the young men was surprising. Descending to the street, I learned from a passerby that they were headed for a nearby *matsuri*. *Matsuri*, it was smilingly explained, was the term for a Shinto shrine festival.

The whimsical patterns on the strollers' robes seemed to reflect their ebullient behavior and prompted me to learn more about *matsuri* and its dress. That resolution evolved into a mission to investigate and record the unique festival textiles of Japan. From 1989 to 2000, I attended and documented over twenty-five festivals throughout Japan (see map, pp. 16–17). I especially sought out *matsuri* that were said to retain traditional features and, whenever possible, traditional attire. Due to my interest in historic textiles, I was particularly eager to spot examples of the artisanship and originality that had become increasingly scarce during the passage of the twentieth century. These examples have become the particular focus of this book, although notable textiles produced in recent times have also been included.

As I traveled, the appearance and atmosphere of Japanese *matsuri* continuously amazed and delighted me. I learned that the rites were held in fulfillment of Shinto ideals of repeated periodic purification of the land of Japan and its people (figs. 1.1, 1.2). Matsuri were scheduled in order to insure the healthy continuation of communities, as well as the productivity of fields and farmlands. Although events loosely follow a pattern dictated by this Shinto purpose, the *matsuri* held in various locales are truly distinct. Each time I felt that I had seen every possible variation of the means to induce this sacred renewal, fresh interpretations presented themselves. In this volume I describe some of the types of *matsuri* textiles and dress that I witnessed and provide a

Detail of fig. 1.3a.

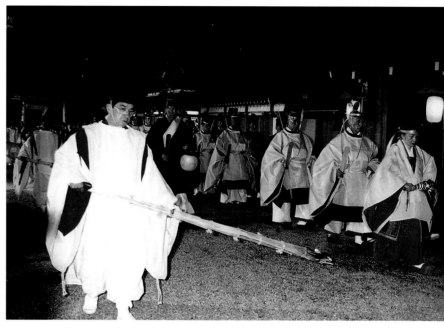

1.1 Izumo Taisha Shrine is the oldest and the largest Shinto shrine in Japan. Legend has it that the sun goddess Amaterasu originally had it built for the god Okuninushi-no-mikoto in recognition of his bequeathing the islands of Japan to her grandson, who would become the grandfather of Jimmu Tenno, the first emperor of Japan. The shrine has been rebuilt twenty-five times. The extant buildings were constructed in 1744 Photograph by GGG, Shimane Prefecture, 1992.

1.2 The procession at the Grand Shrine of Ise celebrates the total reconstruction of the shrine, which takes place every twenty years for purposes of purification (*shikinen sengu*). The priests are led by Atsuko Ikeda, a *miko* (female shrine custodian). At Ise the post of *miko* is usually held by an unmarried princess of the Imperial Family. This photograph appeared in *The Japan Times*, October 4, 1993. Photograph reproduced with permission of Kyodo Photo Service.

synopsis of typical proceedings at which they appear. As the details of each *matsuri* are unique, however, there are no garments or trappings that are found at all *matsuri*. Rather, rites common to many *matsuri* correlate with specific types of textiles designed to enhance a particular segment of the event.

In towns and cities, the textiles and costumes specific to *matsuri* would begin to make their appearance on a designated day at dusk, the traditional beginning of a new twenty-four-hour day in old Japan. As the sunlight dimmed, ordinary street clothes would gradually give way to festival garb—brighter, bolder, and more loosely bound. Robed participants, priests, officials, and spectators would begin to assemble in a local Shinto shrine arena surrounded by trees to witness the preliminary rites. Eerie melodies in minor keys thought to emulate the voice of the deities and sung by officiating priests would gradually fill the air. The shrill notes of the Japanese flute would accompany these otherworldly strains. The thunderous beats of the big *taiko* drums would reverberate through the last rays of receding sunlight, calling the deities from their leafy lairs. The powerful booming drumbeats are intended to urge them to attend the extravagant homage that will soon be offered them.

A shared anticipation seems to course through the crowd attending such an event. An edgy energy moves from participant to participant, filling each with a sense of excitement in the face of impending change. Uncertainty about what the future might bring provokes nervous giggles from the assembled worshipers, who make minor adjustments in their obi or to the shoulders of their cotton kimono. The crowd, nonetheless, waits for the priests to finish the essential rounds of preliminary chants while hesitant optimism mixed with impatience increases the near-palpable tension. Hushed murmurs gradually become shouts as last-minute instructions are repeatedly relayed by neighborhood officials to bearers assigned to the holy ark (*mikoshi*) containing the spirit of the deity. Orders are barked simultaneously to the many porters of the decorated festival wagons assembled for the beginning of the procession.

Along the perimeter of the yard crowds begin to thicken and become three or four deep. The human wall defines a new physical enclosure around the arena. The

tantalizing scents of barbecuing squid and eel doused in soy sauce—to be hawked nonstop at the hot food stands erected for holidays—leap fences and infuse the air. Mixing with the heavy smoke and odors of cooking is the scent of earth, recently dampened by a light rain. The smell of horsehair and animal sweat is evident as well, rising from the manes and hides of shrine ponies awaiting the procession in stables nearby, their tack gussied up and oiled.

Meanwhile on the shrine grounds, lion dancers (*shishi*) frolic. Prancing and swirling, they frequently clack their prominent lacquered jaws. The barking and dancing of *shishi* are said to give pleasure to the gods, motivating them to attend the festivities held in their honor and to extend their benevolent will for the coming period. *Shishi* dances bring abundant fortune to those mortals that they especially pester. Their clamor is happily endured by old and young, although now and then a thoroughly frightened child breaks into tears and seeks the reassuring arms of a nearby parent.

Just moments later, the aural onslaught recedes in importance in the face of an oncoming spectacle of color and pattern, shifting and floating before one's eyes. Soft billboards of heavy cotton, dyed with indigo and emblazoned with bright white Japanese *kanji* (Chinese-derived characters) ripple skyward. The lengthy banners (*nobori*), strung high on bamboo poles, grandly announce the name of the festival.

As preliminary rites draw to a close, the crowd moves from the shrine arena to the main street of the town. Bystanders line both sides of the street, avidly seeking perches on top of walls or along stairways with high visibility for the coming procession. As night descends spectators pour over the sidewalks and bend from overhead balconies, all straining toward the far end of the street. In hilly towns the road turns abruptly upward and disappears around a corner, augmenting the sense of mystery about what lies ahead. Such terrain lends itself to a sudden appearance by the deities, their dramatic entrance considered particularly potent. As crowds continue to grow thicker, no one seems to be concerned about stepping on a fellow celebrant, balanced on tiptoe. The willingness to touch and be touched by strangers in what is usually a self-contained and very private society is striking. Totally engaged, spectators of all ages—seemingly oblivious to being rustled and shoved—vye good-naturedly for the choice spots, appearing as one in their determination to fully absorb the coming spectacle.

Jangling gongs and bells, piercing notes of flutes, and the rhythmic and continuous thunder of drumbeats herald the arrival of the first wagon to round the bend, preceded by its entourage of priests and escorts. Bands of musicians (*hayashi*) and festival dancers, some self-accompanied with hand drums, triangles, cymbals, and bells, can be heard approaching from blocks away. The gilded sculptures and lavishly costumed mannequins on the wagon enjoy a rousing reception comparing favorably with that bestowed on rock musicians at other times and places. This vibrant moving exhibition, produced and manned by neighborhood devotees, receives an increasingly clamorous ovation as the wagons slowly roll by on their huge wooden wheels.

DEFINING *MATSURI*

Matsuri were first established in the beginning centuries of the common era, and they have been celebrated ever since (Tsunoda et al. 1958, 1: 21–23). Before Western influence became widespread in Japan in the twentieth century, *matsuri* were almost universally celebrated with heartfelt devotion (fig. 1.3a,b). Religion played a significant role in the life of the Japanese people, and *matsuri* were their most important religious events. By the Meiji period (1868–1912), the era of Japan's first modern encounter with European and American culture, the significance of local shrine rituals had

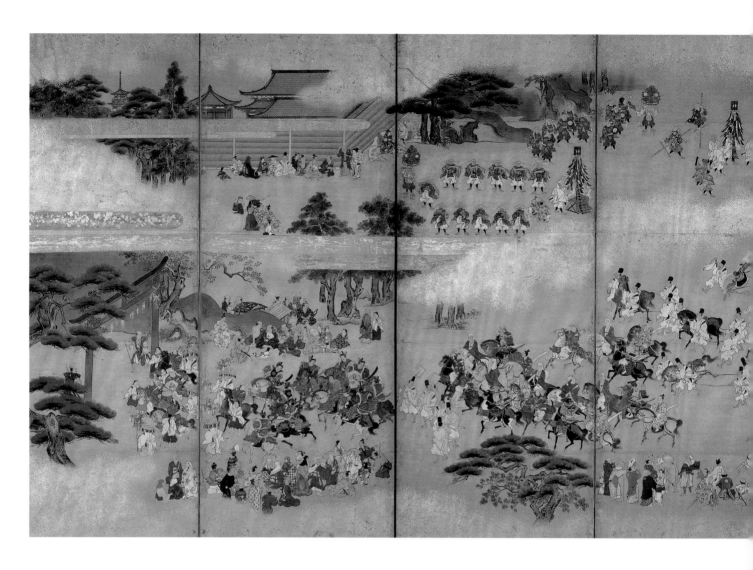

1.3a,b Kanō Ryūsetsu
(1646–1712). *Kasuga Wakamiya
Festival*, Edo period. Pair of
six-fold screens. Color on paper.
Each screen: 161.5 cm x 371 cm.
Collection of Joe and Etsuko Price.

This is the only known screen
depiction of the famed Kasuga
Wakamiya Festival. The festival
procession is shown winding its
way across both screens before
entering the shrine on the right-
hand screen at the upper left.

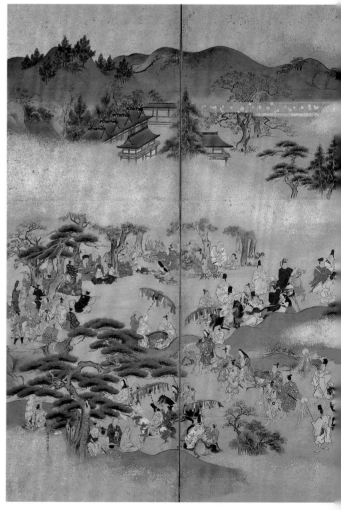

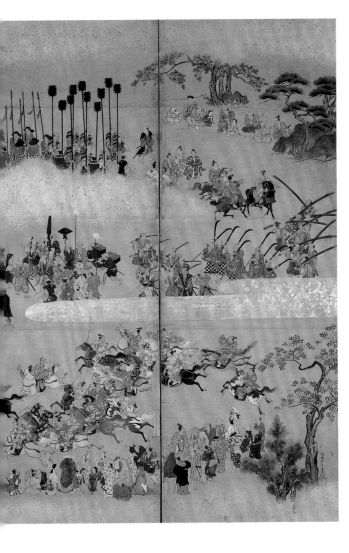

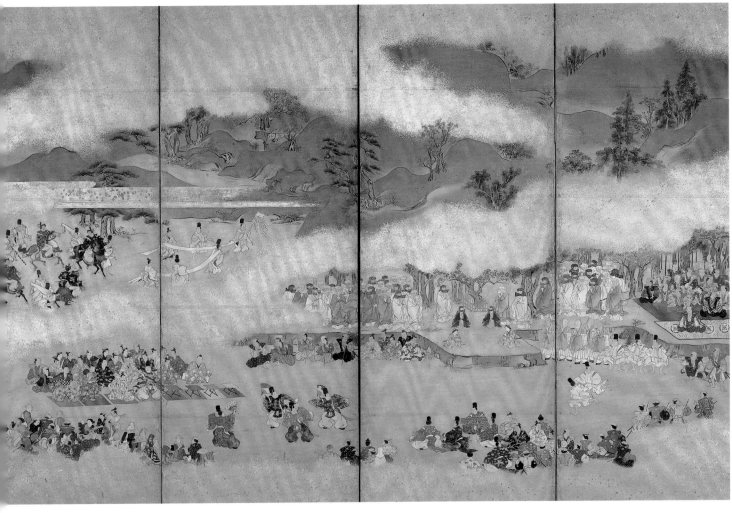

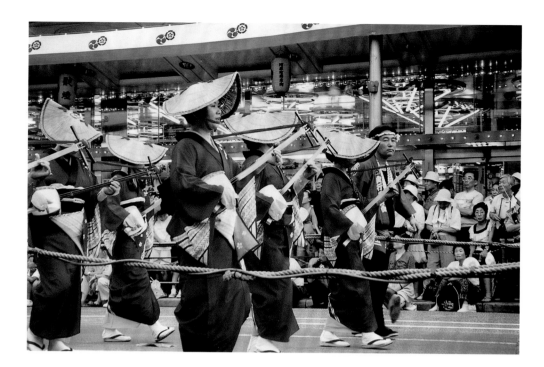

1.4 At Awa Odori Matsuri troops of musicians and dancers promenade from site to site past viewing platforms set up on several streets. These *shamisen* players wear crimson kimono over turquoise *juban* (under-kimono). Photograph by GGG, Tokushima, Shikoku, 1989.

begun to diminish, as industrialization and the consequent population shift to urban centers loosened regional loyalties. Nevertheless, in many Japanese towns and urban neighborhoods today—even where drastic modifications have taken place—*matsuri* rites survive and remain highly anticipated popular events.

The essence of *matsuri* is a prescribed sequence of religious rites held for a group and led by a Shinto priest. The original impetus for establishing a *matsuri* was usually a felt need to commemorate a historic event of local significance or to seek a fortuitous change in the economic or agricultural outlook of a community. To accomplish this, it was deemed necessary to directly interact with the Japanese deities (*kami*) and beseech their cooperation.

Matsuri may last one day or several days, and in addition to the sacred observances, they may include a lively costumed pageant, promenading bands, and semiprofessional dance troops, as well as abundant feasting and drinking. Traditionally all of these elements have been considered facets of the worship proffered the local deity or deities. Today, however, they are increasingly viewed in a secular vein. Entertainment value seems to have become of primary importance for the younger generation, who may in some instances just "walk though" the sacred rites. Interestingly, however, as these same young people marry and have families, many resume their participation, eventually making certain their own children are aware of Shinto—the way of the Japanese gods.

Matsuri are hosted by a particular Shinto shrine (*jinja*) of one community, and organized by its neighborhood association (*chōnai-kai*). Each *matsuri* is, therefore, a unique product of the community that organizes it. Because of this, the forms of ritual and performance seen in *matsuri* are amazingly rich and varied. Although *matsuri* tend to defy precise analysis, attempts have been made by scholars to identify common elements and to group the festivals accordingly. One useful classification has been put forward by Hori Ichiro, who divides *matsuri* according to their function: "(1) Rites relating to the seasons and to furthering agricultural productivity. (2) Rites held for protection against unforeseeable disasters, such as epidemics, fire, and wars. (3) Rites which seek to abet individual ability to cope with unpredictable changes in personal or interpersonal relationships such as birth, adolescence, marriage, and death" (1968, 25).

The scheduling of *matsuri* rites was once determined by the lunar calendar. In each month the new moon, half-moons, and full moon were considered holy days

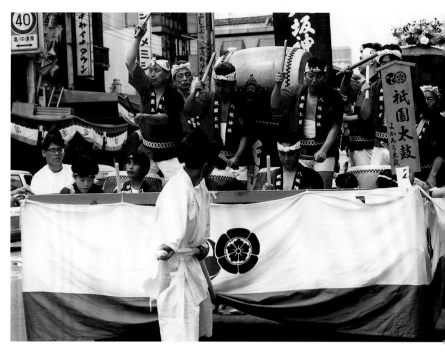

(*hare no hi*) as distinct from ordinary days (*ke no hi*). Although Shinto festivals were in the past scheduled only on *hare no hi,* in light of the modern work agenda many now take place on weekends when it is convenient for residents and visitors to participate. A few, for a variety of reasons, are held on the same date each year. Scheduling is not nationally determined but remains the purview of an individual community. When conflicting dates are set within one prefecture, there appears to be some juggling to reach consensus so that citizens of neighboring vicinities can participate if they so desire.

Although events are organized by the congregation of one particular Shinto shrine, they are not held inside the shrine sanctuary but in an adjacent hall, a surrounding arena, or at a nearby location in the town. This reflects the conviction that the Japanese deities may be invited to temporarily inhabit structures or may exert their will to do so. Shrine sanctuaries, unembellished and of simple modular design, are built to temporarily shelter the *kami*.

The term *matsuri* means "to offer worship" in the sense of serving the *kami* and showing them devotion. During *matsuri,* an extraordinary environment is established in order to capture the attention of the deities and to effect a time of interaction during which the benevolence of the *kami* may be sought for the coming period. The goal of *matsuri,* the renewal of communal and agricultural energies, is believed possible only with the cooperation of the deities.

One of the primary means of establishing such an extraordinary environment is the use of special textiles and trappings, as distinct as possible from the everyday (figs. 1.4–1.6). The vibrant color and large scale of *matsuri* textile designs reflect the optimistic and expansive attributes of Shinto festivals and promote high visibility amidst what is always group worship, frequently crowded with devotees. Worn by participants, unfurled in processions, and displayed at the shrine and on the city streets, *matsuri* textiles make everyday clothing and surroundings seem pale by comparison. Despite the enthusiasm with which they are employed and their religious significance, festival textiles have received little scholarly attention. Their beauty has largely been overlooked by scholars who have dismissed them as "popular arts" not to be viewed seriously.

1.5 *Shaguma* are charcters who appear annually in the Gion Matsuri procession. They wear wigs made of crimson-dyed yak hair and gold metallic and silk brocade garments. Their costumes are decorated in *uroko* (snake scale) motif, a reference to their bestial nature. The red hair of the *shaguma* and their grandiose mannerisms are thought to have originally been inspired by the Dutch traders who arrived in Nagasaki in the 1600s. Kyoto, 1994. The Hali Archive.

1.6 In the days preceding Gion Matsuri, wagons filled with drum corps move through the streets of Kyoto. Their goal is to attract the attention of the deities and to summon participants, while at the same time driving away any malevolent spirits who may linger. Photograph by GGG, Kyoto, July, 1990.

Furyū *and the Aesthetic of Matsuri*

Matsuri behavior, attire, and trappings have their origins in *furyū*, the elements in religious rites that are intended to astonish the deities. In the festival context, *furyū* signifies a captivating commotion, a frenzied and unruly, but nonetheless artful, uproar. This is achieved through rounds of dance, song, and costumed procession, intended initially to gain the attention of the deities and then to appease their malicious aspects while also winning their goodwill for the coming period.

Furyū originated from the Chinese term *fūryū*, which signifies objects or actions reflecting a high degree of sophistication and elegance. During the Heian period (794–1185), *furyū* was used to describe colorful and lively activities (*goryō*) thought to counteract the negative forces of the vengeful spirits who brought about epidemics and natural disasters (Plutschow 1996,10). One type of *goryō* was known as *neri* (snake going). *Neri* were costumed line dances accompanied by incessant loud music. The inability of man to ward off natural disasters may have inspired this frenzied performance—desperation channeled into spontaneous unstructured dances, as well as structured examples. *Goryō* also included performances by twirling, beribboned dancers. These are preserved today in Dengaku (ritual field dances). Dengaku may have been related to the spinning dances or carpet dances (in which the dancer steps and spins on a small round carpet) of central Asia and western China. Dances of this type are suggested by Buddhist cave paintings in Dunhuang, Gansu, China, and portraits of dancers in the Xi Xia Kingdom preserved in museums at Yinchuan, Ningxia Province, and Wuwei, Gansu Province. The twirling and spinning doubtless contributed to the state of disequilibrium deemed most conducive to communicating with supernatural spirits.

In Japan *furyū* dancers were often attired in vibrant costumes with fluttering sleeves and sashes. The fluttering was thought to dispel malicious vapors while beckoning and absorbing beneficial aura. It seemingly inspired the term *chōchō* (butterfly) used to describe the dancers portrayed in Muromachi (1392–1568) and Edo-period (1615–1868) paintings.[*] Thus individuals engaged in *furyū* seem to be beckoning supernatural aid with frenetic movement, while colorfully attired in flowing fabrics. They are sometimes masked and accompanied with drums and *binzasara* (a percussion instrument consisting of several pieces of bamboo threaded on a cord). The dances are presented skillfully, in a manner intended to charm and please the deities and to demonstrate gratitude for their protection. The demonstration of passion and sincerity reflected in the decoration of participants and of the festival is called *furyūza* (Moriya 1985, 72).

Related to *furyū* are associative acts of presentation that employ the notion of *metate* to extend the significance as well as the time frame of an object (Yamaguchi 1988, 2, 3). *Metate* is used to elicit associations with well-known aspects of literature or history, a cherished and ubiquitous cultural and communicative practice in Japan. A presentation or an offering should extend beyond the object or activity itself. It is believed that the Japanese deities do not appreciate objects in their raw state but rather admire that which has been altered by sincere and artful device. One must refine that which is offered to the deities or to one's fellow man. When a gift of flowers or plants is offered, the flora should be refined according to notions of ikebana. When a food such as fish is presented, it should be skillfully cut or presented as exemplified by sashimi. Moreover, the result should indicate that preparation occurred with ease, with no hint of strain. The Japanese deities reject signs of stress in undertakings. Matsuri platforms and decorated wagons should reflect principles of *furyū*, *metate*, and ease. They thus serve as suitable vehicles by which the deities may descend into the festival.

Note

[*] A screen painting of *chōchō* dancing may be seen in the collection of the Sakura National Museum of Japanese History. Another example is the painting *Costume Dances* by Ozawa Kagaku found in the Osaka City Museum.

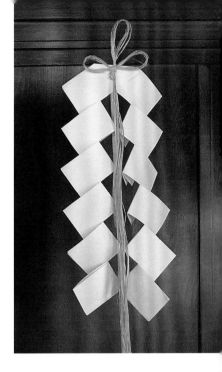

1.7a A contemporary Shinto altar is laden with offerings in preparation for worship services. Photograph by Don Cole, Konko Church, Los Angeles, 2002. Collection of Reverend Doctor Alfred Tsuyuki and Konko Church.

1.7b Pure white paper ritually folded into triangular shapes (*heisoku*) sanctifies a Shinto place of worship and its worshipers. Photograph by Don Cole, Konko Church, Los Angeles. Collection of Reverend Doctor Alfred Tsuyuki and Konko Church.

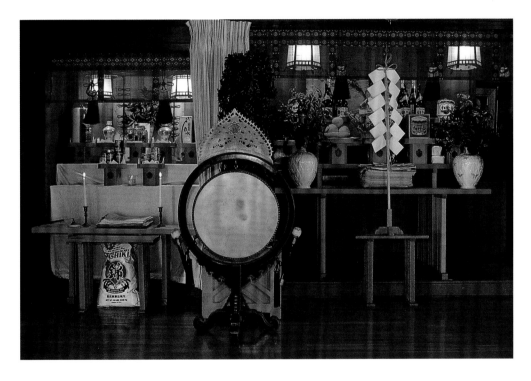

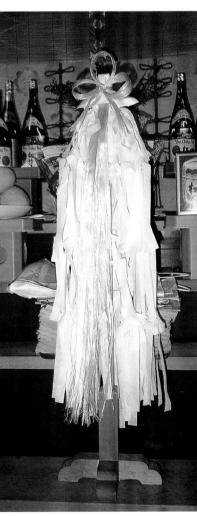

SHINTO

Matsuri are thought to have been held periodically since the earliest beginnings of communal life in Japan (Pearson 1992, 197, 270). They are the most important rites of Shinto (Ono 1962, 63), which is regarded as Japan's indigenous religion (figs. 1.7a–c). Shinto emerged slowly over centuries, crystallizing as a faith combining an early esteem for the divine spirits in nature (*kami*) and the reflection of those spirits in extraordinary beings, including animals and humans. Reverence for the Imperial Family became an important tenet during the Nara (645–794) and Heian (794–1185) periods.

Shinto advocates the pursuit of *makoto no kokoro* (the true heart), as a prerequisite to clear interaction with the *kami*. Ethics emanate from an awareness of the divine (Hirai 1987, 288). Shinto may be distinguished from Western religions in that all is based upon worship of the *kami*. It is polytheistic and has no founder, no scriptures, no commandments, nor any fixed dogma. Its practices emphasize honorable attitudes in the here and now, a focus on ethical behavior in this world. Conduct expected of Shintoists includes the offering of gratitude and supplication to the *kami*, ascetic discipline, social service, and participation in *matsuri* rites.

1.7c A cluster of pure white paper strips or strands of hemp (*haraigushi*) functions to purify the worshipers. Photograph by Don Cole, Konko Church, Los Angeles, 2002. Collection of Reverend Doctor Alfred Tsuyuki.

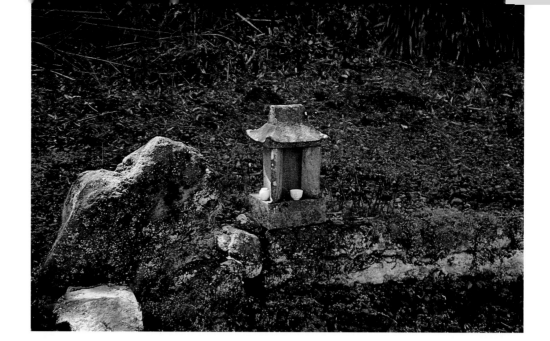

1.8 *Kami* are thought to reside in simple sites in the natural environment. Offerings of sake made by local worshipers can be seen in this impromptu wayside shrine. Photograph by David Mayo, Ariake-cho, Kyūshū, 2000.

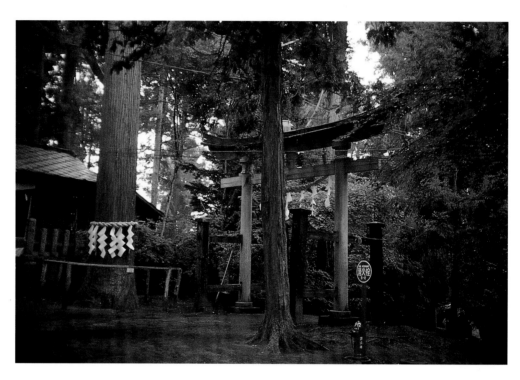

1.9 An unusually beautiful or venerable natural object, such as this tree, may be indicated as sacrosanct by the use of sacred papers (*shide*). Photograph by GGG, Hachinohe, Aomori Prefecture, 1993.

The *kami* consist of an amalgam of legendary Shinto and Buddhist spirits who govern specific areas of the universe in a vague hierarchy (fig. 1.8). They are considered noble and are worshiped for their virtues and superhuman powers (Ono 1962, 6–8). In some cases the anima of an outstanding ancestor or a founder of a community is deified and worshiped. Most *kami* are considered both Shinto and Buddhist in various aspects (Plutschow 1996, 59–64). They are spirits who function harmoniously, cooperate with one another, and value the same conduct on the part of humans (Ono 1962, 5, 7, 8).

An outstanding human being or one notable for some special characteristic might be deified after death. Artists whose talent or craftsmanship is especially notable are thought to have supernatural inspiration and potential power. Japan's deities are believed to inhabit high places, although not as remote in altitude as the Christian heaven. *Kami* are close by, spirits who temporarily inhabit objects and sometimes persons. They may exist in phenomena such as growth and fertility or in a remarkable rock formation, rushing river rapids, or a particularly spectacular peak like Mount Fuji (fig. 1.9). They are not thought to reside in a distant unapproachable place but rather in the nearby forested high mountains. Although nonhuman, they are sociable and descend when called down by means of clapping, signaling, drumming, and chanting (figs. 1.10, 1.11).

1.10 The Japanese *kami* can be called forth by the clapping of hands or the beating of drums. They respond to such a summons whether issued by an ordinary individual or a priest. Photograph by GGG, Ōda-shi, Shimane Prefecture, 1993.

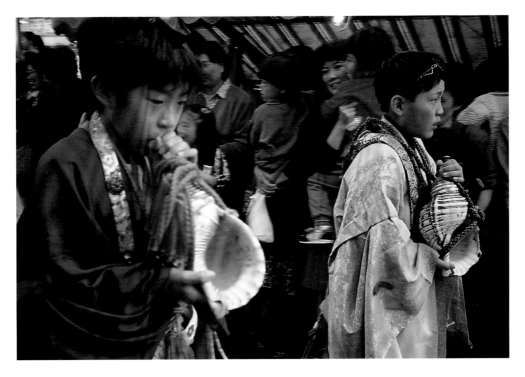

1.11 A young member of a *yamabushi* group (a Buddhist mountain sect) near Ueno-shi in Mie Prefecture beckons the *kami* by trumpeting on a conch shell. Photograph by GGG, Tenjin Matsuri, Ueno-shi, 1991.

Ancestral deities are said to play an important role in agricultural festivals held in rural districts, where the goodwill of supernatural forces is deemed crucial to success with crops (Shibusawa 1958, 366–67). In these celebrations, the timing of the festival and often the inspiration for textile designs are related to the local harvest. Ancestor worship has been practiced from earliest times in Japan, and wet-rice agriculture was introduced to the islands about 200 B.C.E. from the Asian mainland. By deifying a charismatic or successful pioneer agriculturist, it was believed his spirit (*hitogami*) was enabled to continue guiding the community (Moriarity 1972, 134–36). In the case of fishing communities, the size of the catch is thought to indicate the extent of the local deity's benevolence; it also inspires the motifs on textiles. Founding ancestors of clans (*ujigami*), who are remembered as having no serious defects, eventually achieve the status of deities and are considered amalgamated into a universal god-spirit (Hori 1968, 30–34).

It is also common to deify a personage who is felt to have died in an unjust, violent, or premature manner. It is considered reasonable to permit such victims to exorcise their rage by offering them periodic rites intended to assuage their desire for vengeance and eventually quell their malice. Demons are perceived capable of infecting ordinary persons, or even deities, and willing them to perform diabolic acts. Masked

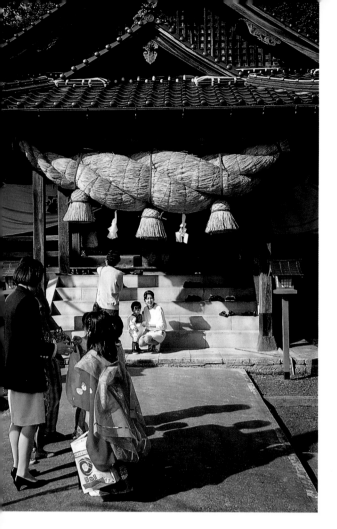

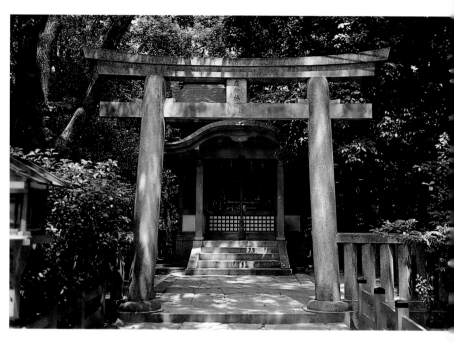

1.12 A *shimenawa* (ritually braided rice-straw rope) marks the boundry of a sanctified space. Photograph by GGG, Koya Hijiri Matsuri, Ōda-shi, Shimane Prefecture, 1992.

1.13 A torii, or gateway, marks the entrance to sacred space. Photograph by GGG, Izumo Taisha Shrine, Shimane Prefecture, 1992.

dances representing such demonic forces are performed. Since exorcism of malicious forces is one of the primary reasons for holding *matsuri,* it is considered important that the demonic forces appear. *Oni* constitute one group of malicious creatures seen at some *matsuri,* although they are perceived more as goblins than demons (see chapter 4).

The prescribed rites of *matsuri* are conducted within sanctified space and time. Sanctified space is an area that has been ritually purified in order to accept the imminent presence of the deities. It is generally bound off by a sacred rope (*shimenawa*), which serves as a barrier and boundary marker designating the space as suitable for the invoking of deities. Such a space, which may become the site of a shrine building, is most often located in a grove of trees within the shelter of mountains and close by a clear stream. Purifactory implements, such as folded paper strips (*shide*) hang from the *shimenawa* and overhead from a torii, or gateway (figs. 1.12, 1.13). Sacred branches, and offerings of bast fibers, salt, and rice derive from the tradition of ritual sanctification (*harae*) and serve the function of ritual cleansers (*misogi*). To accommodate the sacred presence of the deities, worshipers must also be purified. The importance of purity in Shinto is manifested in the requirement that *matsuri* ritualists undergo seclusion for as long as thirty days prior to the event, during which time they must avoid contact with death, disease, menstruating women, sexual activity, and various other conditions seen as polluting. Details of diet and cooking, clothing, and bathing are carefully circumscribed.[1]

During time designated as sanctified by the preliminary holding of purification rituals, the invocation to the deities and interaction with them occurs. This interaction, which is the most important segment of *matsuri,* is also the most important rite of Shinto, thought crucial to the regeneration of the people and the land. Through the worshipers' declarations of awe and gratitude to the *kami,* their presentations of offerings, usually consisting of food and drink, superior entertainments, and displays of artwork, all painstakingly arranged, the deities will be prevailed upon to bestow goodwill on the community. The climax of *matsuri,* therefore, takes place when the spirit of the deity is conveyed by means of a *mikoshi* (sacred ark) through the

The Deities Are Astonished

The ongoing tension between the pure and the polluted is illustrated by a tale from the *Kojiki*, annals of the genesis of the Japanese people, first written down in 712 C.E. and thought to be based on earlier oral histories. The tale is sometimes referred to by scholars as "the first *matsuri*." It describes a confrontation of order with disorder, of the unsullied with the contaminated. Outsiders find the story and its ribald humor somewhat puzzling in that it originates among a people whose image today is one of propriety and serious-mindedness. The main characters are a powerful, if self-willed, heroine, considered the first ancestress of Japan's royal family, the sun goddess, Amaterasu-no-mikami (referred to hereafter as Amaterasu), and her boorish brother, Susanō-no-mikoto, the storm god, (hereafter Susanō), whose pranks provoke a national disaster. Another goddess, Ame no Uzume no Mikoto (hereafter Uzume), a comedian whose jolly yet effective remedy for resolving the catastrophe is lively burlesque dancing, plays a prominent role. The helpful Uzume is nearly always pictured as plump and buxom, sporting a punk hairdo and attired in only a swaying grass miniskirt.

The *Kojiki* describes an argument between Amaterasu and Susanō over whose power is superior, leading to Susanō's display of arrogance in disturbing the order of Amaterasu's rice fields and allowing the dikes to overrun. Susanō, apparently on a binge of brattiness, then defecates in the hall of the tasting of firstfruits. Amaterasu chooses to overlook this serious offense in a spirit of sisterly understanding. However, when he flings the body of a heavenly dappled pony that he has "skinned backwards," evidently a more grievous taboo, through the roof of her weaving hall,

the resulting desecration upsets Amaterasu so much that she wounds herself with the shuttle.[2] Her wound in turn enrages her so thoroughly that she hides in a cave, thereby disastrously concealing the sun from the earth.

The deities, living in darkness and unable to coax Amaterasu from the cave, seek help from the goddess Uzume. Posting herself just outside the cave, Uzume responds by jumping atop an upturned bucket borrowed from her divine colleagues, and merrily baring her breasts and pushing her skirt band down to her genitals, as she bursts into a hilarious dance. Her performance evokes riotous laughter from the other gods. The urge to investigate the cause of this response lures the sun goddess outside. A sacred rope (*shimenawa*) is quickly strung across the cave entrance by the other deities, barring her return. As Amaterasu stares at Uzume, apparently mesmerized by her startling entertainment, sunlight returns to the world (Philippi 1968, 79–85).

The parable is of a world polluted by impure and thoughtless actions and cleansed by the purifying and peace-bringing salve of spontaneous laughter and spirited dance. Executed with robust sensuality, the performance both engages the attention of the deities and delights them. In addition to its important cast of characters and its fundamental theme, the tale's resolution demonstrates the salutary power of earnest entertainment enhanced by the power of dress—and undress. It illuminates the value of shock, which impacts positively, causing a sudden alteration in the disposition of the deities. These elements continue to appear in *matsuri* throughout Japanese history.

celebration for the purpose of this interaction, which enables the assembled to absorb the beneficent aura of the holy spirit.

It is also believed, however, that the fertility of the land, as well as the potential of the community, can only be revived by eliminating stale and contaminated forces built up during the recent past. Human energy deteriorates through time as continuous exposure to everyday humdrum tasks of living destroy vitality. In order to pave the way for a fresh order, tensions enmeshed in human relationships and deterioration in the material world, as well as in society, are brought to an extreme state resembling chaos. During *matsuri* this chaos becomes visible (Ono 1962, 5). The purposeful establishing of a state of disequilibrium at *matsuri* is considered a phase that resembles the periodic deterioration in nature that consistently follows a period of growth.

Renewal after a state of decay is perceived as a recurrent miracle of nature that human action should imitate and honor. During *matsuri*, the cycle of decay and renewal is acted out in dramatic fashion.

THE SOURCES OF THE DESIGNS, MOTIFS, AND INSCRIPTIONS FOUND ON *MATSURI* TEXTILES

Matsuri textiles are distinguished from those used on ordinary days because their function is to both communicate with the deities and to relay the goals of the *matsuri* among celebrants. This is accomplished through their designs, motifs, and inscriptions, which clearly and directly recite the goals of the *matsuri*. In addition, due to their spectacular appearance, they are believed to serve as suitable sites for the spirits of deities during the festivals. By contrast, ordinary textiles are chosen on the basis of durability, fashion, advertising, or personal whim. *Matsuri* textiles exclusively communicate requests for the beneficence or protection of the *kami*. They also serve to strengthen and celebrate membership in a group. To appreciate the messages of *matsuri* textiles, it is helpful to be familiar with the sources of their vocabulary. Shinto and Buddhism are just two of the several inspirations of festival textile designs. Taoist tenets have long been tapped and Confucian ideals have been promoted, as have the

1.14 Theater coat (*hanten*), 1860–1870. Cotton, *tsutsugaki* resist-painted with *takaramono* (precious objects) motif. H: 91.4 cm. FMCH x86.4377; Anonymous Gift.

Shinto, Buddhist, Taoist, and folk beliefs are reflected in the symbols on this elegant *hanten*. It was worn by an actor when performing the Shinto-inspired "Catching the fox" dance in the Kabuki play *Yoshitsune no Senbon-zakura*. See figure 2.16 for a view of the front of this coat and figure 7.2 for a detail.

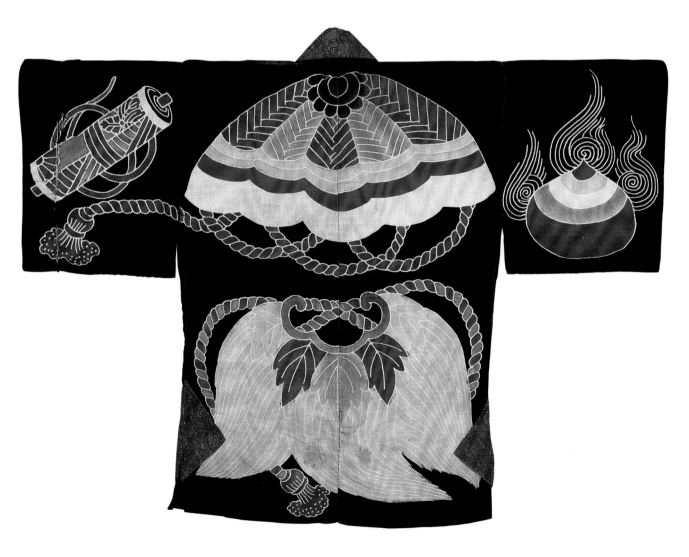

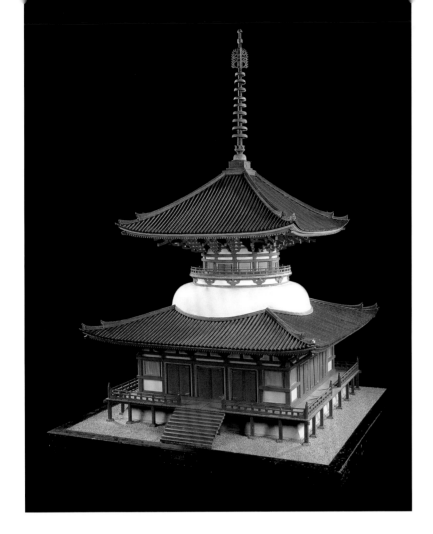

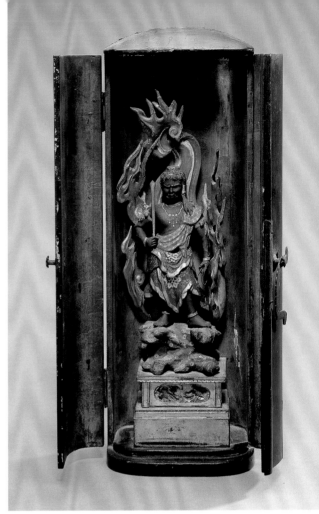

morals bestowed by folk religious tales. All are accepted and appear in conjunction with one another, perceived as complementary components in a rich cache of spiritual energies (fig. 1.14).

Buddhism

Buddhism originated in India and entered Japan in the sixth century c.e. Buddhist monks brought artworks in the form of sculpture, scrolls, and textiles, as well as scriptures (Tsunoda et al. 1958, 1: 91–108). Temples were built and furnished under their supervision (fig. 1.15). Unlike Shinto, Buddhism has an elaborate set of scriptures (sutras), prescriptions for conduct leading to Enlightenment. Buddhists believe that man is doomed to live out an unending cycle of rebirths, each reincarnation dependent on his progress in his previous existences. When he renounces his false pursuit of temporal pleasures, learns to control his appetites, and adopts a strict moral code, he becomes able to "walk in the way of Buddha." He will gradually reach the ecstatic state of Enlightenment, where his soul will be blessed with everlasting happiness, and he will come to know true reality (Varley 1973, 2–32).

Bodhisattvas are spiritual entities who have stored up enough merit through selfless acts in countless reincarnations to themselves receive Buddhahood but who have chosen to stay behind to help ordinary mortals achieve Enlightenment (figs. 1.16–1.20). Traits of the bodhisattvas or areas of their influence may be symbolized on textile designs (see chapter 7). Buddhist philosophy permeates Japanese spiritual life, as it was easily accepted by a people who worshiped nature and ancestors. In sharp contrast to Shinto, which views the Japanese people—descendants of Amaterasu and the other Japanese gods—as being innately good and the pursuit of happiness acceptable as part of their immutable nature, Buddhism rejects worldly pleasures as illusory and impermanent, focusing attention instead on the genuine suffering of this world. Textile motifs that imply impermanence, such as mists, haze, drifting clouds, and partially obscured objects, are popular Buddhist-inspired contributions to festival designs.

1.15 Model of Negoro Temple, 1909. Wood, metal, and paint. H: 193 cm. FMCH X64.1486; Gift of Burney M. Craig.

This is an exact copy of a Buddhist temple in Wakayama Prefecture made at one-twentieth the scale of the original. It was built for the Anglo-Japanese Exposition held in London in 1910.

1.16 Sculpture of the deity Fudo no Miyōō, Edo period. Wood, paint, and gold leaf. H: 45 cm. Collection of Jim and Jeanne Pieper.

Fudo no Miyōō is the Lord of the Passions. *Miyōō* are fierce aspects of the Buddha, symbolizing the transformation of human passions—particularly lust and greed—into Enlightenment. Carved and gilded wooden sculptures of the Buddha and bodhisattvas appear in temples throughout Japan.

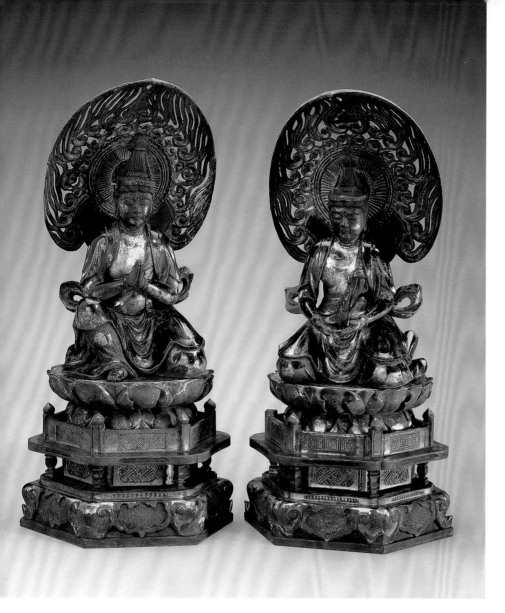

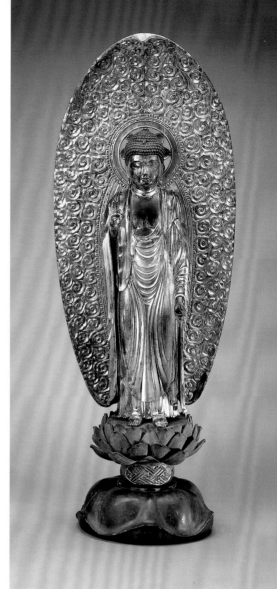

1.17a,b (A) Kannon. Wood, paint, lacquer, and gold leaf. H: 50.5 cm. FMCH x74.1437a–c. (B) Seishi. Wood, paint, lacquer, and gold leaf. H: 50 cm. FMCHx74.1439a–c.

Kannon and Seishi would usually be presented on either side of Amida Buddha. They are heralds and attendants of Buddha. The statues are elevated so that the viewer may receive their comforting downward gaze.

1.18 Amida Buddha. Wood, paint, and gold leaf. H: 113 cm. FMCH x74.1440a–e.

Amida Buddha is the merciful server of mankind. With Seishi and Kannon (see fig. 1.17a,b) on either side, Amida would be the central figure of a triad that is used in a ritual known as the Raigo-e. This group recalls the descent of Amida Buddha from his Pure Land (popularly called the Western Paradise). Amida, Seishi, and Kannon, often accompanied by a host of lesser deities, take the soul of the dying devotee to the Pure Land where the soul awaits rebirth to a higher state of being.[3]

Belief in the "Way of the *Kami*" came to be termed Shinto only after the official acceptance of Buddhism by Japan's Imperial Family and nobility in 564 C.E., as a means of distinguishing native beliefs from the imported "Way of the Buddha." As Shinto is involved with rebirth and the essential life force, it is viewed as a faith of glad tidings and optimism, called upon to record the birth of children and to consecrate marriage. Shinto priests avoid any contact with misfortune, disease, or death. It is Buddhist priests who are geared to offer sympathy and solace, trained to visit the sick and handle funeral rites. Obon, the prominent Buddhist holiday to commemorate the dead, originated on the Asian mainland. Held annually in midsummer to honor and placate the spirits of recently deceased ancestors, it is celebrated in Japan as a festive family reunion complete with impassioned drumming, grave decorating, and folk dancing.

Japan's Syncretic Religious Tradition: Shinto and Buddhism
Buddhism's current easy relationship with Shinto reflects a syncretic doctrine that originally emerged in the Heian period, resolving an early period of confrontation between the imported buddhas and the indigenous *kami*. At that time the Shinto and Buddhist deities came to be perceived as complementary supernatural forces with commingled authority. Buddhist deities were incorporated into the Shinto pantheon, and the Shinto deities were declared to be bodhisattvas. The worship of a *kami* became worship of a buddha in its *kami* form. At *matsuri,* worship may be offered to a Shinto *kami* who was originally perceived as a Buddhist deity.

The dual respect is reflected in the *kami* worship performed on a daily basis in Japanese homes and in household furnishings. Families traditionally reserve an area in the main room for a carved and lacquered altar (*butsudan*), which holds statues of

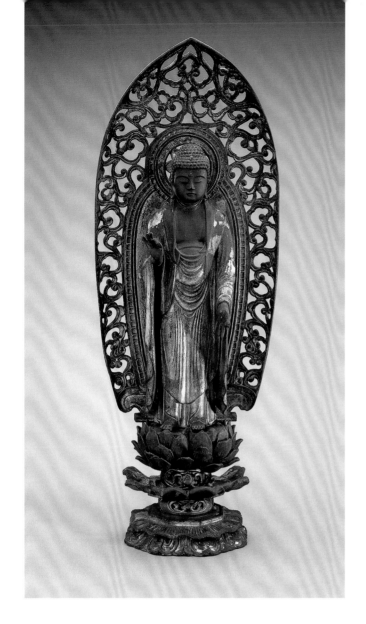

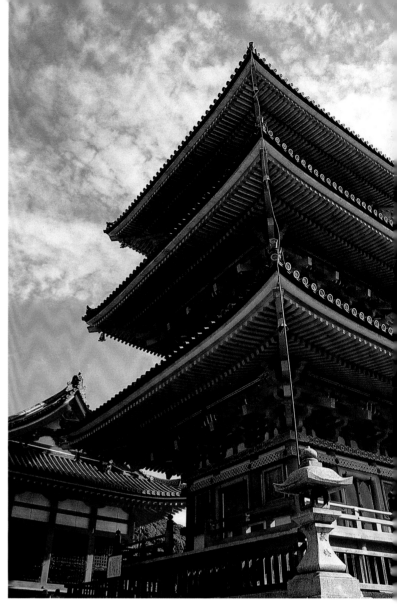

the Buddha and bodhisattvas on a pedestal. In addition, a small tablet (*ihai*) upon which the Buddhist names of deceased family members are written is displayed along with portraits of the departed. Another home furnishing consists of a high shelf (*kamidana*) that holds offerings for the Shinto deities. The *kamidana* is refurbished and the house thoroughly cleaned in preparation for the Shinto New Year's festival, which is observed nationwide in hopes of ensuring an auspicious coming year. Triangular folded white papers (*heisoku*), associated with purification, are placed on stands set on the *kamidana* at this time, along with bottles containing sacred sake, mochi cakes, fruits, and clusters of *noshi* (dried abalone) strips—all of which are offered to the *kami*. All of these offerings have in turn come to serve as textile motifs. A small model of the family Shinto shrine may also be displayed beside paper portraits of folk deities of good fortune and longevity. Due to space constraints in modern apartments, Buddhist *butsudan* and Shinto *kamidana* now often appear in the same room (Jeremy and Robinson, 1989, 62, 67–73), whereas prior to urbanization, they enjoyed separate quarters. Illustrations of components of both displays may appear together on festival textiles.

The period from the last decades of the nineteenth century until the end of World War II, was characterized by increased nationalism that resulted in Shinto being named the state religion. Buddhist symbols and artworks were discarded or minimized. At the end of the war, however, separation of church and state was mandated, and Shinto was abruptly restricted to local affairs, primarily supervision of *matsuri*. Today Buddhist artworks have been resurrected and are considered an indestructible part of the cultural consciousness. As integral components of Japanese spiritual imagery, they appear prominently on *matsuri* textiles and other artworks (Hirai 1987, 498–508).

1.19 Kannon. Wood, paint, and gold leaf. H: 57 cm. Collection of Dr. Harvey C. Gonick.

This figure represents Kannon, bodhisattva of mercy and compassion. Statues of the Buddhist deities are located in temples throughout Japan. They are accorded particular attention at funerals and memorial services held for recently deceased family members and at commemorations of the ancestors. Worshipers generally seek succor from Buddhist priests at times of illness and death, as Shinto priests must refrain from any involvement with death or disease.

1.20 The Buddhist temple of Kiyomizedera is filled with carved statues of the bodhisattvas decorated with gold leaf. The temple is perched dramatically above the city of Kyoto, whose inhabitants it is thought to protect. Photograph by David Mayo, 2002.

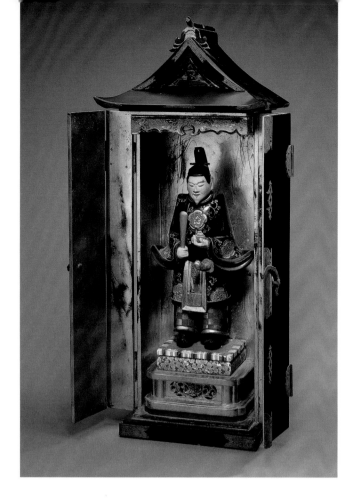

1.21 Sculpture of the deity Tenjin, Edo period. Wood, paint, in a cabinet with gold-leafed interior. H: 58 cm. Collection of Jim and Jeanne Pieper.

Tenjin is worshiped as the deity of scholarship and wisdom; and in his human form he is known as Sugawara no Michizane. He was devoted to the Chinese arts of calligraphy and poetry and is thus always represented wearing the Chinese-style garments of the Tang dynasty (618–907). He is especially worshiped by students and their families.

1.22 A large drum skin (*taiko*) is crowned with a bronze flame-shaped ornament inscribed with the crest of Konko Church, a circle enclosing the character "*kin*." The *taiko* is placed beside the altar and is used to gain the attention of the deities and to summon the worshipers. Photograph by Don Cole, Konko Church, Los angeles, 2002. Collection of Reverend Doctor Alfred Tsuyuki and Konko Church.

Taoism

It is less common for modern Japanese to be consciously aware of Taoist beliefs, which have, nevertheless, become enmeshed in the culture and its artistic repertoire. The lively tales of the *Kojiki* are revered as sacred Shinto texts, but early manuscripts indicate that fragments of Taoist belief were already circulating in Japan at the time of its writing in the eighth century C.E. This is suggested by the description of Emperor Temmu's (r. 673–686 C.E.) right to rule: "Adhering to the Two Essences (Yin and Yang), he put the five elements in right order (water, fire, wood, metal, earth)" (Philippi 1968, 41).

The five elements of Tao correspond to five directions and five colors; that is, red, yellow, blue (green), white, and black. These five colors are echoed in the sacred cords used on Shinto ritual objects. Cords themselves appear frequently on Shinto ecclesiastical garments worn at *matsuri*, probably with the intention of binding off sanctified individuals. Although *matsuri* are basically Shinto in origin, it appears that some Taoist principles were assimilated early on, and these eventually came to be thought of as native tradition (Sonoda 1988, 134–38; Tsunoda et al. 1958, 1: 24–25.)

Taoism's rising influence in China during the Tang dynasty (618–907 C.E.) was concurrent with the importation of Chinese cultural arts to Japan. The spiritual and intellectual precepts of China were transmitted to Japan's ruling classes, along with silk brocades and bronzes (fig. 1.21). While the artwork, literature, and philosophy of Buddhism were acquired by Japan's ruling classes, the practices of Taoism and yin-yang techniques were introduced to farm families and working people. Although Tao was never an organized religion, its ideas spread easily among ordinary Japanese, attracted by its emphasis on longevity and good fortune in this world, as opposed to Buddhism with its promise of reward in a future life (Sonoda 1988, 134). Taoism teaches that man's blessing is in numerous sons and grandsons. Through his multiple offspring he achieves a form of longevity and the likelihood of a happy and secure old age. Numerous Taoist motifs referring to fertility, longevity, and prosperity are adapted to adorn festival textiles.

Tao teaches that all reality can ultimately be reduced to the dialectic between yang, representing the positive, active, penetrating, vigorous, and celestial principle of light, and yin, representing the negative, passive, receptive, and earthly principle of darkness.

Children and Elders at Matsuri

The celebrating of fertility and exaltation of long life in *matsuri* are illustrated by the prominent role played by children and the elderly in processions and entertainments. Groups of children or adolescents parade with special *mikoshi* built to accommodate child bearers. A small drum cart (*dashi*) pulled by adolescent or preteen porters and drummer boys (or in recent decades, drummer girls)— all wearing *ha'pi* coats—usually precedes the children's *mikoshi*, announcing its arrival. Youngsters of all ages participate in aspects of *matsuri*. Even before they are old enough to walk, babies are carried by parents or grandparents in processions. Often toddlers are dressed in *ha'pi*, with firemen or carpenters' children wearing small replicas of their parent's *ha'pi* inscribed with the characters or symbols of their father's *chōnai-kai* (Shinto shrine neighborhood association group).

As the children march the long parade route, they seem to delight in producing thundering drumbeats alternating with sharp strikes against the wooden rim of the drum, the latter creating a loud clacking sound. Over the thumping and clacking, the youngsters chorus a regional chant to maintain their rhythm. Their drums are painted in the center with the *mitsu-tomoe* design, which is also called the "three commas" (or a yin-yang design with three curving spokes), representing constantly renewing sacred energy as well as the power of thunder. The drumbeats are also said to clear the path of any lingering corrupted spirits.

The drum cart is followed by a children's *hayashi* (festival musicians) group made up of ten to twenty members. The young musicians play the flute, drum, gong, and cymbals as they walk the entire procession route. This may mean several miles or most of a day up to and including the evening. At *matsuri* one sees children struggling to keep their eyes open and to maintain the pace. Evidently their parents, usually visible a short distance away observing from the sidelines, are convinced that the benefits accrued from walking in the aura of the *kami* more than make up for the children's loss of sleep. Despite an abundance of ethical doctrines in Japan, there is no formal religious training. It is at *matsuri* that children experience awe of the Shinto-Buddhist deities. *Matsuri* processions also accord status to the elderly, encouraging their participation as representatives of longevity and perseverance. The appearance of older men and women reflects the continuity of the community. Elderly participants are due respect for their lengthy experience in honoring the *kami*.

Happiness can be achieved by absorbing, reflecting, and balancing the two forces, resulting in harmonious resolution of their inherent tensions and facilitating longevity (Rawson and Legeza 1973, 12–22; Earhart 1984, 75–76, 83). In creating *matsuri* textile designs, therefore, it appears that designers instinctively strive for balance between elements of light and dark as well as those reflective of yang and yin energies. This is most frequently seen in the prominent usage of the dragon and phoenix motifs and their multiple derivative images.

Taoist ideas have been absorbed by people as folk religious practices, and the decisions of many ordinary citizens are still brought into accord with them. The most evident of these, which persists in the twenty-first century, is the constant consideration of "lucky" and "unlucky" in daily life. It is common for individuals to subscribe to Taoism's lucky and unlucky times, directions, and actions (Sonoda 1988, 132–38; Tsunoda et al. 1958,1: 58–60). Lucky amulets and charms may be seen as accessories on *matsuri* costumes and may also be painted on as design elements. The Chinese lunar calendar determines the scheduling of *matsuri* with the I Ching serving as a source of forecasts. To the present day, particularly in rural areas, but in cities as well, auspicious dates may be considered before making new garments, planting rice, building a house, traveling, or marrying. Although the Western calendar was officially introduced to Japan in 1873, the Taoist calendar continues to be consulted for practical as well as devotional purposes.

Confucianism

The philosophy of Confucianism was imported from China along with Buddhism, and similarly, its appeal was primarily to Japan's ruling classes. Confucianism has served as the main philosophical pillar of Japan's social structure since its arrival (Tsunoda et al. 1958, 1: 335–45). Confucian values were particularly emphasized during the Edo period (1615–1868) by the government of the shogun, who interpreted its strictures regarding fealty toward parents and obedience to elders as confirming loyalty to the shogunate and to his samurai chieftains (daimyo). Confucian principles governed how one should function morally in each of life's relationships, and these principles continue to influence behavior through the present day, although crumbling in the face of the increased internationalism. Previously the roles and obligations of ruler and dependent, husband and wife, parent and child were carefully delineated. During the Edo period, four classes of society were considered ordained. At the top was the ruling class of samurai whose social interaction was limited to its own members. Below were the commoner classes, who were in order of status: farmers, artisans, and merchants (Varley 1973, 115–18).[4] This structure has often been targeted during *matsuri* celebrations in the form of "unruly episodes" carried out up through the twentieth century (see chapter 2).

During the Edo period fashion reflected the Confucian hierarchical standards of the samurai. Members of the empowered classes were able to wear hand-decorated silks dyed in a variety of hues; the classes below were expected to wear cotton or bast fibers (*asa*), undyed or dyed in muted shades of indigo blue, gray, or brown. Patterns were minimal, although stripes and small-scale designs were sometimes permitted (fig. 1.23). Age, along with social rank, determined acceptable choices of fiber, color, pattern, and tailoring. Costume served as a primary means of social control, and it affected posture, gait, gesture and self-esteem. During *matsuri,* blatant reversals of the clothing regulations became the standard. Sober hues and modest designs were abandoned by participants, as they took full advantage of the license the festival offered.

Historically, neither the samurai nor their families participated in *matsuri* except as honored observers (Sadler 1975, 24–26). They noted holidays by making special visits to shrine and temple and by social rounds of relatives' houses. Feasting, drinking, and exchanging gifts with family and friends, the samurai class celebrated while preserving its ancestral status by refraining from direct participation in the festival uproar. Women of the ruling class—not wanting to miss the opportunity to fall under the beneficent gaze of the *kami* or to receive the envious stares of their inferiors—might be glimpsed through a sliding panel (*shoji*) left slightly ajar or fleetingly witnessed on verandahs high overhead. Thus, the fashionable kimono they donned on these occasions contributed to the spectacle. It was habitual for owners of treasured heirlooms to exhibit them to the public during the *matsuri* period, setting luxurious garments on racks and leaving street-facing *shoji* slightly ajar. To this day, *matsuri* brings forth personal window displays of unusually striking kimono, obi of complex brocades, and other notable textiles, including extraordinary examples of *mingei,* or folk, arts. Also on display intermittently are screens, scrolls, ceramics, and other treasures related to the season. The textiles are draped over lacquered and gold-leafed stands placed prominently in view so that passersby may absorb their extraordinary aura. Modern security concerns have been slow to evolve in Japan, and many homes maintained an "open house" policy until recently. The practice is preserved to some degree, however, by several *chōnai-kai* who open their *tabisho* (wagon-resting place) on *matsuri* eve, setting up interior displays (see the discussion of *yoimatsuri* below).

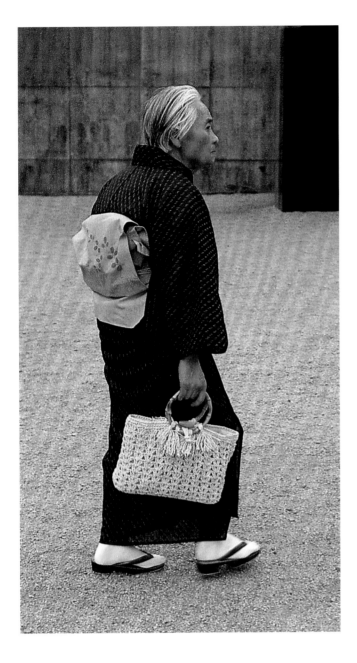

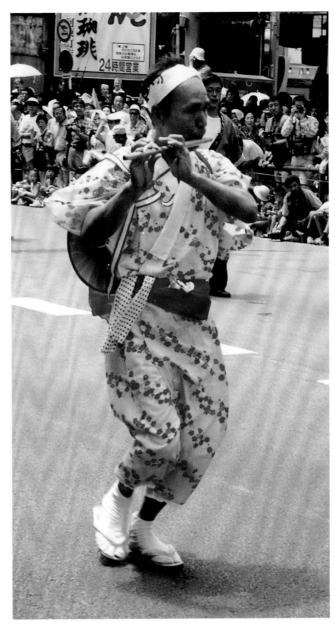

Due to the strong impact of Confucianism and its role in defining and maintaining societal structure, abnormal behavior of any sort threatened to bring shame on one's family as well as on one's ancestors. At *matsuri*, however, such travesties, as well as disregard of the elaborate rules of etiquette in speech and dress, went unremarked or were quickly forgiven and forgotten. The transgressor at these times was believed to be under the "spell" of *matsuri* and was probably, in fact, at least under the spell of sacred rice wine (Osake). Both dress and behavior were permitted to reflect an intoxication with the spirit of *matsuri* (Sonoda 1988, 53–58).

In addition to countermanding dress codes, at some *matsuri*, a tradition of mocking gender expectations also existed (Sonoda 1988, 53–54; Yoshida et al. 1987, 14). To this day, feminine and flowery pastel-colored kimono are traditionally worn by young men and boys at the Ōtsu Hon Matsuri, the Kurama Fire Festival near Kyoto, and elsewhere (fig. 1.24). Men stride down the streets in flowered hats, thickly applied women's make-up, and lacy lingerie at Aomori Neputa Matsuri in Tohoku. In contrast to the restrictions of the past, in today's relatively free-wheeling *matsuri* atmosphere, females celebrate enthusiastically beside males on streets, in restaurants, and in private homes. Some wear the regional *matsuri* attire while others appear in colorful T-shirts and blue jeans, the latter always cut in the latest fashion.

1.23 The Confucianist ideals of the samurai were behind strict clothing regulations that required restraint in the use of color and pattern. Although no longer mandated, plain garments or garments with small-scale woven designs (*kasuri*) continued to be perceived as appropriate for working men and women up to the end of the twentieth century. Photograph by Dr. Harvey C. Gonick, Hakone, 1981.

1.24 During *matsuri*, the dress codes followed in everyday life are rejected and openly mocked. A musician wears a woman's underkimono (*juban*) as he parades with members of Aomori *chōnai-kai*. Photograph by GGG, Otanjōbi Matsuri, Kyoto, 1994.

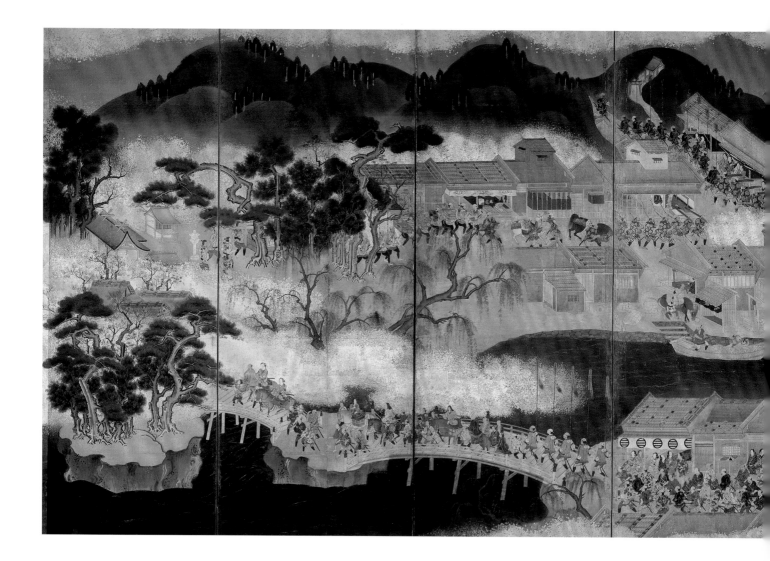

MATSURI IN THE EDO AND MEIJI PERIODS

During the Edo period, lateral control as well as vertical control of society was mandated. People were only allowed to travel outside their town to make religious pilgrimages or to meet the requirements of the shogunate. It was decreed that each samurai lord (daimyo) spend every other year living in proximity to the shogun (*saikin kōtai*), purportedly to protect and serve him, in the capital city of Edo (Tokyo). At the same time, the absence of rural lords ensured that no vassal could easily establish a competing power base outside the capital. Residences were established in the capital as well as maintained in the daimyo's home domain. Every other year the samurai moved retainers, servants, households, and hangers-on to Edo, each move creating a spectacular procession, which concurrently disseminated information and increased appetites for new fashions and material goods (figs. 1.25; 1.26a,b; 1.27).

A darker side of the rapidly increasing popularity of urban life was a substantial increase in danger to personal health. Crowding, fires, and devastating plagues were a recurrent threat. Although smallpox had appeared in Japan as early as the eighth century, possibly transmitted from China or Korea (Pearson 1992, 265), epidemics were connected with the appearance of Westerners who manned Portuguese, and

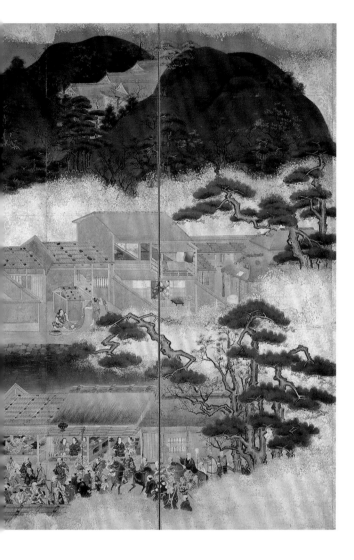

1.25 Anonymous. *A Daimyo's Procession through Seta*, seventeenth century. Six-fold screen. Color on paper. 159.8 x 363.9 cm. Collection of Joe and Etsuko Price.

later Dutch, trading ships in the sixteenth century. The malicious spirits of illness became permanently identified with sources outside the country. Offerings to the deities were placed at city gates and crossroads, and those stricken were placed in ritually purified spaces believed inhospitable to noxious spirits. During the Edo period fear, of communicable diseases provided further impetus for the people to seek more frequent and more elaborate communion with their deities through *matsuri* (Graphard 1993, 70–1, 219–21).

Nevertheless, by the seventeenth century the populations of Edo, Kyoto, and other cities had increased substantially, and new fortunes were being made by those who supplied the samurai establishment. The domiciles established in Edo stimulated a lively commerce allowing artisans and merchants to become wealthy consumers themselves. Luxury furnishings previously available only to propertied individuals became marketable to the lower ranks, although they might not be legally able to flaunt them. From the standpoint of festival organizers, the timing was fortuitous. Increased resources possessed by those who were the most active celebrants meant grander and better-attended festivals. Merchants and farmers, previously restrained by law from indulging in any form of conspicuous consumption, openly manifested

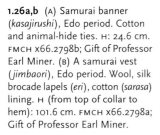

1.26a,b (A) Samurai banner (*kasajirushi*), Edo period. Cotton and animal-hide ties. H: 24.6 cm. FMCH X66.2798b; Gift of Professor Earl Miner. (B) A samurai vest (*jimbaori*), Edo period. Wool, silk brocade lapels (*eri*), cotton (*sarasa*) lining. H (from top of collar to hem): 101.6 cm. FMCH X66.2798a; Gift of Professor Earl Miner.

Many *matsuri* commemorate the past glories of the samurai era with athletic competions as well as processions. This *jimbaori,* would have been worn as an upper garment, over armor (see chapter 4). Originally, the banner would have been attached to the vest.

their newfound affluence under the guise of religious zeal during *matsuri*. Through communal neighborhood associations (*chōnai-kai*), merchants funded special festival attire, decorations, and *mikoshi,* as well as auxiliary floats or wagons.

Kyoto, long the center of luxury textile weavings, set the standard for opulent costumes, hangings, and decorations with its Gion Matsuri (fig. 1.28). Other cities emulated Kyoto as best they could, and several founded their own "Gion Matsuri," complete with processional wagons draped with extravagant silk brocades and embroideries. In Kyoto the storerooms of *chōnai-kai* filled as rivalry among the town's merchant and artisan neighborhoods increased. The intense competition itself evolved into a lively urban festival tradition.[5] Acknowledged superiority of style or performance was perceived as revelation of the intention of the deities to bless that group with a fine harvest or great commercial success in the coming period.

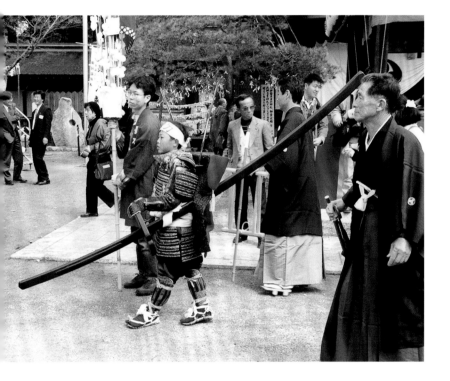

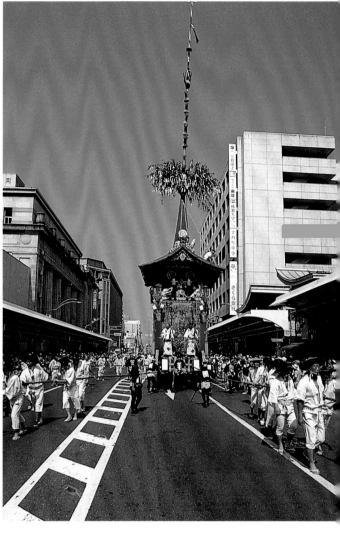

During the Meiji period, the loosening of restrictions on mobility permitted even more members of what were formerly the lower classes to move their families to the growing cities where new economic opportunities were rapidly opening up (Shibusawa 1958, 5: 331–44). Often, however, the pull of long-standing loyalties motivated a return to hometowns (*furusato*) to participate in the rites at festival time. Ordinary townspeople (*chōnin*), the mainstay of *matsuri,* were still perceived as "commoners," although egalitarian laws were passed from 1861 through 1879 disenfranchising the once-powerful samurai and abolishing their domains in 1871 (Jansen, 1989 5: 372–73). Despite the wearying struggle of ordinary citizens' repetitive workday lives, abruptly, during *matsuri,* both imaginations and purses seemed to be loosened. Community shrine officials, whose positions were rotated each year, took the responsibility for collecting donations from households and merchants. Varying degrees of financial latitude were bestowed on those appointed to convert simple sites into festival arenas. In several *matsuri* processions mannequins representing figures in legend or literature were sumptuously garbed in expensive silks and were presented in elaborately constructed papier-mâché settings. These lavish tableaux rolled by atop intricately carved, lacquered, and sometimes gilded festival carts, arrayed with costly carpets, tapestries, embroideries, and silk brocades. The latter were not only produced in Kyoto but also imported from afar (see chapter 5). In many cases, small cities and towns seemed to have been able to tap their citizenry's last resources to produce spectacles worthy of court or professional theater. In those populations where extravagant display was simply impossible, the struggle to mount more than a modest spectacle still seemed to be carried out to the absolute limit of inhabitants' means.

1.27 Fully garbed in samurai armor of the Edo period, this youngster prepares to join a *matsuri* procession. Photograph by Herbert Plutschow. Nagahama Matsuri, Shiga Prefecture, 1997.

1.28 Platforms with tall towers (*hoko*) are rolled slowly on huge wooden wheels down the main streets of Kyoto each July during Gion Matsuri. They are draped with imported textiles, tapestries, and carpets, acquired and maintained over five centuries for this annual moving exhibition. Kyoto, 1994. The Hali Archive.

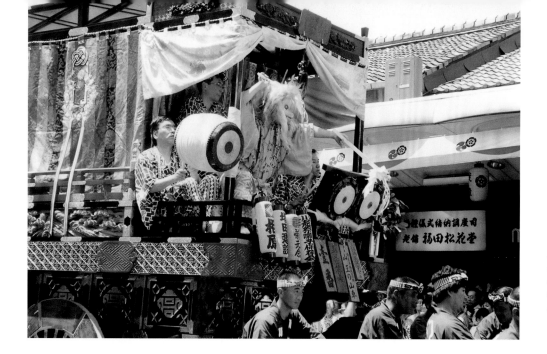

1.29 The fox deity, Inari, who is thought to influence the harvest, waves a *haraigushi*, a wand used to purify, in the direction of spectators from aboard a luxuriantly draped festival wagon (*hikiyama*). Photograph by GGG, Narita Gion Matsuri, 1990.

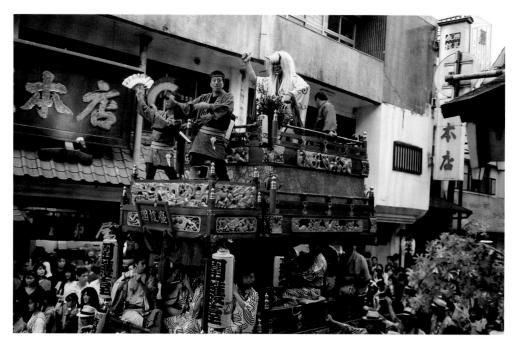

1.30 A female demon called a *han'nya* gesticulates at the spectators lining both sides of the street at Narita Gion Matsuri. Photograph by GGG, 1990.

In the countryside, farmers, who had been designated during the shogunate as socially superior to city merchants, held their own *matsuri* (*taue*). These were particularly focused on the planting of the rice crop. On *matsuri* days, regarded as both sacred and joyous, farmers donned kimono, if they owned them, and their best *geta* (clogs) or *zori* (thong sandals). Farmwives wore deftly tied kerchiefs (*tenugui*) on their heads (Joya 1960, 55). As the only sanctioned opportunity for a holiday, *matsuri* provided the few days a year when farm families could not only refrain from work but also enjoy rare moments of frivolous behavior and dress (Hane 1982, 14–15, 63, 76). Otherwise, the work schedule was relentless, as there were no days off in Japan before the Meiji Reformation (1868), and even afterward, the idea of a regular Sunday or weekday off was slow to take hold in the countryside (Embree 1939, 221–98).

MATSURI TODAY: THE FLOW OF EVENTS

Shortly after a *matsuri* has concluded, the planning for the coming year's *matsuri* gets underway. Within a few months *chōnai* committee members gather in a hall adjacent to the shrine for a ritual called *tejime,* or a ceremonial clapping of hands, a means of attracting the attention of deities. Accompanied by sake toasting, they begin their meeting by performing *tejime* in a special rhythmical pattern, signaling the start of preparations for *matsuri*. The members of the *chōnai* who are in good physical condition

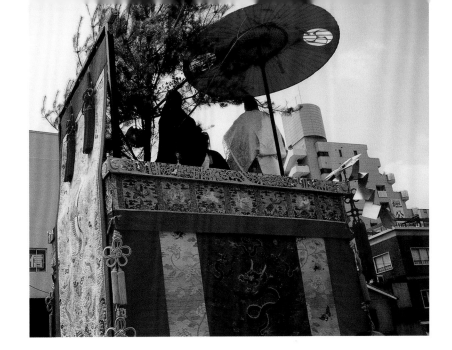

1.31 At Gion Matsuri the *yama*—a platform topped with a papier-mâché mountain and a young pine tree—is surrounded by mannequins costumed as characters from legend and history. The pine branches and clusters are believed to absorb any malicious vapors hovering in the atmosphere. The *yama* join the tall *hoko* (see fig. 1.28) through town. Photograph by GGG, Kyoto, 1994.

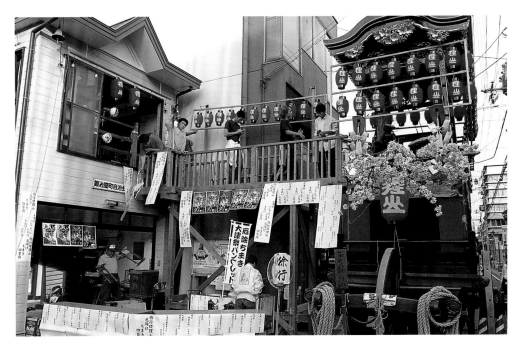

1.32 Preparations for the *matsuri* get underway a few days before with the construction of floats to appear in the procession. At the same time, the traditional luxury hangings that will bedeck the floats are unrolled, inspected, and readied for their role. A walkway connects the float to the storeroom containing the hangings. Photo by Ikko Nagano, JPS, Ōtsu, 2000.

are assigned by a steering committee made up of representatives of the older and wealthier families in the community to build the festival wagons (*hikiyama*). To be considered "alive," or functioning, a wagon requires two leaders, two traffic negotiators, abundant decorations, and a continuous source of music (figs. 1.29, 1.30). The *hikiyama* often carries structures upon which a *yorishiro,* or place suitable for a deity to alight (Sadler 1972, 96), is built. This usually takes the form of a mountain (*yama*) sculpted of papier-mâché (fig. 1.31). It is deemed an appropriate "god-seat" since mountains, particularly impressive mountains, have been considered holy since earliest times (Thompson 1986, 24–25). It is thought that in Japan "sacred mountains" were originally designated as such because of their significance as sources of water for the surrounding farmland (Averbach 1995, 17).[6]

In the weeks preceding the *matsuri* festival, wagons and floats are assembled from parts that have been maintained in a storehouse during the year (fig. 1.32). The sequence of *hikiyama* in the procession is usually determined by drawing lots, although in several places there is a traditional head wagon and sometimes a traditional tail wagon as well. Musicians are alerted to assemble for practice sessions. Local dancers are contacted, and some groups as well as soloists are recruited from nearby towns. Dancers and musicians are often imported so local inhabitants will be free to participate fully in the festival activities (Thompson 1986, 21). Costumes that have been preserved

Yoimatsuri

At several matsuri, including Kyoto's Gion Matsuri, Ōtsu's Hon Matsuri (fig. 1.33), and Takayama's Hachiman Matsuri, a nighttime preview, or *yoimatsuri* (known as *yoiyama* in Kyoto and *yoimiya* in Ōtsu, etc.), is held after dark on the eve of the festival. By this time, the *matsuri*'s formal opening rites led by priests at the shrine have concluded. At these events, a unique opportunity is provided to approach and view the floats and wagons up close. They are parked just outside tall sheds in Takayama or all along the main streets in downtown Ōtsu and Kyoto. One may investigate their artworks in a leisurely manner not possible at the next day's procession when crowds and conscientious policemen prohibit such inspection. On *yoimatsuri* the *chōnai-kai* members arrange to slide open the *shoji* doors to the storehouses, permitting viewers to enjoy some of the treasures that will be in the next day's procession as well as some that will not. Oftentimes gorgeous screen paintings and textiles that are deemed too fragile to travel in the procession are displayed (fig. 1.35). Spectators stroll wide-eyed on these occasions from one *tabisho* (wagon-resting place) in the neighborhood to another, slowly examining the artworks and sharing their delight. The viewers themselves form the procession on *yoimatsuri* as they promenade euphorically from site to site.

On clear nights the streets glow with the reflections of moonlight on silk and gold metallic brocades and on the brass bells and ornaments fixed to the wagon frames. The

festooned vehicles support platforms that serve as stages for costumed mannequins portraying figures from legend and theater and set into tableaux. Strings of lanterns softly illuminate the stationary displays along streets often veiled intermittently by a descending mist or light rain. Lanterns are also positioned strategically just inside the open *shoji* doors of the nearby *tabisho* in order to light indoor displays.

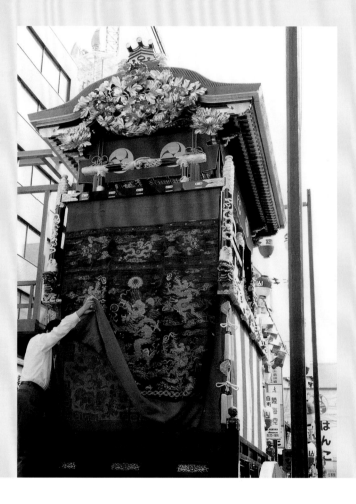

1.33 This *yama* (float or wagon) with its Chinese Qing dynasty (1644–1911) silk tapestry (*kesi*) is parked in preparation for the next day's procession. The silk tapestry protects a more highly valued wool tapestry from Gansu Province before the procession. Photograph by David Mayo, Ōtsu, 2000.

because they are felt to have been particularly effective in the past are retrieved from backyard storerooms (*kura*) of family treasures and laundered. Sometimes costumes belonging to other villages and judged to be exceptionally striking are borrowed and incorporated after being completely refurbished (Shimazaki 1987, 52).

Where there is a shrine hall, its beams are wrapped in broad strips of red and white paper, from which dangle strings of triangular, folded white paper pennants (*heisoku*). Red and white are used to mark sacrosanct objects in Shinto. There are also streamers in the five colors considered sacred to the Shinto deities: blue (or green), yellow, red, white, and black (or purple), in that order. These mark the quarters as sacred space (Grim and Grim 1982, 41–42, 142; Herbert 1967, 148–49; Sonoda 1988, 136). The five sacred colors are a scheme originating in early Indian and Taoist aesthetics, which persists to the present time in cultures throughout Asia.

On *yoimatsuri*, melodies of festival songs are heard everywhere, accompanied by gongs, drums, and sometimes flutes. Along the street or in entryways dancers in *yukata* or kimono may be glimpsed practicing steps planned for the procession entertainment the next day. In Ōtsu young men roost atop the wagons attired in silky patterned *juban* (women's underkimono). They drape their *juban* over the sides of the wagon like curtains and explain that they do this just to be outrageous and because the *juban* are beautiful (fig. 1.34). Hovering on top of the wagons and climbing in and around the floats, members of the *chōnai-kai* make last minute checks and confirm the weather predictions for the following day.

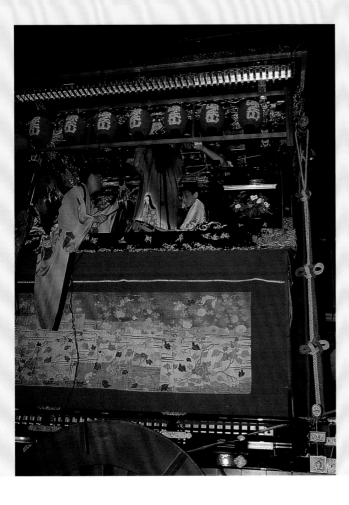

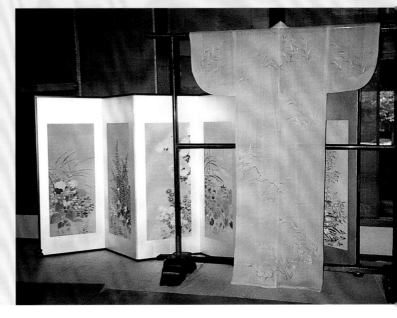

1.34 At Ōtsu Yoimiya (festival eve) All participating young men wear women's silky underkimono (*juban*). They sit on the festival wagons, allowing the kimono to drape over the sides. Photograph by Ikko Nagano, JPS, Ōtsu, 2000.

1.35 On the evening before *matsuri* in Ōtsu, lanterns light treasures—such as this heirloom kimono—which are displayed in windows. They also illuminate the procession route. Photograph by GGG, Ōtsu, 2000.

Ritual cleansing of the site, the town, and the participants takes place through the priest's sacred gestures and chants as well as the actual cleansing of bodies and homes. For participants and observers fresh new raiment is considered optimal. If that can not be afforded, old clothes are scrupulously laundered or, today, dry cleaned. In earlier times the cleaning meant that all seams on clothing were unsewn, the loom widths washed, and each item of clothing was retailored. Fresh collars and bindings were also sewn onto all edges (Shibusawa 1958, 5).

Once the preparations are complete, the three phases of the *matsuri* celebration unfold. In the first phase, the *kami* are welcomed at the shrine and preliminary purification rites are held. In the second and most important phase, interaction with the *kami* occurs by means of a procession or entertainments. Feasts, pageants, dramatic performances, songs, and dances are offered the deity to call forth its blessings.

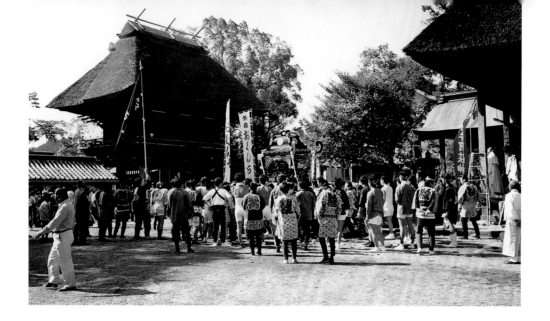

1.36 Participants gather in the shrine arena on the morning of the *mikoshi* procession. Photograph by GGG, Okunchi Matsuri, Hitoyoshi, 1992.

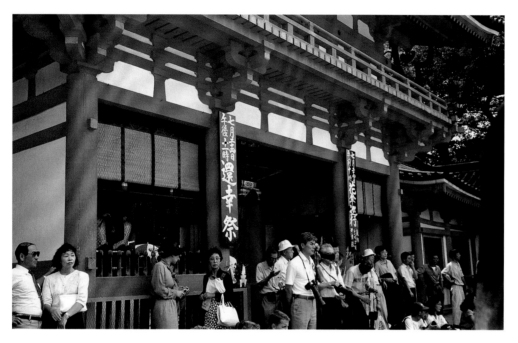

1.37 Spectators often wait for hours until the procession makes its way through the city streets to their location. Here viewers while away the time on the staircase of Yasaka Shrine overlooking the Kanko Sai celebration, one of the many smaller rites held in conjunction with Gion Matsuri. Photograph by GGG, Kyoto, 1990.

Athletic competitions may be held in order to divine future goodwill toward the village. In the third and final phase, the *kami* are brought back into the shrine accompanied by appropriate farewell chants and gestures.

The flow of the prescribed events begins at the shrine at dusk on the evening preceding the *matsuri*. Low thunderous drumbeats resound through the town as the priests chant a welcome to the divine spirit, which must be transferred from the shrine that had served as its shelter to the *mikoshi,* its conveyance to the populace. *Mikoshi* is sometimes translated as "a divine palanquin," and at other times "a holy ark." It is a wooden carriage without wheels, abundantly carved, lacquered, gilded, and decorated, that is built to shelter the spirit of the shrine deity. Many *mikoshi* are topped with a sculpted male phoenix, an image whose meaning has not been consistently explained. The appearance of the mythical bird has, however, been said to signal the ascent of a period of just rule. Through the early decades of the twentieth century, in poorer villages, the *mikoshi* was sometimes just half of an empty sake keg embellished with branches of trees deemed sacred, such as the pine and *sasaki* (Sadler 1975, 16). Today's splendid *mikoshi* is set down for the night in proximity to the shrine after appropriate chants are uttered to encourage the transfer of the spirit to its temporary shelter. The following day, the *mikoshi* is to be carried through the streets of the town to bring the sacred spirit of the deities into the presence of the gathered townspeople.

The morning of the procession day, the young men of the community (*waka-mono*)—accompanied by young women in recent times—wearing their *ha'pi,* assemble

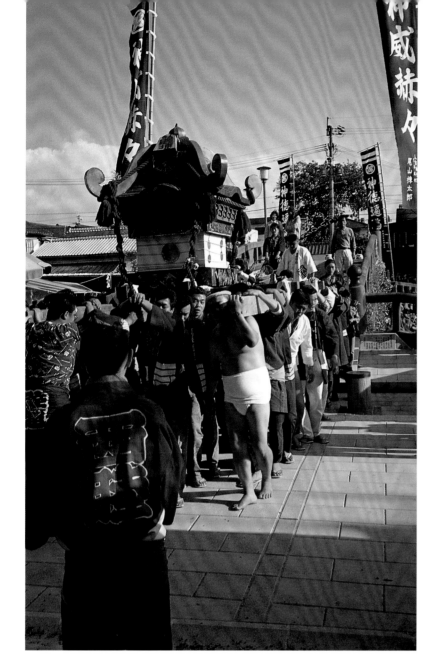

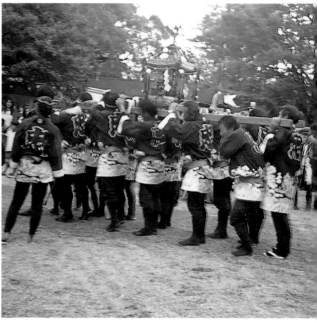

with their families, friends, and spectators, on the shrine grounds (figs. 1.36, 1.37). Before the shrine building, the priests welcome the deities with songs and chants (*norito*). Music is not offered as a hymn to the deities; rather, it is played to pacify their spirits and give them pleasure (Hirai 1987, 291). The priests gesture toward the procession route with the *haraigushi,* or handheld wands ending in clusters of white paper strips or strands of undyed hemp fibers (Ono 1962, 24). These are intended to purify the worshipers and the path they will be taking through the town (Ueda et al. 1985, 13–14).

A symbol (*shintai* or *mitamishiro*) that is deemed a sacred representative of the *kami,* is normally housed in the innermost chamber of the permanent shrine. The *shintai* might be a shrine relic, such as an object of importance to the community's history, or a sacred mirror (*shinkyo*). Mirrors have been treasured as pure since earliest times in Japan. They are said to provide clean light and a clear reflection (Ono 1962, 68). The *shintai* is transferred to the *mikoshi* during preliminary rites. Sometimes this transfer is merely symbolic and the *shintai* is represented by a piece of handmade white paper with the *kami*'s name written on it. During the first decades of the twentieth century in poor communities, the *mikoshi* was, in practice, often empty save for an artifact relating to the history of the community or a relic reputed to have belonged to a deified personage (Sadler 1975,16).

It is regarded as a sign of honor to serve as bearer of the sacred ark, because it is considered a unique blessing to be in close proximity to the *kami* spirit (figs. 1.38a,b). Before World War II, *mikoshi* bearers would have to prepare for their participation in

1.38a,b The *mikoshi* is sometimes referred to as a sacred palanquin or as a divine ark for a deity. It is carried through the town on the shoulders of young men to bring the spirit of the deity into the presence of the townspeople. The *mikoshi* bearers are accompanied by troops of dancers and musicians, as well as by wagons draped in luxury textiles. Photographs by GGG, Hitoyoshi, 1982.

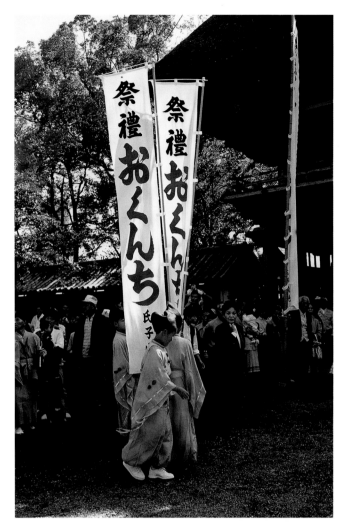

1.40 These young men are dressed for *matsuri* in Heian-style ecclesiastical garments of saffron-colored hemp. They balance tall banners announcing the festival's arrival. Photograph by GGG, Aoiaso Shrine, Okunchi Matsuri, Hitoyoshi, 1992.

1.39 Spectators of all ages line the street during *matsuri*, regardless of the hour and the weather. Photograph by GGG, Hirosaki, 1994.

the holy rites by not only ceremonially submerging their whole body in a stream or in the sea but also by restricting their diets in preceding days to absolutely fresh food. They accepted the necessity of foregoing visits to their own home for a period preceding the festival if there had been any illness or troubles in their family. One would be totally excluded from participation if there had been death in the family during the past year. Death, illness, and even misfortune are still viewed as polluting elements contrary to the purificatory ideals of Shinto and the goals of *matsuri* (Ono 1962, 34–35, 51–52, 64; Sadler 1972, 104–5; Ueda et al. 1985, 76).

At the conclusion of the opening rites, the *mikoshi* bearers are beckoned with shouts that abruptly shatter the atmosphere of quiet solemnity. Long poles supporting the *mikoshi* platform are hoisted to participants' shoulders, which are protected only by the heavy cotton of *ha'pi,* causing the young men to groan intermittently under the substantial weight. Bearing a *mikoshi* normally takes at least forty strong men, half supporting poles on either side. Priests lead the procession accompanied by officials, escorts, and worshipers. As the *mikoshi* is borne through the torii gate marking the boundary of the shrine and onto the main street of the town, officials and escorts oversee its safe passage. Vertical banners strung high on bamboo poles and emblazoned with characters announce the name of the festival and herald the procession (figs. 1.39, 1.40). The *mikoshi* bearers jog in unison while chanting and are joined by festooned festival wagons filled with musicians (*hayashi*) and accompanied by bands of musicians on foot.

The *mikoshi* bearers strain for several hours to meet their challenge. Coordinated lifting up and propelling forward dictate a certain amount of concentration. Their ears are constantly filled with the jangle of metal ornaments and bells affixed to the ark.

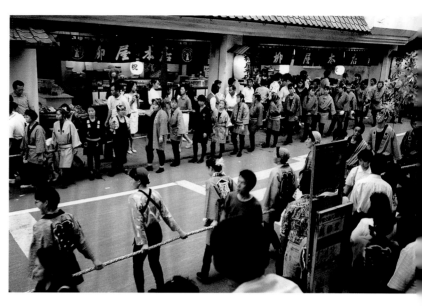

As the *mikoshi* passes, bystanders frequently toss coins (*saisen*) toward the platform as they call out personal supplications. The coins tossed, the bells, the hypnotic vibrations of drum and gong, and frequent congratulatory calls from bystanders pull the bearers' attention one way and another. They struggle to avoid a misstep, which might cause them or their comrades to fall or stumble. Dislocated shoulders and even more severe injuries are regularly suffered at the most frenzied of these events. Seemingly endless reserves of energy are called up each time the gilded and lacquered *mikoshi* is lifted aloft from a rest stop and borne along its designated path. The efforts of the bearers are bolstered not only by the continuous chorusing of rhythmic chants but also by abundant sips of sacred sake consumed at breaks.

In some towns encounters of competing *mikoshi* occur on festival streets. This happens despite the fact that codes of conduct have been established by each neighborhood to handle "unavoidable" clashes in the narrow streets. Nonetheless, when two *mikoshi* meet, the challenging task of maneuvering the palanquin of the deity deftly along its intended course appears to become secondary. Impromptu conferences of the leaders of *mikoshi* about to face a head-on collision are held at an intersection on the pretext of planning efficient traffic flow and determining right-of-way. Meanwhile the *mikoshi* and its long poles are turned into an effective battering ram. One *mikoshi* attempts to pass another "accidentally" sideswiping or directly crashing into it. Urgent consultations are called and the shouts of many authorities on *mikoshi* rights are heard. At the same time, advice is shouted by members of the audience. As minimum adjustments and absolutely essential repairs get underway, the aggressors and the victims pack up and lumber on their way. Nevertheless, further on, one of them is likely to "unavoidably" ram the gate of a resident or shopkeeper. On such occasions the "mishap" is defended to naive and astonished visitors with the explanation that the victim had probably not demonstrated sufficient financial support for the *matsuri*. Amazingly, these transgressions, even extending to human injury and substantial damage, appear to be forgiven by the victims, who shrug them away as inevitable, "the immutable whim of the deity" (Sadler 1972, 92–109). The *kami* is apparently judged as having an unpredictable aspect—a character at once beneficent and malevolent. As the *mikoshi* faces the gates of honored supporters, generous commercial establishments, and the *chōnai-kai* headquarters in the neighborhood, it is made to shake and tilt, a movement reported to provide great pleasure to the spirit of the *kami*. Sites where the *mikoshi* is agitated are deemed to be especially blessed as they thus have become an extension of sacred space.

Another contest involves the porters who push the *hikiyama,* an abundantly decorated wagon set on tall wooden wheels (figs. 1.41, 1.42). These wagons are loaded

1.41 The wheel of a stalled *hikiyama* is examined mid-procession. Photograph by GGG, Tenjin Matsuri, Ueno-shi, Mie Prefecture, 1991

1.42 Porters grasp the heavy ropes that they will use to move the *hikiyama* up and down steep hills and around bends. Photograph by GGG, Gion Matsuri, Narita, 1990.

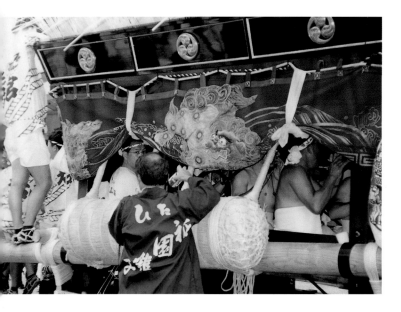

1.43 *Chōnai-kai* members see to it that those who pull the wagons and produce the music accompanying them do not suffer from thirst. Sake is stored within easy reach under the float curtains. Photograph by GGG, Ueno-Shi, Mie Prefecture, 1992.

with live actors, musicians, or life-sized mannequins re-creating a scene. In some locales the sides, front, and back of the wagons are covered with treasured hangings, often of silk and gold metallic thread. These textiles are both domestic and imported (see chapter 5) and are impressively displayed. The porters roll the huge wooden wheels of the heavy wagons forward, sometimes bumping along cobblestone streets, allowing the spectators to enjoy the prized legacies of their communities. Despite their formidable task, the men are coached by their wagon leaders to project a thoroughly optimistic mien in harmony with the forward movement of their heavy vehicles and, hopefully, of the community.

Despite this ostensibly peaceful outlook, the crashing of *hikiyama* has become a tradition at some festivals. Sacred vehicles are turned into crash cars, playfully and not so playfully, smashing into the wagons of competing neighborhoods. An elaborate set of prearranged rules and negotiations governs these crashes, which are deemed to be the will of the deity, and, like the *mikoshi* disasters, are promptly forgiven. In these *hikiyama* crashes, four to six tons of wood and metal—and assorted human bodies— collide noisily with each other. The crashes are the focus of the greatest approval and excitement and occur amid wild cheering and applauding from onlookers. Young women, omnipresent on the sidelines, dressed in alluring *yukata* or designer jeans, frequently stimulate the melee, egging on individual *hikiyama* porters with cheers and calls of encouragement. The alternating ferocity and exuberance of these events are said to electrify community energies, releasing a beneficial stream of new life into a town (Maraini 1959, 292–95). One can still observe such sacrosanct uproars at Kenka Matsuri (Fighting Festival) held in Shirahama, at Himeji-shi in Hyōgo, at Gion Matsuri in Narita City, and at Sanja Matsuri in Tokyo, as well as several other towns. Less riveting but also enthusiastically attended are the variety of conventional Japanese athletic competitions including sumo wrestling, horse racing, archery, and forms of polo and ancient ball games. In these contests, the winner is deemed most favored of the *kami,* his home region thought to have received an omen of good fortune for the coming period (Plutschow 1996,150–52).

In order to meet these demanding physical challenges, while maintaining their *matsuri* spirit, bearers sustain a near-constant state of mild, good-natured inebriation. Modest intoxication is considered a desirable state for ordinary humans attempting to communicate with a supernatural guest.[7] Abundant flasks of "Honorable Sake" are given to the *chōnin* by well-wishers beforehand and along the way, and these are stored under decorative curtains on the wagons within easy reach at rest stops (fig. 1.43). In addition to fortifying the men, it allows them to shed any remaining vestiges of self-consciousness (Thompson 1986, 24–25). It is thought that the celebrants reach

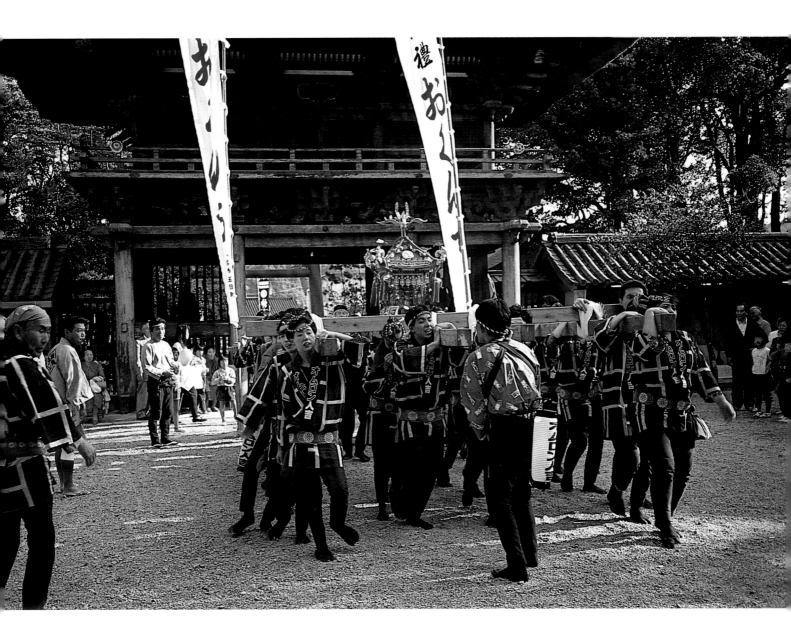

a state of desirable disequilibrium as they repeatedly twist and turn down narrow streets trying to avoid crushing spectators or running into a wall (Sadler 1972, 92–109). Hours of chorused chants, ceaseless ringing of drums and gongs, surges of adrenaline while watching the perilous tilting of the *mikoshi,* and steadily imbibing sacred sake bring the participants to a full state of vertigo. Reaching that dizzying pitch signals total success in their efforts to bring the weary order of the past to destruction, permitting the way to be paved for the entry of a fresh new state of calm and tranquility. The *mikoshi* is borne with this aim through the populace and this is the heart of the *matsuri.*

Numerous *mikoshi* processions have been documented by Japanese and non-Japanese observers alike.[8] From 1989 to 2000, I was able to witness processions in Aomori, Hirosaki, Sendai, Tokyo, Narita City, Takayama, Ueno-shi, Kyoto, Ōda-shi, Nagasaki, Ariake-cho, Hitoyoshi, and Naha, among other sites. I consistently observed the near-palpable sense of exhilaration at the arrival of the *mikoshi* as well as the outpouring of gratitude for its presence even among the most reserved of bystanders. Although the procession of the sacred spirit through the community is the climax of *matsuri,* the decorated floats or wagons that precede it, as well as entertainers accompanying it, arouse much of the excitement (Yanagawa 1988, 9). Troops of spirited dancers are interspersed with featured performers, such as the auspicious *shishi,* who were introduced earlier at the shrine with their teasing antics and clacking jaws. On

1.44 After the procession through the main street of the town, the *mikoshi* is stationed at a shrine arena or nearby park or community hall, where entertainments may take place. Finally, after the performing of appropriate rites, bearers return the *mikoshi* to its sanctuary at the Aoiaso Shrine. Photograph by GGG, Hitoyoshi, 1992.

both sides of the procession, gliding swiftly sideways while simultaneously surveying the processioners and the crowds, smartly uniformed policemen in white helmets, sound short bursts on whistles clenched tightly between their lips.

Throughout all of the purposeful *matsuri* activities described above, rows of portable shops form a lively border around and in front of the shrine arena. Plastic-draped stands are usually festooned with bright banners and balloons, which float above goldfish tanks and cotton candy. Before and after *matsuri* events, nonstop shopping for gifts, snacks, and souvenirs occurs at all shrine festivals. Clusters of customers crowd around the itinerant vendors called *tekiya*, or *roten-shonin*, meaning "heavenly-showers-shop-people," even as they set up and break down the stalls in response to the unpredictable weather. The stands with covers boldly striped in primary colors add yet another animated element to the shrine surroundings.

As activities draw to a close, many young people of marriageable age, intent on taking advantage of an opportunity to casually mingle and chatter, form amiable clusters. These disperse intermittently, when several young men and women, seemingly reinforced by yet another wave of *matsuri* spirit, spontaneously form loose folk dance rings and begin to circle those still gathered, providing their own vocal accompaniment. The festival goers with diminished stamina withdraw to tea houses, cafes, and private homes where leisurely feasting takes place. At the shrine hall or nearby, festival officials and priests enjoy a communal feast where, in addition to ritual prayers, sumptuous holiday food and sake are proffered the *kami*, whose partaking is symbolized by the hearty consumption of the human invitees. When all is concluded, the *kami* is respectfully invited by farewell prayers to return to the shrine. The *mikoshi* carrying the holy spirit is again lifted, and accompanied by songs of gratitude and the waving of *haraigushi*, the *kami* is again firmly ensconced in the sanctuary (fig. 1.44).

THE ROLE OF *MATSURI* IN JAPANESE LIFE

Matsuri has been defined by Keiichi Yanagawa from the standpoint of its function, which he describes as integrating the hearts and minds of the Japanese people, giving them a sense of spiritual unity. Yanagawa further notes that *matsuri* involve two radically divergent elements, that of solemnity and formality on the one hand, and that of a jubilant uproar on the other. Elements in ordinary life are exaggerated during *matsuri*, and its components exhibit the polarity of reverence and revelry (Yanagawa 1988, 5–7).

In his book *Matsuri: The Festivals of Japan* (1996), Herbert Plutschow views *matsuri* as a repeated confrontation between a specific Japanese community and its deities, which takes place during the visits of the latter to that community. Man's behavior during this confrontation is thought to positively or negatively affect the will of the gods toward the community in the coming period. Further, Plutschow feels that the quality of the homage proffered by humans during *matsuri* is conditioned by the character and shape of the visiting deities and that during *matsuri* the deities are made visible in one form or another. The extraordinary atmosphere produced is not considered an end in itself but a stratagem necessary to capture the attention of the *kami* and persuade them to interfere. An irreverent boisterous uproar is felt to convey an urgent need for intervention by a force powerful enough to bring about its reverse—a state of tranquillity and calm (Plutschow 1990, 49–57).

Matsuri function to preserve the links with a cherished native region. They are valued for their role in awakening children to their dependency on the larger world of one's community and to the awesome powers of the *kami* (fig. 1.45). The festivals

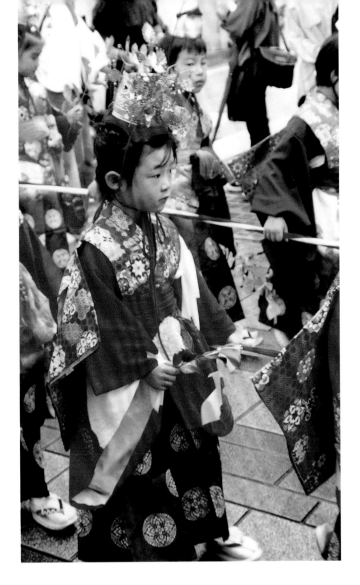

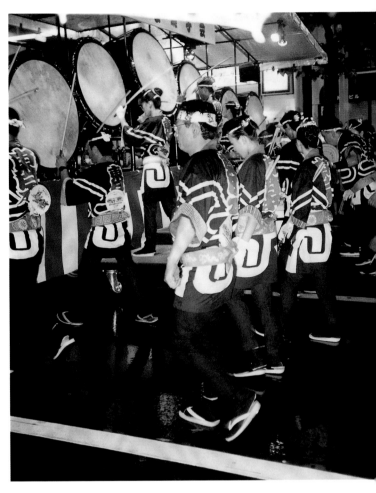

preserve the links to ancestors recent and ancient, as well as providing the opportunity to pass those values on to descendants in a joyful atmosphere. A dedication to the community's *matsuri* arts, particularly its textiles, reflects the deep and tenacious conviction in Japan that beauty is a reflection of goodness.

In an era of rapidly expanding globalism and internationalism, *matsuri* periodically force the attention of the individual to return inward to the strengths provided by the immediate neighborhood. For the days of *matsuri,* the community regains the importance it once enjoyed, as the extent of a householder's world. *Matsuri* is always a cooperative group activity and has the unique impact that a mutual sincerely undertaken endeavor can provide. For the *matsuri* period, while engaged with neighbors in rites and the accompanying ruckus, dressed at one with them, the participant can undo the isolation imposed by electronic wizardry in the form of cell phones, the Internet, and television; relive the virtues of life in an island country protected by oceans and its own exclusive pantheon of gods; and remember what he or she came to request and why (fig. 1.46). ●

1.45 At *Matsuri* young girls emulate shrine attendants, dressing in opulent silks and wearing golden crowns. Photograph by David Mayo, Hachiman Matsuri, Takayama, 1993.

1.46 Drum corps do not allow their *matsuri* rhythm to be interrupted, even in the midst of an unrelenting rain shower. Photograph by GGG, Aomori Neputa Matsuri, 1994.

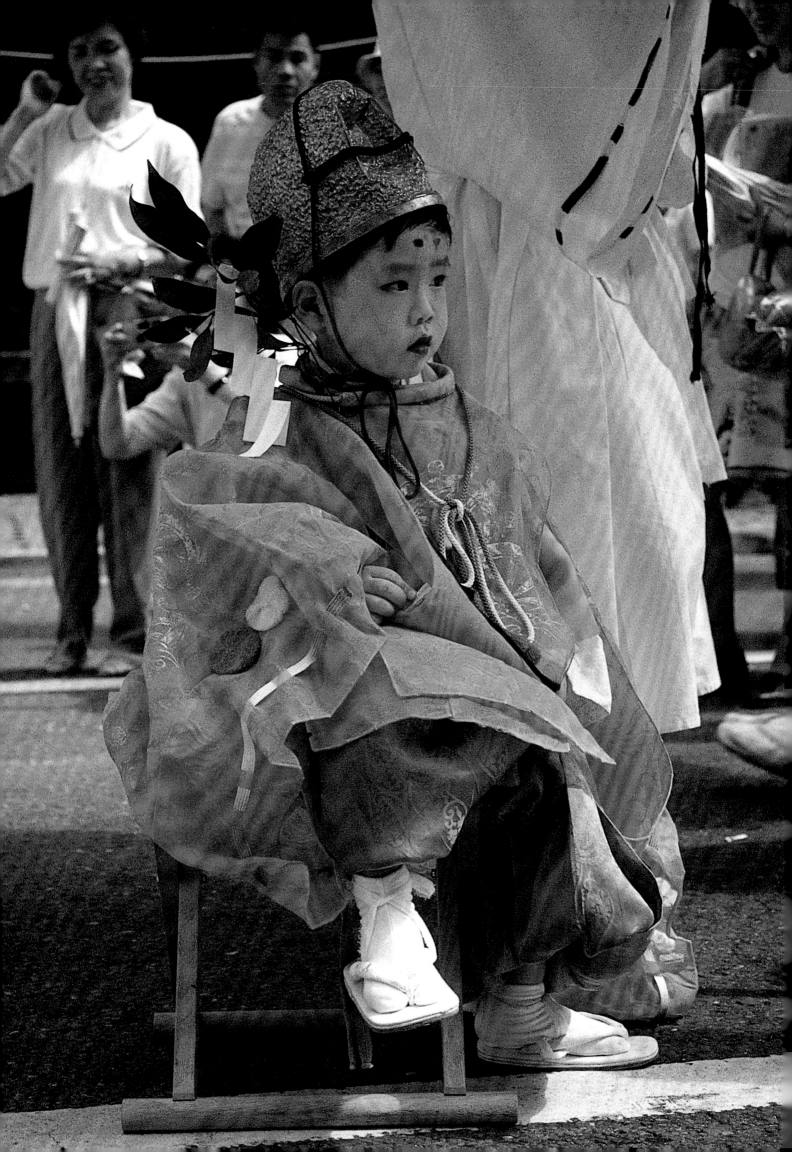

TWO

Politics and Theater in *Matsuri*

HERBERT PLUTSCHOW

IN ORDER TO UNDERSTAND THE ROLE OF MATSURI *IN POLITICS AND THE THEATER AND,* conversely, the role of politics and the theater in *matsuri, we* must first inform the reader of what *matsuri* are, how they are structured, and their functions in and for the communities that organize them. *Matsuri* is a Japanese word meaning festival, ritual, and rite. It derives from the verb *matsuru,* or to worship, offer, and sacrifice. *Matsuri* generally occur in the context of the Japanese religion called Shinto, but many *matsuri* were shaped by the combination of Shinto and Buddhism that has dominated Japanese religion for many centuries. *Matsuri* occur all over Japan, in every community, town, village, and hamlet. They usually are held once a year but in some cases only take place once every seven, twelve, or even twenty years. In the event of a calamity, a *matsuri* can also take place out of its ordinary cycle.

Generally, *matsuri* refers to an extraordinary time that the community periodically sets aside to allow its members to worship and commune with their god or gods. *Matsuri* is extraordinary because it entails behavior that is truly out of the ordinary. It allows people to eat and drink extraordinary food and dress in extraordinary fashion; in other words, they may behave in a manner not allowed during regular times. It is a kind of emotional release of accumulated repressed emotions engendered by living within the confines of law and order, and it creates a psychological balance by liberating man temporarily from that law and order. Of course, *matsuri* does not abolish all order—it is not a time of indiscriminate violence—but it leans toward the disruptive, disrespectful, noisy, competitive, and, traditionally, orgiastic. People tend to break ordinary social rules and taboos. Superiors are no longer superiors; the older are no longer wiser and above the young; and men and women, rich and poor are equal in the presence of the deities.

Matsuri is a time when the deity or deities must be brought into the community and made visible and tangible. A *matsuri* without a deity is unthinkable. Deities are actuated in various ways depending on community traditions, but the most common

2.1 The Chigo boy is a festival mascot at Gion Matsuri in Kyoto. It is believed that only a remarkably attractive and innocent child can effectively absorb the impurities of the community. The boy is "repurified" in subsequent rites. A similar Chigo appears at the Tenjin Matsuri held in Osaka on July 25th. The practice may go back to an ancient custom of sacrificing a community's most beautiful girl or boy to a deity. Kyoto, 1994. The Hali Archive.

means is the *mikoshi,* the portable shrine. These miniature shrines are mounted on poles like litters or palanquins and carried, depending on their size, by as few as two or four or as many as one hundred participants. In some parts of Japan, for example in Okinawa, priestesses represent the visiting deities. In others, the deities are represented by male "actors" wearing or carrying insignia, such as the white zigzag paper strips (*heisoku*) one immediately associates with the divine or the deity's mask. What actresses and actors have in common is the fact that they must live for a while in seclusion and abstain from sex and certain foods. Ritual purity is essential to assuming the role of a deity. Some *matsuri* represent their deities in the form of puppets, hence the puppet theaters that came out of local *matsuri.* The reason to let puppets represent deities is perhaps that the former are easier to manipulate than humans and able to perform the sort of superhuman feats one expects from deities.

Who are these deities so indispensable to the existence of *matsuri?* As with *matsuri,* we must first distinguish between the mythical deities of the emperors and other prominent families and the deities of each community, that is, between national and local deities. Whereas imperial deities and their *matsuri* have a national scope, local ones are only locally relevant. They have in common the fact that they are, in essence, ancestral deities, namely the clan deities (*ujigami*) of the first settlers or later conquerors of, or government appointees to, territory. In some cases, as is evident in the amalgamation of the imperial ancestor with the sun, natural or agricultural deities have been combined with ancestral ones. Local, territorial deities (*ubusuna-gami*) have been amalgamated with ancestral ones and subsumed in the complex system of main and subordinate shrines.

After the introduction of Buddhism to Japan in the sixth and seventh centuries, these local, ancestral deities also became bodhisattvas and buddhas worshiped in a syncretic Shinto-Buddhist manner, as is evident in the Shinto-Buddhist worship of the sun. Another important characteristic of Japanese deities, whether Shinto or Shinto-Buddhist, is their ambivalence. They have potential for both good and evil; they are the tutelary deities protecting the human order but are also the destructive deities who cause natural calamities and social upheaval. Those deities who are feared to cause epidemics and crop failures are also those worshiped to prevent or quell them and to enhance and protect agricultural growth. These deities are basically good with a potential for evil, or evil deities with a potential for good.

An example of such complex deities is the Tenjin deity of the Tenjin Matsuri of Osaka (July 24–25) and the deities worshiped in the Gion Matsuri (July 17–18) of Kyoto. These are the tragic victims of political change, victims intent on taking revenge for their untimely deaths by causing calamities and destabilizing the community and, in some cases, the entire nation. When worshiped properly, however, they become willing tutelaries of the human order. Perhaps most important, they are scapegoat deities on whom the members of a community heap their impurities and sins. The Chigo boy who sits on the leading Naginata float in the Gion Matsuri is a scapegoat believed to absorb all impurities in order to allow the community to start anew (fig. 2.1). Renewal is, indeed, the key to understanding the nature of Japanese *matsuri.*

When the ancient Japanese established order in the land, they believed that this order would not last forever and that, if left alone, it would eventually revert to "chaos" like an abandoned agricultural field. Hence the need to renew the land periodically in *matsuri.* This ritual renewal, however, must also be understood as a resacralization of the community. Resacralization means to make sacred again a human community that has enervated its sacred energy through the breaking of

taboos over time. Once the community has been ritually renewed, it is sacred once more. Since food production was also considered sacred, that is, under the control of the local deities, the human community had to be renewed in the same way that the agricultural cycle had to be renewed every year.

Matsuri often starts with unruly, competitive behavior reminiscent of a situation that preceded the foundation of the community. When the deity or deities are brought into the community at the start of the *matsuri,* people tend to behave as equals and engage each other in fierce competition, games, and disruptive behavior. To create social equality before the deity, people go out into the streets in the evening to shout obscenities, throw mud at one another, smear charcoal or rice powder on each other's faces indiscriminately, run half-naked after a sacred object, or shake their portable shrines and bump them into one another in a competitive frenzy. They do so as if the community's leadership position needs to be filled. At this time people compete to select new leaders and a new order.

Historically the ritual equality of the *matsuri* also affected the relations between men and women. Like the markets, *matsuri* has always been mating season par excellence. The start of a new agricultural cycle was in the past coeval with human reproduction. European (and European-derived) carnivals or masked balls of early spring, also associated with the "mating season," allow a degree of "free sex." The reversals of social structure observed in Mardi Gras and Brazilian carnivals—the poor disguised as wealthy kings and queens, Blacks as Whites, and Whites as Blacks— also characterize Japanese *matsuri.* Less fortunate people have important functions at *matsuri*; professional female entertainers such as the geisha are paraded through the streets as if they were the visiting deities. The same applies to street and itinerant performers who assume important *matsuri* functions despite the fact that they are outcasts in "normal" times. *Matsuri* needs to create universal equality, a lack of differentiation from which a new order can emerge.

After a period of ritual freedom and equality, the community proceeds to ritually renew the order. The visiting deities are put to rest in a community square or a temporary shrine called *tabisho* (travel resting place). As we can observe in the Onmatsuri of the Wakamiya Shrine in Nara (December 17–18) and the Hikiyama Matsuri of Nagahama, Shiga Prefecture (April 14–17), the local dignitaries proceed to the temporary shrine in a parade. This parade mirrors the communities' sociopolitical hierarchy and is the first step to ritually reestablish order after a period of ritual disorder. Once the parade has reached the ritual site, people begin to present songs and dances. In the Onmatsuri, performers dance from around five o'clock p.m. until midnight; at the Hanamatsuri of the village Toei-cho, Aichi Prefecture (December 2), people dance uninterruptedly for two full days. Song and dance are symbolic of "orderly" behavior; song orders language beyond ordinary grammar, and dance structures bodily movement beyond ordinary, everyday action. The community renews itself through artistic behavior radically different from the preceding, unruly behavior; however, these ritual arts are often misunderstood.

MATSURI AND POLITICAL CHANGE

Matsuri and politics have much in common. Most scholars trace the democratic system of periodic elections back to traditions started in ancient Greece. Few realize, however, that the democratic system really owes its existence to ancient renewal rituals, which took place at regular intervals in practically all premodern societies. *Matsuri* gave people the chance to question the social and political leadership before it was

2.2 Anonymous. Segment of *Yume no Ukihashi Emaki* (A dream from the bridge), 1840. Painted scroll. Collection of the Chido Museum, Tsuruoka.

This painting depicts an encounter between the daimyo of Shonai and local farmers (Sakata 1979,89). Enroute to visit the Shogun in Edo, the daimyo and his entourage were intercepted by a group of farmers demanding an audience. Festival gatherings sometimes served as opportunities to present demands to authorities. At some festivals territorial squabbles were dramatized by the holding of "accidental" head-on crashes of neighborhood festival wagons on narrow streets.

allowed to continue into the next period. Unfortunately, there are only a few records of radical political change that occurred during or as a result of a Japanese *matsuri,* but *matsuri* structure strongly suggests that such change was possible. Of course, political leaders could also exploit *matsuri* to gain legitimacy and to continue on the basis of what they believed to be the support of the people and the deity or deities.

Social and political leaders eager to perpetuate their power often sponsored *matsuri.* The Kujo family started the worship of the deity Tenjin (Sugawara no Michizane) in the tenth century. They built shrines (Kitano Tenmangu in Kyoto and Dazaifu Tenmangu in Kyūshū) and sponsored the arts connected with Tenjin, such as the *Kitano Tenjin Engi* scroll, a national treasure, in an effort to legitimize their power. Truly, many natural calamities were attributed to Tenjin in the course of history, but since these calamities did not last forever, the sponsors could easily claim that it was their worship and their sponsoring efforts, and not those of their political rivals, that appeased the deity and allowed the community to overcome the crisis. Political leaders knew how to manipulate the ambivalent nature of Japanese deities to their advantage.

In premodern Japan, *matsuri* seating (*miyaza*) reflected the hierarchy that would be restored, like the loges and booths in Western theaters and operas. In Japanese *matsuri,* special seats were reserved for dignitaries. As in some Catholic churches in Europe, the local dignitaries drew their privileges in part from the fact that they were able to sit nearer to the altar than ordinary people. In Japanese *matsuri,* spectators were seated according to the rank they held in ordinary life, and we know of many local disputes over *matsuri* seating. Certain seats were reserved for people who had the right to a family name, which gave them samurai status. These people drew their social legitimacy from the fact that they were seated nearer to the deity.

The *matsuri* was and still is an occasion for the political and social leaders of a community to display themselves to the public. Since all healthy bodies were supposed to be outside during the *matsuri,* the leaders knew they could count on a quasi-universal spectatorship. When the mayor of a city in the United States parades him or herself in an open limousine behind the high school band, he or she is in fact imitating this kind of public display. This goes back to the custom of parading the church crucifix or the Virgin Mary through the community, and perhaps even further

back to ancient pagan rites. In their parades, the political leaders have merely replaced the deities. Their political legitimacy derives from such public display, which enhances their image. One can certainly say the same of Japanese political leaders who deliver their speeches from cars and trucks, as if they were the parading deities, or at squares, as if they were the deities resting at their *tabisho* (travel resting place) and shaking white-gloved hands with the public.

Since *matsuri* was a time in which the social and political order of the community was dissolved, however temporarily, it presented a potential for religiously legitimate change. This was especially true when a community faced natural calamities: earthquakes, fires, volcanic eruptions, floods, epidemics, famine, and social upheaval. To overcome such extraordinary crises, the community usually organized an ad hoc *matsuri*. People tended to blame such calamities on the "insufficiency" of the previous *matsuri;* therefore, they wanted to improve and offer the deity a greater community effort and a more perfected performance. Community emissaries were sent to the imperial capital of Kyoto to bring back new forms of song and dance to please the deities in times of crisis. Only extraordinary means and effort could appease the "angry" deity and subdue such extraordinary crisis. If this crisis was deemed sufficiently disruptive, the community might consider this ad hoc *matsuri* a total new beginning and structure their future *matsuri* in the same way, scheduling them in the same season in future years or cycles.

As should be clear from the above, *matsuri* contained the possibility of change. This change was not only artistic as suggested above but also political. Many peasant uprisings are on record for the Edo period (1600–1868). They usually occurred during famines, when the peasants did not have enough food to eat or enough rice or money to pay their taxes. The peasants had two means available to protest against unbearable conditions: they could deliver the daimyo (feudal lord) or his representative a written petition. They often did this by throwing their petition into the palanquin of the traveling daimyo or his representative. This means they had to wait for their leaders to leave their castles, which in a crisis situation was often too long. The scroll painting *Yume no Ukihashi Emaki* of 1840 includes precisely such a scene (fig. 2.2). The daimyo of the Shonai domain (northeastern portion of modern Yamagata Prefecture) had imposed special taxes, which the peasants opposed. In very *matsuri*-like fashion and with banners, they presented a petition to the daimyo on his way to Edo and were successful. Another means was to take out the *mikoshi,* the portable shrine of the deity, and parade it through the streets to the daimyo's castle as if it were *matsuri* time. This happened in the Horeki Uprising of 1761–1763 in what is now Nagano Prefecture. Perhaps the authorities could ignore the mob, but they could not ignore the *mikoshi* and had to acknowledge the peasant petition. This type of political protest assumed the form of an ad hoc *matsuri,* the format of which reflected the *mikoshi* parade of the regular *matsuri.*

Since there were ample precedents for such ad hoc *matsuri* in times of natural calamities, this procedure was considered legitimate. By adopting this strategy, the peasants were able to present their petition as if it came from the deity or deities and not so much from human sources. Like the regular *matsuri* priests, the peasant leader could easily be identified with the local deity or deities. Given this association of deity and leader, it was difficult for the daimyo to punish the instigators of the uprising, and even when he did punish them on grounds of insubordination, he had to recognize the legitimacy of their claim and was forced to impose change or "face the anger of the deity."

2.3 Festival gatherings remain a popular occasion for political commentary. Peace and calm are perceived as desirable character- istics of a renewed order. Here a yukata-clad celebrant at Tanabata Matsuri displays a placard decry- ing the use of nuclear weaponry. Photograph by GGG, Sendai, 1989.

Political protest in present-day Japan shows a peculiar affinity with *matsuri* (fig. 2.3). When the protesters zigzag through the streets with their banners and slogans, they imitate the *matsuri*'s parading of the deities (*togyo*). *Mikoshi* are carried through the streets in similar meandering fashion and with equal clamor and frenzy. The *shunto* (spring strikes) are also *matsuri*-like occasions. Like *matsuri,* they occur every year at the same time, whether or not the labor situation calls for strikes. Like *matsuri,* the *shunto* gives the voiceless a voice and the chance to make it heard with vigor and clamor. The May Day Parade in the West has evolved into a similar yearly event.

THEATER IN *MATSURI, MATSURI* IN THE THEATER

Matsuri and theater have much in common. The entire *matsuri* can be understood as a theatrical performance, not only because all procedures are determined by tradition, but because manifesting, entertaining, and returning the deity or deities are a kind of "staging." In *matsuri,* all performers must learn their roles just as our actors must rehearse their plays. Historical documents reveal that Japanese classical theaters such as Noh and Kabuki developed out of *matsuri,* especially *matsuri* dance, something both theaters have retained up to the present. In order to understand the link between *matsuri* and theater, we must discuss briefly the function and nature of *matsuri* dancing.

Most *matsuri* performers today will say that their dances are a human offering to the deities, whereas in the past they were understood as the deities singing and dancing. The deities sing and dance because they want to bless the human order as if it were their own heavenly order. Maybe modern men and women have lost the ability to see actual deities in their actors and actresses, despite the divine insignia and paraphernalia they carry. In premodern Japan, however, *matsuri* performers and priests were looked on as if they were the visiting deities themselves. Japanese myths make it unmistakably clear that the arts of song and dance have a divine origin. This was a divine behavior that the deities had taught, expecting that man would adopt it

when communicating with them. Thus, young girls dance to the rhythm of drums and flutes as they transplant rice seedlings in the many Taue-matsuri (rice-planting festivals). They are garbed in extraordinary colorful dress and hats, as if they were the deities themselves who have come to visit their communities to transplant the rice and bless it with agricultural abundance.

Given the high artistic standard the deities expected from the humans and vice versa, the ritual arts quickly became the prerogative of professional or semiprofessional artists, actors, and actresses. This trend appears in Japanese court poetry as early as the twelfth century. Rather than letting ordinary and unskilled people perform divine songs and dances, it was deemed more effective to entrust them to professionals. Imagine a court musician falling out of tune in a New Year performance; such an event could have portended future disaster. The high standards that the political leadership (emperors, shoguns, feudal lords, and so forth) expected of their artists was behind the professionalization of the ritual arts. The development of *matsuri* song and dance into the theatrical arts also resulted from this professionalization.

Japanese traditional theater owes much to *matsuri*—a time when the past is made present and the present is transported back to the past, to its origins. The entire *matsuri* can, therefore, be seen as a historical drama. *Matsuri* is extraordinary precisely because it transports the community back to its foundation, extolling the founding heroes' extraordinary strength, will, and accomplishments, as well as their relevance to the present order. This is perhaps the reason why, beyond the dramatic nature of *matsuri*, other dramatic forms, not necessarily harking back to the founding fathers, came to be represented in *matsuri*. Thus, at Karasuyama, Tochigi Prefecture (July 25–27), people stage the life of Taira no Masakado (d. 940), a tragic hero, who was not the area's founder. Similarly, in Osaka's famous Tenjin Matsuri, the hero is the tragic statesman Sugawara no Michizane (845–903) and not one of Osaka's founding fathers, say, the warlord Toyotomi Hideyoshi (1536–1598). Similarly, the deities of the Gion Matsuri are potentially evil ones who have to be appeased for the city to prosper. Such "failed heroes" correspond just as well to the purpose of *matsuri* as the founding deities do. They cause natural and social disaster, but as appeased deities, they also prevent calamities and protect the human order from the very same natural and social disaster. In this process, some of them become deities deemed even more powerful and relevant to the community than the founding heroes.

Many communities, therefore, have adopted popular drama into their *matsuri*. Noh, Kyogen, Kabuki, and puppet plays, variously known as Bunraku, Joruri, or Ningyo Shibai, were easily adaptable to a *matsuri* scenario, precisely because they had all once been religious drama and had issued from ancient *matsuri*. Significantly, Noh, Kyogen, and Kabuki are known to have evolved out of ritual dance and, despite their more or less lengthy plots, have retained dance to this day. Noh is a danced drama clearly related to *matsuri*, especially the above-mentioned Onmatsuri (fig. 2.5). Initially, Noh traces itself back to the appearance between the Kasuga Shrine and the Kofukuji Temple in Nara of a local deity who revealed its identity and its divine powers and blessed the community with an oracle and a divine dance. Plays called Okina are still being performed at the Onmatsuri and on many other ritual occasions, as well as in practically all Noh theaters at New Year (figs. 2.6–2.9). Okina was originally a local deity, which, as the theater evolved, came to represent any local deity. Itinerant actors and priests performed Okina plays by request at community *matsuri* all over the central part of Japan. This was before they became the repertory of the Noh Theater and schools of Noh actors. Okina are good deities, but the demons staged

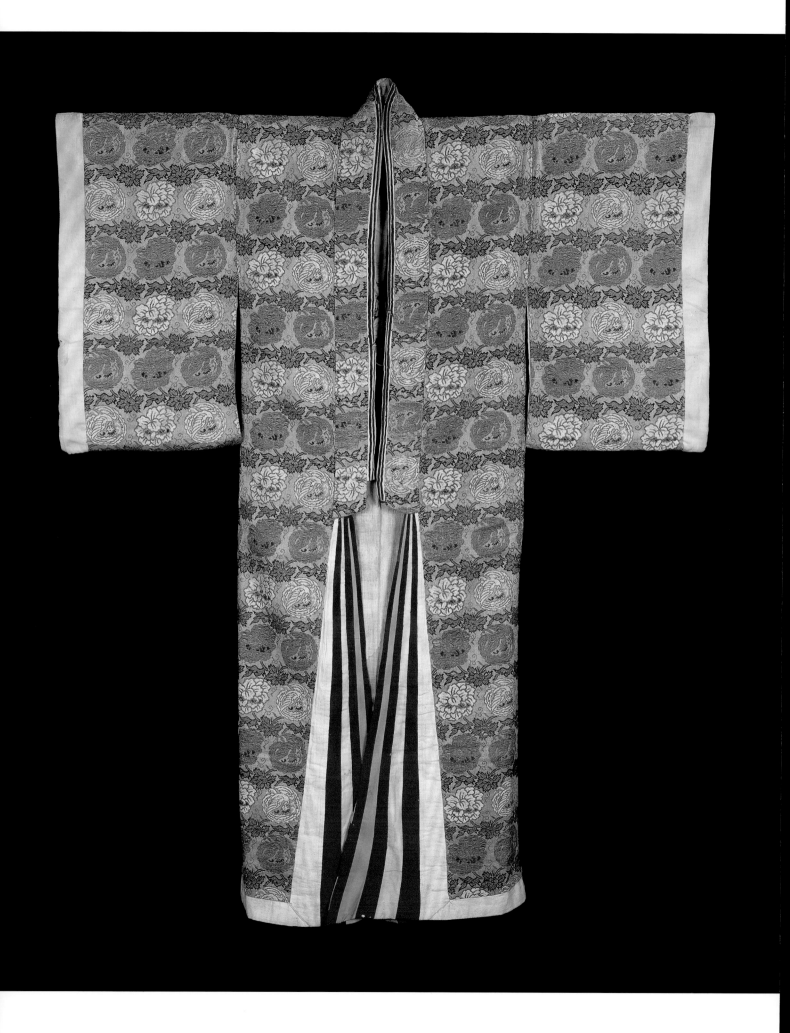

2.4 (OPPOSITE) Robe from a Kabuki costume, Meiji–Taisho period. Brocade, silk, and cotton. H: 158 cm. FMCH X2000.49.1; Anonymous Gift.

Rooster medallions alternating with peonies are brocaded in silk and cotton on the heavy ground of this robe. Rich in appearance and ornamented with auspicious symbols, this robe was intended for use in portraying a noblewoman.

2.5 Noh mask, Edo period. Wood, and paint. H: 21 cm. Collection of Ann and Monroe Morgan.

Noh Theater performances accompanied *matsuri* festivities in several towns and cities. An enigmatic, restrained smile plays about the lips of this mask, which was worn to portray a young woman (*zo-onna*).

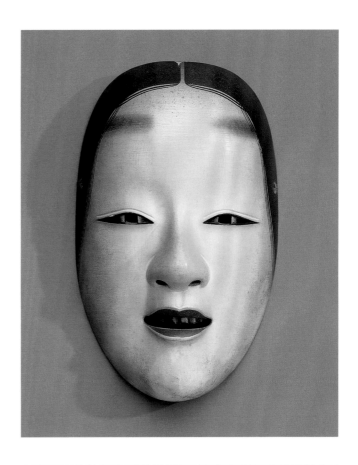

2.6 Upper garment (*haori*) from a Noh costume, early Showa period. Cotton, *tsutsugaki*-painted and stenciled. H: 89 cm. FMCH X86.4386; Anonymous Gift.

Okina plays are performed throughout Japan at New Year's to both divine and influence the fortune of the community for the coming year. Pine trees symbolizing longevity and resilient bamboo frame the crane on this *haori*—all auspicious symbols for the future.

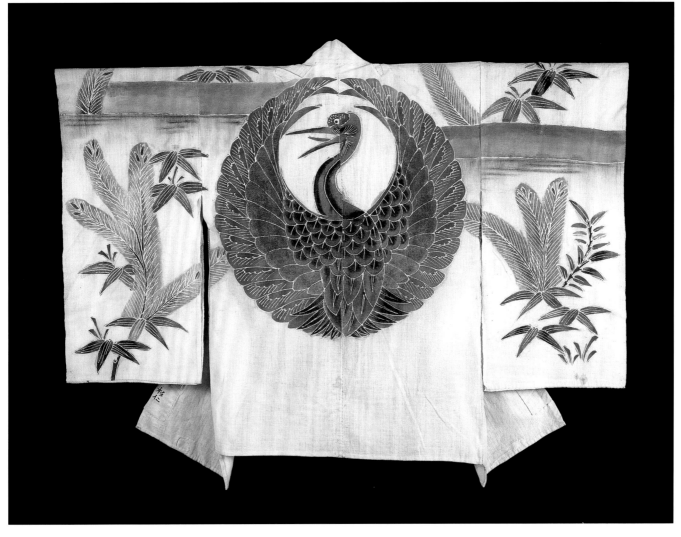

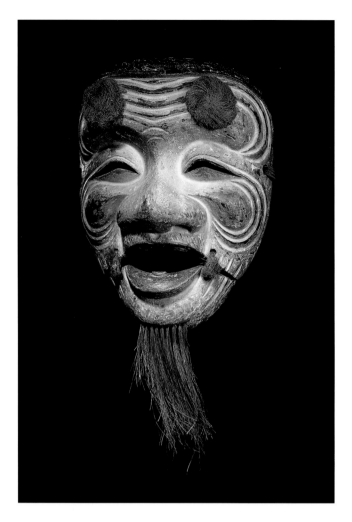

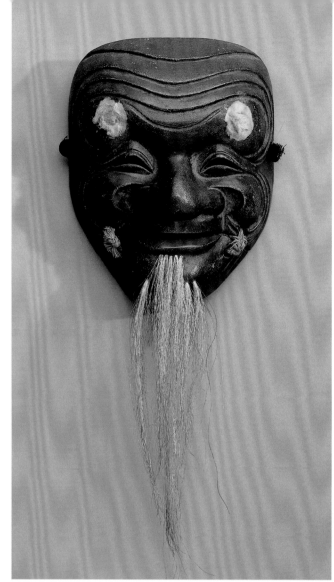

2.7 Mask of Okina, Edo period. Wood, paint, hair, and plant fiber. H: 17.8 cm. FMCH x84.778; Gift of Dorothy M. Cordry in Memory of Donald B. Cordry.

The principal (*shite*) in the Okina play—wearing a white mask symbolic of healthy old age—dances in order to bring prosperity and happiness for the coming period. Of note, the actor stops mid-performance and ceremoniously removes the mask, putting it in a special box. This is the only time in Noh Theater that an unmasking takes place in front of the audience. After this, the *shite*, carrying a fan and shaking a wand of bells, dons the jolly black Sambasō mask and appeals to the deities for a full harvest.

2.8 Sambasō mask, Meiji period. Wood, paint, hair, and plant fiber. H: 17.8 cm. Collection of Ann and Monroe Morgan.

The smiling black face of Sambasō exudes goodwill and indicates an auspicious harvest.

2.9 Mori Sosen (1747–1821). *Monkey Performing the Sambasō Dance*, 1800. Ink on paper. 115.5 x 49.5 cm. Pacific Asia Museum Collection, Gift of Mr. and Mrs. Bruce Ross, 85.55.4.

A monkey performs the Sambasō Dance in this painting by Sosen. He wears a white *haori*, which is painted with cranes, a symbol of longevity, and he holds the traditional accessories for the dance, bells and a fan. The latter is painted with pine boughs, also thought to bring long life.

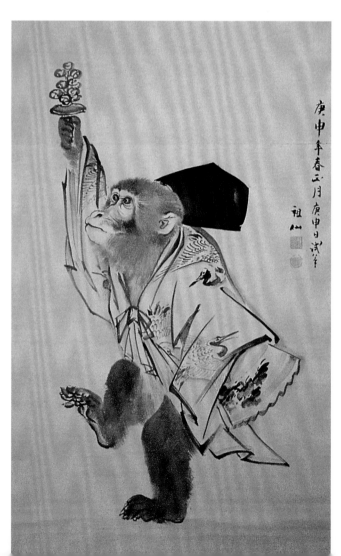

under the *shuramono* category are Noh's evil deities. As one of the Buddhist hells, *shura*, short for Ashura (Sanskrit, "Asura") is the destiny of warriors, hunters, and others who perpetrate, or are victims of, violence. In Noh these are mainly the warriors who killed and were killed in the *Heike Monogatari* (Tales of the Heiki), a tale collection pertaining to wars of the twelfth century, and other tales of violence of the twelfth and thirteenth centuries. These vengeful spirits come on stage to reveal their evil powers; however, they also come to be led to salvation. For them, the stage is a place of healing, of overcoming their grudges, and ultimately a place where they are delivered from the pains of hell. For the living spectators, however, the stage, like *matsuri,* is a place of delivery from the havoc these spirits can wreak, a kind of renewal. By virtue of having appeared on stage and delivered a public confession, these spirits are now harmless and even beneficent. Like the good deities, they dance before they disappear from stage. The community has a vital interest in transforming these spirits from evil to good so that it can begin anew.

The Kabuki plays also came out of *matsuri* (figs. 2.4, 2.10–2.17). They date back to the tenth century when Kuya (also Koya, 903–972), a loosely affiliated Buddhist monk adopted *matsuri*-type mating dances to teach Buddhism to the common people. His dances came to be known as Nenbutsu-odori. The worshipers dance to the rhythm of the recitation of the name of the Buddha Amida (Amithaba, Buddha of Mercy). Interestingly, as they spread from Kyoto to other regions of Japan, these dances preserved their initial purpose, combining a mating ritual with Buddhist worship. They also came to be performed during Bon as means to appease the souls of the

2.10 *Hakama* (culottes) from a Kabuki costume, Showa period. Silk. L: 92 cm. Collection of the Asian Cultural Arts Trust.

This blue and lavender figured *hakama* would also have been worn by an *irō-otoko*, a colorful and passionate young male character (cf. fig. 2.11).

2.11 *Hakama* (culottes) from a Kabuki costume, Taisho–Showa period. Silk brocade (*karaori*) and gold metallic thread. H: 127 cm. Collection of Brenda Buller Focht, Ph.D.

Hakama such as these are worn by an actor playing an adolescent male courtier. The extravagant *karaori* silk brocade technique employed on this garment is usually associated with Noh costume. It was worn for specifically for the role of a *momo no goro* in *Ishikiri Kajiwara*. This is an *ara wakashu* role, or that of a vigorous, young, and often unruly, male.

2.12 Obi for a courtesan (*mananita*) from a Kabuki costume, late Meiji–early Taisho period. Silk, gold and silver metallic thread, and cotton. H: 110 cm. FMCH X86.4449; Anonymous Gift.

This type of large-scale obi is traditionally worn for the role of a courtesan in Kabuki. This one was made specifically for the role of Akemaki—the most renowed courtesan in Kabuki—who appears in the play *Sukeroku*. The design of a carp leaping a waterfall suggests the annual Boys' Day festival in spring.

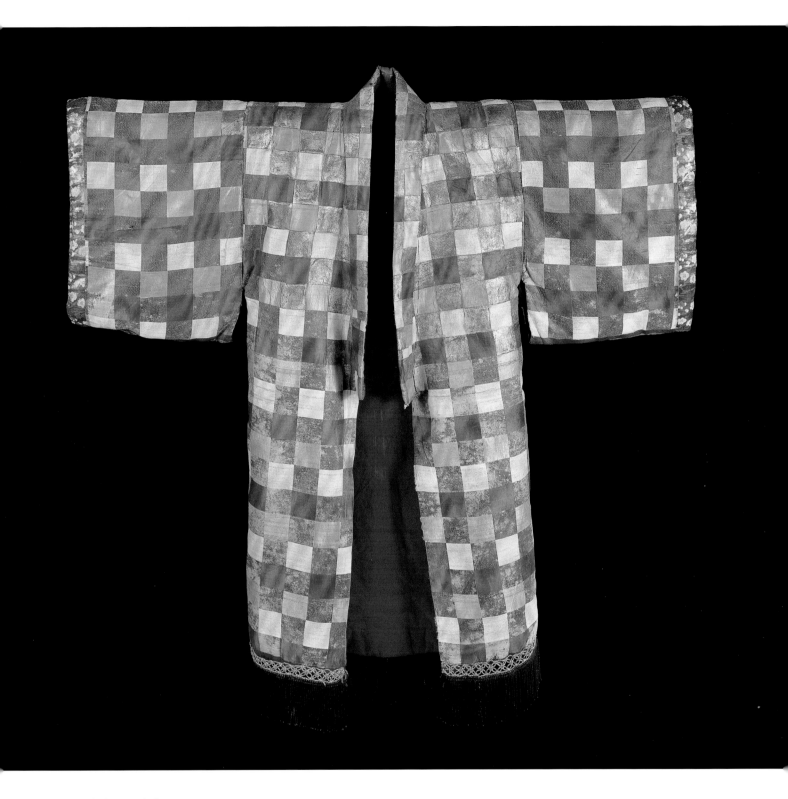

2.13 Robe from a Kabuki costume,
Taisho–early Showa period.
Silk, cotton, and metallic thread.
H: 138 cm. Collection of the Asian
Cultural Arts Trust.

The gold and silk checkerboard
design on this robe suggests
masculine strength, and indeed
it would have been worn by a
Kabuki actor playing the role of
a samurai lord. The actor would
indicate fearlessness by kicking
up the fringed hem of the robe
as he strode across the stage.

2.14 Coat from a Kabuki costume, Showa period. Silk, gold metallic thread, and brocade. H: 86 cm. Collection of the Asian Cultural Arts Trust.

This vibrantly colored coat of silk and gold metallic thread with a ruffled collar would have been worn for the role of Kari-no-hogenkan in the Kabuki play *Yoshitsune no Senbon-zakura*.

2.15 *Nagabakama* (long culottes) from a Kabuki costume, Meiji period. Gold metallic thread, silk, brocade. L: 196 cm. Collection of the Asian Cultural Arts Trust.

These elaborate and elongated silk and gold metallic brocaded culottes known as *nagabakama* could have been worn for the role of a *momo no goro* in the Kabuki play *Ishikiri Kajiwara*. The design, which is known as undulating wave, and the opulence of these culottes represent the character of a vigorous young samurai, a type of role termed *ara wakashu*. The long culottes dragged on the floor as the samurai moved across a room and made it difficult for their wearer to engage in any surprise moves during a court appearance before the shogun.

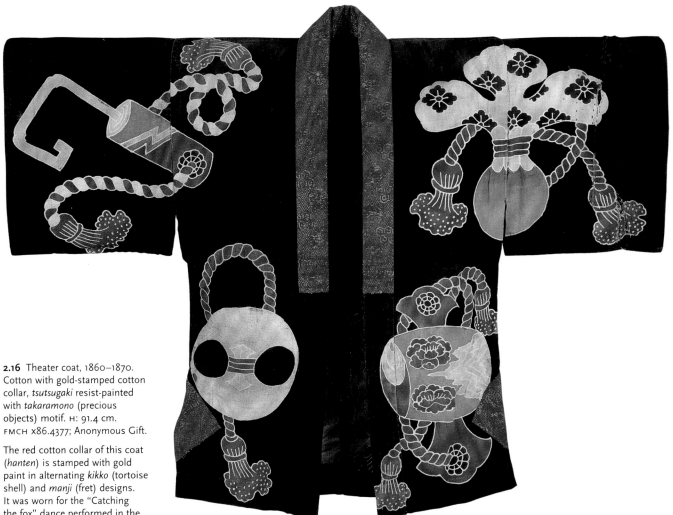

2.16 Theater coat, 1860–1870. Cotton with gold-stamped cotton collar, *tsutsugaki* resist-painted with *takaramono* (precious objects) motif. H: 91.4 cm. FMCH X86.4377; Anonymous Gift.

The red cotton collar of this coat (*hanten*) is stamped with gold paint in alternating *kikko* (tortoise shell) and *manji* (fret) designs. It was worn for the "Catching the fox" dance performed in the Kabuki play *Yoshitsune no Senbon-zakura*, originally popularized by the actor Arashi Sangoro (1687–1739). The coat was created around the time the last performance by a member of the Sangoro lineage in this role is documented. Treasures represented on the front of the coat include the mallet of Daikoku, which was used for pounding out wealth; a weight (*fundo*) used by shopkeepers; a key to the storeroom (*kura*); and Hotei's bag of riches. See figure 1.14 for a back view of this coat and figure 7.2 for a detail.

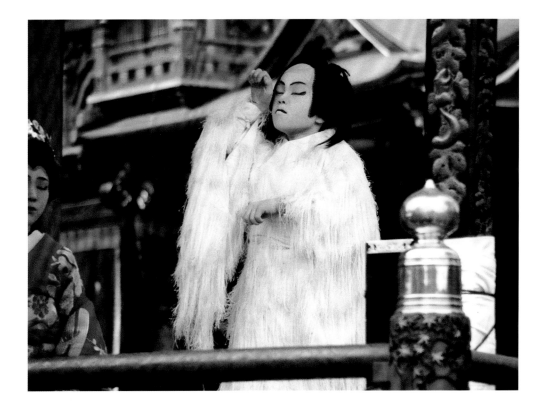

2.17 A modern version of the "Catching the fox dance" from the Kabuki play *Yoshitsune no Senbon-zakura* (see fig. 2.16) is performed by children at the Nagahama Matsuri. Photograph by Herbert Plutschow, 1997.

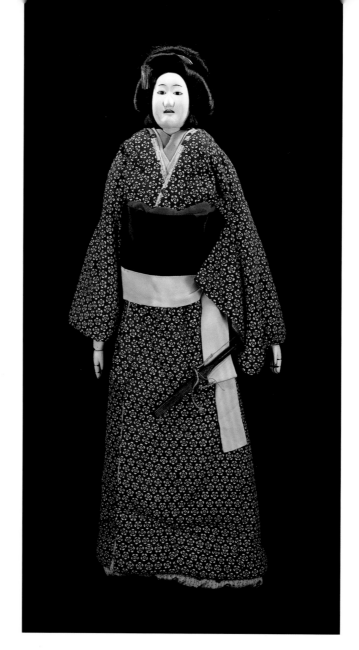

2.18 Yurahiro Hishida, Bunraku puppet, 1965. Wood, paint, cloth, human hair, silk, and satin. H: 126 cm. FMCH X.88.957a.

Bunraku puppet shows were offered in conjunction with *matsuri* celebrations. This well-coiffed puppet wears a kimono and obi of subdued color and modest design, indicating that she is playing the role of a good wife of the upper class. The design on the puppet's kimono is known as *komon*. This puppet was commissioned by the UCLA Theater Arts Department. It specfically represents the character Osono the wife of Hanshichi in the play *Hadesugata onna maiginu*.

dead, even the vengeful dead. Bon was the season, usually late summer, when the dead were supposed to come back to visit the living. It was around the year 1600, a time of deep political and social instability, when Okuni, a professional Nenbutsu dancer from Izumo Province (present-day Shimane Prefecture), performed in Kyoto and became an instant success. Her performance drew mainly from Izumo Province mating dances, which by then had already developed into simple theatrical plays about pleasure girls and their clients. One of her early plays in which she played/danced the roles of her dead lover and herself relates significantly to the Bon "revival of the dead." Like Noh, Kabuki plays came to be performed in *matsuri*. A particularly impressive example is the children's Kabuki of the Hikiyama Matsuri in Nagahama. Some communities, such as Kotohira Village on Shikoku Island, have preserved ancient Kabuki stages dating back to the Edo period (1600–1868).

Puppet plays have also evolved out of *matsuri,* and some are still being performed in and as *matsuri* (fig. 2.18). The Bunya Ningyo of Sado Island (Niigata Prefecture, time undetermined) is a good example of a religious drama where in the end good wins over evil. The puppets of the Kohyo Shrine of Yoshitomi, Fukuoka Prefecture, and the Oshirasama of the northeast of Honshū (all, time undetermined) represent the deities. The puppet of Sanemori paraded in the Mushiokuri Matsuri of Shirokawa, Aichi Prefecture, or the Mushiokuri of Iwami-cho, Shimane Prefecture (July 20), represents the potentially evil Saito Sanemori (d. 1183), a warrior slain in the area. The Itokiri Karakuri of Kutami, Yaezu, Gifu Prefecture (first Sunday of April), are marionette plays performed on wheeled shrines. As previously remarked, puppets allow for a

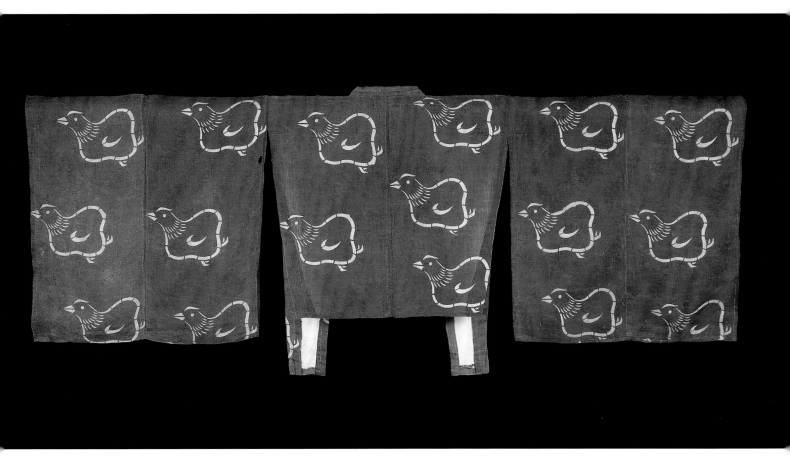

greater degree of extraordinary or "supernatural" action than is possible with living actors and actresses.

The Kyogen Theater comes out of another part of *matsuri*. In its reversal of social roles—the lower classes outwit the ruling ones, women outwit men, the weak overcome the strong—Kyogen is a kind of dramatic reenactment of the leveling of society and of the carnivalesque transgression that *matsuri* brings about (figs. 2.19). An interesting play entitled *Irumagawa* (Iruma River) draws on a defunct local *matsuri*, during which all linguistic meaning was reversed: good meant evil; white, black; deep, shallow; and so on. Based on this reversal, a traveling lord outwits the local one. In the *matsuri* context, Kyogen plays were initially called Modoki. Modoki was an art of parodying serious action and speech, including that of deities: for example, a man who tries to outwit a deity or a feudal lord trying to outwit his servants or his wife only to make a fool of himself. In contrast to the Okina, Kyogen portrays humans as insufficient, helpless, and poor. Humans had a vital interest in showing themselves as weaklings in order to attract the deity's sympathy and succor.

Some *matsuri* preserved their ancient theatrical plays despite the elaboration and refinement that they have achieved as secular, urban theaters. Others, however, readapted themselves to the urban refinement. In the Hikiyama Matsuri, for example, children play Kabuki scenes on the divine floats, but these plays are from the Kabuki theaters of Kyoto and Tokyo and are not locally preserved culture. Other *matsuri* were secretive before the advent of modern Japan; communities were reluctant to reveal their sacred rites to outsiders for fear that such revelation might enervate the *matsuri*'s

2.19 Upper garment (*suo*) from a Kyogen costume, late Edo–Meiji period. Hemp, stenciled with design of plovers (*chidori*). H: 79 cm. Collection of the Asian Cultural Arts Trust.

This is an upper garment (*suo*) worn by an actor in the Kyogen theater. Kyogen is a comic interlude held in conjunction with the performance of Noh plays, which, by contrast, often present sober themes. The plover (*chidori*) suggests a light-hearted role.

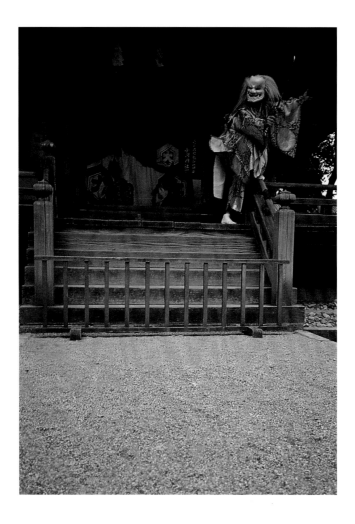

2.20 Each October at Kumano Taisha Shrine, the lives of the earliest Japanese deities are enacted in Kagura dramas often performed in conjunction with *matsuri*. Photograph by GGG, Shimane Prefecture, 1993.

sacred energies. Other *matsuri,* however, were highly eclectic, incorporating as much as possible the newest trends and fashions of Japan's urban centers such as Kyoto, Osaka, and Edo (Tokyo). Thus, some *matsuri*—such as the Onmatsuri in Nara— borrowed dances from India, China, and Korea. Many *matsuri* include Bugaku dances of continental origin. Chinese lion dances are also widespread.

Having discussed *matsuri* and *matsuri* arts, we are now sufficiently equipped to understand *matsuri* dress. Extravagant and colorful *matsuri* dress, sculpturesque hairdos, and towering hats that look more like canopies, contrast with the somber, monochromatic, but practical dress worn by Japanese men and women in everyday life. The Dengaku dancers who perform in many Japanese *matsuri* to bring about a good harvest, wear hats and canopies with colorful streamers—sometimes towering structures—that symbolize rain and agricultural growth. They often play an instrument referred to as clappers (*binzasara*), which reproduces the sound of thunder. The Gion Matsuri Yoiyama is another occasion to wear extraordinarily colorful dress. The streets throng with people from all walks of life. With their colorful *yukata,* the young girls catch attention. Young people traditionally had an interest in involving the deities in their selection of a partner. This may no longer be the case in modern times, but the tradition of showing off is still strong. The Gion Matsuri has, therefore, been an indicator of future economic welfare. The new, colorful *yukata* people would buy for the occasion predicted future consumption and wealth. At this sacred time when the deities were present, people asked them about the future and the *miko* (shrine virgins) delivered oracles, conveying the deities' will to the community.

The actors and their schools treasure the silk costumes of Noh and Kabuki. Handwoven, today their prices would amount to hundreds of thousands of dollars. The costumes are gorgeous divine dress, pyramidal in form, huge in their proportions, and embroidered with extraordinary designs. They give the actors a superhuman,

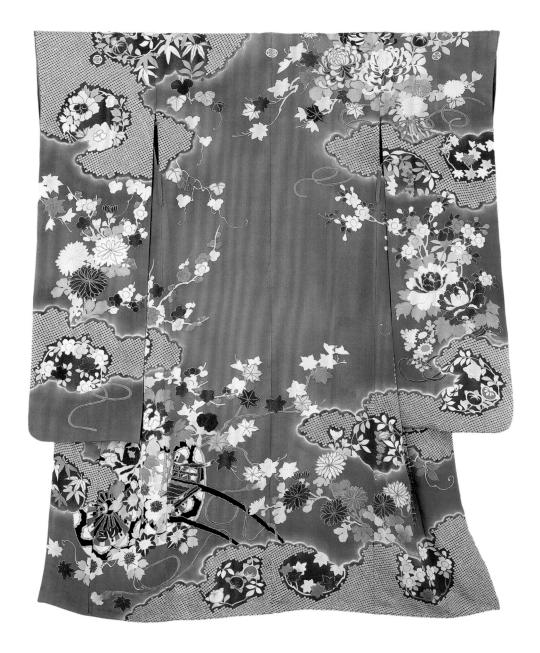

2.21 Kimono for female entertainer, Taisho–early Showa period. Silk, gold metallic thread, and embroidery. H: 172 cm. Private collection.

This kimono was custom-ordered by a young foreign woman who worked as a traveling performer. She reportedly sang in various venues in Japan in the 1920s. That the wearer was a foreigner who performed in the theater is reflected in a choice of colors not usually found together in nature. Japanese women normally select colors linked to each season.

otherworldly aura. The same applies to the twelve-layered *juni hitoe* dress worn by shrine virgins (*miko*) when dancing the sacred Kagura (fig. 2.20). The more important, the more sacred the person, the more he or she has to be packed. This principle applies to persons as well as to important gifts. Disguise is an important feature of *matsuri* dress, since it is an effective means to hide one's identity and to create equality among all. Wearing masks and similarly face-hiding headgear allows one to change identity and go unnoticed. Even if one could still be identified, however, traditionally the Japanese have been generous when it came to *matsuri* behavior and injury, even accidental deaths are "god's will" and go unpunished. Similarly liberal rules applied to the illegitimate children born out of chance *matsuri* liaisons. They were welcome in society as "god's children" (*kamiko* or *kami no ko*); that is, children engendered not by men but by the gods.

In all cultures, the sacred tended to shape the ordinary, everyday world, which is especially true for traditional fashion. Much *matsuri* dress has shaped ordinary fashion and design, especially dress worn at special, ceremonial occasions, such as Tango no Sekku (May 5), Tanabata (July 7), Seijinshiki (Rite of Passage, January 15), and so forth. What is allowed in the *matsuri* will eventually be permitted in everyday life (figs. 2.21). Kabuki dress worn by female impersonators determined the fashion of the so-called geisha. ●

3 THREE The Sacred and the Profane in *Matsuri* Structures

YO-ICHIRO HAKOMORI

MY FIRST MEMORIES OF MATSURI AS A YOUNG CHILD GROWING UP IN JAPAN ARE VAGUE at best; a menagerie of sounds, music, gaiety; adults and children in masks dancing; the abundance of food and games. I remember *matsuri*'s intoxicating revelry and laughter, and I witnessed the sense of freedom people had to exhibit and possess the characteristics deemed appropriate for celebration. One is always tempted to draw parallels to Western festivals such as Mardi Gras in New Orleans. Although similarities exist in that participants at both festivals exhibit the drama of euphoric celebration, these similarities are superficial parallels and each draws its meaning from vastly different origins. Thomas Rimer writes in his introduction to *Spectacle and Spirit: The Great Festivals of Japan* by Ozawa Hiroyuki that

> It is not that we in the West have no experience of our own in what might be described as some variety of communal ecstasy. Those who have visited Mardi Gras in New Orleans talk of the giddiness of those days that precede Lent, a pattern repeated as well in Rio, Munich and many other cities where, in the Catholic calendar, such outpourings of energy precede the somber days that lead eventually to Easter.... In Japan, a vast range of festivals, large and small, have been carried on for as long as there have been historical documents to record them. [Ozawa 1999, 6]

One wonders what the fundamental difference is between a Western festival such as Mardi Gras and a typical Japanese festival. It is simple to point out that with Japanese festivals the Shinto gods to whom the festival is dedicated are present during the event. What then is the relationship between the phenomenal, physical act of celebration exhibited by the mortal participants and the spiritual presence of the deity? Finally, what role do the various *matsuri* structures play in this relationship?

3.1 A *kasahoko* is a type of *hoko*, or decorated wagon, hung with many lanterns. Photograph by Ikko Nagano, JPS, Ōtsu Matsuri, 2000.

3.2 Neighborhood *mikoshi* borne by young participants at the Sensōji Temple. Photograph by Ozawa Hiroyuki. Reproduced with permission of the photographer and Kodansha International, Ltd., from Ozawa (1999, 15).

This chapter will describe the most common *matsuri* structures that play an important role in the mediation between the celebrants and the deity at most Japanese *matsuri*. By *matsuri* structures, I refer not to the immobile architectural constructs that are associated with *matsuri*, such as the shrine itself or other various pavilions constructed to sell food or display trinkets, but rather to the various traditionally constructed structures that are either paraded down the street or play an important role in the relationship between the spiritual and the profane specific to *matsuri* (fig. 3.2). In all instances each type of *matsuri* structure is believed to play an essential catalytic function between the Shinto deity and the human participants. Each structure is dynamic and mobile, constructed not only as beautiful decoration and an exhibition of artistic talent but also as a point of contact between the presence of the deity and human activity. It is not the intent of this essay to describe every type of *matsuri* structure found in the thousands of *matsuri* celebrated throughout the year in Japan. Rather, it will illustrate some common themes found to be prevalent at many *matsuri* and begin to describe, typologically, the various structures.

Matsuri plays two other important roles for the typical Japanese. It serves as a vehicle to perpetuate long-held local artistic traditions, as well as to reinforce identity through the bonding of the citizens to a particular locale. For example, in the preparation for *matsuri*, the construction of ceremonial floats (fig. 3.3) or the wearing of traditional costumes propagates the craft and process of making. Also, although exceptions exist, most *matsuri* are intimately associated with a particular place and its particular *kami* (deity or deities). *Matsuri* is usually not an event celebrated nationwide (Obon being an exception), but a local, site-specific event. Each celebration fulfills a site-specific need or desire: fertility, protection from pestilence, a good harvest, and so forth.

From a broader point of view, it may be argued that *matsuri* as a form of celebration and cultural expression is particularly Japanese and as such is a marker and repository of cultural identity in this postmodern period of cultural globalization. William Currie writes of his observations regarding *matsuri*:

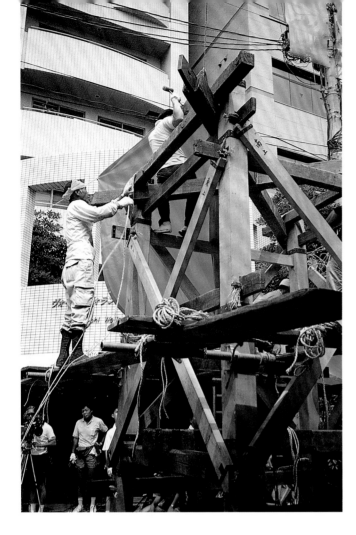

Carnivals and street fairs were not new to me, nor were outdoor religious festivals and processions. But the mixture of the sacred and profane, the solemn and the earthy, rich symbolism and gaudy hucksterism—this was something I had not experienced before. I had the feeling that if one could understand the spirit of the matsuri, then one would have gone a long way toward understanding the Japanese way of looking at the world. [Yanagawa 1988, 9]

THE SHINTO RELIGION AND THE SHRINE

When Buddhism first came to Japan from China in the fifth century, the ancient Japanese already had their own system of beliefs and ritual practices. To be sure, it was undisciplined and lacked clear definition. It was an animistic devotion to natural deities, powerful forces that controlled many aspects of their lives. With the arrival of Buddhism, these beliefs became known as Shinto, the "Way of the *Kami*," to distinguish them from the imported belief system. The ancient Japanese made no clear spiritual distinction between gods, inanimate objects, natural objects, and human beings. Many natural objects such as large stones, mountains, the sun, and large trees were thought to possess spirituality. Natural phenomena such as the wind or thunder were also given spiritual identities and were often anthropomorphized and associated with human forms. Great man-made objects, such as swords or brilliant mirrors, jewels, and sometimes the shrine structures themselves, were also believed to possess spirituality. Finally, great human beings such as the emperor, empress, and fearless warriors were thought to be gods.

In general Shinto gods (*kami*) are spirits inherent in nature and associated with the forces of growth and renewal. Thus, *kami* were probably first worshiped in natural settings, an open clearing among trees perhaps. When shrines were first constructed, natural settings were always very important, the Shinto shrine at Ise being an excellent example (fig. 3.4). It is important to be aware that *kami* do not necessarily reside within the shrine. They descend as visitors when called upon by prayer or through

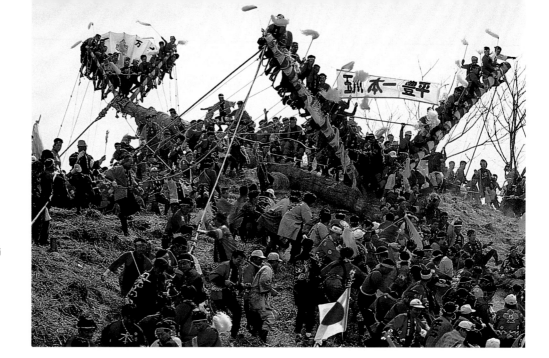

3.5 Participants at the Ombashiri Matsuri in Nagano Prefecture ride atop the sacred pillar. Photograph by Ozawa Hiroyuki. Reproduced with permission of the photographer and Kodansha International, Ltd., from Ozawa (1999, 36).

3.6 The five-tiered pagoda at Horyu-ji in Nara is constructed with a single pillar rising the entire height of the structure. Photograph by Yo-ichiro Hakomori, 2000.

offerings. This process of summoning the deity becomes an important ritual during the early stages of many *matsuri*. Throughout the year, *kami* are typically awoken and prayed to by the ringing of a bell mounted above the prayer area and by loud clapping. There also often exists what might be termed a "conductor" (*shintai*) that facilitates the *kami*'s entrance to the shrine when called upon. Usually located in the inner sanctum of the shrine, the *shintai* can be a man-made object such as a statue of the *kami* or a mirror, or it can be a natural element such as a large tree in or around the shrine grounds.

The precinct of a shrine is almost always marked by a large gatelike structure, or torii. Constructed of two tall columnar structures connected together by two horizontal members, torii gates—and tall trees in general—are regarded as useful in helping to draw the *kami* down to the sacred precinct. Columnar structures are significant as either conductors for the deity or are thought to possess spirituality themselves. The Ombashira Matsuri held in Nagano Prefecture celebrates this belief. In this festival, celebrants ride atop large fir trees down a steep embankment as a test of courage, and these large posts are finally erected as spiritual markers at the four corners of the shrine as the culmination of the festival (fig. 3.5). In the architecture of shrines and pagodas, large columnar structures become symbolic of this association

with spirituality. The five-level pagoda is an architectural manifestation of a columnar structure. The five-tiered pagoda at Horyu-ji in Nara is constructed with a single pillar at its center that rises the entire height of the structure (fig. 3.6). The shrine at Izumo also has a single columnar structure at its center.

Shinto shrines were not only places of ritual and prayer but also frequently the centers of entertainment. Dancing and merrymaking were thought to awaken, summon, and please the deities. It is therefore not uncommon for many of the *matsuri* festivities to be held on the grounds of the shrine proper, where the intermingling of the spiritual and profane can occur.

MATSURI FESTIVITIES AND *KAMI*

To be certain, participation in *matsuri* is a phenomenal act, one that entails physical human involvement. Much like athletic events, the dances, competitions, and dramatic rituals common to many *matsuri* involve physical exertion. These exercises are deliberately fashioned to create the process of catharsis and renewal (fig. 3.7). Thomas Rimer writes of his first experience as a participant:

> I was invited out of hot, then woefully unair-conditioned Tokyo by a friend to spend a weekend in the mountains of Japan, in a small town near the popular resort of Kamikochi, where he had some business for his university. Our visit happened to coincide with the yearly O-bon celebration, a festival or matsuri celebrated in one fashion or another throughout the country during that period of the year. We were invited to participate in the evening dances, eventually joining a huge circle of some hundreds of persons swaying and dancing around an enormous bonfire under the stars. I think this occasion marked the first time in my life when, to the seduction of music, the movement, and the powerful energies of the moment, I felt myself completely, yet safely, abandon any ordinary sense of self in order to become part of a deeper communal rhythm. [Ozawa 1999, 6]

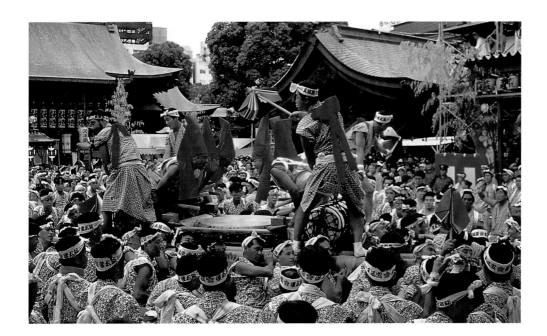

3.7 Young men pound on festival drums to lead the procession at the Tenjin Matsuri in Osaka. Photograph by Ozawa Hiroyuki. Reproduced with permission of the photographer and Kodansha International, Ltd., from Ozawa (1999, 31).

As Rimer has pointed out, *matsuri* is to a large extent about a phenomenal experience and emotional ecstasy. If everyday routine creates a structure for our lives, *matsuri* represents a completely different order, or "anti-structure," and the realignment of one's perception of the world for that short instance (Yanagawa 1988, 8).

Rimer has also pointed out, that *matsuri,* in all cases, reinforce a sense of community and identity. In a large city such as Tokyo, individual districts conduct their own *matsuri* centered around a local shrine. Through its own internal social organization, each district manages to organize the *matsuri* and thus reinforces the sense of place both in its physical manifestation as well as in terms of a psychological and social order.

As mentioned previously, *matsuri,* of course, has at its foundation the Shinto religion and can thus be considered a Shinto ceremony. *Matsuri* often involves the ushering of the Shinto gods (*kami*) in their descent from the spiritual world so that they may participate in the *matsuri* festivities. In many cases, the *kami* are coaxed into taking temporary shelter in what amounts to a portable shrine or palanquin, to be paraded down the streets of the city on the shoulders of many *matsuri* participants in a elaborate and dizzying display of humanity. These palanquins, or *mikoshi,* become the point of contact, the threshold between the deity and mortals. *Mikoshi* are one of the most important *matsuri* structures and will be further discussed below.

SPATIAL TRANSFORMATION

The spatial relationship between the Shinto deity and the typical Japanese citizen is markedly transformed during *matsuri*. Shinto deities are normally thought to reside in the mountains or the forests proximate to the shrine. Most Japanese visit their local shrine to pray for good fortune or to resolve matters that may be troubling in their lives. Their deity's spirit is believed to inhabit the space of the shrine, and thus the shrine serves as the conduit for intimate physical interaction with the deity. It is during *matsuri* celebration that the boundary between sacred space and the space of daily life becomes less clear. Religious space is no longer confined to the limits of the shrine's traditional institutional boundaries.

One can almost imagine the process during *matsuri* in which the deities, or *kami,* are summoned down from the "heavens" or "mountains" near the territory of the shrine, articulating a path of travel along the "vertical axis." Once safely transferred and housed within the *mikoshi,* the *kami* are happy to be carried along the street as part of a processional in communion with mortal celebrants, who articulate the "horizontal axis" of travel. The vertical and horizontal axes differentiate the conceptual separation between the sacred and profane, and trace the movement of deity and mortals during *matsuri*.

In his essay "Manifestation of the Japanese Sense of Space in *Matsuri*," Fred Thompson writes about a distinction between "visual space" and what he refers as "acoustic space." Acoustic space describes the perception of space experienced not by visual perception alone but rather by the working together of all of one's senses— touch, sound, smell, and sight. Thus space is not simply understood through visual perception but through physical experience. Thompson quotes McLuhan:

> The space of a community filled by the activities of the matsuri is unlike
> space conditioned by a visual mode of perception. There is no favored
> point of focus. The yorishiro, a stick with paper decorations, a pole or
> a tree which becomes a God seat during the festival, fills the acoustic

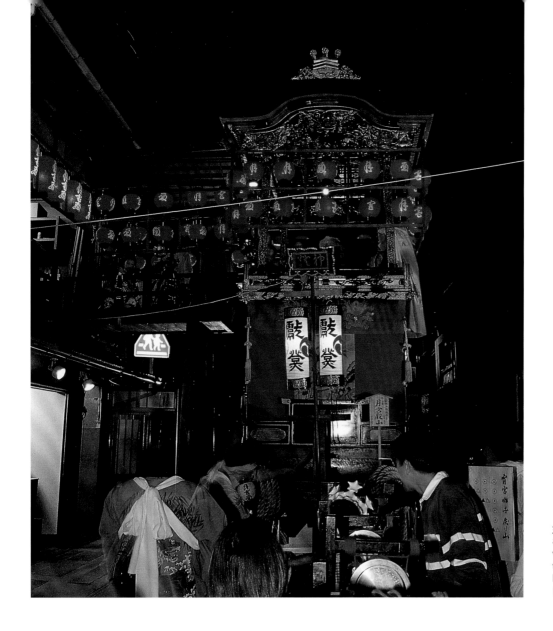

3.8 A connecting bridge from an adjacent building allows visitors to view the interior of the festival wagon the evening before *matsuri*. Photograph by Ikko Nagano, JPS, Ōtsu, 2000.

> space.... Acoustic space is not pictorial space, boxed in, but dynamic,
> always in flux, creating its own dimensions moment by moment.
> [Thompson 1986, 19]

This notion of space as being governed and perceived by faculties other than sight alone is a concept that places the phenomenology of spatial experience at the fore. The idea that space exhibits dynamic movement, changing from moment to moment, is exemplary of the spatial condition during the height of *matsuri* festivities.

It is also interesting to note the fervor exhibited on the night before the *matsuri* celebration is to begin, which is known as *yoimatsuri*. On the night before the descent of the deity and the beginning of *matsuri*, it is not uncommon for the citizenry to participate in a processional viewing of various "festival floats" along the route of the next day's *matsuri*. Similar to the *matsuri* processional, *yoimatsuri* also strongly reinforces the horizontal path of travel for the mortal celebrants. Unlike the *matsuri* processional, however—where the various *matsuri* structures are in motion while most of the celebrants are somewhat stationary—during *yoimatsuri*, the situation is reversed. Festival floats are parked in areas honored by the local festival organizers for all to see prior to the beginning of *matsuri* the following day. The neighborhood members in charge can often be seen preparing the floats with great attention and care. Citizens are permitted to enter the floats and view their interiors, sometimes by crossing a temporary bridge from the second story of the adjacent storehouse, which is connected to the upper level platform of the float (fig. 3.8). In Kyoto, the *yoiyama* preceding the Gion Matsuri brings out throngs of people moving down the processional route to view the festival floats on display.

3.9 During the day and evening preceding the festival, shop owners welcome local citizens to view their "treasures," which are displayed in honor of the *matsuri* celebration Photograph by Ikko Nagano, JPS, Ōtsu, 2000.

Spatially, it is also important to note that on *yoimatsuri,* the front doors and screens, usually closed to prying eyes during the rest of the year, are completely opened up to allow spectators to peer inside and freely visit shops and homes along the processional route. Elaborate displays of the "treasures" of the household are usually exhibited for all to see. These can include folding screens, particularly important to display during *matsuri,* which inicate personal affluence and signify devotion to the festival (fig. 3.9). Folding screens become movable art objects that transform the room into an elegant display space, simultaneously providing a visual barrier to the most private rooms behind. Heirloom kimonos are sometimes displaycd on racks as well, creating beautiful backdrops and soft screens. Thus, during *yoimatsuri,* there is a festive, casual communion among the citizens that strongly reinforces the connection between place and people. While the festival floats remain stationary, both the movement and the gathering of people along the *matsuri* route transform the perceptual and sociological understanding of spatial boundaries in a way unique to *yoimatsuri.* The normal layers between the public realm and the private realm created by shoji screens and front sliding doors are completely abandoned during this time. This unusual display of unique movement of the citizens during *yoimatsuri* articulates the transverse axis from one side of the street to the other.

THE SHRINE AT ISE AND ITS IMPERMANENCE
As pointed out earlier, an understanding of *matsuri* and the function of the various festival structures depends on one's belief and understanding of the Shinto religion. Like *matsuri,* a description of the periodic rebuilding of Ise Shrine and other related examples will illustrate the importance of ritual and process, and in many ways this is at the foundation of the Japanese people's innate understanding of themselves as well as the source of their cultural identity. The shrine at Ise is thought to be the most sacred place in Japan. First built circa 680, this shrine is dedicated to the sun goddess Amaterasu. To experience Ise Shrine for the first time is no less powerful than the first visit to a Gothic cathedral. Whereas at a Gothic cathedral the massive stone structure captures a vastness of space and light that evokes a sense of awe and spirituality, at Ise it is the juxtaposition of the splendor of natural elements, such as the tall cedar trees or the winding river, with the simple but powerful wooden structures that moves one.

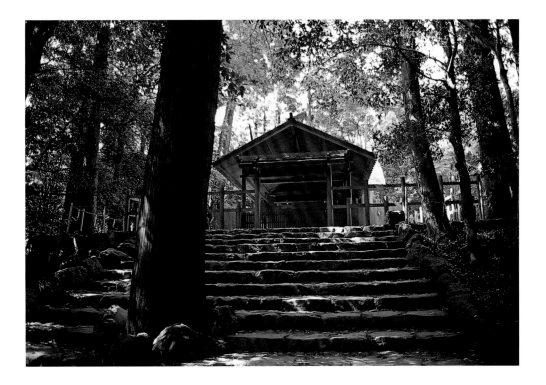

3.10 Stone steps between large cypress trees lead to the main prayer gate at Ise Shrine. Photograph by Yo-ichiro Hakomori, Mie Prefecture, 2000.

Consistent with the values and beliefs of the Shinto religion, Ise Shrine may be considered one of the most beautifully crafted wooden structures to be nestled within a dense cedar forest. Approach to the main shrine requires passage along a winding path on which one can only glimpse the large roof structure beyond the top of its surrounding outermost fence. There are four fences protecting the compound of structures. After ascending a series of stone steps between several very large cypress trees, one encounters the main prayer gate at the third fence (fig. 3.10). A gentle breeze blows the stark white *noren,* or cloth curtains, at the gate as if to trace the ascent and descent of the *kami.* At Ise, visitors are unable to enter any of these structures for they are reserved for the *kami.* For that matter, no one is even able to see fully the main structure of Ise Shrine as it is off limits to mortal eyes.

What is most extraordinary about Ise Shrine—and exemplary of the importance of process and craft in Japan—is the fact that it is completely rebuilt on an adjacent site every twenty years. The main group of structures is thus regenerated in its pure form by a team of craftsmen in exactly the manner that it has been constructed for the last fourteen hundred years. Through the process of rebuilding, the craft and methods of construction perpetuate a tradition of building from generation to generation.

One could argue that this process of destruction and renewal, and the importance of the process versus the product, becomes a reccurring theme in *matsuri,* as well as being the foundation of the Japanese sense of cultural perpetuation, which is contrary to Western thinking. Ise Shrine is an example in Japan where the architecture, as "built artifact," is not the only repository of cultural values.

As most Western cultures would agree, an important historic monument or cultural ruin has value and meaning if its existence is authentic or real. In other words, it is significant if the stone ruins of some Greek temple remain as they were laid down some two thousand years ago. A replica of this temple with identical materials and craftsmanship has little value except as a simple imitation. Value and significance is placed on the artifact, and we experience a feeling of awe when we view or touch the stone laid by some artisan thousands of years ago. This is not the case in Japan. Relating to the example of rebuilding of Ise Shrine, it seems that for the Japanese, there is an underlying agreement that nothing is or should be permanent. Ise Shrine is rebuilt as a Shinto ritual the purpose of which is to eliminate "pollution" from the sacred grounds, considered as an entity that has experienced the passage of time.

At the same time, the repeated rebuilding is harmonious with the Buddhist belief in the impermanence of all matter. In Buddhist philosophy things are understood and accepted to be in a state of continuous transformation, in a process of continuous destruction and regeneration. The world is in a constant state of flux—nothing is thought eternal (Inoue 1985, 170). Thus, value has been placed on process and artistic craft as a repository of cultural identity, rather than bestowed upon ancient ruins or artifacts. Of course, there are places where old structures or locales are preserved, many of them in Kyoto. Several of these "old" structures are actually continuously being repaired, however, and are kept up by a team of craftsman. For the Japanese, these places are regarded as authentic just the same.

It is fascinating to note that Japan is also the only country I know of that registers a living person who practices a specific craft, such as weaving or pottery, with the status of National Living Treasure. This status is akin to that bestowed on important monuments or buildings or places in the United States, which are placed on the National Historic Register. In the United States, this elite recognition is given to places and things. In Japan, there is far less value placed on the "artifact" created with far more value placed on the process or craft associated with the making of the "artifact."

MATSURI STRUCTURES

In the previous sections, the groundwork has been laid and the stage set for the discussion of *matsuri* structures. In this final section, I shall illustrate through the examination of *matsuri* structures, that festivals and festival structures represent physical manifestations of deep-seated values and beliefs, either conscious or subconscious, for the Japanese. The following section is also a topological description of the most common structures found in many Japanese *matsuri* with a brief description of their purposes in a particular festivals.

Various mobile structures are specifically built or preserved for a particular *matsuri*. Some are very elaborate and well-crafted, while others are quite simple. In this section, I will describe the following *matsuri* structures, all of which play an important role in a number of the festivals: the *mikoshi*, the decorated wagons called *hikiyama*, boats, lantern apparatus known as *chochin*, and umbrella structures called *kasa*. In many cases, such as the *mikoshi*, the structures become the point of interaction that makes manifest the threshold between the spiritual and mortal worlds. Often they become the catalyst for the interaction that forms the basis for the *matsuri*.

MIKOSHI

Mikoshi, which may be translated as "palanquin(s) of the gods," are the most common—as well as the most important—structures used in *matsuri* celebrations. They are used to transport the deity through the city on the shoulders of the participants and can be thought of as portable shrines. The ritual involves the carrying of the *mikoshi*, which houses the local deity, by several dozen young men or women wearing short white trousers and *ha'pi* coats, each wearing a sweatband, or *hachimaki*. Generally, the ritual involves the carrying of the *mikoshi* with an energetic up and down movement, accompanied by loud rhythmic chanting. This ritual honors the local deity and enables the people to be blessed. The sudden appearance of the *mikoshi* is designed to effect awe in the onlookers. The sudden rise in the energy level and the chanting and movement of the participants as the *mikoshi* passes are followed by an equally sudden cessation of activity and relative calm.

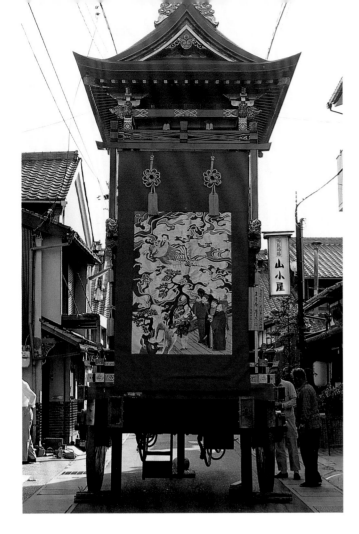 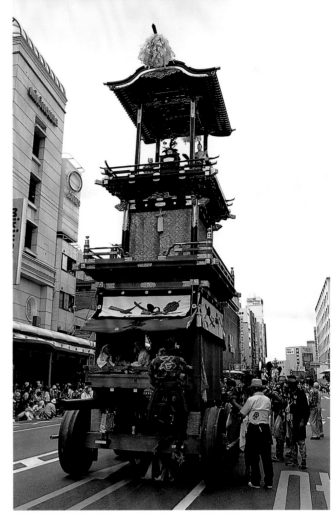

Designed and built to resemble typical shrine structures, the main body and roof of the *mikoshi* are typically lacquered. Gold leaf is often applied to the underside of the roof, and miniature "roof rafters" can be found on the underside, which represent the structure of a full-size shrine. Metal fittings decorate the main carriage, which is placed on a base of lacquered and gilded wood. Miniature torii gates, miniature fences, and decorative rope are placed on the exterior of the main body. A gilded figure of a sacred phoenix (Ootori) is commonly placed at the apex of the roof structure and is a symbol of a just ruler. Two large wood members are placed parallel through slots in the base and two additional members are strapped with rope to the two large members, all used for carrying the *mikoshi*.

Mikoshi sometimes contain the *shintai,* such as a mirror, which acts as the conduit for the deity thought to be present. The *mikoshi* become the focus of many festivals. It is through the carrying of the *mikoshi,* the vigorous up and down movement, the continuous chanting, the physical exercise, and the traditional costumes, that each participant is enabled to reach a psychological state of religious and emotional ecstasy—being trasnported from roles as citizens within the everyday structure to the spiritual and phenomenological world of *matsuri.*

DECORATED WAGONS

Decorated festival wagons known as *hikiyama* and *dashi* or *yatai* are large, multistory wooden structures resembling small shrines on wheels. These structures are typically elaborately decorated with textiles, figurines, lanterns, and carved decorations (figs. 3.11, 3.12). Festival participants, musicians, dancers, and drummers ride on wagons that are pulled by other celebrants at street level (fig. 3.13). Neighborhood sponsors contribute funds to pay for the decorations, and the wagons become the object of a sort of competition among neighborhoods to compare the wealth between participants in the *matsuri.* They also bear the treasures and valuable decorative items, owned by the neighborhood festival supporters, during the *matsuri* procession, as the display of such items is thought to astonish the deity.

3.11 This decorated wagon is hung with a Japanese silk tapestry (*tsutsureori*) of Kuan Yin (Kannon), Goddess of the Western Paradise. The wagons used at Ōtsu Matsuri have three wheels. This facilitates their turns on narrow streets. Photograph by Ikko Nagano, JPS, 2000.

3.12 Costumed mannequins ride atop this wagon at Otanjōbi Matsuri, a celebration of the twelve hundredth birthday of Kyoto. Photograph by Yuge Sei, 1994.

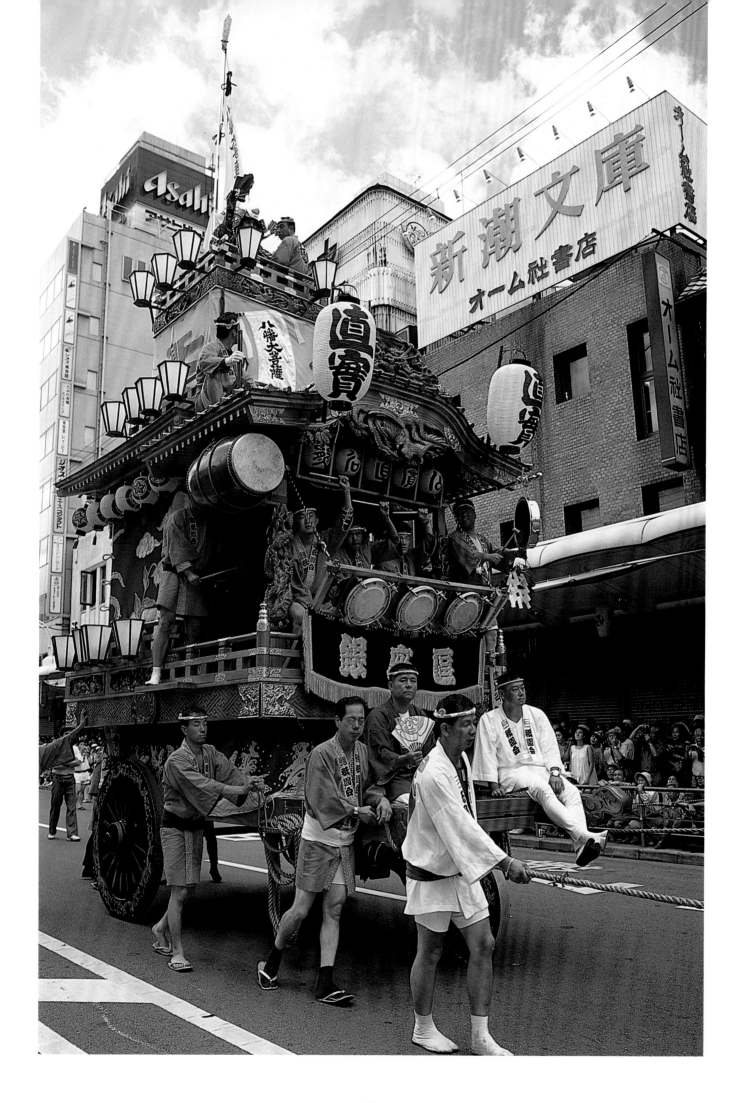

3.13 A decorated wagon loaded with drummers is pulled down the street at Otanjōbi Matsuri, a celebration of the twelve hundredth birthday of Kyoto. The men pulling the wagon wear *ha'pi* coats with multiple obi, or sashes, in bright colors. Photograph by Yuge Sei, 1994.

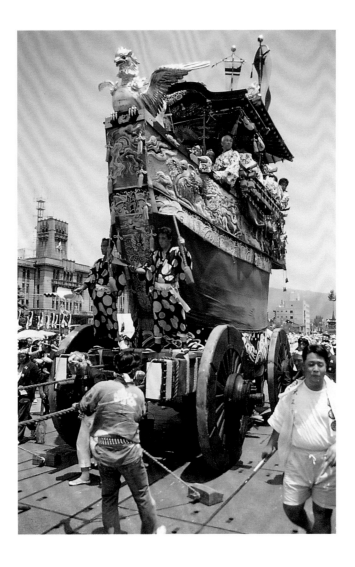

3.14 A *funeboko*, a type of festival wagon in the form of a boat appears at Gion Matsuri in Kyoto, 1994. The Hali Archive.

Hoko and *yama,* two types of decorated wagons, made famous by the Gion Festival in Kyoto, are not used to transport the deity during *matsuri,* as are *mikoshi.* Instead, *hoko,* upon which a halberd is mounted, were used to pierce hovering demons. *Yama,* which means mountain, were thought to be able to absorb demons by means of the young spreading pines atop them. Another decorated wagon seen at the Gion Festival is the *funeboko,* which resembles a boat in shape (fig. 3.14).

FUNE

Fune, or boats, are utilized during *matsuri* at seaside towns or fishing communities in which the deity is associated with water. In such communities, the deities ride fishing boats to the fishing grounds, accompanied by fishermen in other boats. In these celebrations, the boats become synonymous with *mikoshi* in that they are utilized to transport the deities during the festival. In other festivals, boats function like floating stages. At the Mifune Matsuri in Kyoto, one elegantly decorated float boat bears the deity, while other boats carry musicians and dancers who perform while the boat sails down the Oi River. Boats are also used as platforms that bear banners and flags. At the Tomobata Matsuri in Niigata, tall flags are flown on boats to attract and guide the deities coming from distant lands.

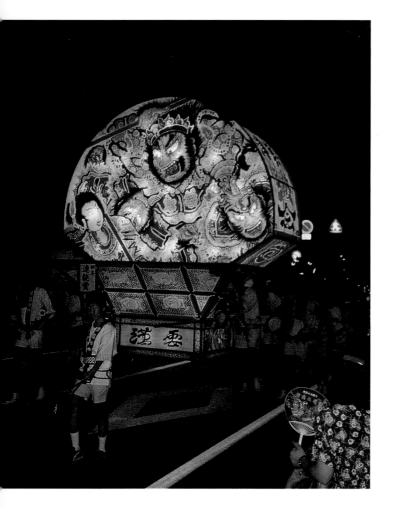

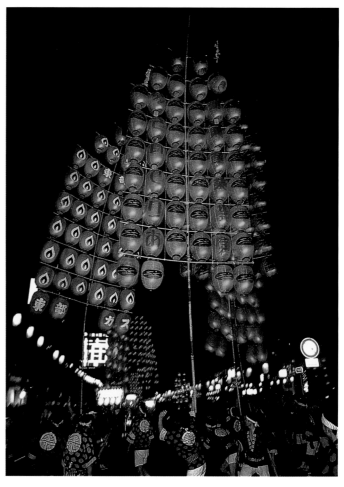

3.15 Large paper lanterns portraying mythical figures appear at Aomori Neputa Matsuri. Photograph by GGG, 1994.

3.16 Multitiered lantern structure (*kanto*) at Akita Kanto Matsuri. Photograph by Ozawa Hiroyuki. Reproduced with permission of the photographer and Kodansha International, Ltd., from Ozawa (1999, 59).

CHOCHIN

Chochin, or lanterns, are very common at many festivals held after dark. They function to create a dazzling display of light and make visible and highlight the various structures such as the *mikoshi* or *yatai*. The most spectacular display of lanterns occurs at Chichibu Night Matsuri and Neputa Matsuri. At the Chichibu Night Matsuri, two *kasahoko,* or *hoko* with tiers of umbrella-shaped decorations, are lit with many hanging lanterns (fig. 3.1). They are paraded down the main street in a beautiful display of light, which purposefully creates a completely different atmosphere from daytime. At Aomori Neputa Matsuri, large figures made of colored paper and lit from within, become elaborately made lanterns, which are carried on floats down the processional route (fig. 3.15). Twenty-four of these spectacular creations are paraded down the street for the duration of the *matsuri,* and on the final night, they are carried on boats across Aomori Harbor.

Another interesting use of the lanterns are the tall, multitiered structures called *kanto.* A *kanto* consists of a single bamboo pole with approximately eight secondary bamboo members that hold the *chochin,* much like a mast and sail (fig. 3.16). At the Akita Kanto Matsuri, young men lift these structures in an amazing feat of balance. At night the structures are internally lit to produce a colorful plane of *chochin.* During the evening some twenty *kanto* gather in the streets, and the youngest townsmen display their skills by balancing *kanto* on their hands, shoulders, hips, and foreheads.

KASA

Kasa, which may be translated as "umbrellas," are portable structures that are carried by one individual. They resemble an umbrella only in that there is a single post in the center supporting sides of fabric or rope and draped in quilted and embroidered fabric. This type of *kasa* is prominent in the Nagasaki Okunchi Festival, where each

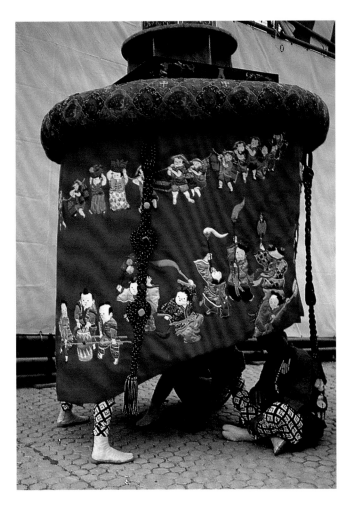

3.17 *Kasa*, umbrella-like structures, are prominent at the Nagasaki Okunchi Matsuri. They make reference to the Europeans who arrived in the sixteenth century. Parasols, trapunto, and heavily embellished felt draperies were unknown in Japan before that time. Like floats or festival wagons in other towns, each of the *kasa* represents a *chōnai*, or neighborhood. The *kasa* serve as vehicles for the descent of the deities into the *matsuri*. *Kasa* bearers wear tight-fitting *momohiki* trousers. The *momohiki* visible in this photograph are decorated with festive resist-stenciled designs. Photograph by GGG, 1992.

3.18 *Kasa* are wheeled along at the Gion Festival in Kyoto. These *kasa* are painted with Buddhist designs inspired by cave paintings found in Dunhuang China. The young pine trees and their branches atop the *kasa* are thought to absorb any malicious vapors lingering in the atmosphere. Photograph by GGG, 1994.

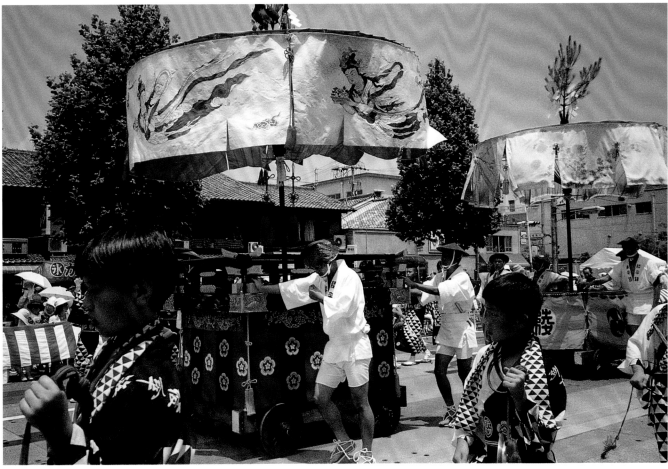

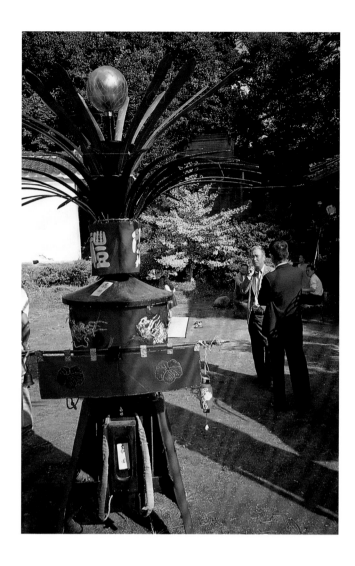

3.19 Beautifully decorated portable sutra cabinets like this one are carried on the backs of worshipers at Koya Hijiri Matsuri. The cabinets honor a priest who walked from Mount Koya to Ōda-shi to deliver the holy sutras to the populace. Photograph by GGG, Ōda-shi, Shimane Prefecture, 1992.

neighborhood is represented by a single *kasa* (fig. 3.17). A large space is demarcated in front of Suwa-jinja shrine, and each neighborhood *kasa* is paraded and twirled in front of the gathered spectators, spreading good spiritual vibrations. *Kasa* are also mounted above small wagons such as the ones seen at the Gion Festival in Kyoto (fig. 3.18).

Also termed *kasa* are the portable sutra cabinets carried on the backs of worshipers at Koya Hijiri Matsuri at Ōda-shi in Shimane Prefecture (fig. 3.19). These are long, wooden, decorated containers intended to honor the extreme devotion of one priest of the Shingon Sect. The monk reputedly walked the many miles from Mount Koya to Ōda-shi bearing the sutra scrolls in a similar container on his back, bringing the holy words to the worshipers of that town. His accomplishment is emulated each year at Koya Hijiri Matsuri as the villagers walk the length of the main street of the town and up the stone steps of the steep hill that leads to the shrine (fig. 3.20). The families of Ōda-shi store the heavy cabinets during the year and bring them out to prepare for the procession. *Nobori*, which resemble tall banners, are attached to the smaller containers.

CONCLUSION

Comparing Japanese *matsuri* with Western festivals illuminates their differences. As was previously mentioned, in Japanese *matsuri* the deities are present as part of the celebration. It is, however, abundantly clear that *matsuri* is not just a religious rite. In his essay "Festival and Sacred Transgression," Sonoda Minoru points out that *matsuri* has "two polar elements characterizing mutually opposed principles of action, that is the sacred (ritual) and profane (festival)" (1988, 41). When *matsuri* is thought of strictly as a religious event, many of its aspects become difficult to explain. The

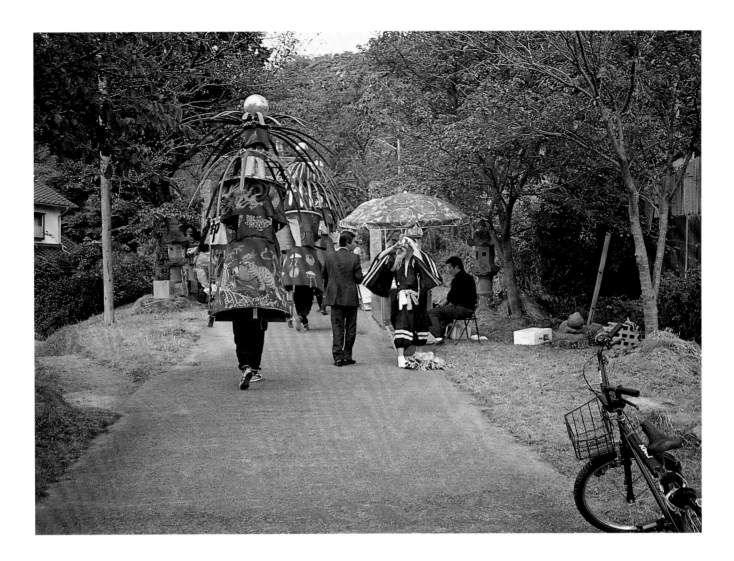

3.20 Worshipers walking the processional route carry portable sutra cabinets at the Koya Hijiri Matsuri. At the roadside a man costumed as a *tengu* (an imp) halts momentarily to chat. Photograph by GGG, Ōda-shi, Shimane Prefecture, 1992.

public's often wanton exhibition of uncontrolled celebration, and sometimes destruction, stands in contrast to the solemn Shinto rites and rituals performed by Shinto priests. Yanagawa Keiichi writes that

> [w]hen viewing the structure of a matsuri in this way, its characteristics appear to involve two radically divergent elements. One is the element of extreme solemnity and formality, while on the other hand there is also what might be called course, or even obscene aspect, the element of informality. As a result, a matsuri appears to contain both an extremely formally correct, "polite" side together with a side representing impropriety of disruption of order.... A related point of view would indicate the fact that a festival may begin with an extremely solemn ritual, in the midst of which follows an occurrence which introduces a kind of revelry totally at variance with the initial solemn atmosphere. This kind of analysis would note that a matsuri contains an exaggeration of these kinds of polar elements which would be unthinkable in normal everyday life. [Yanagawa 1988, 6]

It must be acknowledged that *matsuri* is about this "binary phenomenon," and those *matsuri* exhibiting vitality today are characterized by elements coming from both aspects. Thus, *matsuri* structures mediate between two poles, providing a focus and a point of contact between the phenomenology of the physical participation by the masses and the sacred symbolism of the Shinto religion. The *matsuri* at Chichibu, for example, has two main ceremonies, one held during the day and one held at night.

The official public rite is held in the morning and is attended by representatives from the Association of Shinto Shrines, thus involving the participation of powerful public officials. In contrast, the night festival, attended by the townspeople, is considered the main public rite, and for the people living in the area, the night festival is considered the actual festival. As was previously described, the Chichibu Night Festival involves large festival wagons decorated with many lanterns, which are pulled from the main shrine along the main street to a temporary shrine atop a small hill. The festival culminates when these floats are manually pulled up the hill accompanied by the beat of drums and the cries of pulling youths. As the floats inch up the steep incline, the spectacle is watched by throngs of people. By the time the floats reach the temporary shrine, thousands of people inundate the area surrounding the temple, where the rhythm of drums, bonfires, Japanese lanterns, and music overwhelm the otherwise quiet closing rites held simultaneously. Thus, at this moment, the juxtaposition of the sacred and profane is made visible, culminating in fireworks that mark the end of the Shinto ceremony. Their explosions are accompanied by cheering and shouting from the crowd, which overwhelm all other activities.

As was previously mentioned, participation in *matsuri* is a phenomenal act for the participants. It is also interesting to note that the dualistic nature of *matsuri* can be interpreted as one that involves the "spiritual mind" and the "celebratory body." The interrelation between mind and body is another expression of the dichotomy that can be witnessed at Japanese *matsuri*. Yanagawa Keiichi makes the relationship between the sensual and the spiritual aspect of *matsuri* explicit writing:

> [W]hen we take up the problem of matsuri, rather than as a matter of religious faith, it is in the form of sensations that the phenomenon is recorded in our memories.... If we then were to attempt an expression of the concept of the matsuri using different words, whether the very simple definition introduced earlier or something else, we might say that a matsuri involves taking the conscious states received through the senses, namely sensual experience, and indulging it, or using it to the greatest possible limits, without begrudging or restricting it in any way.
>
> When viewed in this light, the problem of matsuri can be linked to one of the methodological streams which I noted earlier, a stream which considers the problem of our attitudes toward the body, or the "flesh." Among us, and even more within Christianity, there has been a considerably strong sense of dualism. As a result, since sensation is a kind of conscious experience which occurs through our bodies, the acceptance of this kind of physical sense impression and the signification which it brought with it, was viewed with considerable suspicion. In contrast, others would say rather that the body and mind are more closely interrelated, and that there are problems involving the "fleshly" physical body which cannot be resolved by the kind of dualistic view which claims merely that the spirit is pure and the body impure. [Yanagawa 1988, 12]

To summarize, the experience of *matsuri* relies on the five senses as well as the sense of balance represented by the inner ear, motor senses, and visceral sensations. What one senses begins to exert great influence on the psychological and emotional state of the participants of *matsuri*. Yanagawa Keiichi quotes William Currie relating his experience of *matsuri*:

Recently I attended the Night festival at Chichibu, on the outskirts of Tokyo, one of the most colorful matsuri in all Japan. All the elements were there that make the matsuri an exciting event: expectant crowds of people gradually becoming more and more involved in the action; the ceaseless rhythm of drums and jingling, bell like instruments; the wild procession of mikoshi, or "temporary dwelling places of the gods," weaving in and out through the crowds. What makes the Chichibu festival particularly colorful is the brightness radiating from the hundreds of lanterns strung around the mikoshi…. The stalwart young men pulling the floats and riding on them showed more than the usual degree of "divine intoxication" expected of mikoshi bearers, with sake and contagious enthusiasm provided most of the intoxication. [Yanagawa 1988, 9]

In *matsuri* we thus have a situation where there is a direct relationship between conscious experience as a result of sensations. It is abundantly clear that certain states of consciousness exhibited by the celebrants are the result of physiological conditions caused by immediate environmental factors including the music, the rhythmic beating of drums, the colors of the banners, the smell of food, and the costumes. Logically, we can then view and understand *matsuri* structures as contributing to the physical and physiological condition that promotes a state of consciousness and the close interrelationship between the body and mind.

Spatially, *matsuri* is about movement: vertical movement of the deity descending from the heavens and from the shrine to the *mikoshi*. It describes the movement of mortals along the horizontal axis on the night of *yoimatsuri* and on the day of *matsuri*. It is about the movement of the procession at a critical point when the deity travels on the shoulders of the mortals, the point at which the celebrants are intermingling with the deity. In the Gion Festival the *hoko* clears a path and pierces any bad spirits. The *yama* draws them into the single tree at the top of the mountain. There is movement, dancing, singing, physical exertion, and catharsis. Finally there is calm the next day where the streets have been regenerated, full of good spiritual energy. The *mikoshi* can be seen as both the catalyst for the spreading of the sacred spirits from temple to town and as a point of interaction between the spiritual forces and mortal physicality. It is through this process of spiritual participation, of celebration with the deity, that the streets are renewed.

Matsuri is the living archive of history, myth, and ritual. A festival, therefore, embodies the oral transmission of myths and the recovery of these myths through people's festive actions in the streets…. The matsuri is the re-enchantment of this great myth, restoring energy to the people who take part in it. [Thompson 1986, 20] ●

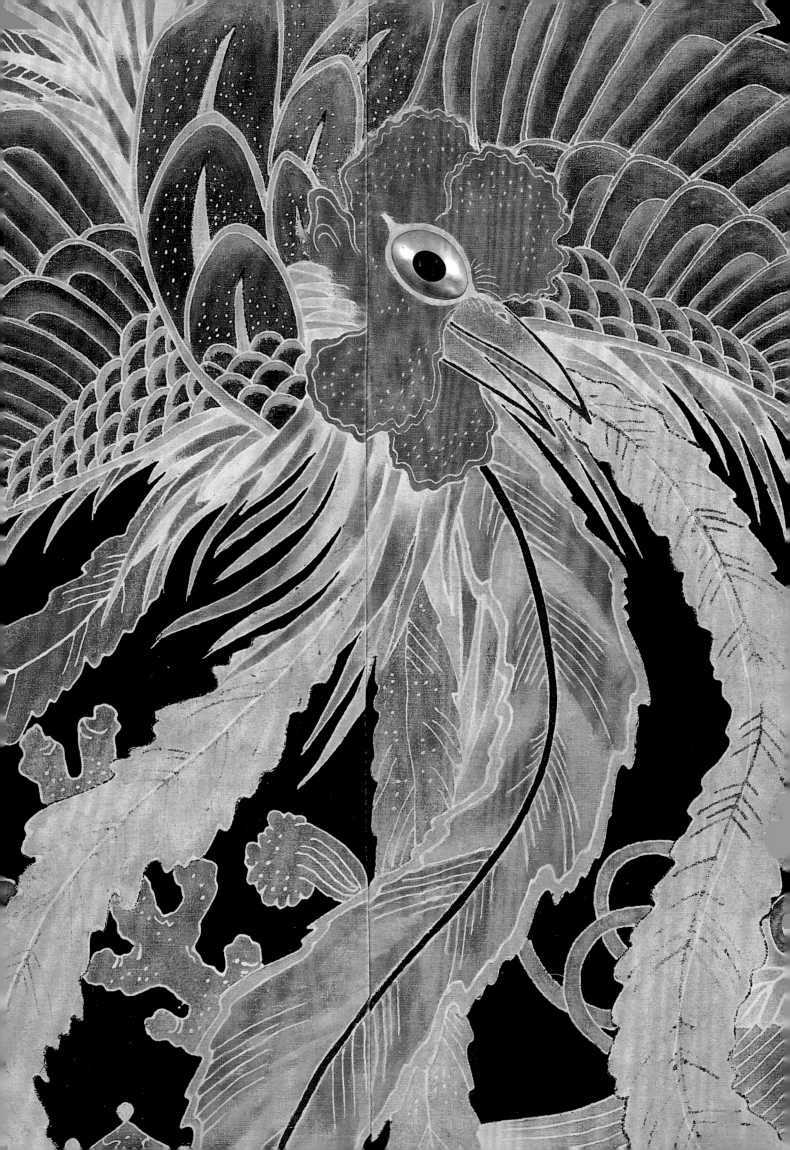

Matsuri Textiles and Dress Created in Japan

GLORIA GRANZ GONICK

The spirit of fūryu [furyū] supplied the art of representation in Japan with an essential vision. It is understood that the Japanese gods do not appreciate true things. One must add something to that which already exists in order to present it to gods or to show it in public. The tradition of fūryu [is one of] astonish[ing] gods with [a] new device. It is therefore an aspect of eccentricity that was appreciated most.

<div align="right">Yamaguchi (1988)</div>

Detail of fig. 4.58.

FOR FESTIVAL CELEBRANTS, EXTRAORDINARY DRESS IS THOUGHT TO AUGMENT THE STATE of joyous chaos that is considered prerequisite to the establishment of a new order (Yanagawa 1988, 4–17). *Matsuri* attire is thus characterized by bright colors and bold designs intended to contrast sharply with the subdued appearance of everyday clothing, and much forethought is given to special garments and trappings. Since *matsuri* is thought to be a crucial period determining the future welfare of the community, fortuitous motifs based on religious precepts are the first choice for festival designs. Tradition has it that motifs possess an auspicious aura that may be absorbed by their wearer, bearer, or viewer. The notion of the absorption of visual imagery has been prevalent on the Asian mainland since ancient times (Rawson and Legeza 1973, 12–13, 20–22), and it may have come to Japan with early waves of migration to the islands.

Traditionally, Shinto and Buddhist symbolism are employed to decorate festival trappings. It is common for one garment to reflect the auspicious ideas of both belief systems in a combined message. Festival jackets and coats were often embellished with multiple Buddhist symbols of prosperity and longevity. On the same apparel references to Shinto values of purity and wishes for fertility of the land and the people appear. Allusions to the attributes of both Shinto and Buddhist deities may also decorate the same banner or festival hanging. Using iconography derived from multiple belief systems is thought to increase beneficence. The designs that result are of

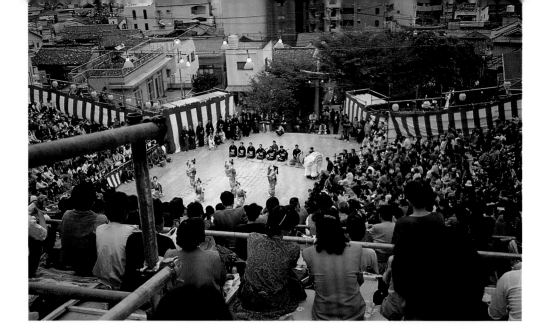

4.1 Colorful bunting holds back the crowds at *matsuri* processions and performances. It is usually vertically striped in crimson and white, colors associated with Shinto. Bunting frames the processions and performances and unifies and controls the spectators. Photograph by GGG, Nagasaki Okunchi Matsuri, 1992.

4.2 *Taiko* drummers perform on a stage behind colorful bunting at Tanabata Matsuri. Photograph by GGG, Sendai, 1989.

varying degrees of complexity but are easily comprehensible to most festival attendees (Hearn 1976, 491).

Festival textiles and trappings become sanctified through their proximity to the deities, who are welcomed into the *matsuri* by the head priest's prayers and gestures. Conversely, textiles and attire serve as vehicles for the descent of the holy spirits into the *matsuri*. The conspicuous symbols and inscriptions on the textiles relay to the deities the community's pleas for good fortune in the coming period. Messages in striking calligraphy placed on the textiles are believed capable of attracting the sacred spirits, as well as absorbing and projecting their powerful aura.

In this chapter the various types of textiles created in Japan for use at *matsuri* will be described. Unlike the textiles imported from other lands and adapted for *matsuri*, which will be described in chapter 5, domestic textiles are designed specifically to serve *matsuri* rites. Even the simplest suggestion of a costume at *matsuri* acquires the significance of disguise and serves as a means of converting an ordinary human into an instrument of the festival. Undress—nudity or partial nudity—also serves in some places as a kind of costume with skin replacing everyday clothing with its clear indications of societal roles.

The spectrum of *matsuri* dress and textiles includes inscribed jackets (*ha'pi*), distinctive and colorful performer's costumes, and hand-decorated firemen's coats. At summer festivals participants and spectators wear whimsically designed cotton kimono (*yukata*). Dazzling theater costumes are seen in the multiple performances

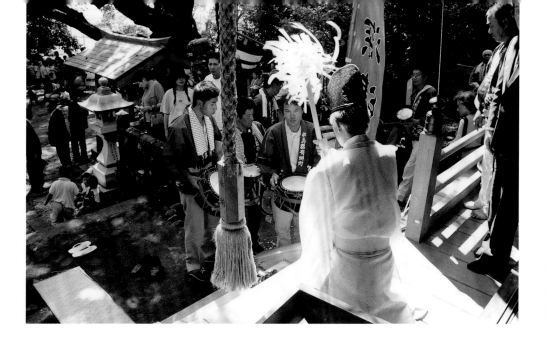

4.3 A cluster of sacred cloth strips (*haraigushi*) attached to a rod or wand is shaken over objects or worshipers to purify and sanctify them. Photograph by David Mayo, Ariake-cho, 2000.

held in conjunction with *matsuri* and are also displayed on mannequins in the festival processions. Shinto priests in formal ecclesiastical dress befitting the sanctity of the occasion lead the opening and closing rites at the shrine and also accompany the sacred palanquin (*mikoshi*) which bears the spirit of the deity through the town. Festival officials, representing the host shrine community, appear prominently in the procession wearing formal black overkimono (*montsuki*). These dignified costumes, in addition to the stiff historic *kamishimo*, a two-piece outfit worn by the escorts who accompany participants and festival vehicles, lend prestige, continuity, and authority, to the proceedings. Waving above and around the various types of festival attire are the inscribed banners, decorated curtains, and opulent float hangings (figs. 4.1, 4.2). These textiles are not seen isolated from one another but rather together in a festive, often disorderly, juxtaposition. At various times—depending on the season, regional history, traditions, and economic resources—a selection featuring a few of the types described would be seen. Decisions determining *matsuri* dress and decor are always local. The textiles and items of dress described below are those that have appeared in many *matsuri* throughout the country. A number of them survive to the present as forms of *matsuri* adornment. Today, however, the majority of them are no longer created by hand with natural fibers and dyes. For this reason—as explained earlier—in assembling examples for this book and the exhibition that it accompanies, the emphasis has been placed on textiles and garments created and used between 1850 and 1950.

 Matsuri function to preserve material culture related to their performance. Costumes and textiles created to adorn *matsuri* have often been preserved for years, and sometimes even centuries, for the future performances of those events. In most communities, the trappings are maintained in communal storehouses. In some towns a rotating official guardian stores them under his own auspices. With scant written documentation of the holiday clothing of ordinary Japanese, the preserved textiles provide a glimpse of how popular religious festivals actually appeared in years past.

BANNERS

In Japan banners are more than soft billboards heralding an event. The fluttering of cloth or paper in the Shinto tradition indicates the power of supernatural spirits. Since ancient times Japanese ceremonies have begun with the purification of the surroundings by the energetic waving of a cluster of strips of white cloth or paper attached to a wand (*haraigushi*; fig. 4.3, and see figs. 1.7c, 1.29). Strands of hemp, a bast fiber signifying purity, have sometimes been attached as well. This ritual efficacy of cloth and paper may be related to its high value as a commodity requiring special skill and intensive labor to produce.

 Many more examples of the importance of cloth and banners can be found in the *Kojiki*, the Japanese annals completed in 712 C.E. The first offering made to the sun goddess Amaterasu to indicate her royal mission and status was a necklace of

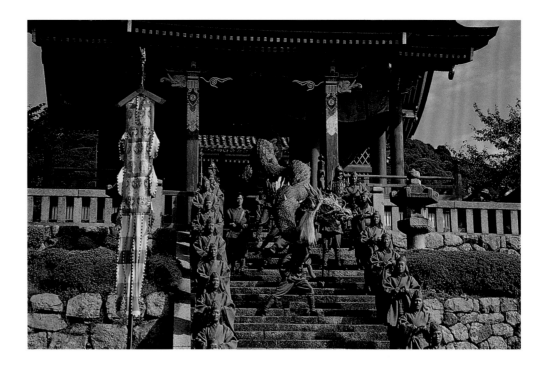

4.4 Cylindrical ritual banners ending in long streamers—like the one seen at the left of this image—are thought to dispel pestilence and to promote the circulation of good vapors. Photograph by David Mayo, Kiyomizu Temple, Kyoto 2000.

magatama beads, the comma-shaped jade gems that have been found repeatedly at archaeological sites in Japan and Korea. The motion and the jingling of these beads is thought to have been used to pacify spirits, a belief later transferred to the fluttering movements of cloths or banners blowing in the breezes (Philippi 1968, 74–77). In the *Kojiki*'s descriptions of the lives of the *kami*, the waving of cloth banners or long sleeves of garments is used to beckon the deities and facilitates their descent into the space of mortals. Moreover, fluttering banners (fig. 4.4) and scarves are described as efficacious in repelling snakes or bees and more generally in warding off evil or harmful spirits (Philippi 1968, 74–80, 83, 99, 407–408).

Before it was common to build shrines to shelter a deity, large or impressively shaped trees were sometimes worshiped, or a grove of trees served as a shrine. Cloths attached to such trees to mark their sacred significance were an early form of Japanese banner (see fig. 1.9). This practice eventually evolved into the attaching of cloth banners to tall poles. Another precursor of festival banners was a type of flag flown from a pole or bamboo rod carried by caravans moving goods within Japan. Such flags, called *hata*, alerted everyone coming into view of the presence of the caravan and the direction in which it was moving.

Banners also adorned early religious ceremonies. Five or six hundred large and small Buddhist banners, also referred to as *hata*, dating from the Asuka period (552–645) through the Nara period (645–794) have been preserved to the present day in temples and museums all over Japan. Most are in the Shōsōin, the imperial repository at Nara established by the Empress Kōmyō in 757 to commemorate the one-year anniversary of the death of her husband, Emperor Shōmu. The repository was one of a number originally attached to the Todai-ji Temple, which was funded, as were the textile acquisitions, by the Japanese Imperial Family. The temple's banners hung at Buddhist rituals and were regarded as surviving proof of the early close relationship between the Imperial Family and Buddhist prelates. The banners are woven of silk and include examples made by various techniques, including silk and gold metalic brocade (*nishiki*), tapestry weave, resist dye, and embroidery (Matsumoto 1984, 212–15).

Long *hata* similar in materials and shape to the Buddhist banners at the Shōsōin have traditionally graced Japanese court processions and rituals. In the Heian period (794–1185), the term *hata* came to refer to the long, narrow silk brocade banners used to herald court processions and other events. These *hata* were attached to horizontal wooden or bamboo crossbars that were tied by cords to the tops of vertical poles. This

allowed the *hata* to hang vertically from the bar even though the pole was held high. Sometimes plain heavy silk was used for court *hata*, and in some cases these *hata* were inscribed with symbols, characters, or painted images as well. *Hata* made of opulent fabrics continued to be used in court ceremonies up to and throughout the twentieth century. Today, however, the term *hata* is most often used to refer to flags.

By the time of the samurai in the late twelfth century, the term *kohata* (small *hata*) was applied to small cloths worn by those warriors who had been entrusted with leading an attack on the front line. The *kohata* were attached by cords to the backs of the warrior's helmets and hung down over their necks (see fig. 1.26a). These frontline samurai were called *hatamoto*. A little pennant (*kasajirushi*) was also attached to their helmets (figs. 4.5a–c). Streamers known as *hata-nobori* became especially popular with samurai warriors during the Onin Civil War (1467–1477). Like the *hata* of the imperial court, *hata-nobori* hung from horizontal crossbars attached to poles so that the cloth could stream in the wind (Dower 1971, 11). Another means of hanging banners was invented in 1456 by Hatakeyama Masanaga, a famed general of the Muromachi period (1392–1568). He originated banners that had cloth loops sewn at regular intervals along one long side and across the top. Rods were inserted through the loops that permitted the banner to hang down straight and remain flat. The term *nobori* has come to be used primarily for this specific style of banner. After their invention, *nobori* were used widely on the battlefield. Throughout the Edo period (1615–1868), *nobori* continued to be used to identify the clan loyalty of a squad of samurai warriors. A samurai, sitting erect upon his steed, would hold aloft his group's banner as they approached the forces of another clan or neared a new town.

From these imperial, religious, and military roots, *nobori* eventually came to be adapted to peaceful uses at shrine festivals and ceremonies. Inscribed *nobori* and flags mounted on tall bamboo poles became a long-standing tradition at most shrines and were often the first sight to greet the eyes of visitors. The inscriptions enhanced the protective function of the *nobori* and, at the same time, publicly proclaimed the names of donors who funded religious services or the construction and maintenance of shrine buildings. Often additional information such as a date or place name was included in the inscription. *Nobori* were often hung on either side of a torii gate, which was considered an entrance to a sacred area or a boundary demarcating the beginning of sanctified space (fig. 4.6). These *nobori* were placed on posts adjacent to the pillars. The inscriptions on them named the shrine or announced special occasions such as *matsuri*.

4.5a–c A small banner attached to the helmet is called *kasajirushi*, and a similar banner attached to the shoulder armor is known as *sodejirushi*. Reproduced with permission of Kashiwa Publishing Co., Ltd., Tokyo, from Sasama (1982, 3, 195).

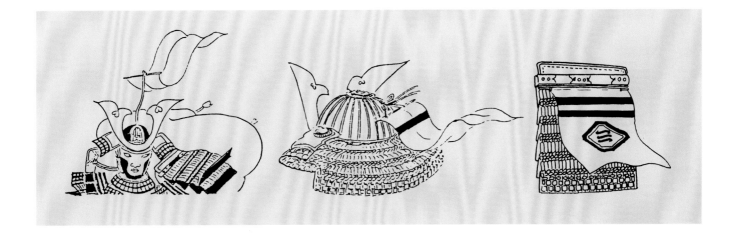

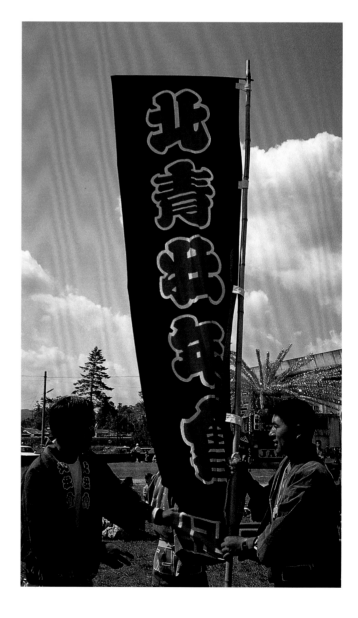

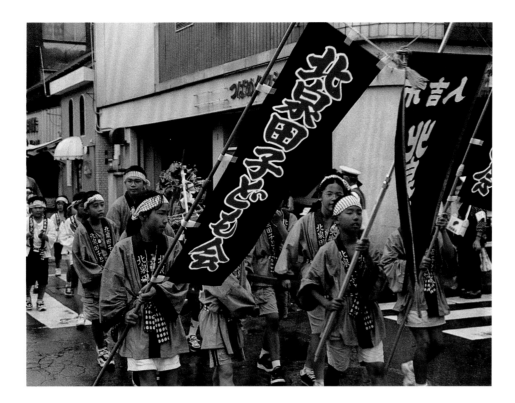

Prior to the middle of the nineteenth century, when cotton became widely available, banners were woven of hemp. They were dyed using the *katazome* or *tsutsugaki* technique. By the beginning of the twentieth century, most banners were made of cotton, which was easier to dye than hemp, although not as durable. Some banners, however, have continued to be made of hemp to the present day.

The height of *nobori* and the prominent white characters appearing against an indigo-dyed ground make them visible for long distances to both *kami* and *ujiko* ("children of the *kami*," i.e., their flock of parishioners). The characters or other symbols are sometimes boldly accented in red as well. The inscriptions are designed with clarity and legibility as the main priorities, in contrast with the detailed and stylized characters used on garments that are intended to be viewed at close range. Special banners used for festival days often have grounds of red or purple, vivid colors suggestive of optimism and auspicious tidings (figs. 4.7–4.10). The inscriptions on these banners call out the name of the festival, the host shrine, the region, and sometimes an auspicious slogan such as "peace and prosperity" (fig. 4.11).

Nobori used for celebratory purposes are often adorned with a family crest (*mon*). Many shrines also use *nobori* bearing a *mon*; in this case the *mon* may incorporate depictions of objects sacred to Shinto or unique elements of shrine architecture such as the ornamental cross beams (*chogi*) or torii gates. Types of trees widely planted in shrines, including ginkgo, oak, and *sakaki*, are also common subjects of *mon* designs, as are images related to animals considered to be sacred messengers of the deities, including tortoiseshells (associated particularly with the shrines of Matsuo and Izumo) and the antlers of the sacred deer (associated with the Kasuga Shrine in

4.10 The girl at the left wearing a yellow *ha'pi* carries a long banner inscribed "Kitasenda Kodomo-kai" (Kitasenda Children's Association). Photograph by David Mayo, Hitoyoshi, Kyūshū, 2000.

4.11 These banners are inscribed "Kaido jinja gozen mae" (Herein may be found the spirit of the deity of Kaido Shrine and those of the ancestors). Photograph by David Mayo, Ariake-cho, 2000.

4.6 (OPPOSITE, UPPER LEFT) Banners parallel the torii gate leading to a shrine and announce the coming *matsuri*. Photograph by GGG, Kita Hachiman Jinja, Ōda-shi, Shimane Prefecture, 1992.

4.7 (OPPOSITE, UPPER RIGHT) The banners welcome worshipers at Koya Hijiri Matsuri along the path to the sanctuary at Kita Hachiman Shrine. Photograph by GGG, Ōda-shi, Shimane Prefecture, 1992.

4.8 (OPPOSITE, LOWER LEFT) The banners at Otsunahiki Matsuri in Okinawa hangbeneath arrangements of tropical plants and grasses. This one bears the message, "Be inspired!" Photograph by GGG, Otsunahiki Matsuri, Naha, Okinawa, 1993.

4.9 (OPPOSITE, LOWER RIGHT) A *nobori* banner reads "Sei nen kai," or young men's association, and the bold fret motif (which signifies "manifold blessings" in Japan) calls forth abundant good fortune for the future on worshiper-celebrants at Hitoyoshi Okunchi Matsuri. Photograph by GGG, 1992.

4.12a Shrine banner, early Meiji period. Wool and hemp, appliquéd; reverse of banner inscribed with *sumi* ink. L: 300 cm. FMCH X2000.42.1; Gift of Glenn Granz.

The circular crest on this banner was identified with the deity Tenjin, and the banner itself was most likely draped before the Tenjin Shrine in Tokyo. A stylized plum blossom was created with disks of cream-colored wool gabardine. The disks have been appliquéd onto the red wool ground. The inscription on the back states that the banner was a devotional bequest made in the early Meiji period. The European wool fabric was likely imported earlier and would normally only have been available to members of the samurai class in the Edo period. Red wool was perceived as an exotic, weather-resistant foreign textile and may have been considered a generous donation to the temple.

4.12b Reverse of figure 4.12a.

Nara). Other *mon* were associated with a particular deity honored at the shrine. Banners for the Tenjin Matsuri, for example, were decorated with the *mon* of Tenjin—the deity of poetry and learning, who was known as Sugawara no Michizane in his human existence. His *mon* was a stylized plum blossom (fig. 4.12a,b), based on the nostalgic poetry attributed to him extolling these flowers in the garden of the Kyoto home that he had enjoyed before he was unjustly disgraced and exiled.

Senbon-Nobori

At the approach to a shrine, small cloth banners about a foot long or paper flags of a similar size frequently appear alongside the path attached to twigs stuck in the ground (fig. 4.13a–e). Inscribed with a few characters written large in *sumi* ink and naming a deity, these are called *senbon-nobori* (lit., "a thousand flags"). A supplicant who has a special prayer or request to make of the *kami* creates the small banner and places it on the route to the shrine sheltering the deity's spirit. The worshipers who create and place the *senbon-nobori* believe in the efficacy of their banners in helping realize their dreams. At some shrines that are particularly well frequented, hundreds of these small banners line both sides of the lanes approaching the shrine. Many become illegible from exposure to the elements, but fresh ones are continually installed by devout worshipers.

Street Banners

In modern times, horizontal banners may be draped across busy traffic intersections or the main streets of a town, to herald a *matsuri* and alert worshipers. The bright-colored banners that dot the festival area make it impossible to ignore. Their vibrant colors and bold inscriptions are highly visible against the grays and browns of city-scapes as well as against the verdure of the peaceful Japanese countryside (fig. 4.14).

4.13a–e Votive banners (*senbon-nobori*).

(A) 1931. Cotton, inscribed with *sumi* ink. L: 72.4 cm. FMCH X89.1037; Gift of Dr. Daniel C. Holtom.

A female worshiper whose name and address are inscribed as Miura Chiharu from Miyagi-ken, Shichigahama village, created this cotton banner as a token of her devotion. It was attached to a branch set before Yamanogami Shrine on June 1, 1931.

(B) 1926. Handloomed cotton, inscribed with *sumi* ink. L: 116 cm. FMCH X89.1038; Gift of Dr. Daniel C. Holtom.

A woman named Shishido Chiyo of Karita-gun, Shiraishi village offered this *senbon-nobori* dated August 13, 1926.

(C) 1914. Handloomed cotton, inscribed with *sumi* ink. L: 100 cm. FMCH X89.1039; Gift of Dr. Daniel C. Holtom.

A devotee made this *senbon-nobori* and placed it at Zai Ten Shrine.

(D) Early twentieth century. Cotton, inscribed with *sumi* ink. L: 91.7 cm. FMCH X89.1041; Gift of Dr. Daniel C. Holtom.

This *senbon-nobori* is an offering made by Aizawa Rin of Miyagi Prefecture, Shichigahama village, Hanabuchi Yama no Kami Sha. It is inscribed "Hōnō" (Offering).

(E) Early twentieth century. Handloomed cotton, inscribed with *sumi* ink. L: 42 cm. FMCH X89.1040; Gift of Dr. Daniel C. Holtom.

A seventy-six-year-old woman named Kobayashi Haru, presented an offering to "Sekitome Gami" (The god who cures coughs).

4.14 The announcement on this street banner in the vicinity of Nagoya reads "Hirokoji Summer Matsuri." Photograph by GGG, 1991.

4.15 A shrine entrance draped with a curtain of purple silk appliquéd with silk brocade disks announces that the period of *matsuri* rites is to begin at Aoiaso Shrine. Photograph by David Mayo, Hitoyoshi, Kyūshū, 2000.

Shrine Curtains (Maku)

Shrine doorways and entrances are usually draped with special curtains (*maku*) announcing a *matsuri* (fig. 4.15). These are often dyed purple, a shade that indicates joyous sacred events in Shinto. Characters and crests created using the *katazome* or *tsutsugaki* technique appear in bright white on the purple ground. In contrast with shrine banners, entryway curtains are hung horizontally over a doorway. At the conclusion of a *matsuri*, it is common to see shrine priests or their assistants carefully lowering, folding, and storing banners for the next holy event.

Boys' Day Banners

Billowing Boys' Day banners are often seen around the fifth of May, particularly in the countryside (figs. 4.16, 4.17, and figs. 7.9–7.11). They are usually decorated with family crests and references to samurai culture and legendary heroes or warriors. Originally, a May festival was held to celebrate the first rice planting of the year. The village maidens who were to set out the young plants would gather in one house. The roof of the house used as the gathering place was decorated with *shobu* (a type of iris with swordlike leaves), as the plant was believed effective in driving away evil. Boys would slap the ground with the iris stalks to "drive away demons," and they would play at war using the *shobu* fronds as swords. The term *shobu* came to suggest the encouragement of martial arts, and May fifth became a celebration for boys, wishing them a strong and successful manhood. Banners to celebrate the day were usually custom ordered by a boy's maternal grandparents. The banners served as joyous notices announcing far and wide that a strong healthy son was growing up in the family (Brandon 1986, 17).

The tall *tsutsugaki* Boys' Day banners are created somewhat differently than other banners and curtains. Instead of using natural vegetable dyes, they are created with bright pigments obtained from mineral dyes, which are more weather resistant. They are also brighter and easier to see from afar. The images on the banners are not covered with resist paste (as in other *tsutsugaki*-dyed textiles) but are painted directly with mineral dyes on white cotton. The background is left plain white in many cases. On other examples, it is brushed with indigo blue dye. Some of the banners are extremely long, on occasions reaching over a hundred feet into the sky. They are frequently constructed of double loom widths (a single width equaling twelve and one-half inches), although sometimes they were only one loom width.

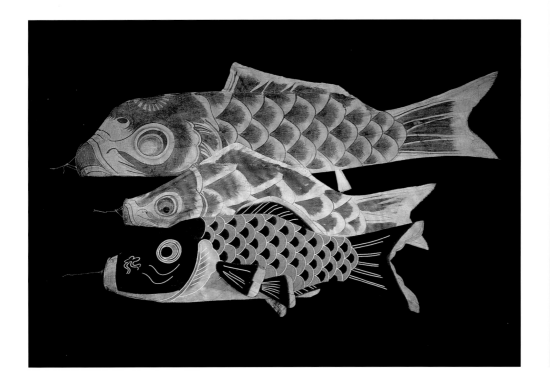

Koi nobori are a set of cloth banners made in the shape of carp (*koi*), which are strung up near homes around Boys' Day (fig. 4.16). The *koi* banners are three dimensional, and the wind gives them depth as it fills and expands their bodies. *Koi nobori* began to be used around the middle of the Edo period and continue to be popular to the present time. They are typically accompanied by *fukinagashi*, colored streamers that blow in the wind to spread beneficent vapors, scatter harmful ones, and drive pestilence from the crops. The *koi* itself is a symbol of high aspirations, as it is said to persevere in swimming upstream against the current. There are usually four or five *koi* banners in a *koi nobori* set, or sometimes one for each boy in a family. The largest is usually painted red for the color of the sun and as a sign of vitality. It stands for the eldest son in the family, the smaller *koi* for his younger siblings.

Smaller and shorter Boys' Day banners may be hung indoors as well. These are sometimes elegantly handpainted (*yuzen* dyed) on fine silk *chirimen* (crepe); see figure 7.9. They are placed on stands amid an indoor display of miniature samurai artifacts and armor, including a dressed and bridled model horse. The indoor silk banners are painted with wishes for the boy's success in life. Like the tall outdoor banners, they refer to samurai heroes and their armor, trappings, and lifestyle (see figs. 4.19a,b).

Horse Banners (Umagake)

Horses were considered messengers between the celestial and earthly spheres. They were also regarded as "mounts of the *kami*." White horses in particular were symbolic of purity, and they were presented as important gifts to the shrine and stabled on its premises. Horse banners (*umagake*) were *tsutsugaki* painted on sturdy hemp cloth and tailored to cover the horse's back and shanks, so they functioned as covers as well. Two loom widths of hemp were joined to create the decorated covers. The unjoined lengths of the fabric were tied at the ends into an oversized decorative loop on the horse's back for festival processions (figs. 4.18–4.21). The horses, draped with the covers and festooned with scarlet- and white-fringed trappings, were ridden by priests and high officials in processions. Horses wearing decorated banners were often painted on *ema*, the wooden votive placards hung on shrine premises by worshipers. These usually show a dark horse if prayers for rain were requested, while prayers for an end to floods were expressed by paintings of light-colored horses (Yoshida et al. 1985, 131).

4.16 Carp banners (*koi nobori*), Edo period. Cotton *tsutsugaki* resist-painted. L (of longest): 256.5 cm. FMCH x86.4303; Anonymous Gift.

4.17 Boys' Day banner fragment, Meiji-Taisho period. Cotton, *tsutsugaki* resist-painted. L: 146 cm. Collection of the Asian Cultural Arts Trust.

This banner is unusual in that *tsutsugaki* rather than direct hand painting has been used. It makes reference to a tale in the *Kojiki*, the Japanese annals recorded in 712 C.E., that tells of a rabbit jumping over waves.

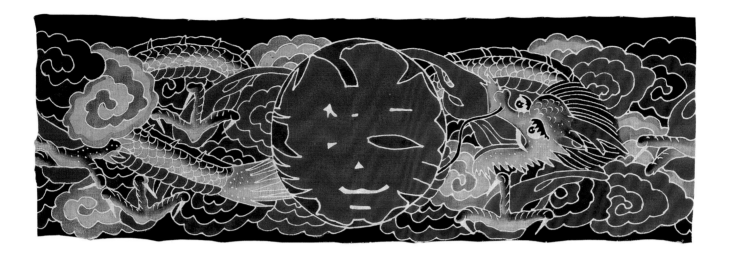

4.18 Partial horse trapping (*umagake*), Meiji period. Hemp, hand-painted with mineral pigment. L: 102.5 cm. Collection of the Asian Cultural Arts Trust.

This Boys' Day horse trapping is inscribed "Shiawase" (Happiness).

4.19a Horse trapping (*umagake*), nineteenth century. Hemp, *tsutsugaki* resist-painted. L: 543.6 cm. FMCH X86.4292; Anonymous Gift.

The carp swimming upstream used to decorate this horse trapping was a favorite motif for Boys' Day Banners since the carp demonstrated perseverance and strength as he swam upstream against the current, thus inspiring boys to overcome all obstacles to success.

4.19b Drawing of a horse wearing a trapping similar to that in figure 4.19a.

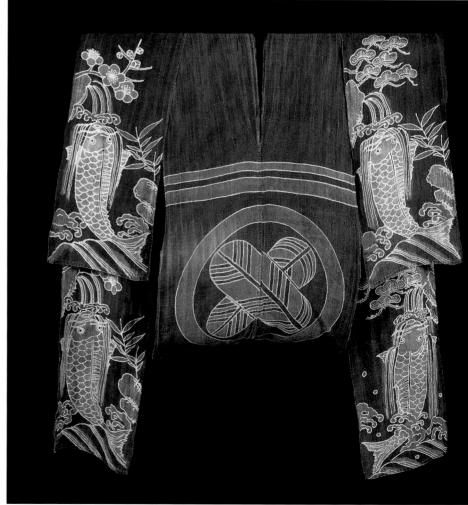

Fishermen's Banners (Tai Ryo)

Tai means "great" and *ryo* signifies an Edo period currency denomination. *Tai ryo* thus became the name of banners used to celebrate a big catch (figs. 4.22, 4.23). The banners were strung up when a successful voyage was over and the boat was sailing into port. Elaborate pictorial fishermen's banners resemble Boys' Day banners in that they are also painted in the vibrant shades that can be achieved with mineral dyes. They may be rectangular or tall and narrow, and their themes are related to good fortune, riches, and the sea. Some feature portraits of fish. *Tai ryo* created a spectacular sight when several were strung up on one boat or when a number of the festooned boats entered a harbor. The arrival of the boats created great excitement among the fishermen's comrades and families waiting on the shore (figs. 4.24, 4.25).

4.20 Horses as sacred mounts of the deities were ridden by the *kannushi* (Shinto priest) in the festival procession at Okunchi Matsuri, Hitoyoshi, Kyūshū. A white horse dressed in red trappings represents purity and joy. Photograph by GGG, 1992.

4.21 Votive plaque (*ema*). Wood, paint. 32.5 x 47.6 cm. FMCH x89.872; Gift of Dr. Daniel C. Holtom.

This is a wooden votive offering (*ema*) with a painting of a shrine horse festooned with a banner similar to those seen in figures 4.19a,b. It is secured with a large showy loop on the back of the horse.

4.22 Fishing boat banner, Showa period. Cotton, hand-painted. L: 201 cm. Collection of Jean and Gary Concoff.

This type of banner is flown on fishing boats during fishermen's festivals and to signal a great catch.

4.24 This shop banner is inscribed "Takaratsuri" (Treasure fish game). The shop is located in a marketplace outside shrine grounds. Photograph by David Mayo, Aoiaso Jinja, Okunchi Matsuri, Hitoyoshi, 2000.

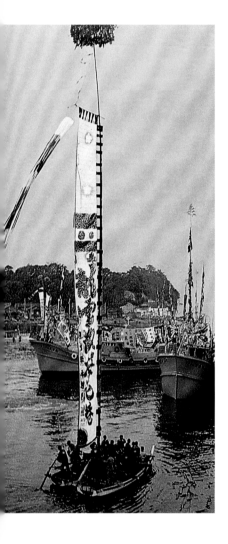

4.23 A tall seaman's *nobori* guides the *kami* coming from distant lands as it leads the fishing boats back into the harbor at Tomobata Matsuri (Festival of sea comrades), Ogi-machi, Niigata, 1970. Reproduced from Haga (1970, 55).

4.25 This stand is cooking *ika yaki* (grilled squid), an extremely popular *matsuri*-time delicacy. Photograph by David Mayo, outskirts of Aoiaso Jinja, Okunchi Matsuri, Hitoyoshi, 2000.

THE DRESS OF SHINTO PRIESTS AT *MATSURI*

When not performing rites or attending at the shrine, Shinto priests (*kannushi*) wear ordinary street clothing (Ono 1962, 42–44). On the first day of a *matsuri*, which begins at dusk, the priest responsible for conducting the opening rites arrives at the shrine with a small carrying case containing his equipment and his most formal vestments (Ashkenazi 1993, 2). After he has assembled the branches of evergreens and strips of white paper required for altar offerings during the ritual, he dons his garments. These include a white kimono worn under long culottes (*hakama*). As the head officiating priest for a *matsuri*, he wears a heavy silk outer garment with long full sleeves, called a *hō* (figs. 4.26, 4.28a–e). This garment differs from the outer garment ordinarily worn by priests, the *kariginu* (fig. 4.27), which has somewhat shorter, detachable sleeves. The costume is completed with white cotton split-toed socks (*tabi*), black lacquered clogs (*asagutsu*; see fig. 4.28e), and a tall, brimless black gauze hat (*eboshi*) or a more elaborate hat known as a *kanmuri*. The priest also carries a box wrapped in silk brocade containing the holy symbol of the shrine to be placed on the altar (Ashkenazi 1993, 2).

In Japan as in many other cultures, ecclesiastical attire reflects the dress of earlier eras (figs. 4.29–4.31a–c). Archaic dress suggests eternal truths. Garments worn by Shinto priests are based on the court dress of the Heian period (794–1185).

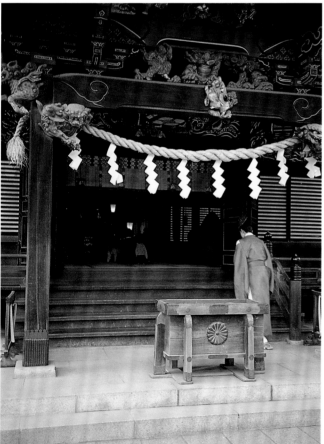

4.26 (ABOVE, LEFT) This Shinto priest wears a silk outer garment with long full sleeves called a *hō* and a hat known as a *kanmuri*. He holds a *shaku*, or narrow paddle, at festivities for Okunchi Matsuri in Hitoyoshi, Kyūshū. Photograph by GGG, 1992.

4.27 (LEFT) A Shinto priest robed in a saffron-colored silk brocade *kariginu* bows to the *kami* before Chichibu Shrine. Photograph by GGG, Chichibu-shi, Saitama Prefecture, 1992.

4.28a–e (A) Shinto priest's robe (*hō*), Showa period. Heavy blue silk with red silk lining. L: 200 cm. Collection of Sandy and Kenneth Bleifer. (B) Shinto priest's hat (*kanmuri*). Wood, hair? silk? lacquer. H: 15.5 cm. FMCH X91.1962a,b; Gift of Catherine E. and P. Lennox Tierney. (C) Culottes (*hakama*), Showa period. Light blue silk brocade. L: 90 cm. (D) Shinto priest's paddle (*shaku*). Wood. H: 39 cm. (E) Shoes (*asagutsu*). Wood and lacquer. L: 27 cm. Items C–E: Collection of Reverend Doctor Alfred Tsuyuki and Konko Church.

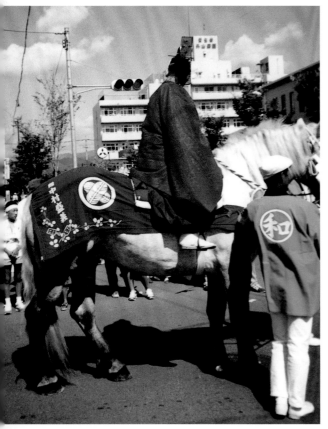

4.29 (ABOVE, LEFT) Reverend Taiichi Tsuyuki (1913–1985) served as the head minister (*guji*) at Konko Church, a Shinto sect, in Los Angeles for fifty-seven years. In this photograph Reverend Tsuyuki is shown wearing a ceremonial costume called a *saifuku,* a formal outer garment of white silk, over blue silk brocade full-cut trousers (*hakama*). He holds a *shaku,* or paddle. Collection of Reverend Doctor Alfred Tsuyuki. Photograph Toyo Miyatake Studio.

4.30 (LEFT) Astride a sacred white shrine pony, the head priest leads the procession from Aoiaso Shrine through the town of Hitoyoshi. On his head is the formal hat known as a *kanmuri,* worn with a red-figured silk *hō,* a full ceremonial robe. The pony is covered with a horse banner inscribed with the name and crest (*mon*) of Aoiaso Shrine. Photograph by GGG, Okunchi Matsuri, Hitoyoshi, Kyūshū, 1992.

4.31a–c Shinto priest's two-piece garment, early twentieth century. (A) Upper garment, Showa period. Silk and metallic green brocade with hemp lining. L: 86 cm. FMCH X2000.43.1a; Gift of Dr. and Mrs. Yo-ichiro Hakomori. (B) Culottes (*hakama*), Showa period. Silk brocade. L: 86 cm. FMCH X2000.43.1b; Gift of Dr. and Mrs. Yo-ichiro Hakomori. (C) Shinto priest's hat (*eboshi*). Animal stomach lining and cordage. H: 18 cm. FMCH X91.1964; Gift of Catherine E. and P. Lennox Tierney.

The green silk brocade upper garment has been extended solely to indicate the volume of the sleeves. A shinto priest normally maintains his arms close to his body. The upper garment is lined with woven white hemp fabric. Bast fibers such as hemp were often preferred for Shinto priests' garments, as they were felt to be closer to nature and to Shinto tradition. The *hakama* are silk brocade in a design of wisteria spandrels enclosing floral disks and lozenges.

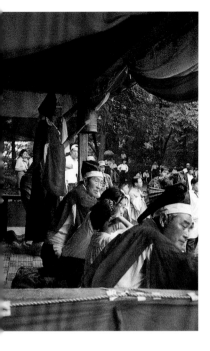

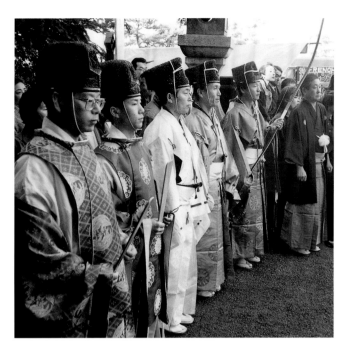

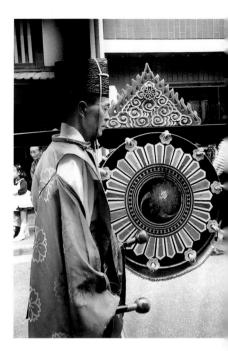

4.32 These priests in red *kariginu* (outer garments) officiate at the athletic competition accompanying a *matsuri*. Photograph by GGG, Hachinohe, Aomori Prefecture, 1994.

4.33 An assembly of priests dressed in the outer garment known as a *kariginu*; culottes, or *hakama*; and a hat known as an *eboshi* at New Year's Festivities in Okayama. Photograph by Hiroyuki Nagahara, 1993.

4.34 (ABOVE, RIGHT) A Shinto priest wearing the outer garment known as a *kariginu* and a hat called an *eboshi* strikes a gong painted with the five colors sacred to Shinto. Priests provide much of the music heard during *matsuri* processions as well as the auxiliary performances of dance and drama (Kagura). Photograph by GGG, Takayama Hachiman Matsuri, 1991.

The historic costume engenders an aura of sanctity, setting the wearer apart from his fellow men who are involved in secular pursuits. In Japan ecclesiastical garments suggest that the authority of noble ancestors has been bestowed upon the wearer. Japanese priests in turn—through prayer, gesture, special gait, and patterns of movement—can impart sanctity to objects selected for reverential use during *matsuri*, including the robes, trappings, and artifacts used in welcoming and interacting with the *kami*.

The practice of indicating a priest's rank by the color of his garments was established during the Heian period and modeled after the use of various colors of outer garments by imperial courtiers of differing rank. Purple or deep-red outer garments with an insignia brocaded in gold metallic thread were worn by the highest-ranking priests. Plain purple silk and light blue silk were worn by priests of lesser rank. Colors also varied with the age of the wearer and the season of the year. Present-day outer garments are black, red, light blue, or white (figs. 4.32–4.34). These colors still relate to rank, age, and season. Some priests feel that white outer garments are primarily for everyday duties (fig. 4.35), while colored ones are more appropriate for *matsuri*.[1] The white of the underkimono indicates purity (Ono 1962, 44).

The *kariginu* (everyday priestly outer garment) was originally a hunting costume, and it is characterized by its round collar and separate front and back panels. It may be lined or unlined, and is always paired with the long, *hakama* culottes. During the changes that were mandated during the Meiji Reformation of 1868 the fabric of the *kariginu* was changed from bast fiber (*asa*) to silk. The layered and flowing forms of a priest's garments both permit and emphasize the stylized movement and gestures required in Shinto ritual. Together with special forms of speech and song, these movements affirm connection of the Shinto priest to the otherworldly spirits.

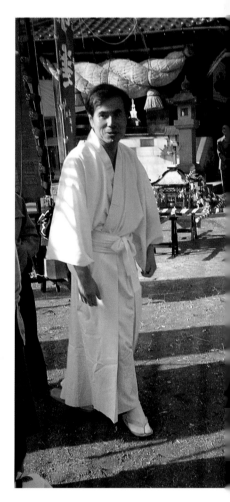

4.35 A head priest wears a white kimono and *zori* (sandals) at Kōya Hijiri Matsuri. Photograph by GGG, Ōda-shi, 1992.

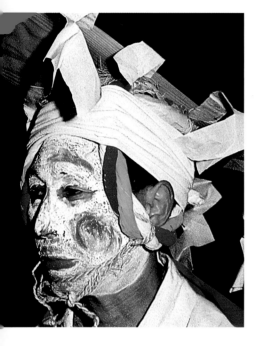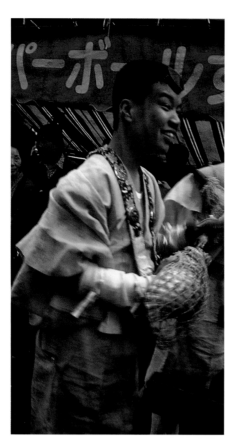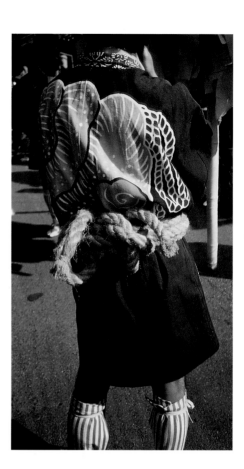

4.36 This *yamabushi* (a member of a Buddhist sect of mountain ascetics) wears a special makeup as a type of mask at the festival. Reproduced from Haga (1970, 149).

4.37 This novice *yamabushi* wears a conch shell attached by a cord to his waist. Photograph by GGG, Tenjin Matsuri in Ueno-shi, 1991.

4.38 This man wears a jacket with the conch shell motif associated with the *yamabushi*, a group of mountain ascetics. His torso is bound with thick ropes. Photograph by GGG, Tenjin Matsuri, Ueno-shi, 1991.

A.W. Sadler noted that novices are taught to move so that all their actions appear seamless and harmonious, as evidenced in these instructions: "In ascending the steps to the sanctuary doors, take one step at a time, baby style. In walking, see that your foot is always touching the floor (that makes the priest's walk more of a slide, as in *noh* and *kagura* theatre). Take four steps for one breath cycle. 'That,' I was told, 'is the customary pace for the ordinary priest. But priests of high rank take only two steps with each cycle of breath.'" Sadler also observed that "With tabi [split-toed socks] the big toe rises with each step and falls when the foot is placed down, then rises again; that one (separated) toe seems to guide the whole foot—it leads, and then the whole foot glides along, as over ocean waves" (Sadler 1974, 22–23). Precise directions regarding walking in the lacquered ceremonial wooden shoes were also offered in an effort to maintain dignity since clomping about in these heavy shoes (*asagutsu*) was judged noisy or comical.

Similar instructions govern the presentation of offerings, an important sacred duty of priests that has influenced secular presentations as well: "To carry the *an* [table for offerings], place the right hand on the forward right-hand supporting post, then place the left hand flat under the table, and lift." The proper presentation is perceived as an important means of transforming secular objects into sacred. As discussed in chapter 1 of this volume, the *kami* prefer that objects be thoughtfully altered before presentation.

While these garments and traditions apply generally to Shinto shrine priests with little variation throughout Japan, the priests of some sects adopt special manners of dress (figs. 4.36–4.38). Perhaps the most distinctive of these are the *yamabushi*, a sect of mountain ascetics, who feel they can interact and communicate best with the *kami* by living simply in isolated mountain passes and peaks. They often wear distinctive billowing trousers and full jackets with checkerboard designs that are considered characteristic of their group. In addition they wear conch shells, attached by a cord to their waists, into which they blow to communicate across the mountain passes.

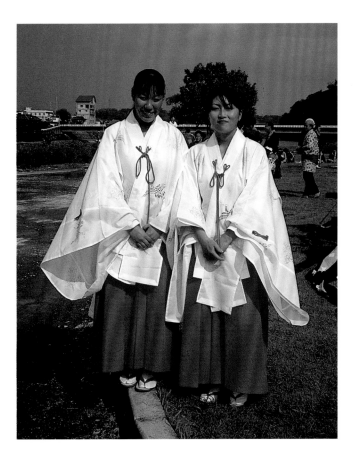

There are also clothing traditions for women, who have always had important roles in Shinto shrines (in contrast to the worlds of Japanese commerce or politics, which have only recently begun to empower women). By tradition, an unmarried female princess from the Imperial Family serves as head priestess of Ise Shrine, the most important shrine in Japan (see fig. 1.2). She wears a white silk kimono tucked into crimson silk *hakama*. Young unmarried "shrine maidens" (*miko*) still perform ceremonial dances, in addition to other duties such as distributing amulets knows as *omamori* in return for a small donation. The *omamori*, which are made of wood, paper, or metal and have the name of a *kami* written on them, are worn by the purchaser as a symbol of the deity's divine protection. As with the head priestess of Ise Shrine, *miko* are recognizable by their red *hakama*, worn with a white silk kimono tucked inside (fig. 4.39). The red and white colors are considered sacred in Shinto. To perform ritual dances at the shrine, a *miko* wears her hair in a long ponytail that hangs down the center of her back and is tied with a vermilion ribbon. *Miko* also wear a small floral headdress above the center of their forehead. On their feet they wear white *tabi* and *zori* (Ono 1962, 42–44). They carry bells and a fan of cypress wood. At the shrine the *miko* lend a note of youth, grace, and color to the usually unadorned wooden surroundings. In addition to their traditional role as *miko*, during the second half of the twentieth century women have succeeded in obtaining official certification as Shinto shrine priests. When officiating, they wear the same ecclesiastical garments as male priests.

THE ATTIRE OF FESTIVAL OFFICIALS AND ESCORTS

While priests usually conduct the Shinto rituals that occur within the context of a *matsuri*, most of the festival events are actually organized by a group of secular officials, a neighborhood association (*chōnai-kai*), drawn from the constituency of the shrine. These officials wear a special type of outfit characterized by a short black silk overkimono (*kuro montsuki haori*) with five crests. Great importance is placed on these garments; they must be in proper condition and create a uniform impression for members of the group (fig. 4.40).

4.39 These young girls are dressed as *miko*, or shrine maidens, and wear the customary white silk kimono and jacket (*haori*) and red *hakama* (culottes). Photograph by GGG, Hitoyoshi, 2000.

4.40 A senior official garbed in formal *montsuki* is further distinguished by a red ribbon. Photograph by GGG, Aoiaso Jinja, Hitoyoshi Okunchi Matsuri, Kyūshū, 1992.

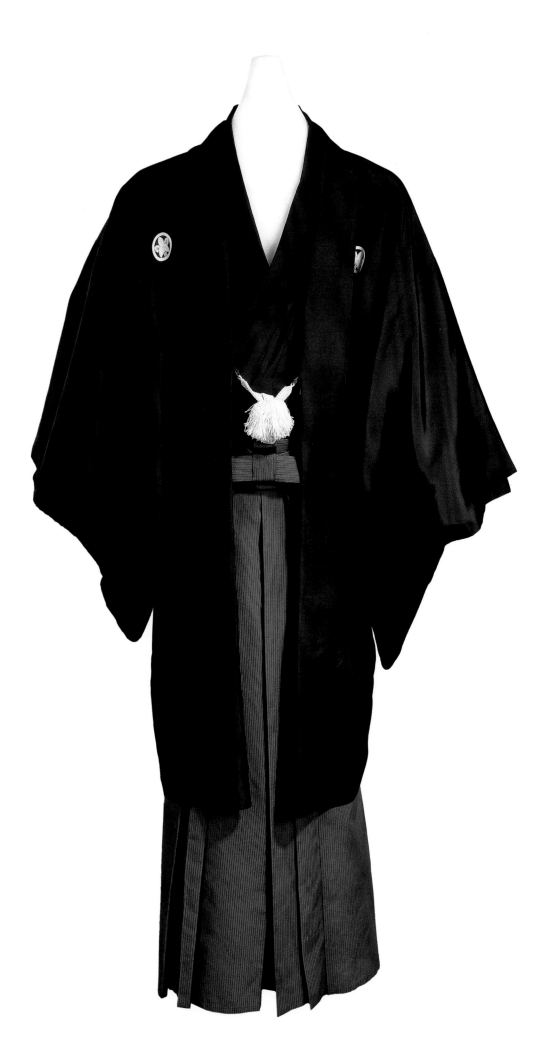

4.41a–d Official's four-piece garment (*montsuki*). (A) Man's short, black overkimono, Meiji period. Silk. L: 127 cm. Collection of Sandy and Kenneth Bleifer. (B) Culottes (*hakama*), Showa period. Silk. L: 90 cm. Collection of Sandy and Kenneth Bleifer. (C) Long black kimono, Showa period. Rayon. L: 152.4 cm. Collection of Sandy and Kenneth Bleifer. (D) Front closure cords (*himo*). Silk. L: 25 cm. Collection of Annie Mizutani.

The *montsuki* is made of black *habutae* silk with stencil-reserved white family crests (*mon*) on each shoulder, front and back, and also at the center back. The front closure cords (*himo*) are white with white silk tassels that rest on the chest. The *montsuki* reaches to the thighs and is worn over a plain silk kimono tucked into a pair of striped taffeta culottes (*hakama*; fig. 4.41). The *hakama* are self-tying, with a self-covered stiffened board at the back of the waist and a long waistband, the narrow ends of which are wound around the waist and tied neatly in front. The closure knot is usually placed a few inches below the waist. This accentuates the swaybacked stance that festival officials sometimes adopt with their chests thrown forward in a manner suggestive of the bravado associated with samurai. An official's *tabi,* or split-toed socks, are dark blue and worn with sandals (*zori*). A wide-brimmed hat made of sedge (*ichimonji-gasa*) might be worn on the head (fig. 4.42).

Prior to World War II, only a man of wealth and position in a town could don the outfit of a festival official and stroll along in the procession as a member of the honor guard. In the Kyoto area, for example, the participants were organized into guilds whose membership was limited according to family lineage and property ownership (Shibusawa 1958, 366–67, 373–74). It was my impression in Kyoto during the 1990s that this system was still operative. In less conservative towns in the postwar period, however, any male family member of a participating household could join the festival procession as a representative of his neighborhood (*chōnai*), with the privilege some-times rotating among different families. As walking the entire length of the festival procession is often physically challenging, particularly in midsummer's heat, alternate officials often take over at the halfway mark. In this manner, many family patriarchs have acquired the special garments required for officials (Schnell 1999, 85, 264).

In some cases Shinto priests do not perform all the religious rites at a *matsuri*. Instead leading members of the community in their role as festival officials temporarily step in. When presiding over services, they wear the same garments as ordained priests (Ono 1962, 44). According to tradition, such officials are required to be purified by observing numerous forms of abstinence for a period of several days, weeks, or even a month before the festival. Their food must be cooked over a special fire by men who have also undergone a period of abstinence. The officials are forbid-den from entering a house where illness or a death has occurred, where there was a menstruating woman, or where a birth had taken place. They must refrain from particular foods, forego spicy or odorous food, refrain from sexual intercourse, and bathe frequently in pure water. In most cases, the responsibility for serving in such a role was rotated among community officials (Earhart 1984, 182–83). In some com-munities, preparatory restrictions of the sort described are still followed, although many have been liberalized.

Another type of outfit, the *kamishimo* (figs. 4.43–4.46), is worn by the escorts who accompany participants in the festival parade and who act as representatives of the *chōnai-kai* in presenting invitations to holiday feasts to festival participants and honored guests. The *kamishimo* (*kami* meaning "upper" and *shimo* meaning "lower") is a two-piece outfit consisting of a stiff vest (*kataginu*) and culottes (*hakama*) made of starched cotton or finely woven hemp. In the Edo period it served as samurai attire, and it has been nostalgically preserved as the dress of festival escorts. The *kataginu* is stiffened at the shoulders so that it lifts up slightly, giving the shoulders a raised or winglike appearance. The *hakama* are of a matching fabric and usually feature a small stencil-resist overall repeating pattern known as *komon*, an incredibly labor-intensive technique that was formerly the prerogative of the samurai class. Most *kamishimo* are

4.42 Official escort in procession wears the two-piece garment known as a *kamishimo* over a formal black silk kimono. On his head, he wears a wide-brimmed straw hat (*ichimonji-gasa*). Photograph by GGG, Takayama, Gifu Prefecture, 1991.

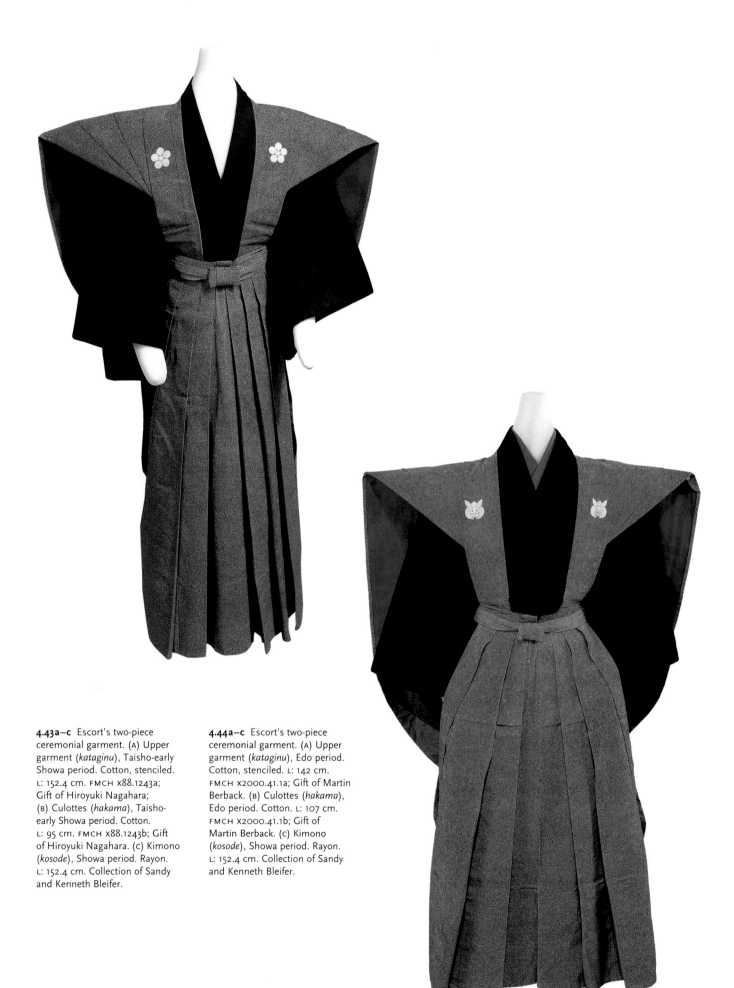

4.43a–c Escort's two-piece ceremonial garment. (A) Upper garment (*kataginu*), Taisho-early Showa period. Cotton, stenciled. L: 152.4 cm. FMCH x88.1243a; Gift of Hiroyuki Nagahara; (B) Culottes (*hakama*), Taisho-early Showa period. Cotton. L: 95 cm. FMCH x88.1243b; Gift of Hiroyuki Nagahara. (C) Kimono (*kosode*), Showa period. Rayon. L: 152.4 cm. Collection of Sandy and Kenneth Bleifer.

4.44a–c Escort's two-piece ceremonial garment. (A) Upper garment (*kataginu*), Edo period. Cotton, stenciled. L: 142 cm. FMCH x2000.41.1a; Gift of Martin Berback. (B) Culottes (*hakama*), Edo period. Cotton. L: 107 cm. FMCH x2000.41.1b; Gift of Martin Berback. (C) Kimono (*kosode*), Showa period. Rayon. L: 152.4 cm. Collection of Sandy and Kenneth Bleifer.

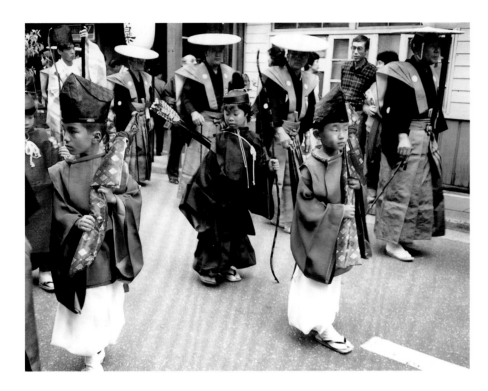

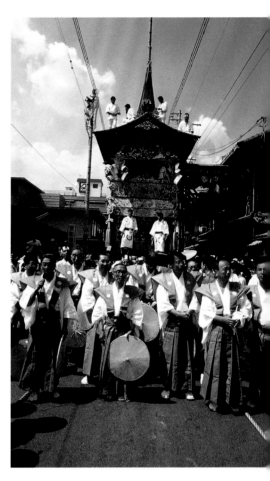

light or medium blue with the designs reserved in white or another neutral color such as gray or tan, although some were unpatterned. A dark silk formal kimono with five stenciled crests is usually worn under the *kamishimo*. Those who recall the historical prestige associated with the *kamishimo* and its *komon* pattern probably enjoy promenading in garments with such an exalted history. An ample sedge hat (*ichimonji-gasa*) may be worn on the head, and in some places its wide brim is drawn down at the sides.

The wearing of these official costumes was overseen by a powerful group of retired community representatives. These mature citizens monitored every aspect of the appearance of the festival and had the responsibility for supervising the maintenance and preservation of the costumes, as well as the hangings and other festival accessories. A prominent example of such a group is the Gion Matsuri Yamaboko Rengokai, the association of participating floats in Kyoto's Gion Festival. This organization has maintained elaborate records on the details of festival dress from the seventeenth century on.

Groups organizing *matsuri* still play a powerful role today in regulating the dress of festival officials and escorts. In his description of *matsuri* taking place in Yuzawa, a rural town in Akita Prefecture, Michael Ashkenazi described the *waka-mono-kai* (lit., "young men's association," but actually an ongoing association of officials), as the real power in the organization and presentation of the parade. Each year the members appeared wearing the *montsuki* with its five *mon*. The formality of this costume demonstrated to the spectators the importance of the officials' role in the festival and the seriousness with which its successful performance was taken. At the top of the power structure, guiding those wearing the *montsuki*, however, were the retired but still powerful commercial and political leaders of the community. They dressed in Western business suits and were seated in an exclusive area during the procession. They also served as guardians of the procession and strolled along interspersed throughout the parade where they could carefully survey the participants' progress (Ashkenazi 1993, 61–63).

4.45 These children are dressed in priestly garb consisting of blue silk *kariginu* and black *eboshi*. Their escorts are dressed in *kamishimo* over formal kimono. Photograph by GGG, Takayama, Gifu Prefecture, 1991.

4.46 Escorts at Gion Matsuri, Kyoto, July, 1994. The Hali Archive.

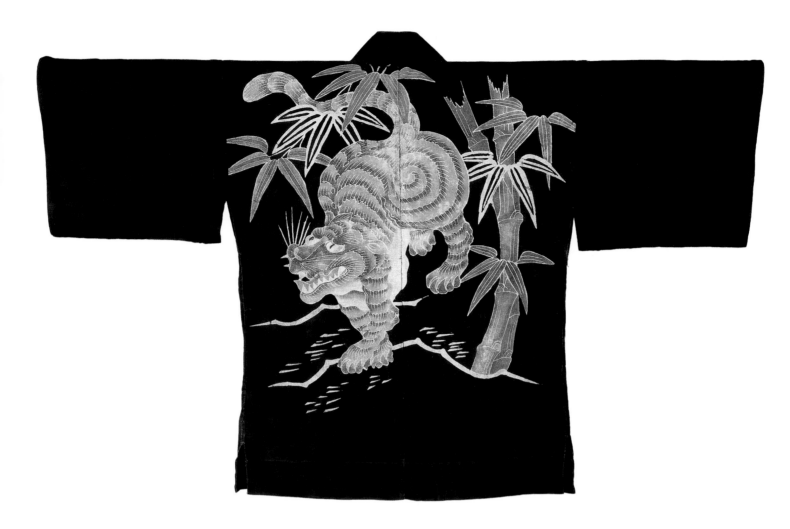

4.47 Coat (*hanten*), Saga Festival, Kyūshū, Meiji period. Cotton, *tsutsugaki* resist-painted. L: 81.3 cm. FMCH x86.4375; Anonymous Gift.

This motif celebrates the historical role of Saga Prefecture as the base of operations for the Japanese forces undertaking military action on the Korean Penninsula. The tiger in the bamboo grove had a lengthy history in legend but came to be associated in Japan with the tigers that inhabited Korea and the bravery of Japanese warriors who supposedly had to face them.

COATS AND ROBES OF FESTIVAL PERFORMERS

Some troops of festival dancers and musicians, as well as soloists, adapt the *hanten*, a cotton work coat, for festival attire (fig. 4.47). It is then decorated with festival motifs, paintings, and sometimes minimal inscriptions. *Hanten* are of varying lengths, with most hovering between the thighs and the knees (fig. 4.48). They are typically longer than *ha'pi* but shorter than kimono (*hanten*, in fact, means "half-kimono"). On these coats the surface is devoted to decoration reflecting the role of the wearer rather than the identification of his group. As festival garments, *hanten* provide more surface area for embellishment than *ha'pi* and thus have more impact, while still permitting freedom of movement. *Hanten* are constructed of two joined loom widths, each about thirty-two centimeters wide. These panels pass over the shoulders seamlessly, each covering the front and the back of one side of the wearer. The sleeves, usually three-quarter length, are constructed of auxiliary panels joined to the body of the coat at the side seams. They are tubular or triangular in shape and are close-fitting at the armhole in contrast to fluttering kimono sleeves. Narrower sleeves are desirable because *hanten* are intended for fairly strenuous activities, including dancing, strolling in unison, and playing a variety of musical instruments. The *hanten* is usually worn closed with a narrow lightweight cotton obi securing it about the waist, although on some occasions it is left unbelted. It is worn over close-fitting or full-cut cotton pants or occasionally over *hakama* (culottes). *Hanten* are generally unlined, but in some locales they are quilted or embroidered to provide strength and warmth.

Festival *hanten* are boldly painted with widely known imagery or with emblems of local significance, in either the freehand resist-painting technique (*tsutsugaki*) or with stencil resist (*katazome*). The imagery may be related to the goals of the local festival, such as a good harvest, a big catch, or prosperous times in business. Sometimes the

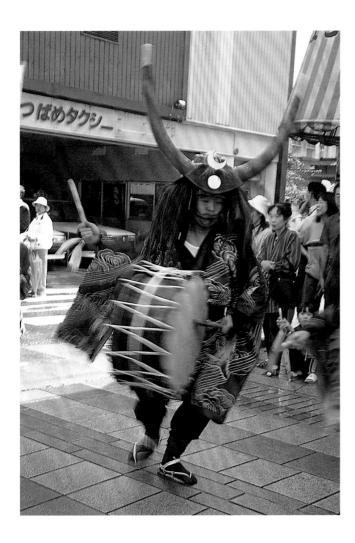

4.48 This dance performed annually at the Okunchi Matsuri pays homage to a historic samurai battle. The dancers are divided into the general, the cavalry, and the infantry. Their *hanten* are resist painted with motifs designating their roles. Photograph by GGG, Hitoyoshi, Kyūshū, 2000.

designs portray well-known figures from legends or literature, or they may merely suggest them with graphics referring to their attributes. Often the designs are whimsical or humorous, echoing the combination of play and solemnity that is characteristic of Shinto celebrations. Some portray aspects of goblins or demonic creatures (*oni*). These have the function of scattering lurking malevolent spirits. The images are dyed with bright primary hues, most often on an indigo background. The designs are planned to be attention getting and expressive of *matsuri* spirit. When inscriptions are used, they are mainly functional and appear quietly along the lapels.

Many of the paintings on *hanten* that have survived from the Edo through the early Showa period, or from approximately 1850 to 1950, are outstanding examples of folk painting distinguished by their charm and spontaneity. They are often unique freehand paintings, but in some cases a crew of apprentices under the guidance of a master artisan produced multiple *hanten* with nearly identical decoration for groups of dancers or musicians. This was possible because of early and careful planning of most aspects of the festival including costume details. Shortly after one *matsuri* ended, preparation of the costumes for the next frequently got underway. Cost was a factor influencing costume decision, however, and wearing custom hand-painted *hanten* meant a substantial investment on the part of the *chōnai-kai* or its individual members. Stencil-resist painting (*katazome*) was therefore a less expensive and faster method of producing multiples and was often substituted for *tsutsugaki*. Today many are machine printed.

Some very long group festival coats were constructed more like *yukata*, or summer kimono, although they functioned as parade robes like *hanten*. An example dating from the late Edo to early Meiji period, or circa 1850–1900, shows the number three (*san*) identifying the neighborhood performing troop (fig. 4.49). This flamboyant

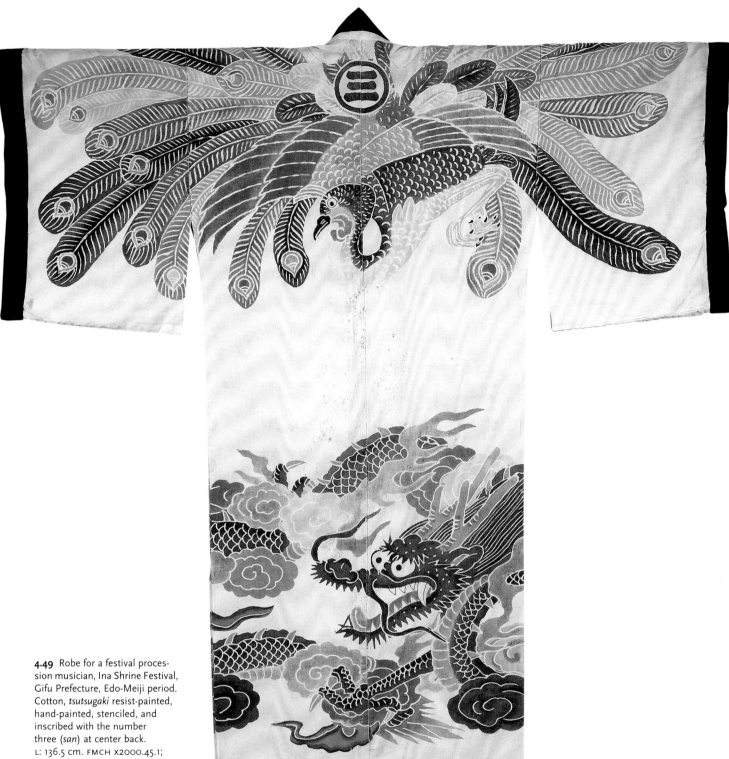

4.49 Robe for a festival procession musician, Ina Shrine Festival, Gifu Prefecture, Edo-Meiji period. Cotton, *tsutsugaki* resist-painted, hand-painted, stenciled, and inscribed with the number three (*san*) at center back.
L: 136.5 CM. FMCH X2000.45.1; Gift of Stefan Gonick.

Robes similar to this one are worn by members of festival musician troops who play flute, drum, and gong each autumn at Takayama's Hachiman Festival. The Takayama festival is particularly known for the *karakuri ningyo* (Chinese dolls), which are elaborate mechanical puppets who perform on Festival floats before huge outdoor assemblies. The puppets are also garbed in Chinese costumes of opulent silk brocades.

costume was worn in the Hida region of the Japanese alps in Gifu Prefecture. Several techniques were combined to produce this striking robe. In contrast to other costumes, whose backgrounds were normally dyed indigo blue, the background is entirely reserved in white, symbolic of purity. The phoenix, which suggests homage to feminine beauty, is accompanied by the dragon, representative of masculine spirit. On the back of the robe, the phoenix spreads its tail feathers along the wearer's shoulders, while around the hem a lively dragon claws at billowing clouds. The design is directly hand-painted with pigments and also *tsutsugaki* resist-painted with dyes. It also incorporates portions of *katazome* (stencil-resist painting). These motifs are associated with Chinese

culture and suggest sophistication as well as evoking widely recognized Taoist references. The design was inspired by Chinese court costumes, called "dragon robes" due to their main motif. In imperial China, robes portraying the dragon encircled by clouds were once reserved for the emperor, his family, and courtiers (figs. 4.50, 4.51).

The image of the phoenix spread across the shoulders of a robe from Takayama is reminiscent of the style that prevailed during China's Ming dynasty (1368–1644) and was also a style worn by the queen of the Ryukyu Kingdom (Okinawa) up through most of the nineteenth century. Handmade mechanized puppets dressed in opulent Chinese brocades (*karakuri ningyo*) may also have inspired the exotic Chinese theme in this inland Japanese mountain town. These appear in the famous puppet shows held at the Takayama Hachiman Matsuri.

While some performing groups may be identified by matching robes or *hanten*, other performers require costumes unique to the characters they portray in the *matsuri*. Well-known examples include *oni* (devilish horned mythical creatures), *shishi* (lion-dogs capable of bringing rain and riches), *shika* (deer), *tengu* (long-nosed mythical rascals), and *sagimai* (heron dancers), as well as others. The costumes for these characters may consist solely of festival *hanten* or may include masks or even more elaborate character-specific paraphernalia. The *hanten* often have minimal inscriptions, such as a simple character, and some have no lettering at all. They are perceived, as are theatrical costumes, as devices through which the performers are transformed into the character represented. In the *matsuri* tradition, to don a *hanten* or a mask is to totally submit to the supernatural aspects of the represented character; the performer once outfitted is no longer considered to possess a personal identity. The *hanten* becomes a vehicle for the descent of the spirits into the festival. It becomes a *shinza*, or god seat, and the wearer merely an apparatus moved by the deity according to its will (Moriarity 1972, 94–95; Yoshida et al. 1985, 59, 129).

4.50 Drawing of the Chinese court costume often referred to as a "dragon robe."

4.51 The leader of a children's troop at Takayama Hachiman Matsuri wears a *hanten*, or festival coat. This example with checkerboard in the variation in the upper-coat design is worn by one community in the Hida region, Gifu. The children, following their adult guide, wear *hanten* with characteristic spreading phoenix and dragon motifs. Photograph by GGG, Takayama, Gifu Prefecture, 1991.

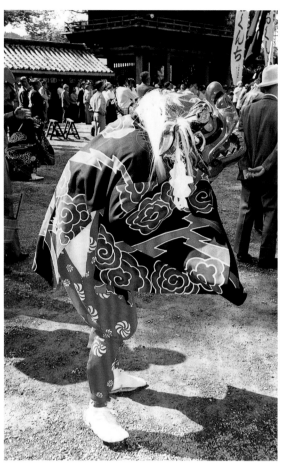

4.52 A pair of *shishi* (lion-dogs) dance in procession at Otanjōbi Matsuri in Kyoto. In the foreground the fierce *shishi* mask is attached to a long green cloth "body" decorated with water-related symbols including eddies of rainwater and the swirling spokes indicating thunder. Photograph by Yuge Sei, 1994.

4.53 This *shishi* (lion-dog) wears a *hanten* with motifs of clouds and lighting that refer to his power to bring rainfall. *Shishi* mingle with families at the shrine arena bringing good fortune to those they pester. Photograph by GGG, Hitoyoshi Okunchi, Kyūshū, 1993.

Shishi Mai *and* Shika Mai

Shishi mai (lion dances) and *shika mai* (deer dances) are two different types of dances based on the movements of animals. They are also known as *shishi odori* and *shika odori*. They are distinguished from one another by different movements, masks, costumes, and meanings. Both are performed at numerous *matsuri* by dancers wearing costumes suggestive of the respective animals. *Shishi mai* were usually performed to control rainfall and spread auspicious vibrations thought to bring prosperity (figs. 4.52, 4.53). *Shika mai* were traditionally danced and drummed to appease the spirits and gain the cooperation of deer and other animals, such as wild boar, that were threats to the young rice crop (Miyao 1968, 193).

Shishi make an appearance at many *matsuri* and their feigned ferocity usually elicits delighted applause from adults and giggles from children. The *shishi* are sometimes described as "lion-dogs," since their portraits on textiles and other artworks often resemble dogs rather than lions. In some *matsuri* that feature *shishi* dances, a rack is set up either at the shrine arena or nearby to display the shrine's collection of gorgeously carved and painted *shishi* masks (figs. 4.54–4.57). In actuality lions never inhabited Japan; the concept and popular dance were imported long ago from China.

Shishi dancers are often glimpsed for the first time on the shrine grounds during the preliminary rites. They loiter about while bowing their large heads and shaggy manes toward gathering celebrants, who invariably chuckle at their advances. Later, in the procession, they usually assert themselves prominently, bringing a parade to a halt when they begin their comical, though auspicious, dances. Drums and loud music provided by *hayashi*, or festival musicians, accompany the grandiose steps and gestures with which the *shishi* call forth good tidings for the coming period. As noted, *Shishi* dancers wear oversized wooden lion masks that are carved, lacquered, and lavishly gilded. (Of note, an extraordinary mask may also serve as a *shinza,* or god seat.) The jaws of a *shishi* mask are hinged, allowing the dancers to clack them loudly.

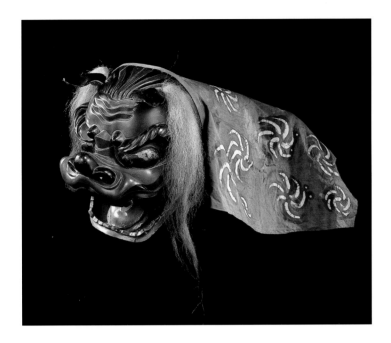

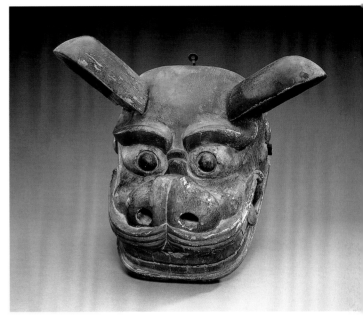

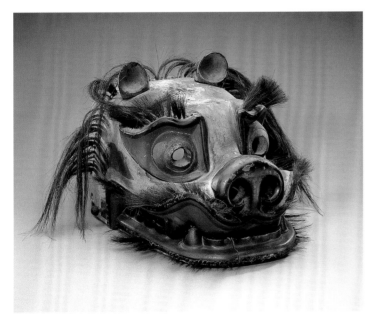

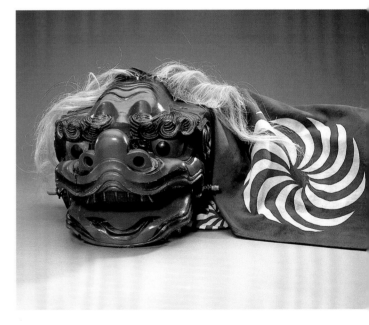

4.54 (UPPER LEFT) Lion-dog (*shishi*) mask, Meiji period. Wood, cotton, paint, and hair H: 29 cm. FMCH X91.2057; Gift of Catherine E. and P. Lennox Tierney.

This mask with a hinged jaw has an attached *shishi* "costume" patterned with rain eddies and swirls that were created on this example using wax-resist technique (*rokechi*).

4.55 (UPPER RIGHT) Lion-dog (*shishi*) mask. Wood and paint. H: 25.5 cm. Collection of Jean and Gary Concoff.

4.56 (LOWER LEFT) Lion-dog (*shishi*) mask, Meiji period. Wood, paint, and hair. H: 28 cm. Collection of Ann and Monroe Morgan.

4.57 (LOWER RIGHT) Lion-Dog (*shishi*) dancer's mask and attached costume, early Showa period. Wood, paint, lacquer, and attached costume body of printed cotton. L: 254 cm. Collection of Tyler Hakomori.

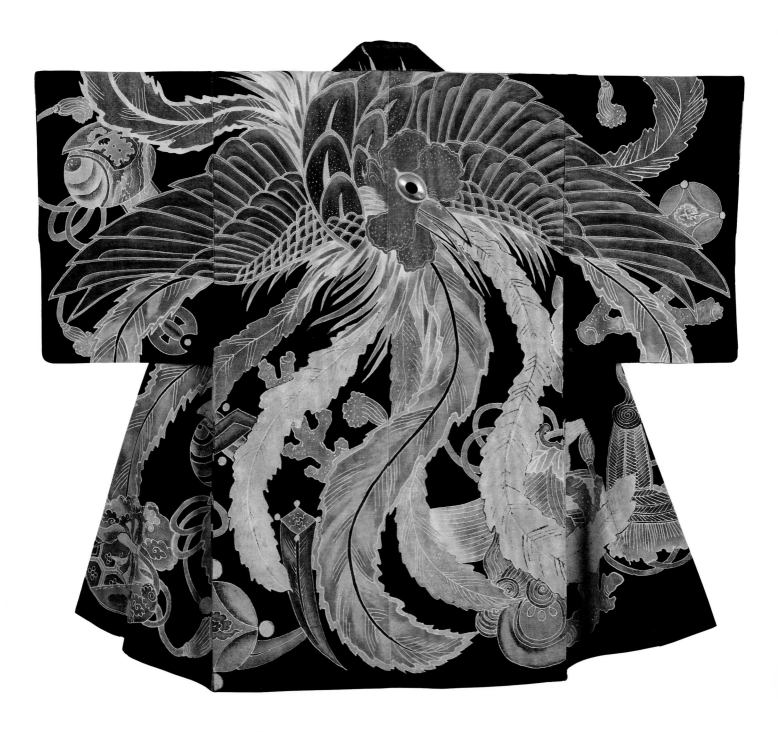

4.58 Festival coat (*hanten*) for a *shishi* dancer, Kyūshū, Edo period. Cotton. L: 123.2 cm. Honolulu Academy of Arts Purchase, Beatrice Watson Parrent Memorial Fund, 1986 (5485.1).

This coat is decorated with motifs including a phoenix, a magical hat, a lucky mallet, and a money bag.

The clattering is thought to suggest coming riches as well as thunderclaps signaling rain. Where there is a single *shishi*, he often wears a boldly decorated *hanten* with the mask (fig. 4.58). The *hanten* is often resist-painted or printed with symbols of clouds, thunder, and lightning (see figs. 4.52, 4.53). In other *matsuri*, the *shishi* dancers move in pairs covered in one elongated baggy "body." In these cases the dancer moving the head has the challenge of dancing while gesticulating with the heavy mask, while the dancer in the rear section must syncronize his rhythm and steps with those of the head, while keeping the torso together as he animates the tail. The body of the costume is traditionally made of cotton that is dyed green or greenish blue, with resist-dyed white swirling motifs that suggest thunder and eddies of rain (see fig. 4.57).

The term *shika* used to refer to all kinds of wild beasts, particularly wild boars, that were deemed threats to the young rice crop. Homage was paid to the spirits of the beasts to make them desist from destroying the grain. In accord with the often-dichotomous nature of creatures in Japanese lore, deer were also highly respected, as they were considered to be the mounts of the deities. The deer herd kept at the

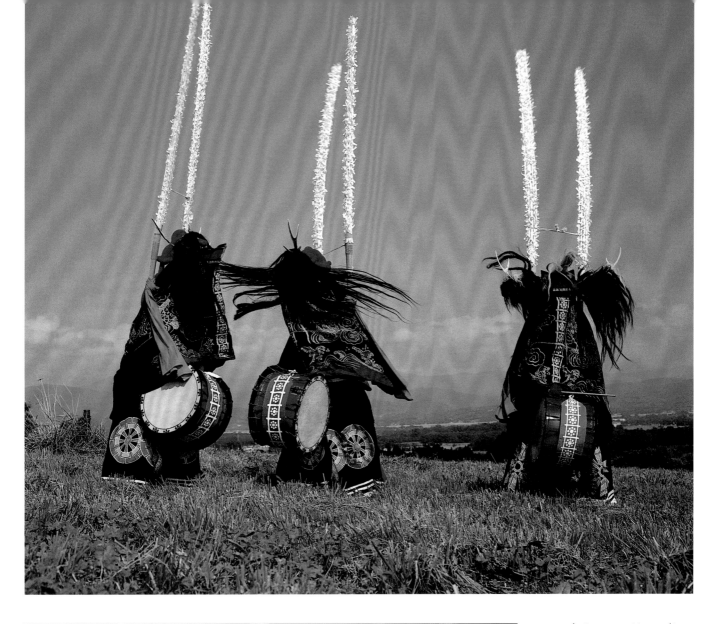

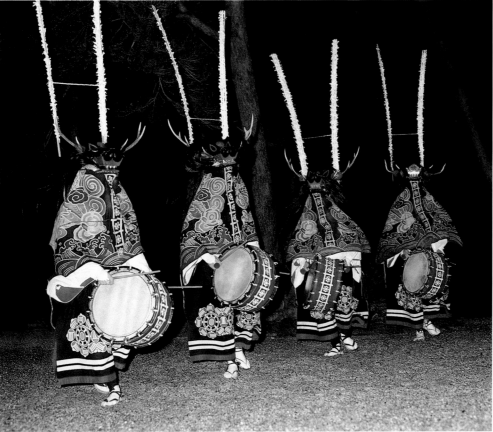

4.59a,b Dancers at Hanamaki performing the *shishi mai*. Although this dance is called *shishi mai* or *gongen mai* in Hanamaki—which is usually translated as "lion dance"— the dance pantomines a legend about a deer and is said to have originated at Kasuga Shrine in Nara. This particular dance is based on Buddhist values of empathy for a deer who fell victim to a hunter's arrows and for the rest of the deer in his herd who must grieve for him. Costumes are by Kuzumaki Yukio. Photographs courtesy of Hanamaki City.

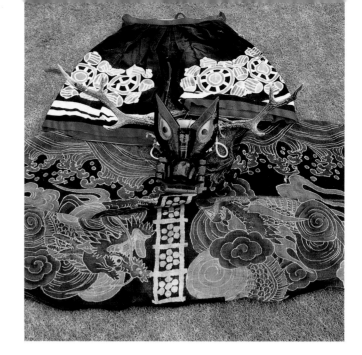

4.60 A deer dancer's costume and mask with antlers displayed on a lawn near a small neighborhood temple in Hanamaki. Photograph by Fran Krystock, 2000.

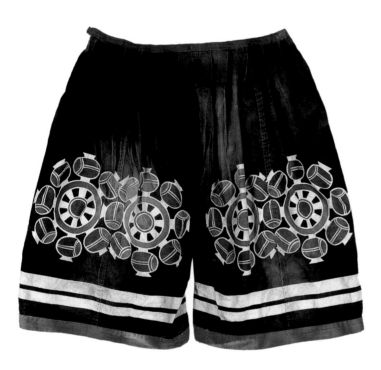

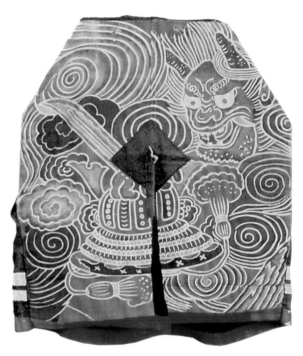

4.61a Culottes (*hakama*) from a Hanamaki Matsuri deer dancer's costume, Taisho-Showa period. Stencil-dyed cotton and straw. L: 72 cm. FMCH X99.47.4b; Gift of the Eva F. Granz Trust, Los Angeles.

These striking stencil-dyed culottes—decorated with very different motifs on the front (fig. 4.61a) and back (fig.4.61b)—are filled with straw. During the performance this causes them to make a swishing sound as the dancers move.

4.61b Back of *hakama* shown in figure 4.61a.

famous Kasuga Shrine in Nara was particularly sacrosanct. At some festivals in the past, shrine deer were paraded as symbols of the *kami*. Humans wearing deer masks with antlers began to imitate the deer in the *matsuri* dances known as *shika mai* or *shika odori*. In some cases the lion dances have replaced *shika mai*, but in several towns in northern Honshū as well as in Ehime Prefecture on Shikoku Island, the *shika mai* have been retained to the present day.

I visited the town of Hanamaki in Iwate Prefecture in Tohoku, northern Honshū, to document their renowned *shishi* dance in the fall of 2000. Although locally this dance is termed a *shishi mai* or *gongen mai,* it is performed as a *shika mai* (figs. 4.59–4.61). The explanation of this *shishi* dance offered by the dancers, who were costumed and masked as deer, was that they were dancing an enactment of the phases in the life of a deer who had been tragically slain. Their dance had Buddhist rather than Shinto inspiration and was in fact choreographed centuries ago by a Buddhist monk living beside Kasuga Shrine in Nara (see figs. 1.3a,b). The monk created a pantomime in which he danced a tale of his empathy for a young deer he had observed frolicking in the forest, which had been suddenly killed by a heartless hunter. The monk told his followers of the tragedy he had observed and explained further that he sensed that

the slain deer's playmates were grieved at the innocent animal's death. He spoke of observing the surviving deer mourning their loss by dancing out their grief as well as their joy as they celebrated the slain deer's life and innocence.

The Nara Kasuga deer dance was transmitted eventually to a temple celebration in Tokyo and then taken northward to Hanamaki in the Tohoku area. Mimi Yiengpruksawan, a professor of art history at Yale University, also witnessed the Hanamaki dancers in their striking costumes a few years ago while living in Tohoku and described the confrontation of the performers with the townspeople. She described the deer dancers as, "rather spectacular looking, strutting around and swinging their heads. I remember that they made me nervous, since they seemed wild and looked quite arresting with the headdress and black-white-red costumes" (personal communication, 2000). The costume includes a voluminous garment woven of hemp, which drapes around the upper body and ties in back. The cloth is *tsutsugaki* resist-painted with motifs of dragons, waves, and spray surrounding a *katazome* stenciled vertical lattice enclosing seven circular disks. The disks represent stars (*hoshi*). A back shield is decorated with illustrations of deer. The culottes (*hakama*) are thickly filled with rice straw, which makes a loud swishing sound when the dancers move. The outfit is worn with a skillfully carved and lacquered deer mask and antler headdress with an additional pair of two-meter-high bamboo poles covered with folded and cut white papers (*sasara*) attached at the shoulders. *Sasara* often appear on Shinto regalia and are felt to purify and to emanate an aura of sanctity. The tall *sasara* produce a highly dramatic effect, particularly when the top-heavy "deer" sways as he dances, bows, and gestures, with the tall projections seemingly challenging the dancer's sense of balance. Still another Hanamaki dance performed in the tall deer costume is slow but energetic and formal. It is described as honoring the light from the sun, the moon, and the stars. Some observers consider this Hanamaki dance to be one of the most fascinating presentations offered anywhere in Japan (Bauer and Carlquist 1965, 133–34).

Oni

Oni were originally described by Taoist yin-yang diviners as invisible spirits that caused illness. Gradually, the image of a demonic yet comical figure entered dramas as well as paintings and folktales. *Oni* were thought to dwell in the spirits of those who had died prematurely or on the battlefield, as well as in destructive animals, natural disasters, and foreigners. They were also imagined to live in mountain bands, on remote overseas islands, or in the netherworld in the domains of *oni* chieftains (Komatsu 1999, 3). At night they would appear to inflict mischief on humans. They may be depicted in several different hues, but are usually red or blue (fig. 4.62). Often they look very much like short, sunburned, burly humans clothed in tiger skin loincloths (as remarked earlier, tiger skins have long been used in Japanese festival costumes and float covers to indicate exotic and barbaric origins). *Oni* are enacted at festivals as powerful deified spirits (figs. 4.63–4.65). They serve the role of scapegoats by taking in and absorbing the malicious intentions of ordinary mortals. They wear horned masks, disheveled hair, tusks, and most often bulging, padded suits bound in with a thick *obi* and in some places additional bindings of rice straw (figs. 4.66–4.69). Although fearsome, *oni* are actually perceived more like goblins than devils. They are more guilty of mischievous good-natured pranks than unqualified evil (Haga 1970, 136–139). Nevertheless, the role of a *oni* at festivals was an unpopular one and had to be rotated, or even hired out, as townspeople conscripted for the part felt somewhat out of sorts for a time afterward (Sadler 1975; Takahashi 1968, 13–28).

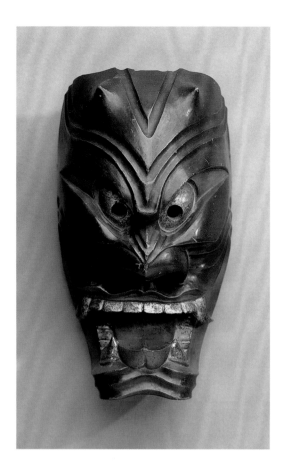

4.62 *Ryū oni* mask, Ariake-cho, Saga Prefecture, Taisho-early Showa period. Wood and lacquer. H: 29.8 cm. Collection of Jean and Gary Concoff.

4.63 Festival coat (*hanten*), Mem Furyū Matsuri, Saga Prefecture, Meiji–Taisho period. Cotton, resist-dyed. L: 92 cm. FMCH X2002.12.1 Anonymous Gift.

This coat is similar to that worn by the dancers in figure 4.64.

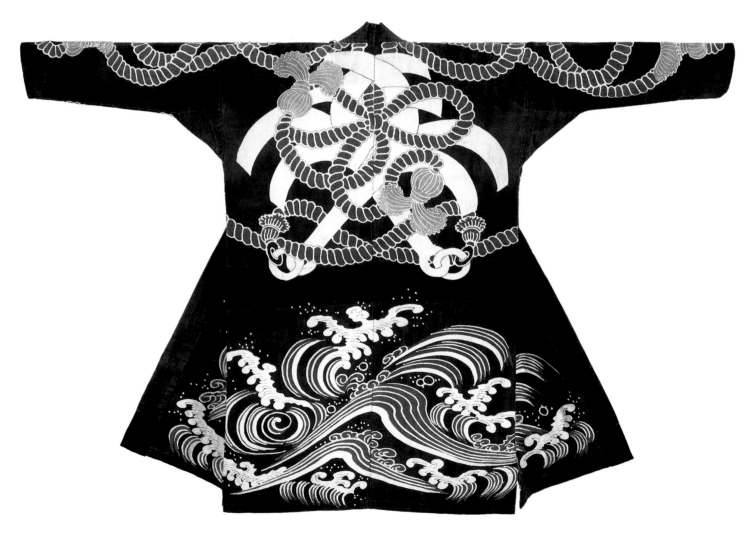

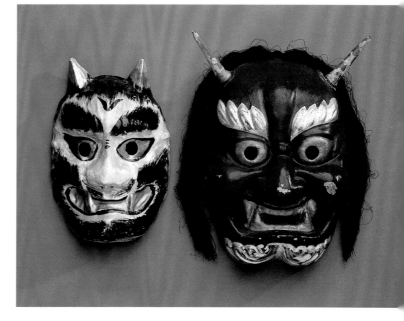

4.64 (UPPER LEFT) The mask and dance *hanten* of Mem Furyū are worn at several matsuri in Saga Prefecture, Kyūshū. The dancers' costumes are *tsutsugaki* resist-painted with ropes that appear to bind their torsos above a depiction of a turbulent sea. Ropes are sometimes seen on *oni* (demons or goblins) and serve to bind in or control their malevolent tendencies. Photograph by David Mayo, Ariake-cho, 2000.

4.65 (UPPER RIGHT) This drawing illustrates a Mem Furyū dancer at Ureshino-machi in Saga Prefecture. The dancer accompanies himself with a small drum tied to his waist.

4.66 (LOWER LEFT) Some *Oni* wear padded red suits bound with thick rope obi, which serve to restrain their malevolent tendencies. These *oni* are leaving the shrine at Toyohasi-shi, Aichi. Photograph from Haga (1970, 127).

4.67a,b (LOWER RIGHT) (A) *Oni* mask, twentieth century. Papier-mâché and paint. H: 18.4 cm. Collection of Ann and Monroe Morgan. (B) *Oni* mask. Papier-mâché, paint, and thread. H: 27 cm. Collection of Jean and Gary Concoff.

 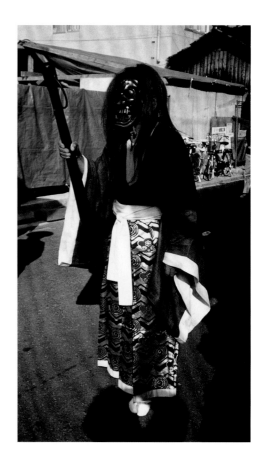

4.68 This blue *oni* grasps an *oni* rod (*kanabō*) at Aomori Neputa Matsuri. Photograph by GGG, 1994.

4.69 An elegantly clad *oni* appears in the *oni* procession at Ueno-Shi Tenjin Matsuri, Mie Prefecture. This festival is held in honor of Tenjin, god of Chinese calligraphic skills and Buddhist learning. Because of the association with Tenjin, the *oni* in this *matsuri* are opulently dressed in Chinese silk, satins, and brocades woven with auspicious symbols. Their wigs and masks, however, reveal their devilish aspects. Unkempt hair suggests indifference to civility. Photograph by GGG, 1991.

Sagi Mai *(Heron Dancers)*

Tsuwano, a small town in the Sanin region of western Honshū, has become renowned for its performance and preservation of a hauntingly beautiful and somewhat eerie heron dance (*sagi mai*), performed annually on July 20 and 27 at Yasaka Jinja shrine (fig. 4.70). It is said to have been influenced by a dance of the same name that originated in Kyoto around the fourteenth century. The Tsuwano clan is recorded as having learned the dance from Kyoto performers in the seventeenth century. Soon afterward the dance was discontinued in Kyoto, but it remained in the repertoire of Tsuwano festival dancers, who, in return, taught it to Kyoto dancers in 1954. It has been performed in both locations ever since.

Tengu

Tengu are mischievous rascals with birdlike beaks and extremely long noses, who carry large fans made of feathers (figs. 4.71, 4.72a,b). A *tengu's* presence might be suggested solely through the motif of its feathered fan, which also sometimes appears as a crest on festival *ha'pi*. *Tengu* have red faces, said to have been inspired by the appearance of Dutchmen who arrived in Japan in the seventeenth century. They are blamed for various forms of depravity, including kidnapping children and abducting young females. Perhaps the *tengu's* rather phallic nose is a signal of its propensity for getting young women "in trouble." *Tengu* are not all bad, however, as most Japanese demons and goblins have an amiable aspect, and occasionally *tengu* perform acts of goodwill. At festivals, they appear in processions and also play roles in open-air folk dance-dramas (Joya 1960, 477–78; Moes 1985, 45).

Maiwai *(Fishermen's Robes)*

Since Japan is an island country, seaports are numerous, and fishing has always been a major industry. In fishing communities, *matsuri* may be held to express gratitude to Ebisu, the deity of fishermen, and also to local shrine deities. The fishermen, known for pride in their daring occupation, also enjoy their reputation for holding colorful

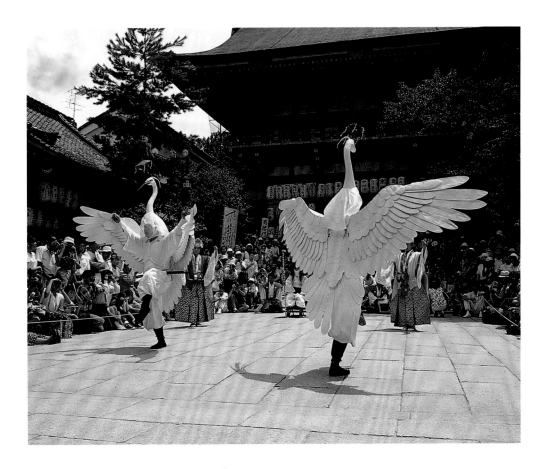

4.70 The heron dance (*sagi mai*) is performed at the time of Gion Matsuri in Kyoto. The heron is a habitue of the rice fields and therefore signals a thriving crop. Photograph by Yuge Sei, 1994.

4.72a,b (A) *Tengu* mask, 1960s. Papier-mâché and paint. H: 20.3 cm. Collection of Ann and Monroe Morgan. (B) *Tengu* mask, Edo period. Wood, paint, and straw. H: 34 cm. Collection of Ann and Monroe Morgan.

Tengu are always costumed and wear masks with long noses and long hair. It is sometimes thought they may have been inspired by the Dutch who arrived in Nagasaki in the mid-1600s to conduct trade.

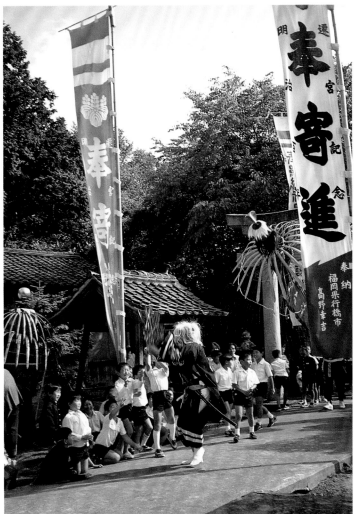

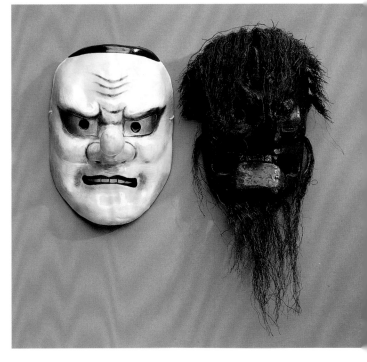

4.71 *Tengu*, unpredictable goblinlike creatures, are known for unsavory behavior, including kidnapping. Tengu are often vividly described by parents attempting to inspire obedience in their children. This *tengu* evoked giggles and shrieks from the children at Ōda-shi Matsuri in Shimane Prefecture. Photograph by GGG, 1993.

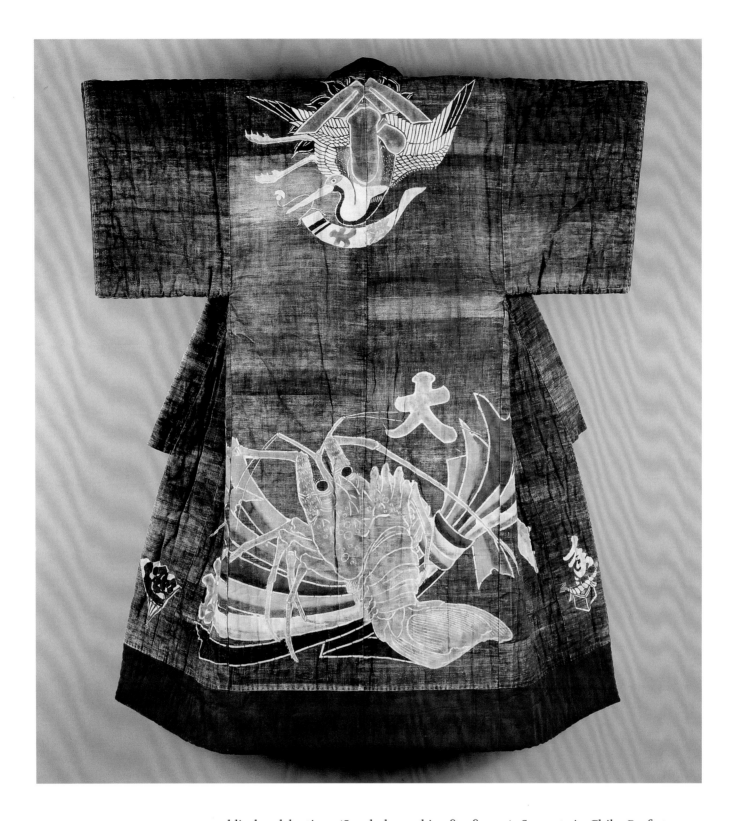

4.73 Fisherman's festival robe (*maiwai*), Edo period. Cotton, resist-painted and stenciled. L: 162.5 cm. Gift of Lloyd E. Cotsen and the Neutrogena Corporation, Museum of International Folk Art, a unit of the Museum of New Mexico, Santa Fe, #1995.93.536. Photograph by Pat Pollard.

Maiwai is the term for fishermen's robes worn at festivals celebrating the catch in the fishing ports of Chiba Prefecture.

and lively celebrations (Senshoku no bi 1980, 89–95). Seaports in Chiba Prefecture, including Chōsi City, Kujukurihama, and Kisarazu City, were particularly prominent among the fishing communities that produced *maiwai* robes from the early nineteenth century to the early twentieth century, and in fact the term *maiwai* originated there (fig. 4.73). *Mai* is a colloquial variant of *man* (the number ten thousand), and *wai* is a colloquialism for *ryo*, an Edo Period monetary denomination. The term is based on practices at Kujukurihama, where fertilizer was made out of dried mackerel and then packaged into jute bales, a convenient form for transporting it to farmers in the countryside. When ten thousand bales were filled, the fishing crew was considered to have earned its reward, which consisted of custom-dyed fabric to be tailored into robes.

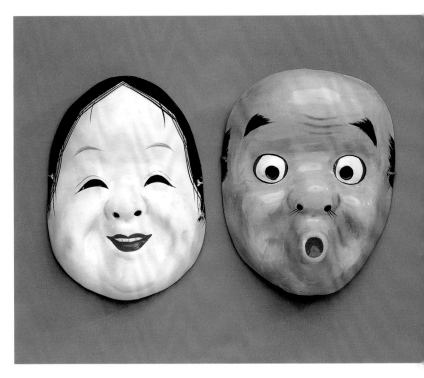

The boat captain would visit an indigo dyer and order the dyeing of anywhere from twenty to two hundred *tan* of handwoven cotton cloth, which was to be prepared by the time of the Obon Matsuri, held on August 15 (one *tan* equals twelve meters, the length of fabric required to make one kimono). The fabric was to be stencil-resist dyed or sometimes *tsutsugaki* painted with symbols relating to past and future success in fishing. Such auspicious symbols on coats and banners were thought to promote successful catches. Many of the coats were inscribed with symbols for longevity, which was a special concern for men who daily braved deep and often unpredictable waters. The characters for *tai ryo* (profitable catch) were also placed on banners (see fig. 4.22) and on crests (*mon*) that appeared in the center-back designs on the coats.

At the time of the Obon Matsuri, the captain would distribute one *tan* of cloth to each of his crew and request that the robes be made by the end of the year. Each man either took the cloth home to his wife to be sewn into a padded robe or took it to a professional tailor. On January 2 the captain and his crew assembled at the local shrine dressed in their gorgeous coats and paid their respects to the *ujigami* (local shrine deity). Afterward they formed a procession that wound along the beachfront, followed by hours of camaraderie, feasting, and sake drinking.

Hyottoko and Okame

Hyottoko and his female partner, Okame (known in her humorous folk interpretation as Otafuku), are associated with fertility and appear prominently at spring festivals (figs. 4.74, 4.75a,b). The masks worn by those representing these characters are often highly suggestive of male and female genitalia. The two are characterized as somewhat foolish or simple country people, and they often engage in farcical imitation of the sex act. This is intended to bring fertility to the land and the people.

Fertility is a recurrent theme in *matsuri*. It is especially prevalent in rural festivals, which are often held in or near the rice fields to assure an abundant harvest. *Dengaku*

4.74 Hyottoko prances and gestures at the Hitoyoshi Okunchi Matsuri procession. He wears a funny mask and hat, suggesting a foolish but enthusiastic country fellow. He serves as a charm to prevent fires and to induce prosperity. Photograph by David Mayo, 2000.

4.75a,b (A) Okame mask, early Showa period. Papier-mâché and paint. H: 21.59 cm. Collection of Ann and Monroe Morgan. (B) Hyottoko mask, early Showa period. Papier-mâché and paint. H: 21 cm. Collection of Ann and Monroe Morgan.

Hyottoko and his equally simple country maid, Okame, are partners in lively sexual antics at *matsuri*. Together the two represent the fertility of the human population as well as fertility of the land.

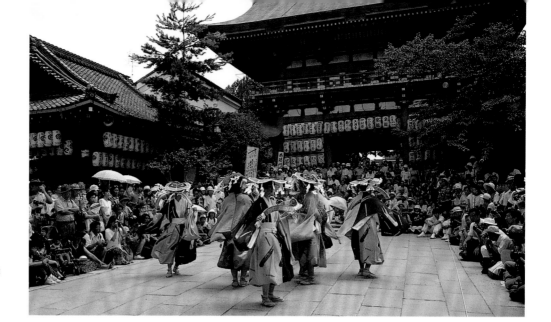

4.76 *Dengaku* dancers perform at Yasaka Shrine in rites held in conjunction with Gion Matsuri, Kyoto. The dancers whirl and spin, their round flat hats and drums suggesting the rice field and the harvest. They are self-accompanied with the instrument known as a *binzasara*, made of joined bamboo slats. Photograph by Yuge Sei, 1994

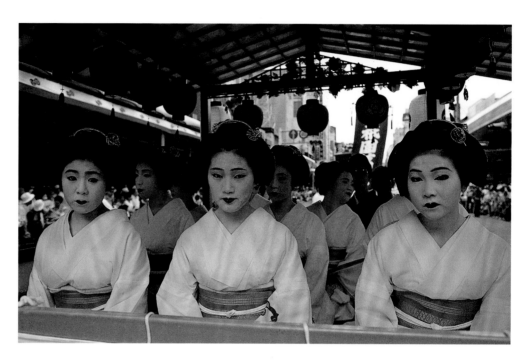

4.77 A group of *maiko* (young women in training to become geishas) appear in procession in Kyoto. Their appearance is considered an auspicious omen. Photograph by Yuge Sei, 1994.

dancers perform one such field dance in conjunction with Gion Matsuri in Kyoto (fig. 4.76). The term *dengaku* refers to dances related to the rice culture of Japan. Some are held at the site of cultivation, but others are performed in urban surroundings remote from the fields. At court, a field dance (*ta mai*) has been performed since the seventh century. The rice transplanting dance (*taue odori*) and other aspects of the stages in the cycle of rice growing are performed to recitation and drum beats. The drum represents the field, and the movements mime agricultural labor. Often there is a decorated pole or structure rising from the dancer's back or beribboned headgear with a flat top, the latter representing the rice field (Hoff 1978, 143–46). Some dances lead toward possession, these are characterized by circular motions and gradually increasing tempo. Although trance was the original purpose, in today's performances, these dances are prayers, performed to encourage fine harvests (Hoff 1978, 218).

Geisha

Geishas are highly expert entertainers. Their skills extend to dance, song, playing the *shamisen*, poetry, storytelling, flower arranging, tea ceremony, and other arts of presentation. Geishas and *maiko,* or geishas in training, are frequently invited to appear in festival processions in Kyoto and Tokyo. It is thought that their beauty radiates an auspicious aura (fig. 4.77).

HA' PI, THE JACKETS OF PARTICIPATING GROUPS

Both *ha'pi* and *hanten* are customarily donned on ordinary days by workmen preparing for physical labor. The very act of putting on a *ha'pi* signals that a commitment to a physical task is about to be made. In a festival context, however, both *ha'pi* and *hanten*, appropriately inscribed and decorated, indicate the full commitment of the wearer to the goals of the *matsuri*.

During the Edo period (1615–1868) the term *ha'pi* was applied to lightweight jackets worn by male servants of the samurai (Thornton 1989, 11–12). These jackets were characterized by a large crest (*mon*) identifying the regional lord (daimyo) whom the men served. In the last decades of the Edo period, merchants and affluent farmers became important supporters of shrine festivals as a means of expressing their growing economic power and status. As a result, by the Meiji period (1868–1912) the ranks of *mikoshi* bearers had swelled with young men from merchant and farming families. These young men adapted their own everyday work coat, the *ha'pi*—decorated with holiday inscriptions and motifs—to a festival purpose (fig. 4.79).

Since the beginning of the Meiji period, the term *ha'pi* has meant a hip-length, unlined, close-fitting jacket with tubular, three-quarter length sleeves. Most are made of indigo-dyed cotton. Today *ha'pi* are omnipresent at *matsuri*, where their bold inscriptions and crests identify the wearers as members of a specific group, usually a shrine neighborhood (*chōnai*). These designs are placed primarily on the center back of the jacket, with smaller identifying lettering along the front lapels; on occasion, a design is repeated around the hips. The decorative emblems are familiar to community members, and the inscriptions, crests, and symbols are easily decipherable even from afar. Although they are often worn by *mikoshi* bearers, they are also worn by the teams who pull the festival wagons (*hikiyama*) or other festival objects such as floats, boats, papier-mâché sculptures, or giant umbrellas (fig. 4.78). Finally, they are widely worn by groups of rank-and-file participants in the procession.

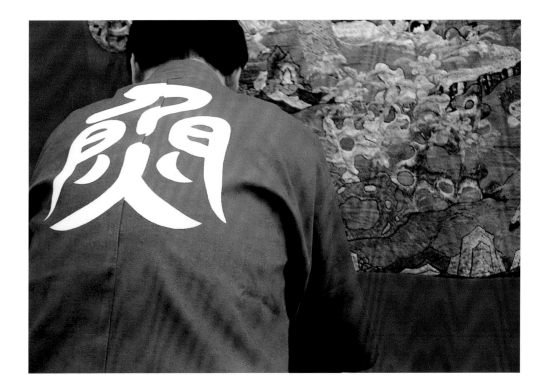

4.78 A *ha'pi* stenciled with a single character is worn by a *hikiyama* (festival wagon) porter at Tenjin Matsuri in Ueno-shi. The wagon hanging is a rare Ming dynasty (1368–1644) silk embroidery. Photograph by GGG, 1993.

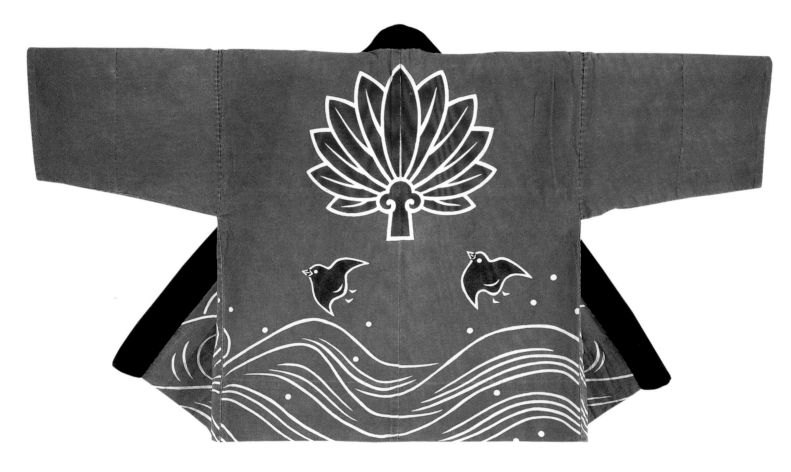

4.79 Festival jacket (*ha'pi*), Showa period. Cotton, resist-stenciled. L: 71.5 cm. Collection of the Asian Cultural Arts Trust.

This summer festival *ha'pi* is decorated with motifs of waves and plovers (*chidori*). It is inscribed "Kawana ku seinankai" (Kawana ward young men's association) in white on black on the front lapel (*eri*).

Festival *ha'pi* (fig. 4.80) are easily distinguished from commercial *ha'pi* worn by workmen because the inscriptions on the festival jackets declare the wearer's shrine or neighborhood affiliation (fig. 4.81), while those on the commercial *ha'pi* advertise the employer's shop or business. In the past, however, workmen of the same occupation or craft often lived in the same part of town, attended the same shrine, and worshiped the same *kami* (Thompson 1986, 21). It was likely that workmen pursuing the same occupation would be members of the same association. Commercial *ha'pi* representing businesses do sometimes appear at festivals when a company elects to use the opportunity to advertise (fig. 4.82).

Although simple in form, inscribed *ha'pi* are very effective in converting townsmen and farmers into focused festival participants. The inscriptions are meant not only to identify festival groups but also to promote group loyalty. Wearing the *ha'pi* enhances excitement and a sense of camaraderie, increasing the desire to participate wholeheartedly and to proclaim publicly the group's commitment to the *matsuri*. *Ha'pi* also serve to erase distinctions of class and related obligations within the group. At the same time festival organizers are visibly assured by the inscribed *ha'pi* dotting the festival arena that they have garnered substantial response to their efforts on behalf of the community's welfare. The rows of *ha'pi* passing in a festival procession excite the onlookers and, hopefully, astonish the deities with wave after wave of dazzling inscriptions.

Wearing a *ha'pi* with the name of one's association on it has a restraining as well as an energizing effect. In a land where avoiding shame is a continual concern, indulging in behavior deemed beyond the limits of acceptable rowdiness while wearing

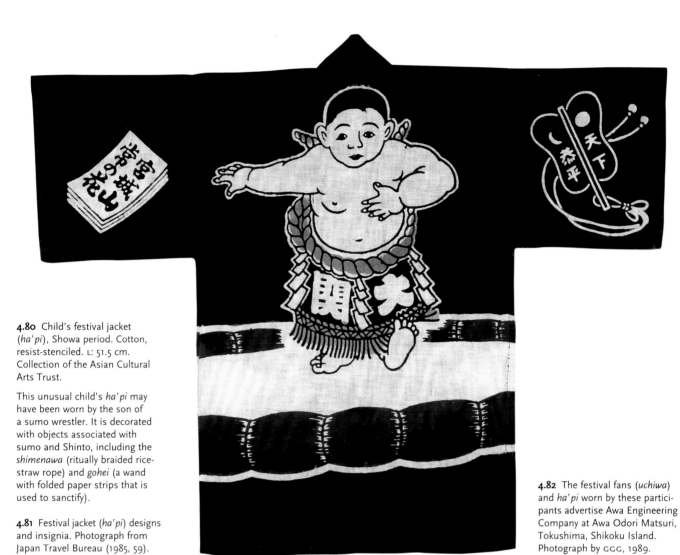

4.80 Child's festival jacket (*ha'pi*), Showa period. Cotton, resist-stenciled. L: 51.5 cm. Collection of the Asian Cultural Arts Trust.

This unusual child's *ha'pi* may have been worn by the son of a sumo wrestler. It is decorated with objects associated with sumo and Shinto, including the *shimenawa* (ritually braided rice-straw rope) and *gohei* (a wand with folded paper strips that is used to sanctify).

4.81 Festival jacket (*ha'pi*) designs and insignia. Photograph from Japan Travel Bureau (1985, 59).

4.82 The festival fans (*uchiwa*) and *ha'pi* worn by these participants advertise Awa Engineering Company at Awa Odori Matsuri, Tokushima, Shikoku Island. Photograph by GGG, 1989.

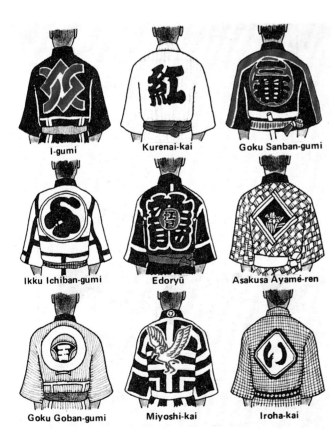

I-gumi

Kurenai-kai

Goku Sanban-gumi

Ikku Ichiban-gumi

Edoryū

Asakusa Ayamé-ren

Goku Goban-gumi

Miyoshi-kai

Iroha-kai

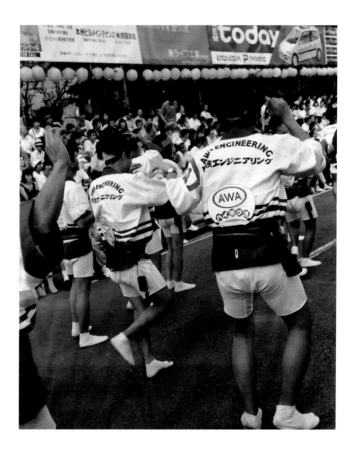

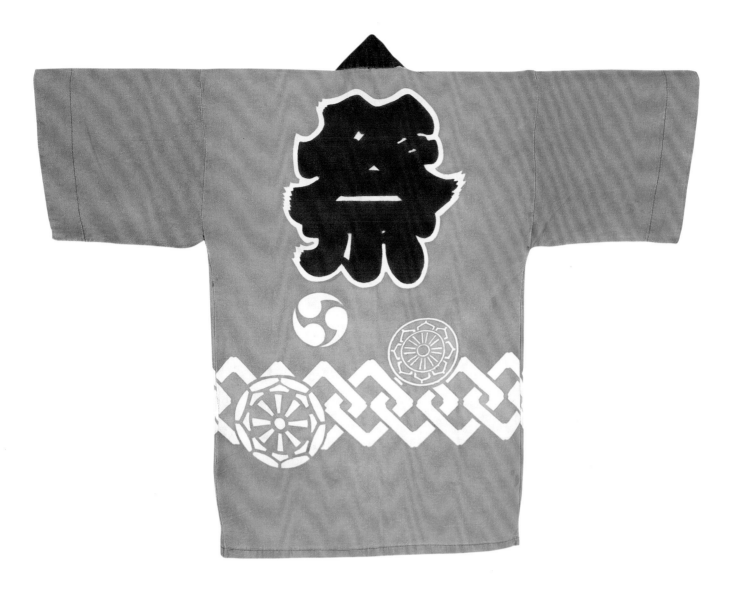

4.83 Generic festival jacket (*ha'pi*), circa 1930s. Cotton, resist-dyed. L: 64 cm. Collection of the Asian Cultural Arts Trust.

Generic *ha'pi* can be purchased by visitors at *matsuri*.

a *ha'pi* could invite censure. It is likely that the wearing of identical costumes tended to reinforce common values (Yoshida et al. 1987, 17, 72). Donning an inscribed *ha'pi* implies that the wearer is acting as a representative of the group and accepts its standards. However, since rules of propriety have always been substantially broadened during *matsuri*, if not totally lifted, this did not produce undue anxiety.

Possession of a group *ha'pi* is generally restricted to members of the neighborhood association, or *chōnai-kai*. Inscribed jackets are rarely given, sold, or lent to outsiders. Designated family participants are entitled to receive a *ha'pi* because the household contributes funds, typically in the form of dues assessed by the festival committee. Generic *ha'pi* with a simple auspicious character or just the character for festival (*matsuri*) are sometimes used by visitors (fig. 4.83). A. W. Sadler reported that in mid-twentieth-century Tokyo enthusiastic volunteers were provided with *ha'pi* if they applied at the local headquarters (*o miki-sho*) where the *mikoshi* were temporarily stored before the procession. Guest bearers needed to submit to purification rites performed by the shrine priest. In the nineteenth century this would have meant complete immersion in a clear stream or in the ocean. Later on, washing one's hands and face, and rinsing one's mouth, came to be deemed sufficient (Sadler 1972, 105).

Ha'pi are by far the most ubiquitous festival garments in Japan. Prior to World War II, wearing a *ha'pi* was a familiar experience for nearly all ordinary citizens. For these people, however, a certain nostalgia has now become attached to seeing a cluster of *ha'pi* coats (Sonoda 1988, 34). Due to its strong association with *matsuri* memories, even today the *ha'pi* coat evokes a sense of camaraderie and exhilaration.

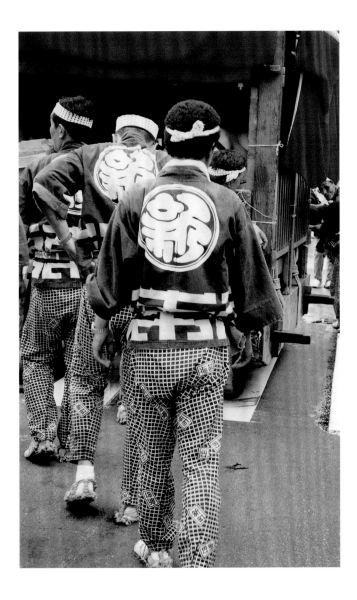

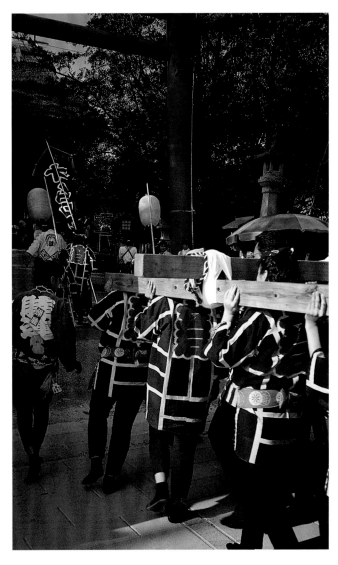

Although the *ha'pi* stirs considerable nostalgia, it is a simple garment. Two panels of cotton about thirty centimeters wide are joined to create the body. The *ha'pi* is basically unlined, but areas that have to withstand the stress of festival tumult are sometimes reinforced (fig. 4.85). Old *ha'pi* may therefore have collars, shoulders, lapels, and cuffs that have been backed with cotton linings made from fabric scraps or recycled segments of worn garments (see fig. 4.99b). These fragments of old *yukata* or *tenugui* (towels) sewn into *ha'pi* are hidden treasures for students of Japanese textile history, as women in many households maintained caches of usable fabric scraps for such purposes for generations.

The ground color of the *ha'pi* is most often a deeply dyed shade of indigo, while the inscriptions or other motifs are resist-stenciled in white using the *katazome* technique (fig. 4.86). Occasionally there are red or reddish-brown accents (fig. 4.87). As has been noted previously, until the Meiji Reformation, ordinary people were restricted to somber colors of dress. A lingering sense that these were the only suitable hues lasted long after the turn of the twentieth century. Nevertheless, woven or dyed stripes, plaids, or checks were sometimes added to *ha'pi* fabric for interest. In the warmer and more humid climates of southern Japan, *ha'pi* are sometimes left white with the inscriptions in red or black. For example, white-ground *ha'pi* are worn at the Hakata Matsuri in Kyūshū as well as in other nearby festivals. To the north in Honshū's Aomori Prefecture, where mist and fog are common even in summer, bands of musicians playing festival music (*hayashi*) at the Aomori Neputa Matsuri dress in *ha'pi* with bright blue, yellow, and red floral designs and broad blue stripes on a white ground (fig. 4.88).

4.84 The indigo-dyed *ha'pi* worn by these *hikiyama* (festival wagon) porters at Ueno-shi Tenjin Matsuri have been frequently laundered and are now a mellow shade of blue reflective of the aesthetic ideals of *mingei* (Japanese folk artistry). The trousers worn with the *ha'pi*, however, are machine printed with bright blue chemical dyes. Photograph by GGG, Mie Prefecture, 1993.

4.85 The sturdy cotton fabric used for *ha'pi* provides a measure of protection for *mikoshi* bearers in the Hitoyoshi Okunchi Matsuri. Photograph by GGG, 2000.

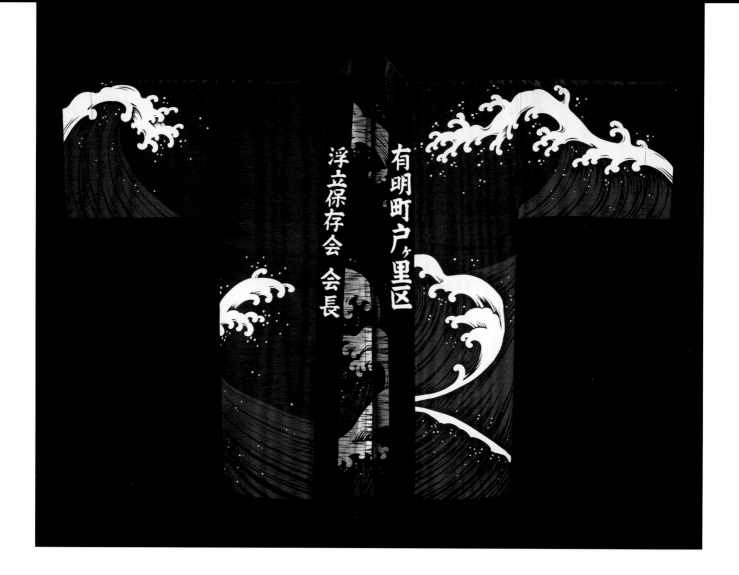

有明町戸ヶ里区

浮立保存会 会長

4.86 Festival jacket (*ha'pi*),
2000. Cotton, stenciled.
L: 95 cm. FMCH X2000.48.1;
Museum Purchase.

Waves and spray form an
unusually animated design on
this *ha'pi*, which is worn each
October by devil dancers (*oni*)
and musicians at Ariake-cho
in Kyūshū. They also wear
fierce-looking lacquered masks
and accompany themselves
on drums.

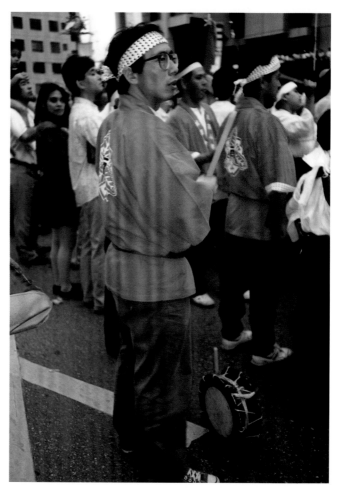

4.87 These *ha'pi* reflect the lush
hues characteristic of Okinawa.
Photograph by GGG, Otsunahiki
Matsuri, Naha, 1994.

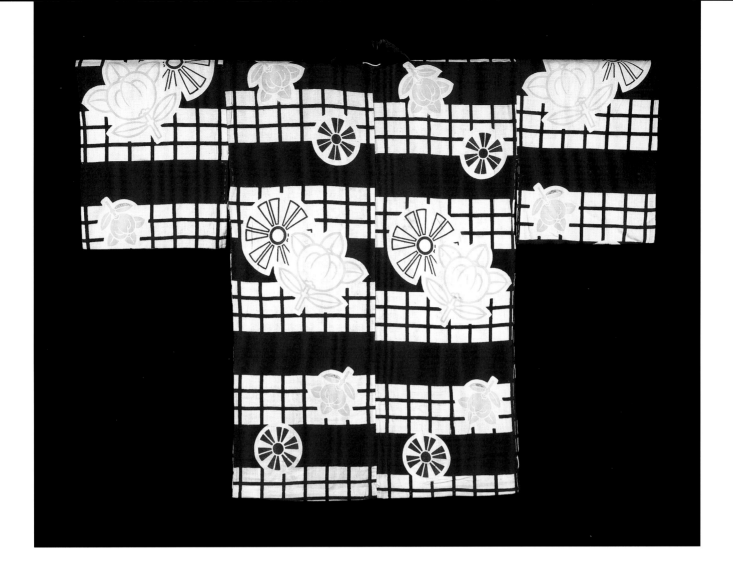

A typical *ha'pi* communicates a festival group's name and frequently its location (the neighborhood within a city, or if it is a small town, the name of the town or the host shrine). It often bears a symbol connected with the neighborhood or the shrine, which may stand for the deity enshrined there (fig. 4.89). Often the neighborhood name incorporates the characters for east, west, north, or south. Many locations are identified by geographical features such as mountains, rivers, valleys, or well-known man-made features, such as bridges or torii gates. Sometimes the name of the festival may be inscribed on the coat, or the rank of the wearer (for example, the leader of the group or supervisor of a district). If the personal name of the owner appears at all, it is usually only functional and written on the inside of the lapel. (See the interview with Mr. Hatanaka Kinya, an owner-designer of a successful Tokyo festival *ha'pi* workshop, for a better idea of how the *ha'pi* designs are produced, p. 147.)

During the Edo period, the cotton or hemp yardage for most *ha'pi* was both woven and dyed at home, but some towns had dye specialists who were engaged to prepare *ha'pi* for *chōnai-kai* members. These artisans owned dye workshops called *some ya*. The dyer had close relationships with festival association organizers who respected his experience and artistry. By 1890 fewer *ha'pi* were woven or dyed at home, and professional town dyers took over most of the task of dyeing *ha'pi* for festival groups. They were able to handle large orders and achieve uniformity in design, a difficult challenge for home dyers. During the twentieth century it gradually became common for the festival committee to have the jackets machine-printed to order.

In many locales, it is considered important to use the same motif on *ha'pi* each year, although in some instances color accents, backgrounds shades, or the styles of designs were altered according to fashion. In past generations, particularly renowned stencil or dye artisans could make changes that would be respected out of admiration for their taste and skill. In some places, however, festival garb is totally refreshed in keeping with the spirit of renewal. In Yokohama formerly worn garments are discarded

4.88 Festival jacket (*ha'pi*), early Showa period. Cotton. L: 97 cm. FMCH X99.47.1; Gift of the Eva F. Granz Trust.

A contemporary *ha'pi* from Aomori Matsuri in Tohoku is adorned with a vibrant floral design in primary colors against a blue-and-white tile grid.

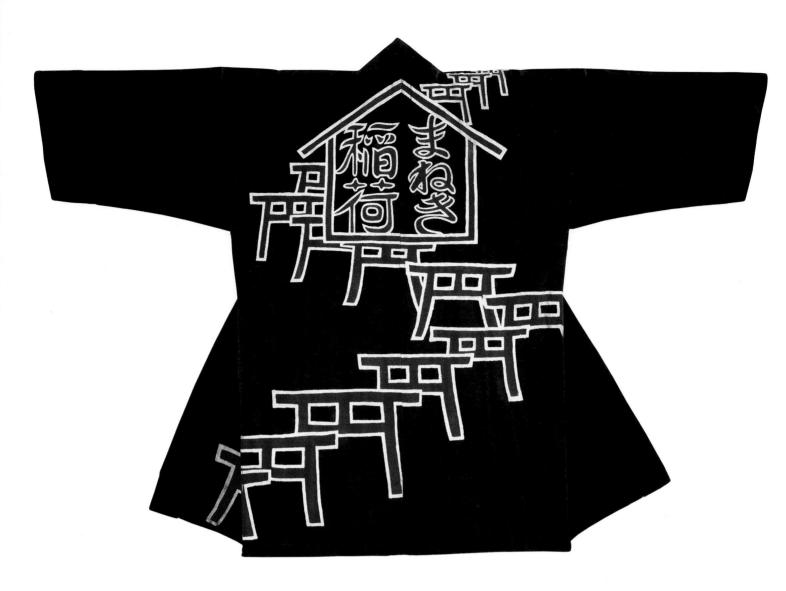

4.89 Festival jacket (*ha'pi*), Taisho period. Cotton, resist-stenciled. L: 90 cm. FMCH x87.1568; Gift of Mary Chesterfield.

The back of this *ha'pi* bears the inscription "Maneki Inari" (Welcome Inari). The spirit of the deity Inari, the god of the grain harvest, is worshiped in thousands of Inari shrines throughout Japan and is honored at several *matsuri* (Notehelfer 1992, 403–4, 538–39; Joya 1960, 422, 572; Japan Travel Bureau 1985, 138). A geometric drawing of a shrine at the center back of this festival jacket forms a crest that encloses the inscription. Multiple red torii gates are a renowned feature of Inari shrines and are often associated specifically with the Inari Shrine at Fushimi, near Kyoto. This *ha' pi* might have been used in events held there.

and totally new clothing is donned (Notehelfer 1992, 199). At times of economic stress, local opinion decreed change based on the conviction that alterations in the festival would turn around sagging fortunes.

Each vicinity has its own manner of wearing *ha'pi* and its own styles of accessories. In some places *ha'pi* are worn unbelted, but more often they are wrapped closed, left side over right, and secured with a narrow cotton obi (fig. 4.90). The obi may be wound around the waist or just below according to local practice and also in keeping with the demands of the festival task, such as lifting, carrying, bearing musical instruments, dancing, and so on. Originally, a loincloth (*fundoshi*) was worn with the *ha'pi*; this tradition has persisted in some festivals such as at Hakata's Gion Yamagasa Matsuri (fig. 4.91). More often today the *ha'pi* is worn with three-quarter-length, thin white cotton trousers (*zubon shita*) or with shorts. In some *matsuri* the bearers wear black workmen's tights (*kyahan*) on their calves, and black *tabi* (close-fitting split-toed cotton socks) on their feet. Pure white *tabi* may be worn with *waraji* (braided straw sandals) or *zori* (thongs). Rubber soled *tabi* (*jikatabi*) are worn in many places without sandals or thongs.

The common headgear worn with the *ha'pi* is the *hachimaki*, created from a thin rectangular cotton towel (*tenugui*) about ninety centimeters long and thirty-five centimeters wide (fig. 4.92). It is rolled, folded, wound around the head, and knotted in dozens of different styles. Much attention is lavished on local traditions for tying the *hachimaki*, and each *chōnai* has an identifying style associated with a particular form of labor or character from folklore. Wearing the *hachimaki* also signals that strenuous effort will be exerted. *Tenugui* served as popular festival souvenirs and were

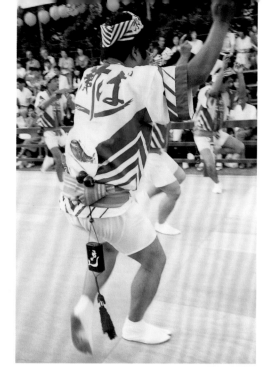

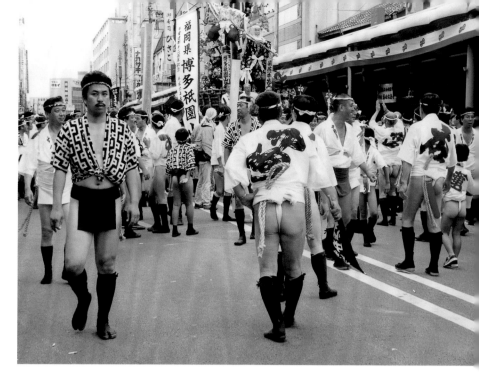

4.90 This dancer at Awa Odori, Shikoku Island, has secured his *inro* (tobacco case) with a gourd-shaped *netsuke* (toggle). His *uchiwa* (round fan) is tucked into his obi. Photograph by GGG, 1989.

4.91 (ABOVE, RIGHT) Hakata *chōnai* participants from Kyūshū Island celebrate Kyoto's twelve hundredth anniversary. They wear *fundoshi* (loincloths) beneath unbelted *ha'pi* knotted jauntily at the wasit. Their footgear resembles that of couriers and porters of the Edo period and consists of black *zori* and leggings. Their goal of serving the *matsuri* with honest effort is made clear by the functional rope accessory that hangs at each man's waist. Photograph by GGG, Otanjōbi Matsuri, Kyoto, 1994.

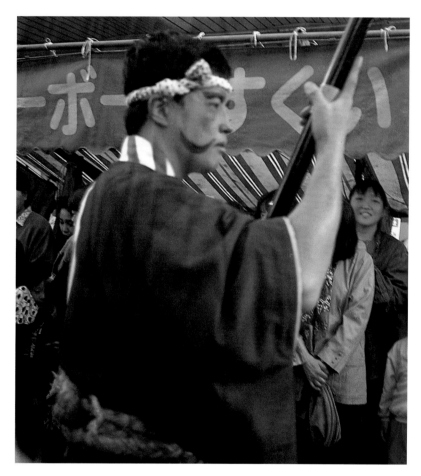

sold or given away at stands. They were stencil-resist dyed or printed with whimsical designs related to the festival (figs. 4.93–4.95).

Some festival groups use the *tenugui* to form simple but effective masks (see fig. 4.95). The wearer leaves a large section of the cotton towel untwisted and allows it to cover the lower portion of the face or the forehead, then tightly twists the rest of the cloth into a cord to secure the "mask" around the head. Awa Odori Matsuri in Tokushima, Shikoku Island, was particularly renowned for imaginatively shaped and tied *hachimaki* and masks created with *tenugui*. Their celebrants managed to coordinate humorous facial expressions suggestive of typical occupational headbands or reminiscent of a character from folklore.

4.92 The *hachimaki* tied around the head of this celebrant at Tenjin Matsuri implies single-minded effort and sincere dedication. This man, wearing a *ha'pi*, has just assisted *yamabushi* (members of a Buddhist mountain sect) in erecting a gigantic *haraigushi* (a cluster of sanctified papers) in the middle of a busy street. Photograph by GGG, Ueno-shi, Mie Prefecture, 1991.

4.93 Headband (*hachimaki*),
Showa period. Cotton, printed.
L: 98 cm. Private collection.

This *hachimaki* is decorated with
motifs of Hyottoko, a foolish
country character, and his wife,
Otafuku. Together the pair
function as fertility symbols.

4.94 Assorted headbands
(*hachimaki*), Showa period.
Cotton, printed. L (of longest):
92 cm. Private collection.

4.95 Mem furyū Matsuri dancers
at Ariake-cho, Saga Prefecture,
wear *hachimaki* and sunbonnets
to evoke Hyottoko, a foolish
country character who along with
his wife, Otafuku, functions as a
fertility symbol. Photograph by
David Mayo, 2000.

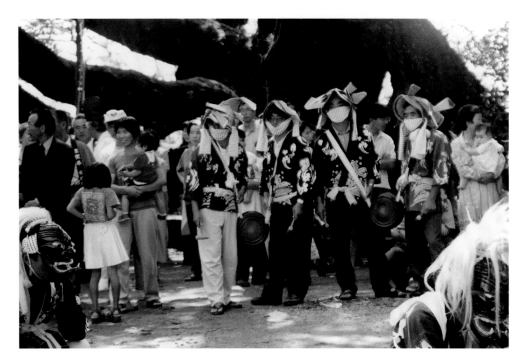

4.96 (OPPOSITE, LEFT)
Mr. Hatanaka Kinya in his design
studio. Photograph by GGG, 1991.

4.97 (OPPOSITE, RIGHT) Festival
jacket (*ha'pi*), Showa period.
Cotton, resist-dyed. L: 63 cm.
Private collection.

This is a classic *matsuri ha'pi*
of dark blue indigo-dyed cotton
accented in red and inscribed in
white. The character (*kanji*) in red
on the back of the jacket refers
to pine needles and is the name
of a neighborhood.

Interview with a Ha'pi Designer

In 1990 I had the opportunity to interview Hatanaka Kinya (fig. 4.96), chairman of the Hatanaka Hanten Shōten in the Kanda district of Tokyo. Several months to one year before a *matsuri*, he meets with festival organizing committee leaders in his studio to review designs. He is particularly involved with the three large Tokyo festivals in the Kanda, Ueno, and Asakusa districts.

Mr. Hatanaka explained that four main types of inscriptions appear on *ha'pi*: crests (*mon*), characters (*kanji*), numbers identifying the group, and stylized symbols typically based on elements in nature that have come to represent specific shrines. A typical example of the latter would be pine needles (fig. 4.97). In a few cases the symbols are based on man-made elements with sacred references, such as the multiple torii gates that front the Fushimi Inari Shrine near Kyoto (see fig. 4.89). In selecting the number identifying the group, four and nine are never used; four is *shin* in Japanese, which also means death, and nine is pronounced *ku*, which also means pain. The designs on the *ha'pi* may refer to the name of the host shrine, the name of a group of participants, the name of the town where the *matsuri* takes place, or a generic idea such as the *kanji* character or *hiragana* letters meaning *matsuri*.

Hatanaka explained that the number of crests in general use was limited, so it would be difficult to identify the vicinity from which a *ha'pi* originated solely on the basis of its crest, since there were duplications in various locales. Most often a character (*kanji*) or, in many cases, the lettering using the phonetic alphabet (*hiragana*) was added to fill out the information identifying the origin of a garment. He noted that the *katakana* alphabet, used for words of foreign origin, would never be used for *matsuri ha'pi*, as foreign lettering would be inappropriate for beckoning Japanese deities.

I inquired as to why I had so frequently encountered the character *tai* (big). He explained that the meaning was not "big" in this context, but that *tai* was used frequently because it served as a shorthand symbol for *dai go*, which means "group." In his opinion it was also commonly used because it was simple. Hatanaka noted that styles of inscriptions originated from long-standing traditions. Among the makers of *ha'pi*, the term for the identifying letter, character, or number inscribed on the *ha'pi* was *moji*. Kabuki *moji* would connote a style traditionally preferred by Kabuki actors, a basket (*kago*) *moji* meant a style that resembled a basket weave and was likely linked to the fishermen who supplied the Tsukiji fishmarket. The peony style (*botan*) *moji*, used as a crest or character whose petal-like edges undulated like those of the peony blossom, was particularly popular in the festival districts of Tokyo.

Terms have also evolved for the parts of the *ha'pi* among artisans, designers, and tailors associated with its production. The end of the sleeve is called *koi guchi* meaning carp mouth. The term *donburi*, or bowl, was used to describe the mid-section of a *ha'pi*.

In Hatanaka's opinion, "The districts of Kanda, Ueno, Fukugawa and Asakusa in Tokyo demand the most sophisticated lettering and motifs and are the most receptive to style changes in accord with fashion. This is in contrast to *ha'pi* produced for the countryside, where motifs are sometimes retained for several years, and designs are inspired by elements in nature."

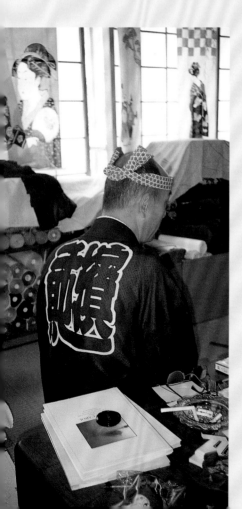

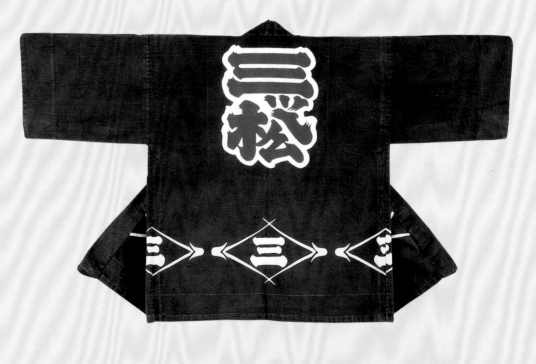

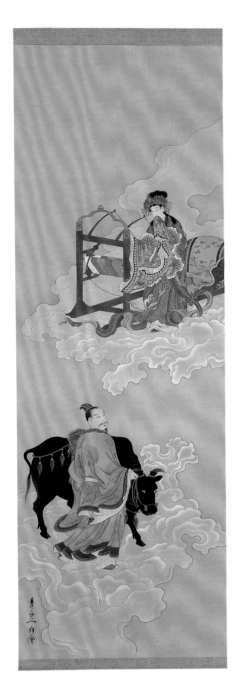

4.98 Suzuki Kiitsu (1796–1858). *Tanabata*. Hanging scroll. Color on silk. 110.9 x 39.3 cm. Collection of Joe and Etsuko Price.

This scroll depicts the theme of Tanabata Matsuri. *Tanabata* means "weaving loom," and the tale tells of a weaver-princess and her lover, a simple cowherd. Parted by her father, the king, and placed on either side of the Milky Way, the princess and her cowherd, are able to meet just once each year on the seventh night of the seventh month. They are aided by sympathetic magpies who spread their wings to create a bridge. In Japan Tanabata Matsuri became a celebration of romance, fertility, and poetry, as well as the textile arts.

YUKATA

The *yukata* is an unlined cotton kimono worn in the summer (figs. 4.98, 4.99a,b). Its name is derived from *yukatabira* (bathing *katabira*), a lightweight, blue-and-white unlined kimono traditionally worn after the bath to aid in drying off. Bath towels were unknown in Japan before the Meiji period (1868–1912), and bathers put on clean, dry *yukata* one after another until the body was satisfactorily dry. This explains an alternative name for the *yukata*, *minugui*, or body wiper. The cloth for *yukata* was originally woven of ramie or other bast fibers, but cotton has been preferred ever since it became widely available in Japan in the mid-nineteenth century. The natural absorbency of cotton made it ideal for the original bath-time function of the *yukata*. Cotton also had the advantage of readily accepting indigo dye, which permitted a wide range of patterning by a variety of techniques including *katazome, tsutsugaki, shibori,* and direct hand painting. Women dressed in *yukata*, which were sometimes sensuously draped or appeared partially damp and intermittently translucent, became a favorite subject for Edo period Ukiyo-e artists, and the *yukata* came to be perceived as innocently seductive, projecting a sense of ease, spontaneity, and guileless beauty.

4.99a (OPPOSITE, UPPER RIGHT)
Informal summer kimono
(*yukata*), nineteenth century.
Cotton, *katazome* resist-stenciled.
L: 132 cm. FMCH X82.1363;
Gift of Minoru Higa.

The overall stencil design
(*katazome*) on this *yukata* is
of chrysanthemums, a motif
thought auspicious and associated
with longevity. Designs anticipated
the coming season, and chrysan-
themums, an autumn flower,
would have been especially
appropriate as a symbolic antidote
to the summer heat.

4.99b The interior of the *yukata*
in figure 4.99a reveals multiple
patches. Patches were often
donated by family members
as a gesture of affection. They
frequently serve as a treasure
trove of information for the
textile historian.

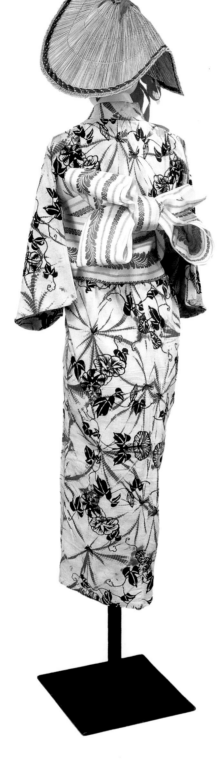

4.100a–c (A) Informal summer kimono (*yukata*), Meiji–Taisho period. Cotton, *shibori*-dyed and stenciled. L: 120 cm. Collection of the Asian Cultural Arts Trust. (B) Summer obi, early Showa period. Silk, grosgrain weave. L: 245 cm. FMCH X91.2114a; Gift of Catherine E. and P. Lennox Tierney. (C) Sunbonnet, Showa period. Straw and silk ribbon. H: 24 cm. Collection of the Asian Cultural Arts Trust.

On this *yukata*, an indigo-on-white, resist-dyed pattern produces elusive morning glories that seem to appear and disappear amidst vines and leaves. The obi is made of silk grosgrain brocade. This weave is said to have originated in the city of Hakata on Kyūshū Island. The brocade is deemed ideal for securing obi on women's *yukata*. Obi are usually dyed a vibrant hue, which is striking against the blue and white of the *yukata*. The sunbonnet shown here was collected on Sado Island.

4.101 A young woman, flushed with the heat, recuperates at home on the cool tatami after attending morning festivities at the Tanabata Matsuri procession. Photograph by GGG, Sendai, Miyagi Prefecture. 1989.

Before modern plumbing allowed the installation of private bathtubs (which became widespread in Japan only late in the twentieth century), public bathhouses were important centers of social interaction. Beginning in the Meiji period, public bathing became increasingly segregated by gender in most places. Men and women in their respective bathhouses lingered in their *yukata* and chatted, enjoying the sensation of recovering quietly from the hot bath while spending relaxing moments among neighbors. These pleasures were an especially welcome social interlude in isolated rural communities. The *yukata* was also considered usual attire for promenading to the neighborhood public bath and back home again (fig. 4.100a–c).

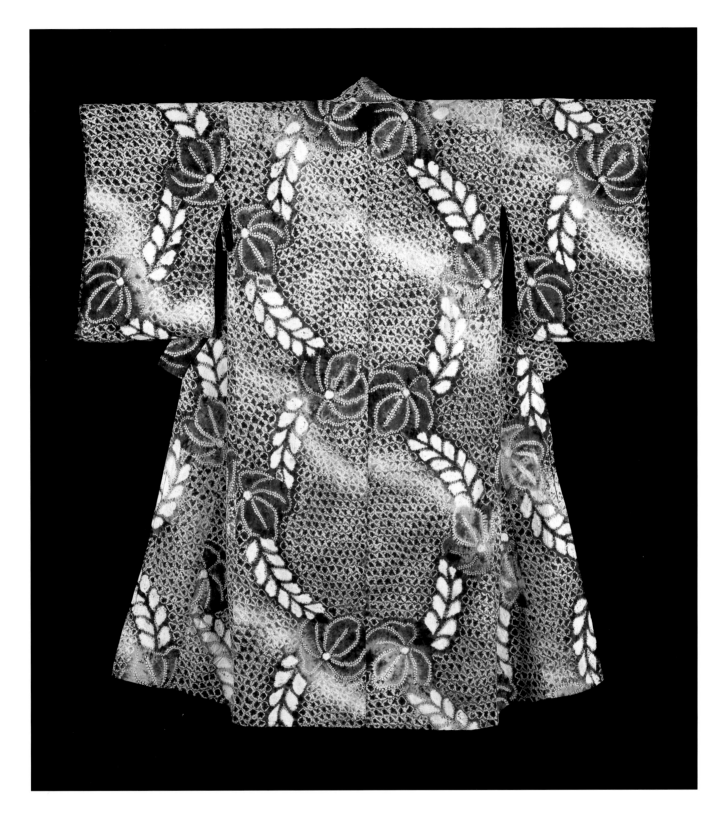

In former times, it was also customary for people to water their gardens in the late afternoon or early evening of hot summer days, to enjoy the onset of cooling breezes (figs. 4.101–4.104). Family members would then take their hot baths, dress in *yukata*, and sit down for a cool summer meal. Afterward, they might stay outside and watch the fireflies, gaze at the moon and stars, or go shopping in the many small shops that run through the main street of every neighborhood in Japanese towns. Thus *yukata* came to suggest the end of the workday and the beginning of a period of leisure. In the dense heat of Japanese summers, it was very appealing to don a fresh crisp garment. In order to be considered inviting, *yukata* were meticulously laundered

4.102 Informal summer kimono (*yukata*), Meiji period. L: 148 cm. Cotton, *shibori* tie-dyed and stenciled. Collection of the Asian Cultural Arts Trust.

Wisteria vines and leaves were *shibori* dyed in a descending double spiral on this *yukata*.

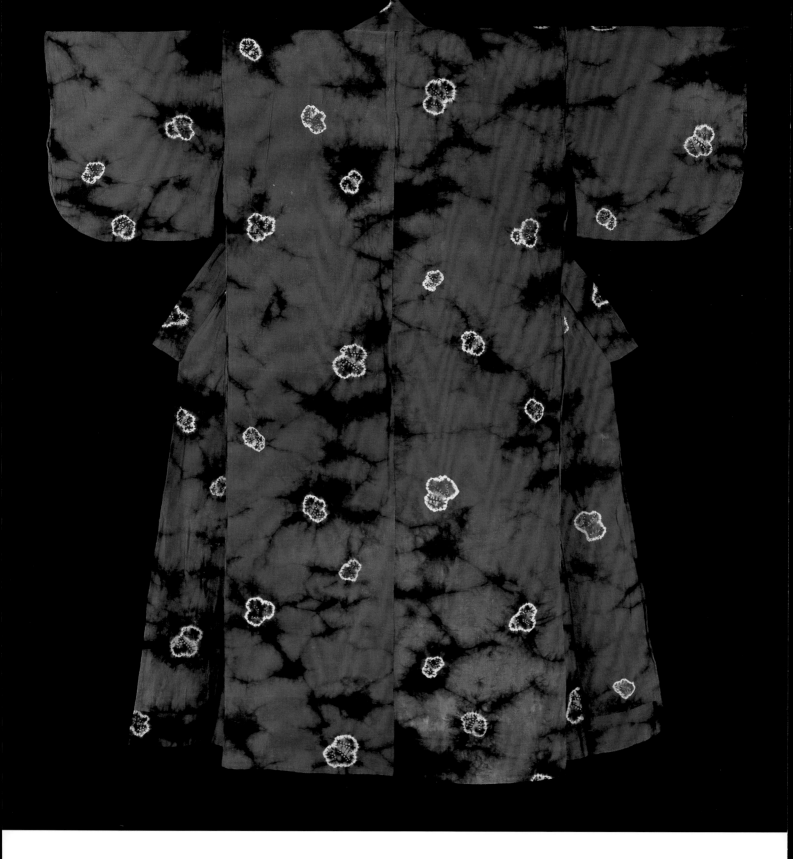

4.103 Informal summer kimono (*yukata*), Meiji period. Cotton, *shibori* technique. L: 136 cm. Collection of the Asian Cultural Arts Trust.

Raindrops on a rich blue indigo ground were deftly created on this *yukata* using an irregular *shibori* technique. The motif was thought to evoke a sensation of coolness.

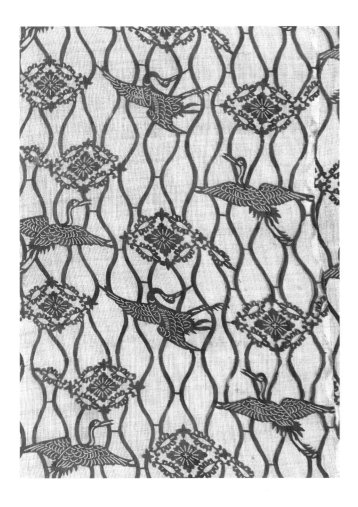

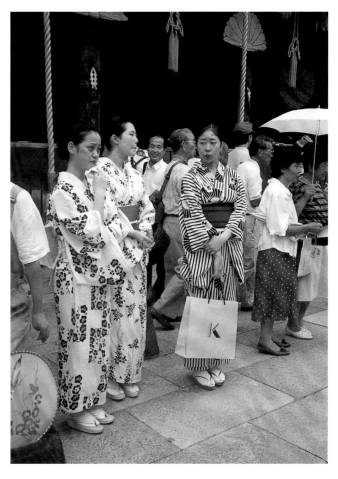

daily, pressed, and often starched to make them stand away from the body. Fabric clinging to the body in summertime was considered exhausting to the wearer and unattractive to the viewer.

Yukata also served as cool and comfortable loungewear at home and were sometimes seen at informal social occasions. Rural hot spring resorts—as well as urban counterparts trying to create a rural atmosphere—often offered their guests *yukata*. These would be inscribed with the name or the logo (*mon*) of the resort or with a special design associated with it.[2] In this setting, the *yukata* served to transform the mood of the patrons and to act as highly visible advertising when the guests happened to cluster in the gardens or venture out to shops on nearby streets. By the mid-twentieth century, *yukata* had become so popular that they were, and still are, commonly worn in public anytime the weather was warm. *Yukata* however, were never worn to work. They appear especially charming when seen on clusters of young women indulging in window shopping (fig. 4.105). The *yukata* has come to be considered informal but chic, comfortable yet as alluring in its own way as a gorgeous silk kimono.

Yukata are normally dyed in some combination of indigo and white (figs. 4.106, 4.107), but young women sometimes favor *yukata* with accents of red or yellow, worn with a bright red or yellow silk, grosgrain *han habi obi* (half-width obi); see figure 4.108. Men also wear *yukata* in public, but they are dyed in darker shades of indigo, and their designs are generally small in scale. Bright colors on *yukata* are considered signs of feminine vivacity.

4.104 Fragment of an informal summer kimono (*yukata*), late Edo–early Meiji period. Ramie and silk, *katazome* resist-stenciled. L: 155 cm. Collection of the Asian Cultural Arts Trust.

This is a fragment of a once-elegant *yukatabira* woven of ramie and silk with *katazome* resist-stenciling of alternating cranes and diamond lozenges on a ground of undulating waves.

4.105 Young women assemble in Kyoto's downtown shopping district during a break in the preparations for Obon Matsuri. Photograph by GGG, 1991.

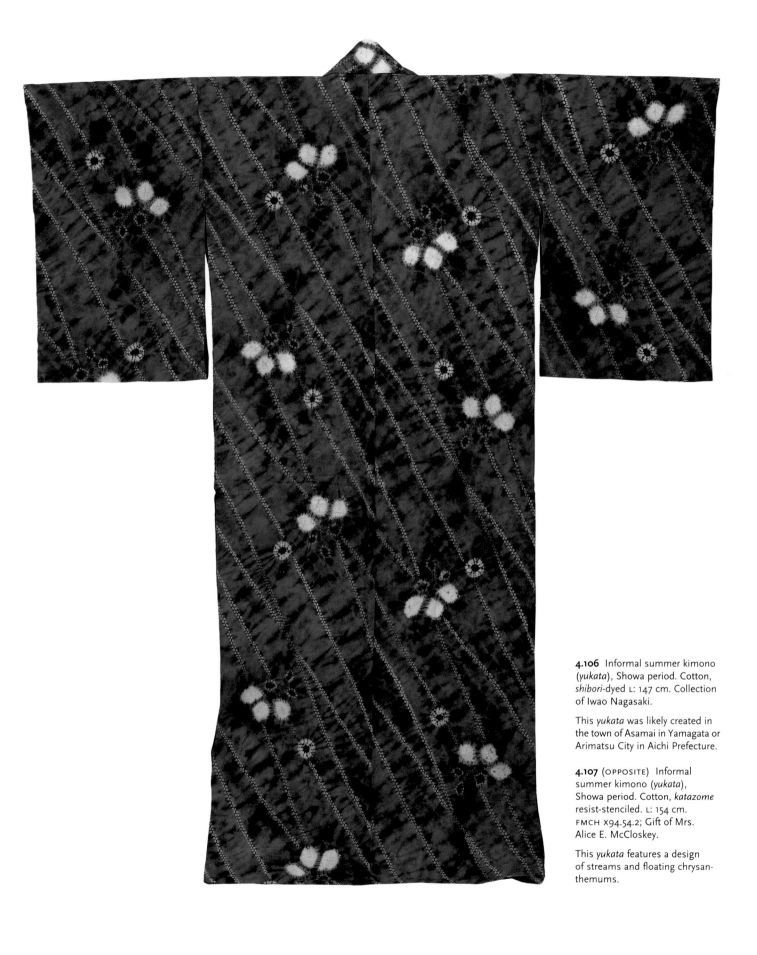

4.106 Informal summer kimono (*yukata*), Showa period. Cotton, *shibori*-dyed ʟ: 147 cm. Collection of Iwao Nagasaki.

This *yukata* was likely created in the town of Asamai in Yamagata or Arimatsu City in Aichi Prefecture.

4.107 (OPPOSITE) Informal summer kimono (*yukata*), Showa period. Cotton, *katazome* resist-stenciled. ʟ: 154 cm. FMCH X94.54.2; Gift of Mrs. Alice E. McCloskey.

This *yukata* features a design of streams and floating chrysanthemums.

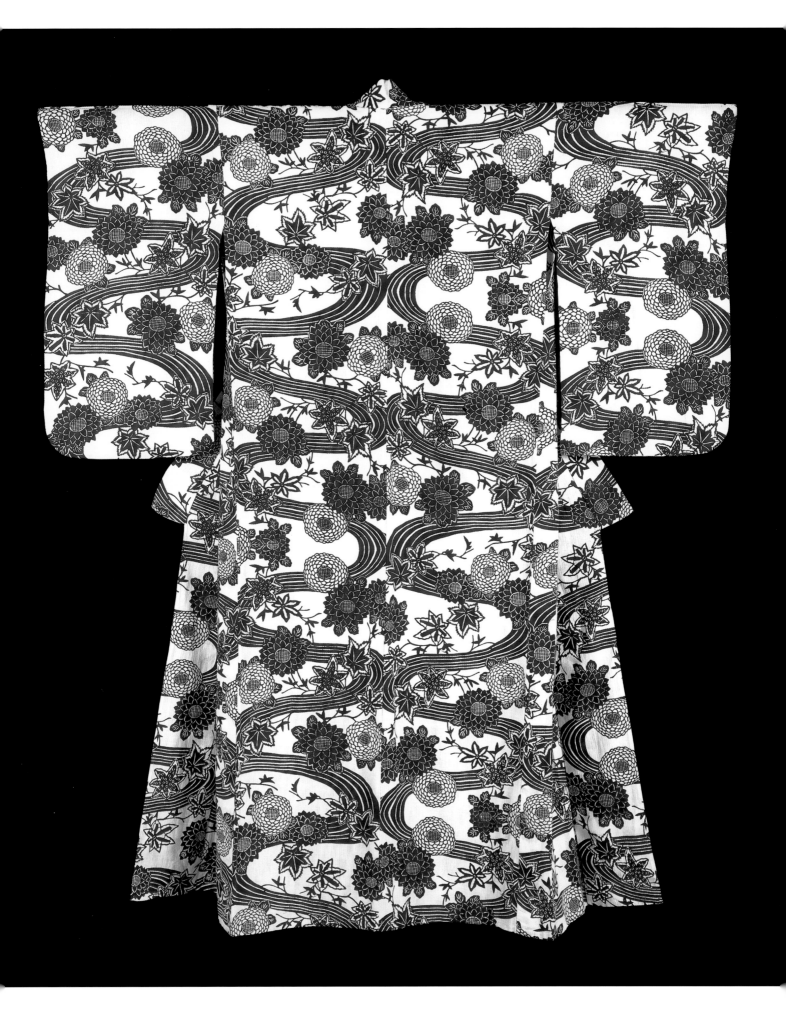

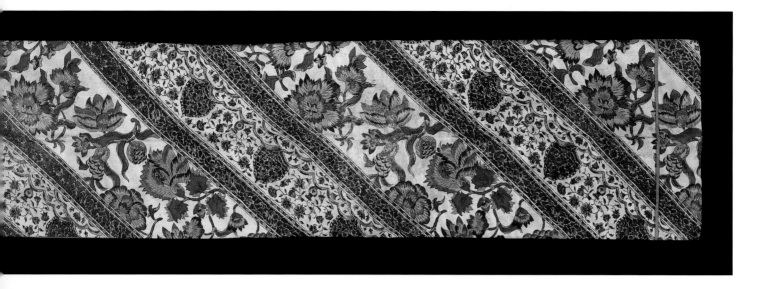

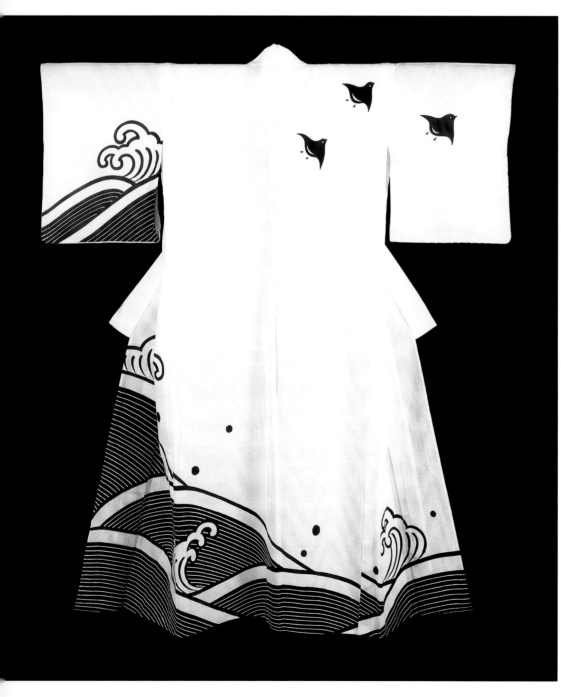

4.108 Obi for an informal summer kimono (*yukata*), Edo–Meiji period. Cotton, *sarasa*, block-printed. L: 300 cm. FMCH X86.4419; Anonymous Gift.

This richly designed cotton obi of Indian *sarasa* would have been appropriate for a *yukata* or silk kimono. This fabric was produced in India and imported as early as the sixteenth century; it was considered exotic and fashionable. During the Edo period, however, restrictive laws prohibited its importation, and the colorful, popular *sarasa* designs were imitated with Japanese block prints. During the Meiji period, imported fabrics could again be seen on the streets.

4.109 Informal summer kimono (*yukata*), Showa period. Cotton, printed. L: 155 cm. Collection of the Asian Cultural Arts Trust.

This *yukata* reflects the popularity of waves and plovers (*chidori*) as a motif considered to be refreshing and cooling. This garment was probably created as a *soroye-yukata* (group uniform) for a troop of festival dancers or musicians.

4.110 Informal man's summer kimono (*yukata*), 1994. Cotton, stenciled. L: 135.5 cm. Collection of the Asian Cultural Arts Trust.

This is a *soroye-yukata* (group uniform) worn by celebrants from Minami Kannon Float Association, Gion Matsuri, Kyoto. Group *yukata* designs were essentially retained in the various Gion Festival Neighborhood Float Associations (Gion Matsuri Yamaboko Rengokai) with some features updated or altered each year. If a period of bad times precedes the festival, serious discussion will be held to decide upon a design more pleasing to the *kami*.

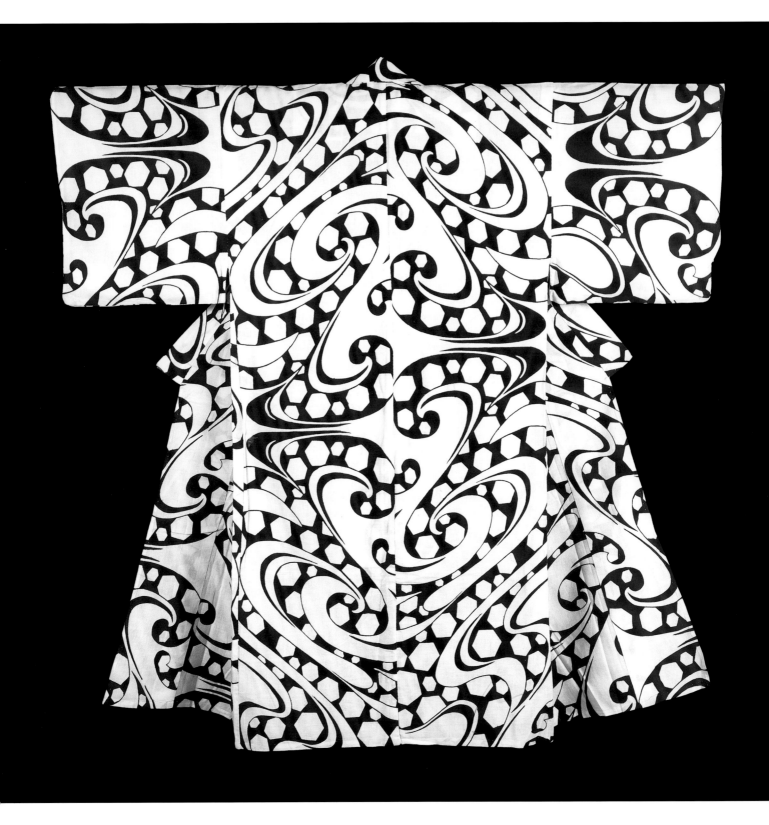

Due to its light weight and its appropriateness for relaxation and warm weather, the *yukata* also came to be associated with *matsuri*, many of which were held in the summer months. Men and women of all ages turned out in indigo-and-white *yukata* for these *matsuri* (figs. 4.109–4.111). Until the mid-twentieth century, *yukata* were, in fact, the most common type of garment seen at summer *matsuri*. Their popularity on these occasions has persisted in certain contexts, and even today folk dancers at summer *matsuri* don *yukata* for comfort and because of their association with summertime festivities (figs. 4.112, 4.113).

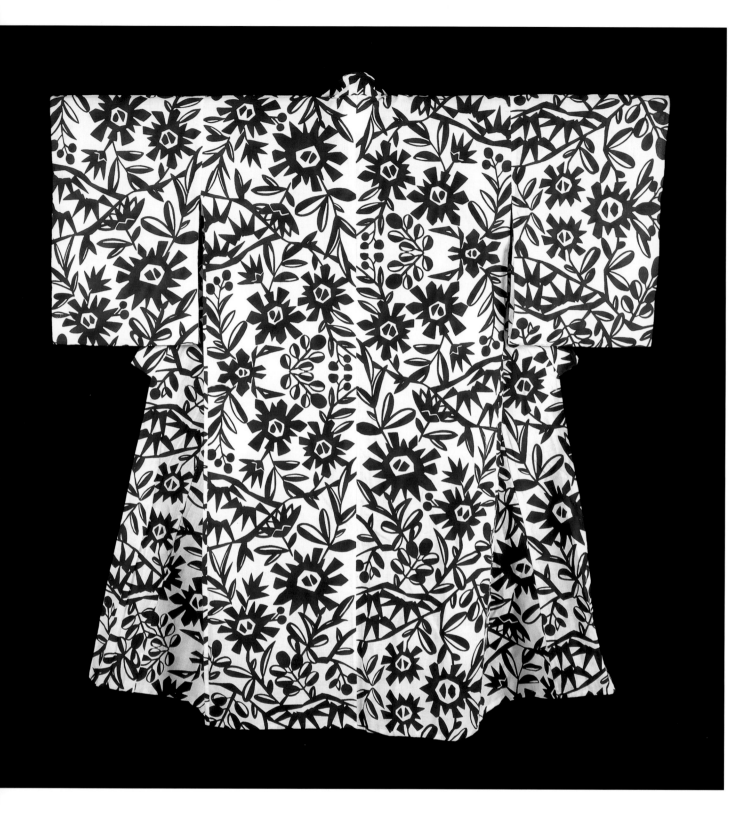

4.111 Informal summer kimono
(*yukata*), Showa period. Cotton.
L: 139 cm. FMCH X94.54.3a;
Gift of Mrs. Alice E. McCloskey.

This eccentric design of full-blown
blossoms on this *yukata* captures
matsuri spirit.

4.112 This youngster wears a *yukata* with a *shibori*-dyed silk obi in preparation for joining the Obon celebration at a park during Takamatsu Matsuri. Spontaneous Bon dancing is usually led by a local folk dance performer, and all bystanders are encouraged to join the circle. Photograph by GGG, Shikoku Island, 1989.

4.113 A contestant in the "Most Beautiful Yukata Contest" at the Obon festivities in Kyoto. Photograph by GGG, 1991.

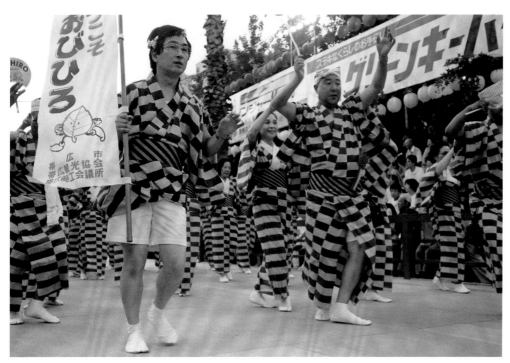

4.114 In the last decades of the twentieth century, contemporary designs in a range of unconventional hues appeared at *matsuri*. Here unusual designs appear at Awa Odori Matsuri. Awa Odori is an exhilarating experience for the casual visitor; its spirit, song, and array of designs are mesmerizing and unforgettable. Photograph by GGG, Tokushima, Shikoku Island, 1998.

Prior to the beginning decades of the twentieth century, *yukata* were primarily made and dyed at home. Eventually, however, they came to be recognized as a vehicle for displaying the talents of professional dyers, especially because the single plane of fabric—broken only by a slender obi—provided an ideal canvas for uninterrupted design. Indigo blue designs are perceived as cooling in Japan, and, as noted, the majority of *yukata* are dyed in shades of it. Since *yukata* are informal or recreational wear, the patterns are often playful in order to promote a relaxed atmosphere. This also makes *yukata* ideal for the ordinary participants in *matsuri*—a time of relaxation and relief from the formality of most traditional Japanese clothing (fig. 4.114).

4.115 A troop of *shamisen* players herald the coming of Awa Odori Matsuri. They wear *geta*, *tabi*, straw sunbonnets, and a cotton *yukata* over a revealed under-kimono (*juban*) of pink silk. Their obi are secured in place with a pink *obiage* cord. *Yukata* hiked up over the knees or sometimes dropped off one shoulder—by either sex—indicate the intention to dance unrestrainedly. Photograph by GGG, Tokushima, Shikoku Island, 1989.

4.116 Abundance in every form is welcomed at *matsuri*. Sumo wrestlers often play a prominent role in processions and are highly sought after as they are thought to be endowed with supernatural powers. A *yukata* serves this sumo wrestler as a dance robe. It is worn with white *tabi* and a *hachimaki* (headband). Photograph by GGG, Awa Odori Matsuri, Tokushima, Shikoku Island, 1989.

The motifs on *yukata* are suggestive of cooling and often involve water in the form of waves, spray, floating clouds, or raindrops. Shellfish forms evoke the sea and its abundance as well. Designs may also be whimsical, with references to comic figures in folklore or literature. Dolls, other toys, and amusing inscriptions in calligraphic styles may be printed on *yukata*. Seasonal designs drawn from nature have always been favorites in Japan and these are popular for *yukata* fabric as well. Various botanical motifs (such as chrysanthemum or pine for longevity and cherry blossom for happiness are considered able to counteract the dangers traditionally presented by hot weather and dense stale air.

In former times *yukata* designs for *matsuri* would be agreed upon by members of a community. Each family would have them made in the specified manner, or a dyer might be engaged to create uniform *yukata* (*soroye-yukata*) for all those participating in the *matsuri*. Neighborhoods competed to create the most intriguing and attractive *yukata* design. This competition arose most often in preparation for summer *matsuri*, especially the Obon Festival, which community groups practiced for months in advance. For those not dancing at the *matsuri*, the *yukata* showed to advantage when joining in the procession, standing in the audience, or shopping in the hundreds of nearby stalls.

Various accessories are worn with *yukata*, including sunbonnets for women and *geta* for both sexes (figs. 4.115, 4.116). Specially constructed headdresses are worn at some *matsuri*. These often involve an apparatus atop a hat that holds streamers, sculptures, lanterns, or other paraphernalia. As noted earlier, the obi worn with cotton *yukata* are smaller, simpler, and softer than those worn with silk kimono. The preferred type of obi is made of silk grosgrain and is called a Hakata obi, after the name of the city where this type of cloth was first woven. Obi for *yukata* are also often referred to as *hanhaba*, meaning a half-width obi. The silk, dyed bright red or yellow, is sometimes brocaded with a simple design. The obi thus provides color and visual interest in addition to keeping the lightweight *yukata* bound snugly around the waist. Men often wear a *kaku obi* (stiff obi) or a soft silk *shibori*-dyed *heko obi* (soft obi), with the

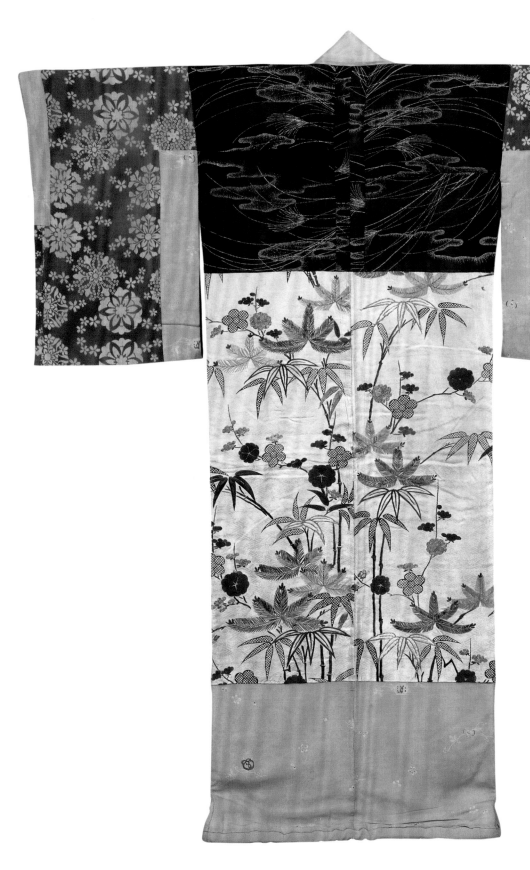

4.117a *Kasane* (layered under-kimono), Edo-period patches. Silk, patchwork. Collection of Iwao Nagasaki.

During Bon dances in Aichi Prefecture, the *kasane* serves as an outer kimono. Ordinarily, however, *Kasane* were worn as part of a set beneath an outer silk kimono to provide greater warmth as well as an opportunity to use luxury fabrics. These patchwork *kasane* were one way ordinary people in the Edo period could flaunt luxurious silk fabrics and costly hand-decorating techniques.

design resisted in white against a dark blue silk ground. Frequently a carved or decorated toggle (*netsuke*) of lacquered wood or ivory would dangle from the *obi*, securing a decorated tobacco case (*inro*) or a gourd (a symbol of plenty and fecundity). A flat, round paper fan, or *uchiwa*, would be thrust through the back of the *obi* as well, convenient for grasping during a dance or for waving during the summer heat (figs. 4.117a,b, 4.118).

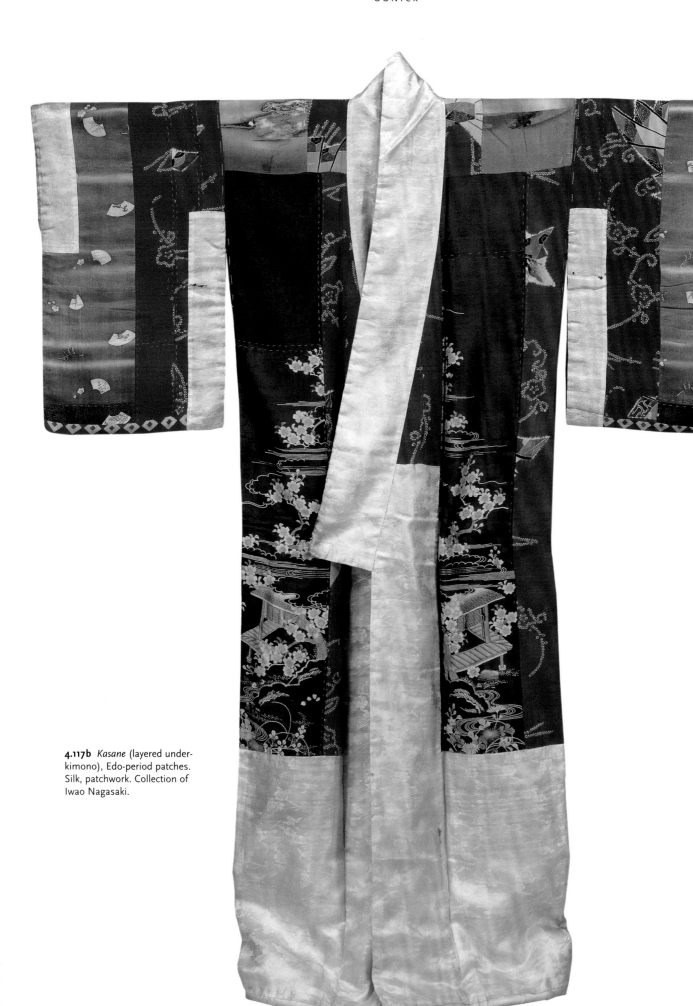

4.117b *Kasane* (layered under-kimono), Edo-period patches. Silk, patchwork. Collection of Iwao Nagasaki.

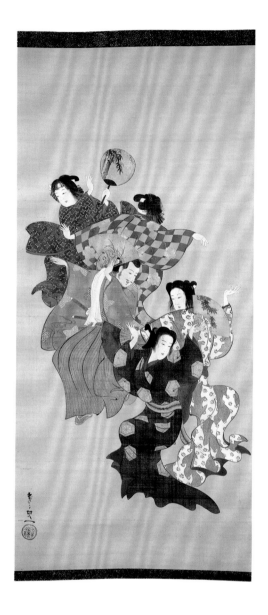

4.118 Suzuki Kiitsu (1796–1858). *Dancing.* Hanging scroll. Color on silk. 105.9 x 49.7 cm. Collection of Joe and Etsuko Price.

The procession of dancers in a variety of informal kimono designs reflects the joy and visual splendor of festival dance. The *uchiwa*, or festival fan, and the dancers' movements suggest that a Bon dance is underway (see fig. 7.1).

4.119 Kobayashi Kiyochika. *The Ryōgoku Fire Sketched from Hamachō,* January 26, 1879. Color woodblock print. Image: 21.5 x 34.7 cm; paper: 24.9 x 36.9 cm. Los Angeles County Museum of Art, Gift of Carl Holmes. Photograph ©2002 Museum Associates/LACMA.

This Ukiyo-e woodblock print depicts a blaze that occurred on January 26, 1879, at Ryōgoku, a bridge in Tokyo. The man running toward the blaze wears a *ha'pi* coat with an inscription that reads *daiku* (carpenter). Many ordinary firemen (*machi bikeshi*) were conscripted from the ranks of construction workers, who were used to climbing scaffolds and tearing down buildings.

GARMENTS FOR FIRE

Fires were particularly devastating in Japan, as houses were built of wood and paper (fig. 4.119). Centrally located indoor stoves provided the only source of cooking and heating fires. Combustible material abounded in all directions, and fires spread rapidly. Clothing of silk and cotton was highly flammable, and fleeing a fire was made difficult by the long, voluminous garments worn by both sexes. In Edo quick escape from conflagrations was also prohibited by the helter-skelter arrangement of crowded streets and buildings. Finding one's way in the city was difficult. The irregular roads had no names, which is still true in many cases today. After Edo was established around 1600 by the first Tokugawa shogun, Iyeasu, it developed in rapid bursts, without an overall master plan or regular street grid (Nouët 1990, 46).

The ravages of an Edo fire were vividly described by Hendrik Deoff, a Dutchman who spent two decades in Japan. As head of the Dutch East India Company warehouse in Nagasaki, Deoff had occasion to travel to the capital, and on a visit to Edo in 1806, he reported:

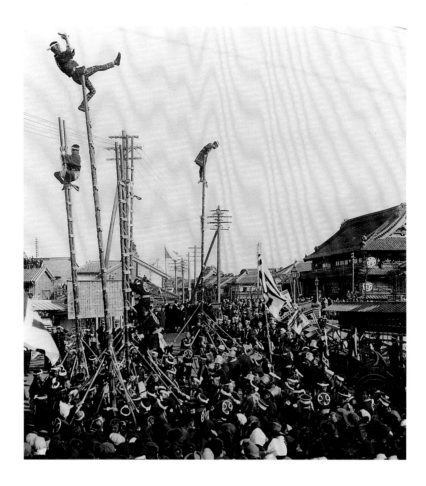

4.120 Photographer unknown. *Fire Brigade Performance at Yoshida Bridge*, Yokohama, circa 1890. Print from a lantern slide. Photograph courtesy Peabody Essex Museum, neg. no. A9043. This photograph shows firemen performing acrobatics (*dezomichi*) atop high ladders to showcase their bravery and agility and to display their fire-fighting techniques. Their comrades below steady the ladders with their long "bird beak" hooks (*tobiguchi*).

We learnt that a fire had started about two leagues from our locality. We paid scarcely any attention to the news for fires are so frequent in Edo. Every beautiful night has its fire. By contrast, a foggy night is a matter for rejoicing. But the flames continued to come closer and at 3 o'clock four houses caught fire quite near us. We went down into the street to see what was happening. Everything around us was burning. It would have been dangerous for us to flee in the same direction as the wind. By taking various side streets we succeeded in reaching an open space behind the fire. This field was bristling with the flags of the princes who had left the palace with their wives and children. We followed their example and planted the Dutch flag on the spot which we wanted to keep. We could now see the whole fire. I have never seen anything so terrible in my life. The horror of this sea of flames was increased by the crying and moaning of the women and children as they fled.... The next day, about midday, heavy rain put out the fire. We learnt that 37 of the daimyo's palaces had been destroyed and that 1,200 people had perished, including a granddaughter of the Prince of Awa. [Nouët 1990, 160–61]

The members of highly organized fire-fighting companies wore special garments according to their rank. Fire wardrobes originated in the need for bodily protection and quick identification. Multiple Ukiyo-e prints created during the Meiji and Taisho periods document the firemen's unique and legendary place in Edo, where they were admired as chivalrous heroes who strove to rescue hapless victims. The firemen's credo was "duty, sympathy, and endurance." Their appearance reflected their cocksure manner as they approached a raging blaze and their unflinching determination in the face of cataclysmic destruction. Japan's painters and early photographers were inspired by the dramatic lives of the firefighters (fig. 4.120). Edward Morse, an American who stayed in Japan in the 1870s and 1880s, reported:

I again witnessed the bravery and heat endurance of the firemen. At
a distance of at least three hundred feet from one building the heat was
so intense that it was impossible to look at the fire except through the
openings between my fingers: yet the firemen were within ten feet of the
blaze, and only retreated when their clothing was actually in flames, and
even this condition they did not notice until streams of water were directed
on them. [They] wore padded garments and the water pumps functioned
more as a device for wetting down than actually dousing the blaze. It was
the primary job of firemen to dismantle the burning structures as rapidly
as possible in order to prevent the fire from spreading. Long hooks were
used for this purpose to tear down the walls and roofs, collapsing the
structure and removing it from the path of the fire. [Fetchko and
Hickman 1977, 69]

After 1857, pioneer photographers repeatedly recorded the firemen in action, as
well as documenting their striking wardrobes and their daring acrobatics at *matsuri*.
Souvenir portraits of firemen and their activities in Edo were purchased by Japanese,
as well as foreign travelers, as souvenirs of the vibrant and brash society of Edo
(renamed "Tokyo" after the Meiji Reformation of 1868).

Companies of firemen were also familiar sights to the citizens of Edo on their two
special festival days, January 6, when they appeared as part of New Year's festivities,
and again on May 25, at the Firemen's Memorial Day Matsuri. On these occasions,
and sometimes at local shrine festivals as well, firemen promenaded in their fire
coats. The term *fire coats* actually refers to a variety of garments worn by firefighters,
including those of ordinary townspeople and those worn by the privileged classes who
guided the efforts of those ranked below. The most renowned of the garments associ-
ated with firefighters' festivals, however, were the elaborately hand-painted (*tsutsugaki*)
and hand-quilted (*sashiko*) reversible firemen's work coats (*hikeshi banten*), worn by
some of the higher-ranking firemen among *chōnin* (ordinary townspeople) and those
fortunate enough to have received them as gifts. These coats originally developed as
functional fire-fighting attire during the Edo period, although their fame is based on
their appearance at celebratory events, at which time they were worn with their inner
surface decoration revealed (figs. 4.121, 4.122). The painted firemen's coats reflect the
style and vitality associated with the Edo period. They possess the quality of *iki*, loosely
translatable as "chic," which is particularly identified with that time. They are also
regarded as particularly admirable examples of the strong collaboration that existed
between artisan and client in Edo. After the Edo period, they were often referred to
as *shōbō*, derived from the first part of the term that eventually came to be used for
the fire-fighting service itself, *shōbōgumi*.

Some of the utilitarian coats, made of several *sashiko*-quilted cotton layers,
were worn at parades. The coats were tailored to varying lengths determined by the
personal taste of the client, with short lengths seemingly to be more popular than
long. The back of a coat was made of two joined panels. There were no shoulder
seams, the same length of fabric going over the shoulder and serving to cover the
front and back of the body.

Sashiko for firemen's coats was created with three layers of cotton stitched
together with a running stitch (fig. 4.123). The stitches were placed in parallel vertical
rows, approximately one centimeter apart. The thread used was composed of two
strands of cotton, and it was visible, creating an intriguing striated surface. The dense

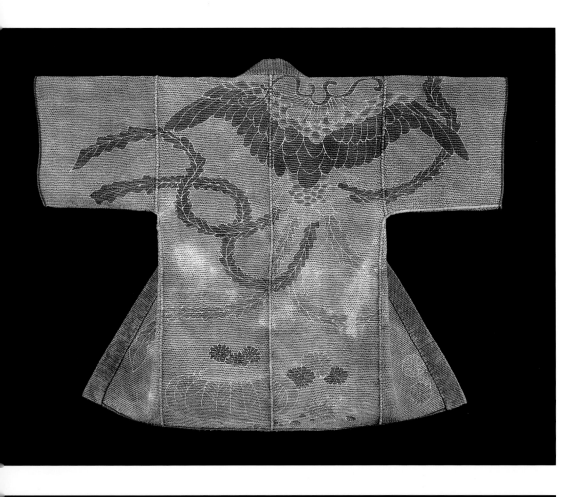

4.121 Interior of a fireman's coat, Meiji period. Cotton, *sashiko*-quilted, *tsutsugaki*-painted.
L: 97 cm. Private collection.

A winged cape (*hagoromo*) worn by an angel (*tennyo*) is depicted on this firemen's coat from the early decades of the twentieth century. In the well-known Noh play *Hagoromo*, an angel visiting earth leaves her feathered cape by the shore while she goes bathing. It is noticed by a young fisherman who picks it up. The *tennyo* begs the fisherman to return her cape. He agrees but only after she performs a heavenly dance. Once she has retrieved her winged cape, the angel flies away forever (Joya 1960, 187). Fantastic tales were popular subjects for paintings featured on the interior of firemen's coats.

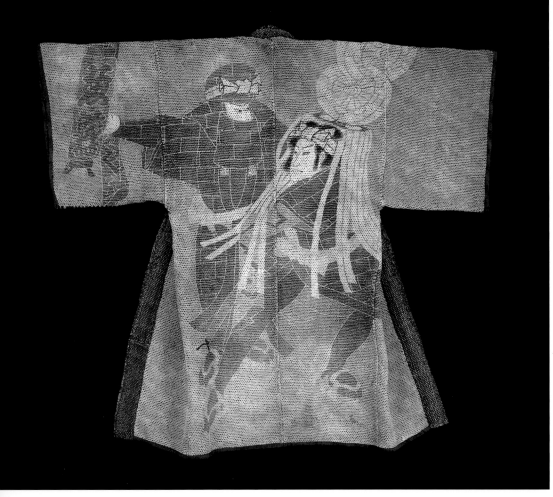

4.122 Interior of a fireman's coat, late Edo–Meiji period. Cotton, *sashiko*-quilted, *tsutsugaki*-painted.
L: 118 cm. FMCH X84.626; Gift of Dr. and Mrs. David Rosenbaum.

The painting on the interior of this coat shows a fireman planting his group's *matoi* (standard) on the rooftop of a burning building. His fellow firefighter swings a lantern aloft to assist the endeavor.

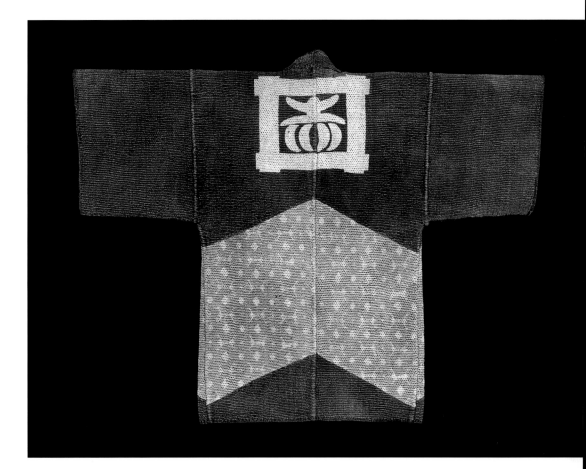

4.123 Fireman's coat, Meiji period. Cotton, *sakshiko*-quilted, *katazome*-stenciled. L: 89 cm. Collection of Sandy and Kenneth Bleifer.

This fireman's coat bears a crest that has been variouly identified as a well frame enclosing a vegetable, a rice measure enclosing a pumpkin (*kabocha*), or a stylized version of the character *aka* meaning "red." The rows of hollow diamond-shapes stenciled in a rosy shade (probably brighter originally) are a Buddhist motif known as linked jewels (*shippō*).

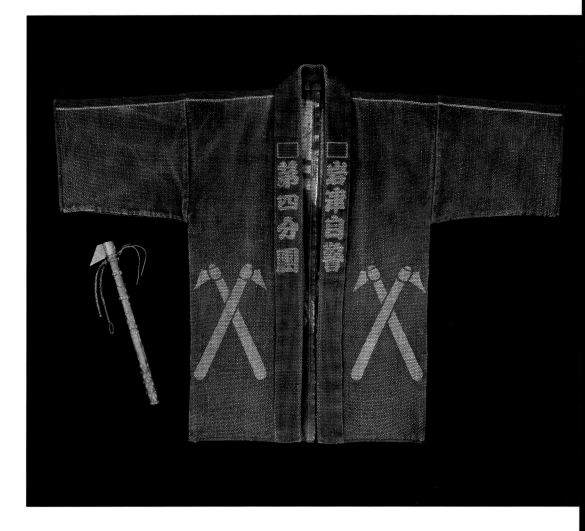

4.124a,b (A) *Tobi* (fireman's tool), Meiji period. Iron, wood, and leather. L: 39 cm. FMCH x88.1245; Anonymous Gift. (B) Firecoat, Meiji–Taisho period. Cotton, exterior: *katazome* stencil-resist dyed; interior: *tsutsugaki*-painted. L: 87.5 cm. FMCH x82.1361; Gift of Minoru Higa.

This fireman's tool was called a *tobi*, short for *tobiguchi*, meaning "bird's beak," which it was thought to resemble. The firemen who used the *tobi*, along with carpenters, were also called *tobi*. A *tobiguchi* on a long pole measured 1.5 meters in length and was used to tear down buildings in the path of the blaze, the primary method of containing a fire during the Edo and Meiji periods. This coat's exterior, which would have been seen during actual fire fighting, is stenciled with *tobiguchi*. The motifs in this case refer to the number of the fireman's company as well as to his profession. The interior of this coat is painted with waves and spray and might have been revealed during firemen's processions.

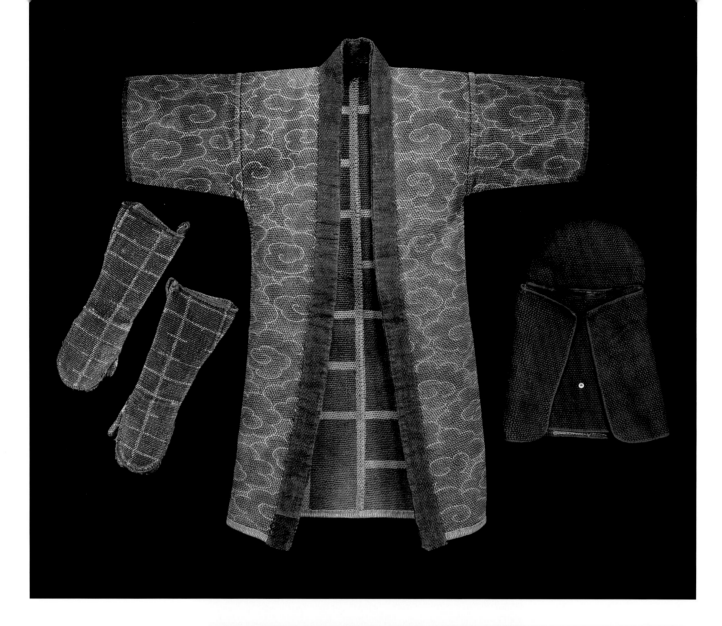

4.125a–c (A) Fireman's coat, late Edo–Meiji period. Cotton, *sashiko*-quilted. L: 117 cm. FMCH x82.1385a; (B) Firemen's gloves, Meiji period. Cotton, stenciled and padded. L: 46 cm. FMCH x82.1385c,d; (C) Fireman's hood with visor, Meiji period. Cotton, *sashiko*-quilted. H: 56 cm. FMCH x82.1385b. Objects A-C: Gift of Keigi Higashi.

The design of drifting rain clouds, a fortuitous motif for men struggling to contain a raging blaze, was stenciled on this *sashiko* coat but would have been worn on the inside during active fire fighting. The exterior tile motif would have provided important identifying information to comrades who could "read" the number of tiles that created the pattern. For a back view of this coat, see figure 6.2a.

4.126 Interior of fireman's hood and mantle shown in figure 4.125c. The dragon, who was thought to control thunder and rainfall, was considered the friend of firemen.

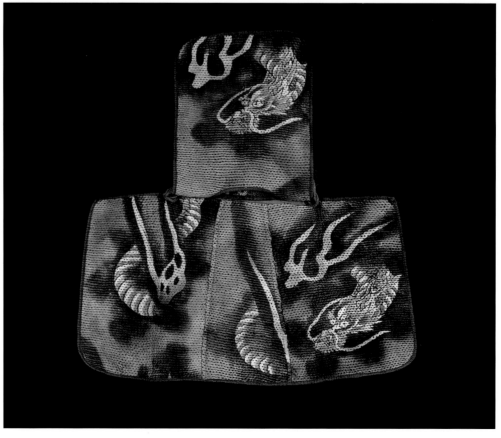

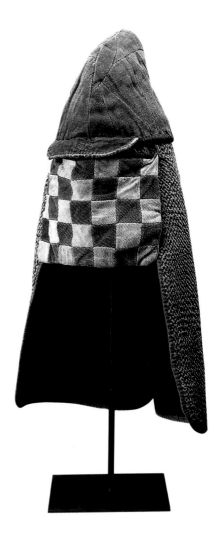

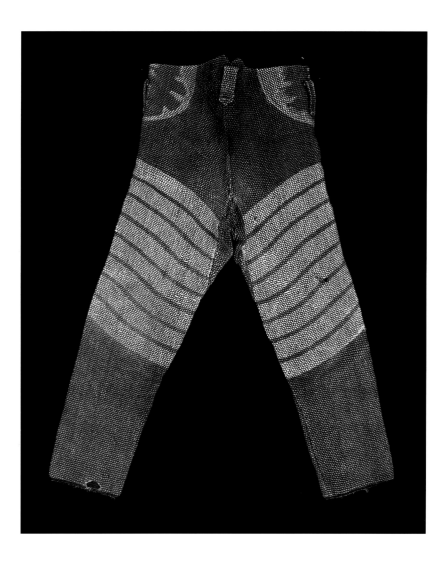

sashiko quilting gave ordinary cotton variety, substance, and texture. During the Edo period, *sashiko* quilting was primarily done by the fireman and his wife, along with other family members; later, the quilting was gradually turned over to workshops.

The main function of the quilted *sashiko* coats was to protect the wearer from falling objects and burning timbers during a fire. As noted above, the method used for fighting fires was to tear down burning buildings judged to be in the path of the blaze, thus creating a firebreak. As burning embers, flying sparks, and fire-weakened wood and furnishings came tumbling down, the coats served as protective armor against them. Sometimes ladders were used as battering rams to collapse a building. The firemen's long beak-shaped hooks (*tobi*) were used to punch through the roof of a building in an attempt to get the fire to burn vertically down the shaft created, limiting its horizontal spread to adjacent construction (fig. 4.124a,b). The fully dressed fireman was thoroughly wet down just before he ran into the raging flames. During actual fire fighting, it was customary to wear two coats, a long coat left open over a shorter one that was belted with an obi sash. The coats were soaked with water sprayed from portable pumps, and thus they acted as fire-retardant shields and permitted the fireman to withstand high temperatures even in the midst of flames. When the quilted cloth was wet, it might weigh as much as seventy-five pounds (figs. 4.125–4.128).

As noted, the firefighters' coats were reversible. On the plain, dark indigo blue exterior, which would show during actual fire fighting, identifying characters or numbers were paste-resist stenciled in white with the fire brigade's *kanji* (character) or number. The inscriptions might indicate the wearer's position within the brigade or his rank in order to communicate the information to fire captains, fellow firefighters,

4.127 Fireman's Hood, Edo–Meiji period. Cotton, *sashiko*-quilted. H: 66 cm. FMCH X91.624; Anonymous Gift.

This patchwork hood and its mantle are padded to provide greater protection.

4.128 Fireman's trousers, Meiji period. Cotton, *sashiko*-quilted, stencil-resist, and *tsutsugaki*-painted. L: 103 cm. FMCH X82.1388; Museum Purchase with Manus Fund.

The eight white bars decorating each leg of this pair of tight-fitting trousers (*momohiki*) stand for the number of the fireman's company. A crest is split in two with half of the character (*kanji*) appearing on each hip. A fully garbed fireman, soaked down preparatory to approaching a burning building, carried approximately seventy-five pounds of weight in wet clothing. Great strength was required to climb ladders and scaffolding under these conditions.

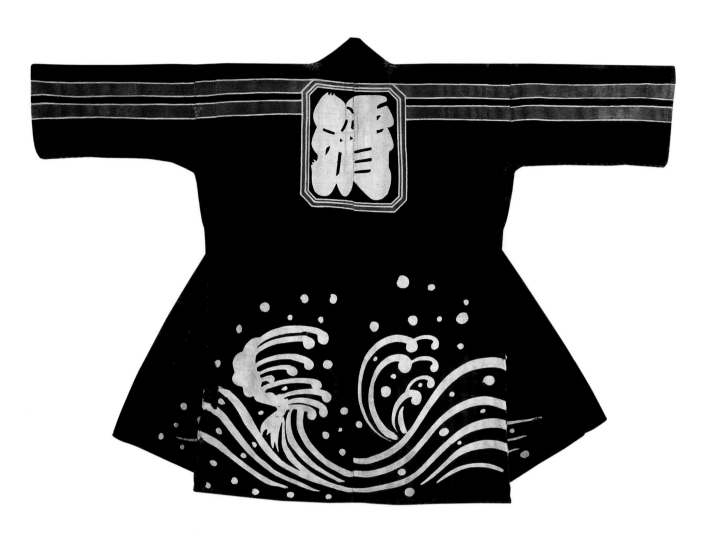

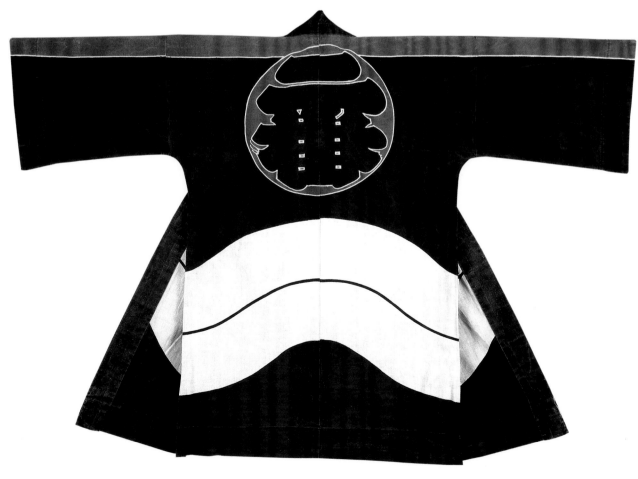

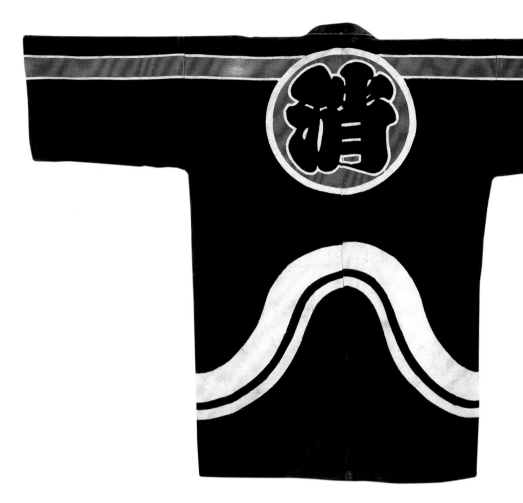

4.131 Fireman's coat. Taisho–Showa period. Cotton, unlined, stencil-resist dyed. L: 92 cm. Collection of the Asian Cultural Arts Trust.

The *kanji* (Chinese character) for "to extinguish" is stenciled at the center of this coat. The red line indicates the fireman's rank.

4.129 (OPPOSITE, TOP) Fireman's coat, Edo–Meiji period. Hemp (*asa*), *tsutsugaki*-painted. L: 91 cm. Collection of the Asian Cultural Arts Trust.

This coat for a *machi bikeshi*, or fireman recruited from the town, is decorated with waves and watery spray, a favorite motif among firemen. The character (*kanji*) meaning "to extinguish" is stenciled at the center back. The red lines indicate the fireman's rank, two being the highest.

4.130 (OPPOSITE, BOTTOM) Fireman's jacket, Taisho–Showa period. Cotton, stencil-resist dyed. L: 95 cm. FMCH X82.1384; Gift of Keigi Higashi.

Unlined jackets inscribed with identifying characters or phonetic letters (*kana*) designating the sections of Tokyo were worn by the rank and file *machi bikeshi*. "*Niban*" on the back of this jacket stands for second group. The single red line identifies the fireman's rank of vice captain.

4.132 (RIGHT) Fire alarm, Taisho–Showa period. Cherry wood. L: 18 cm. FMCH X91.2130a,b; Gift of Catherine E. and P. Lennox Tierney.

Wooden clappers sounded the alarm and identified the location of a fire for the *machi bikeshi*. Cherry-wood clappers are still carried by neighborhood fire wardens, a post rotated among residents in Tokyo to the present day.

observers, and members of other brigades. There might also appear a highly visible geometric pattern that stood for the brigade's number. For example, a series of boldly repeated hexagons might stand for company six and octagons for company eight. The count of stripes and lattices provided numerical information. In the many tile designs, the number of tiles grouped together conveyed the number of the group (figs. 4.129–4.133). If a circular form appeared, the number of round motifs would convey the significant number. White lines around the waist of a garment stood for the number of the fire company, with straight lines standing for odd-numbered companies and curvilinear lines for even-numbered.

On the interior surface of the coat, decoration was produced by skillful *tsutsusgaki* painting. Swashbuckling heroes drawn from drama or literature were pictured as well as subjects symbolic of sources of water, the fireman's friend. The latter included clouds, raindrops, waves, spray, and mists, as well as the dragon (see fig. 4.126), the

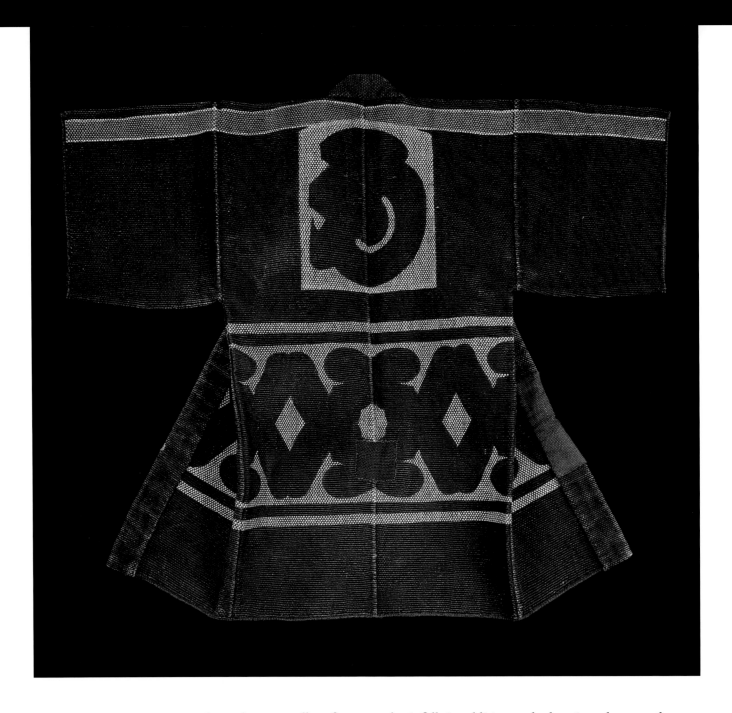

4.133 Fireman's coat, Meiji period. Cotton, *sashiko*-quilted and stencil-dyed. L: 104 cm. Collection of the Asian Cultural Arts Trust.

The stylized phonetic letter "*mo*" on this coat identifies the fireman's company, and the single red stripe across the shoulders indicates the rank of vice captain. Red stripes were inaugurated during the Meiji period when the fire companies officially came under the authority of the Tokyo city government.

legendary controller of water and rainfall. In addition to the heroic and watery themes, there were paintings that depicted humorous or whimsical topics, also taken from and legend and lore. The *chōnin* firemen had a reputation for recklessness and brazen behavior, and they became an ideal of machismo and glamour. These qualities were reflected in many of the *tsutsugaki* paintings that Ukiyo-e artists and other skilled artists and dyers were engaged to create. The ground of the side that served as the painting's background was usually dyed with watered-down indigo to produce a lighter blue. Some interiors were left undyed, while others still were dyed a neutral tan or gray. As noted, the coats were turned inside-out and worn with the decorated side showing during festivals, processions, and special ceremonies (figs. 4.134, 4.135). Reportedly, those who owned the hand-painted coats also donned them for impromptu processions that occurred when a company had succeeded in extinguishing a raging fire. After the flames had been put out, the firefighters removed their coats and turned them inside out to reveal their flamboyant interiors. Thus arrayed, the men would file gallantly through the town from the site of the quenched blaze back to their home neighborhood. Since the hand-painted coats were expensive, less costly versions that attempted to emulate the former by means of complex stencils were also produced. Many members of fire brigades simply paraded in their everyday fire-fighting coats with their exterior surfaces of bold hand-stenciled lettering and motifs.

Among those who could afford to acquire the hand-painted coats was an official neighborhood representative who received funding for the acquisition from members

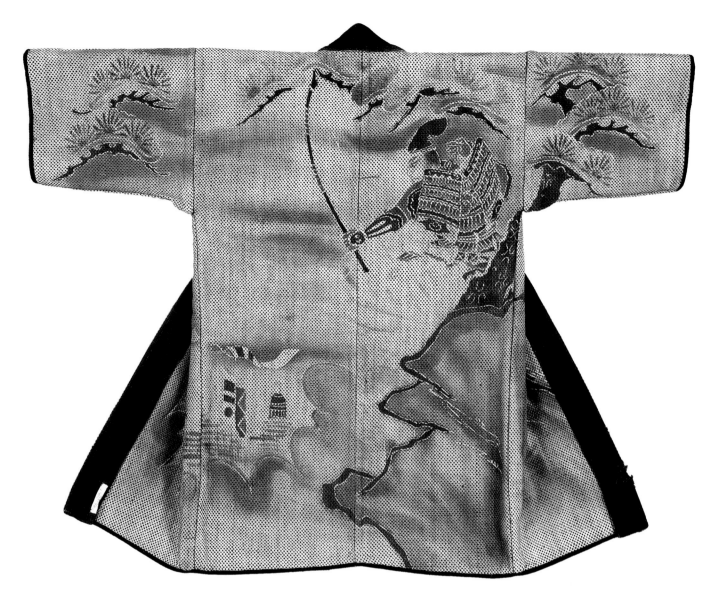

of the firefighters' brigade. He was usually a respected neighborhood resident, whom the firemen selected to represent them and was often their supervisor. The chosen representative would wear one of the hand-painted coats at ceremonies. Additionally, the coats might be acquired and worn by a local merchant who wished to show gratitude for the firefighters' services and who counted firemen heavily among his clientele. The merchant would normally make customary condolence visits to bereaved families of fallen firefighters wearing a hand-painted *sashiko* coat. These men wore the coats with their elaborately hand-painted interiors reversed and exhibited, but their coats were plain on the outside, as there was no practical reason to stencil such coats with recognizable fire-fighting identification.

In Ukiyo-e paintings of firemen's festivals, the men are also depicted wearing the decorated, heavily quilted coats in acrobatic performances (*dezomichi*), which became a famous feature of these events. At these times the firemen demonstrated their agility, strength, and daring by performing acrobatic feats atop tall ladders. The firemen were often called *tobi*, short for *tobiguchi*, the name of the beak-shaped carpenter's tool they carried. During their acrobatics, they used the *tobiguchi* to steady their tall ladders (see fig. 4.120). The daimyo of Iyo Province on Shikoku held the first exhibition of *dezomichi* at Ueno Tōshōgu Shrine in Edo. Daimyo (samurai lords of the provinces of Japan) were required by the shogun (the military ruler of the nation) to live every other year in Edo (a practice referred to as "alternate residence"). In this manner the shogun sought to insure loyalty to his government and to quell any

4.134 Interior of a fireman's coat, Meiji–Taisho period. Cotton, *sashiko*-quilted, *tsutsugaki*-painted. L: 99.5 cm. FMCH x82.1385f; Gift of Keigi Higashi.

The interior *tsutsugaki* portrait on this coat depicts a samurai archer taking aim against a background of mist, fog, and pine trees. Firemen felt that they were warriors protecting the populace from harm and thus identified with the ideals of the samurai. They were particularly devout believers, fond of Buddhist-inspired motifs, including mists and clouds, which suggested the evanescence of life. Such motifs were also suggestive of water.

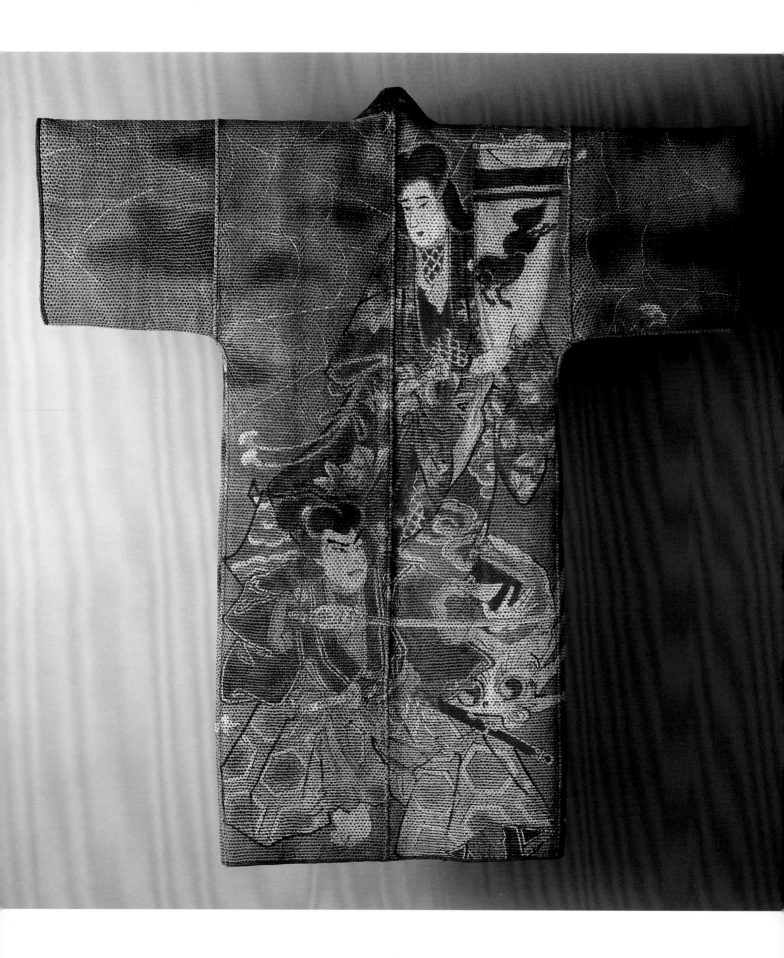

attempt to build a power base outside Edo. Each samurai brought his contingent of retainers with him. These retainers formed the first recruits of what would become the *daimyo bikeshi,* or samurai firefighters.

After the particularly devastating Meireki Fire of 1657, which had caused general despair, the daimyo from Shikoku initiated daring acrobatic performances to restore public confidence in firefighters' agility and skill. The heights reached on ladders and the thrilling gymnastic tricks performed by the men instilled fresh respect for their strength and fitness. The performance was instituted as a regular feature at firemens' festivals. The popularity of *dezomichi* resulted in their being emulated during the Meiji period by firemen's groups in various Japanese towns, and the performances continue to be held in several places to the present day. The hand-painted *sashiko* coats, however, are for the most part relegated to museum or private collections, and lightweight stenciled *ha'pi* clothe the firemen-gymnasts today.

The firemen's festival established on May 25 serves as a memorial day to reflect on the bravery of the men and to honor the spirits of those who have fallen. According to the Shinto belief system, it is thought that the spirits of those who die prematurely or unjustly, including victims of accident or fire, must be pacified intermittently by entertainment and offerings. Otherwise it is feared that their spirits will remain agitated and restless, becoming vengeful and threatening the welfare of survivors (Hori 1968, 72–73). The date selected for the memorial day coincided with the end of the "fire season," the time from November to May when strong northwest winds blowing across the Kantō Plain fanned sparks into roaring conflagrations. This is an example of the frequent practice of scheduling *matsuri* at junctures between seasons, as these were perceived to be particularly vulnerable periods. The May 25th *matsuri* expressed gratitude to the *kami* for preserving those who had survived the "fire season" and beseeched them to stave off new hazards.[3]

The establishment of formal fire-fighting organizations also dates to the aftermath of the Meiriki Fire of 1657 (Morioka 1985, 121). Although this catastrophe brought about widespread anxiety and a sense of urgency relative to the creation of an effective fire-fighting force, the retention of hierarchical privilege (and its identification through costume) continued to be of overriding importance. Even in the face of disaster, it was felt necessary to respect the class divisions of the Edo period (samurai, farmer, artisan, and merchant, in that order). The people of each class lived in separate neighborhoods designated for them and governed from above (Shibusawa 1958, 379).[4] Special regulations guided the fire-fighting organizations and their dress. When fire threatened, visual clues regarding social status were considered essential to the chain of command and to orderly evacuation. Manpower from the four classes was divided into three defensive categories: the *daimyo bikeshi,* or lords of the realm and their immediate households enlisted in rotation for firefighting service; the *jō bikeshi,* an elite corps of professional firemen drawn from the samurai warrior class; and *the machi bikeshi,* or ordinary townsmen serving as firefighters.

The first two groups fell into the category called *buke bikeshi,* or samurai warrior firemen, and they had as their primary responsibility the protection of the samurai residences and Edo castle. The government of the shogun funded the *buke bikeshi,* which were organized into ten companies in 1704. Each company had numerous members, whose duty it was to preserve the property and lives of the samurai residences in one area. Five or so high-ranking officials in each company assigned duties to several low-ranking officials and low-ranking samurai, who directed the service of hundreds of commoners under them. The leaders of fire companies rode caparisoned horses and

4.135 Interior of a fireman's coat, late nineteenth century. Cotton, *tsutsugaki*-painted. L: 127 cm. Gift of Lloyd E. Cotsen and the Neutrogena Corporation, Museum of International Folk Art, a unit of the Museum of New Mexico, Santa Fe, A.1995.93.552. Photograph by Pat Pollard.

This coat is *tsutsugaki*-painted with a scene from the Noh play *Tsuchigumo* in which a giant demon spider threatens the hero, Minamoto no Yorimitsu. Firemen particularly favored motifs of heroic figures drawn from history or legend. Some of these more elaborate coats are said to have been provided by local merchants eager to demonstrate their support and gratitude to firemen for protecting their shops.

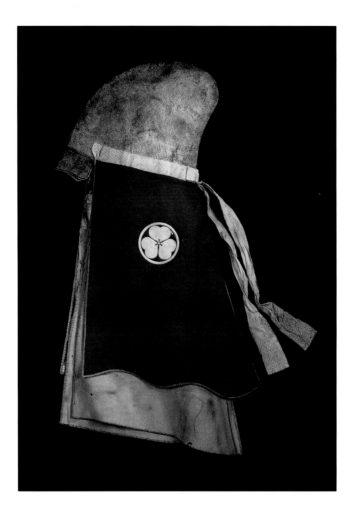

4.136 Fireman's hood, Edo period. Leather, gold leaf, wool, and silk. H: 86 cm. FMCH X87.1332; Museum Purchase with Manus Fund.

This hood of gold-leafed leather would have been worn by a samurai fire commander (*jō bikeshi*). The red mantle is made of *rasha*, the term for imported European wool. Wool was believed to be waterproof. The crest (*mon*) appliquéd in white felt is the leaf of the wood sorrel flower, a pattern that enjoyed a tremendous vogue among the samurai class. The figured silk ribbon tie is patterned with the *manji* motif bespeaking hope for eternal life.

led the brigades. The men in charge of the horses came after them followed by the lowest-ranking samurai, and finally, the commoners. At the beginning of organized fire fighting, the elite professional firefighters (*jō bikeshi*) were responsible for safeguarding neighborhoods throughout the city. After a while, these elite firefighters were diverted to concentrate on protection of the samurai residences and Edo Castle, leaving the guardianship of the rest of the city to the *machi bikeshi*.

The life of an elite-class firefighter has been described as the "final bastion of heraldry in all its pre-Tokugawa vigor" (Dower 1971, 17). Raging flames had replaced the human enemies of Japan's middle ages. During the Edo period, the terrible blazes offered the only front where warriors could still receive recognition for brilliant planning and courage. It was perceived as just such an opportunity by samurai officers, who vied to be put in charge of fire companies in order to achieve recognition for superior performance or cunning strategy, a singular means of advancement in the military of a nation at peace.

Naturally, differences in rank were reflected in dress. During fire fighting the chief of the *jō bikeshi* wore a *kaji baori*, or wool *haori*—a *haori* being a short unbelted coat worn with the lapels folded back. The *kaji baori* had a slit at center back to facilitate horseback riding and the carrying of a sword, prerogatives of the wearer's rank as a samurai. The chief also wore a decorated helmet with a mantle, a pair of *hakama* (culottes), a belt, and a chest protector (*muneate*), all of wool, appliquéd with a crest and other motifs in silk or felt (fig. 4.136). The wool, called *rasha*, was manufactured in Europe, and either imported directly to Nagasaki by European traders or imported

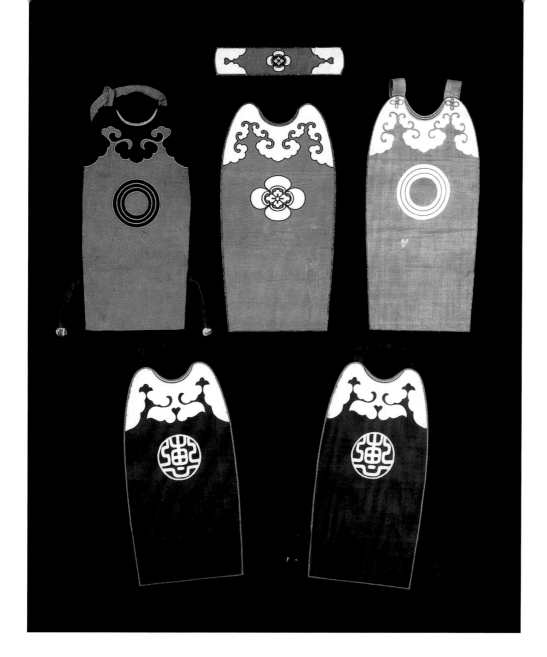

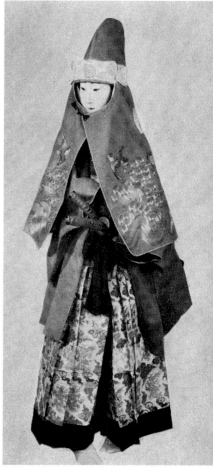

to Nagasaki via China. Wool, as an animal product foreign to Japan, was a material that suggested a certain alien roughness and was believed to be fire resistant. High-ranking officers serving under the chief wore fine cotton *haori* with a crest appliquéd on the center back. Ordinary samurai retainers wore unlined cotton *haori*.

Although women did not participate in fighting fires, those of the samurai class and their children donned special dress when flames threatened. Women's outfits included a hood, mantle, coat, *hakama*, belt, *muneate* (fig. 4.137a–e), and *haori* slit at the back to permit riding (fig. 4.138). It was felt crucial that samurai wives and their children be quickly identifiable in a disaster scene, so that even in a crisis proper deference could be accorded them and so that they could be assisted to evacuate rapidly. Samurai families thus strove to have complete sets of fire attire for each member. In addition, it was thought necessary to follow seasonal fashion dictates. Sets of fire garments were maintained for each member of the family in shades and fibers deemed appropriate for summer as well as for cold weather. A fire wardrobe was quite costly, according to the *Morisada Manko,* an encyclopedia of Edo etiquette and dress written in 1850. A complete set including coat, hat, *hakama*, chest protector, and belt cost nearly as much as a full set of samurai armor (Kitagawa 1992, 14, 248–51).

The *daimyo bikeshi* wore brown leather *haori* with crests on the back (fig. 4.139). Their officers wore brown leather *haori* as well. The leather coats (called as a group *kawa baori*) were not only suggestive of animal strength but were also reputedly fire-resistant. *Kawa baori* were tailored from a single hide and decorated by means of a process called *inden*, or smoke resist. Designs were stenciled on the hide, then covered

4.137a–e Chest shields (*muneate*), Edo period. Variously cotton, ramie, flannel, and wool with appliquéd crests. L (of longest): 59.7 cm. Private collection.

These shields represent elements in the fire wardrobes of three distinct samurai families. Chest shields in fabrics and colors appropriate for the four seasons were worn under matching fire coats to offer a daimyo and each member of his family further protection from flying sparks.

4.138 All members of a samurai family had their respective fire wardrobes. These fire garments would have been worn by the wife of a daimyo (samurai lord). Collection of the Tokyo National Museum.

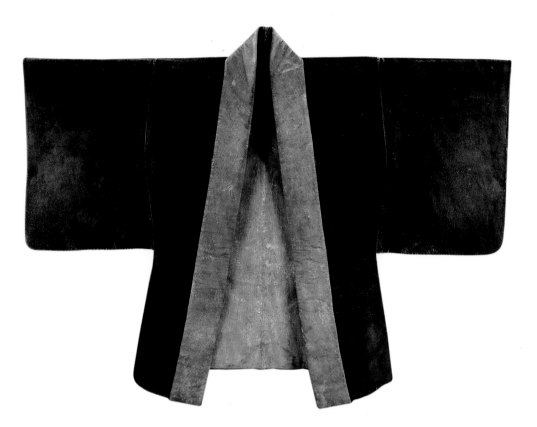

4.139 Leather fire coat (*kawa baori*), Edo period. L: 100 cm. Leather, smoke-dyed. Collection of the Asian Cultural Arts Trust.

Leather fire coats were permitted to the lower-ranking samurai who supervised a town's firemen. They wore them at the twice-yearly firemen's festivals (New Year's, January 6, and Firemen's Memorial Day, May 25.). This example has a simple overall design of subtle gray striations. Patterning on these coats was created by smoke dyeing the leather with smoldering rice or pine needles (*inden* technique).

with resist paste to protect the design before the hide was rolled around a cylinder and allowed to rotate over smoldering pine needles or rice straw. The type of hide that was used for the leather, although said to be deerskin, has been something of a puzzle, since the coats were made of one large hide and Japanese deerskins are quite small. As Morioka has noted, the hides are somewhat thicker than usual for deerskin and were likely imported, possibly through Nagasaki. Morioka speculates that they might be water buffalo hides imported from Southeast Asia (1983, 125). It is also possible that they were yak hides; during the Edo and Meiji periods the goods exported from northwestern China to Nagasaki are known to have included yak whisks.

The leaders of the ordinary townsmen (*machi bikeshi*) serving as firefighters were entitled to wear leather coats. These men did not ride horseback, however, and there was no slit at the back of their coats. The coats were styled straight across the back at the hem and their lapels of leather laid flat. The leaders of the *machi bikeshi* were also likely to be among those of their rank who were able to acquire and wear the hand-painted *sashiko* coats described above. Rank-and-file members of the *machi bikeshi* normally wore unlined cotton *ha'pi* dyed dark indigo blue. These were hip length and worn secured by a flexible cotton obi. Firemen's *ha'pi* were the most frequently seen fire-fighting attire, and they served as festival attire as well. The crest and auxiliary designs stenciled on the cotton coats identified the fire company, serving as a source of neighborhood pride when the men paraded after a fire or at festival processions. The number of red stripes across the shoulders showed the rank of the fireman. Lettering on the lapels gave the name of the wearer and his position. The majority of firefighters were conscripted from the commoner or laboring classes, frequently drawn from the ranks of construction workers and carpenters (Leupp 1992, 135–36). These men were considered particularly desirable as firefighters since they all had extensive experience climbing scaffolds and handling the all-purpose tool known as the *tobiguchi*.

The *machi bikeshi*, who by the nineteenth century were funded and directed on the local level, divided their ranks up into six fire-fighting positions, including the team leader, advisors, standard bearers (*matoi*), ladder carriers, hook bearers, and men who carried buckets and water pumps. These task forces were further divided

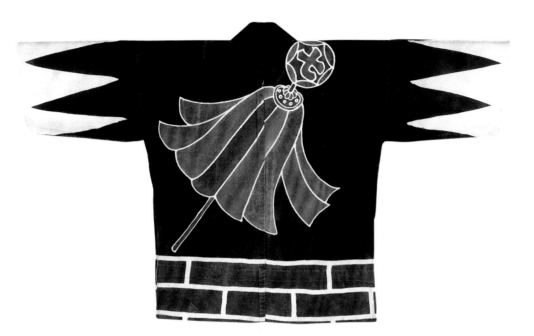

into forty-eight groups corresponding to the letters of the Japanese phonetic alphabet (*kana*). One of the letters, *hi*, which means "fire," was rejected. Three other letters, commonly used in slang, including *he*, meaning "flatulence"; *ra* meaning "penis"; and *un* meaning "feces," were also discarded. Substituted were *man* (ten thousand), *sen* (thousand), *hyaku* (hundred), and *hon* (book). The letters were assembled into ten regional groups that divided the map of the city among them. Two of the ten regional numbers had to be discarded soon afterward since the number four in Japanese is pronounced *shi*, which means "death," and the number nine, or *ku* is the first syllable in *kurushii*, which means "pain," leaving eight geographic divisions.

Many of the men elected to have portraits tattooed on their bodies—often by master tattoo artists. The themes on the coats echoed tattoos that some workmen traditionally wore on their bodies. These included eye-catching portraits of heroes of the theater or legend, or of images related to sources of water. Rain clouds, waterwheels, crashing waves, the sea, and the dragon were all particularly popular tattoos. As the men came face to face with the flames, at times the intense heat induced them to remove their coats, on which occasions their colorful tattoos would be revealed. The tattoos helped them to retain their dignity while they dashed about the streets in their loincloths, the coats tied around their waists. Taking attention away from their nakedness, the tattoos gave them a rakish air.

The men of the fire company assembled and risked their lives beneath a standard called a *matoi* (figs. 4.140–4.143). In 1719 a judge in Edo named Ooka Echizen no Kami established the original *matoi* in the form of a long banner that hung beneath a finial. The format changed several times until the Tempo era (1830–1840) when it became set as a three-dimensional papier-mâché standard painted with an emblem and set on a wooden rod. A fringe of streamers hung just below the bottom of the sculpted papier-mâché, and whoever carried the *matoi* aloft could duck under the fringe to shield his eyes from clouds of smoke. The top of the *matoi* was constructed of paulownia wood, pasted over with rice paper covered with four coats of white paint. The black letters and symbols were painted with lacquer. A final coat of seaweed glue made the surface shine. Its glossy finish permitted it to reflect moonlight and firelight

4.140 Child's coat, Taisho–Showa period. Cotton, unlined, stenciled. L: 70 cm. Collection of the Asian Cultural Arts Trust.

This child's coat is stenciled with a *matoi* (standard) motif in three colors and a tile pattern below in white. The finial on the stenciled *matoi* shows the number seven.

4.141 Yoshitoshi Tsukioka (1839–1892). *The Sixth Company of the Best Great Districts*, from *A Paragon of Firemen's Standards of All Great Districts*, 1876. *Ukiyo-e* (wood block print). 39 x 24 cm. Scripps College Collection, no. 93.3.25.

179

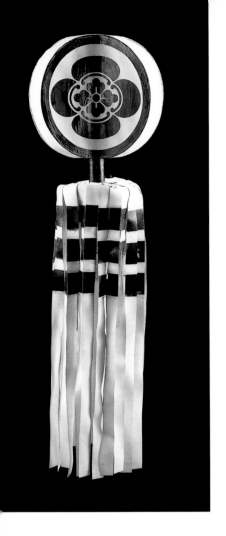

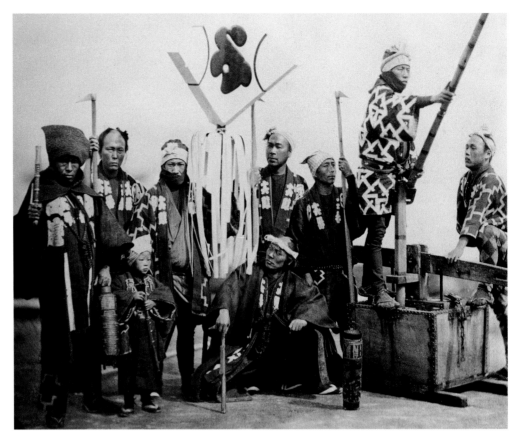

4.142 *Matoi* (fireman's standard) for a child participant in firemen's festivals, Taisho–Showa period. Paulownia wood, rice paper, white paint made of powdered shells and *sokkui* (rice-paste glue), seaweed glue or shellac, with black areas created with black lacquer (*urushi*). H: 118 cm. Collection of the Asian Cultural Arts Trust.

Matoi were used during the Edo period as fire-resistant and highly reflective signs that could identify firemen's groups from a distance. They were inspired by the vertical banners that were carried by mounted samurai to identify their clan and gradually evolved into a unique three-dimensional form. *Matoi* are no longer used in actual fires but have been preserved as festival parade regalia. A full-size *matoi* has a pole 9 centimeters in diameter, is around 1.5 meters long, and has iron legs to brace it on either side. The fringe is made of folded-over cotton cloth padded inside with paper. During the Edo period firemen would duck under the fringe to shield their eyes from smoke and sparks.

and to be seen through the smoke. The character used for *matoi* appeared as a crest on coats, as did the character for "to extinguish," the latter also often placed on the coat worn by the *matoi* carrier.

Carrying the *matoi* was a hereditary position, viewed as the most prestigious and the most dangerous. The carrier climbed to the tallest building at the edge of the burning area where, in his judgment, his men could try to establish a firebreak against the blaze by tearing down all the buildings in the fire's path. The other men followed the lead of the *matoi* carrier, climbing to perches on buildings nearby, declaring their *matoi* would not burn. The men were eager to claim the blaze as their own purview, as the company recognized as having extinguished the flames would receive a reward. After the fire was extinguished, small wooden tags with the company's symbol would be left on adjacent buildings.

The men did not serve full-time; rather the duties were rotated in normal times, with those off-duty remaining "on call." Those on duty manned watchtowers built as observation posts in order to spot fires in their early stages. Again the height, efficiency, convenience, and even the type of alarm, was determined by the class of firemen assigned to using it. Watchtowers built in privileged neighborhoods were higher and easier to access by the person on duty, as well as more comfortable for his stay. The alarm sounds were also coded so that firemen could listen for the signal that told location of the fire. Alarms from samurai neighborhoods were louder and more effective than those for neighborhoods serving ordinary people. By comparison, in small villages or towns, originally all men between the ages of twenty-five and forty served as volunteer firefighters. Over time, responsibilities became more structured and duty was rotated with one young man from each household participating in turn. Villagers on duty also wore special inscribed coats and headgear. The leaders of the neighborhoods belonged to a town organization, and the town's representative participated in a national association headed by a member of the nobility (fig. 4.144a,b). A strong strain of nationalistic fervor was said to have sustained these associations in the 1930s (Embree 1939, 169–70).

4.143 (OPPOSITE) Felix Beato (1825–1908). *The Fire Brigade*, 1867–1868, Yokohama. Photograph courtesy of Peabody Essex Museum, neg. no. 32, 197.

This image by the important nineteenth-century photographer Felix Beato shows a company of firemen steadying their *matoi* (standard) and *tobiguchi* (beak-like tools) beside a portable water pump. A small boy in an inscribed fireman's coat stands proudly beside a fireman, possibly his father.

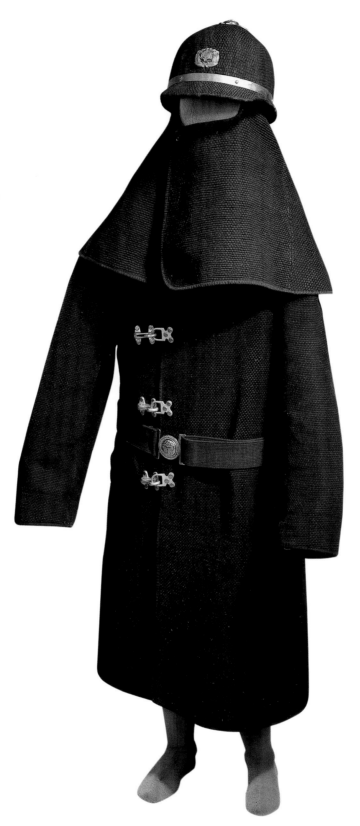

4.144a.b (A) Fireman's coat, Meiji period. Cotton, velvet, and metal. L: 111 cm. Collection of Sandy and Kenneth Bleifer. (B) A fireman's helmet, Meiji period. Cotton, *sashiko*-quilted. H: 52 cm. FMCH X87.1331; Museum Purchase with Manus Fund.

This early twentieth-century fireman's coat shows the influence of Western fabrics and tailoring. It features reinforced machine-woven cotton, a velvet collar, attached belt loops, and a belt with a brass buckle bearing the fire company's insignia. The helmet has an attached mantle and woven silk cords affixed to the inner surface. A cotton tag is sewn onto the interior and is inscribed in *sumi* ink: "Sapporo-shi Jiei Yamagataya Shōbō-tai." The term *shōbō* was used to refer to the firemen and their coats during the Meiji period.

Although officially divested of their political aspect during the American occupation, some degree of loyalty to the emperor and nationalism functions to preserve their membership to the present time. The organizations function much as neighborhood community associations elsewhere, rotating tasks perceived as necessary for the community's safety and welfare. When rural towns recovered from the devastation of World War II (in Japan, "the Pacific War"), however, fire fighting was placed primarily in the hands of professionals, who wore uniforms and traveled in fire trucks. ●

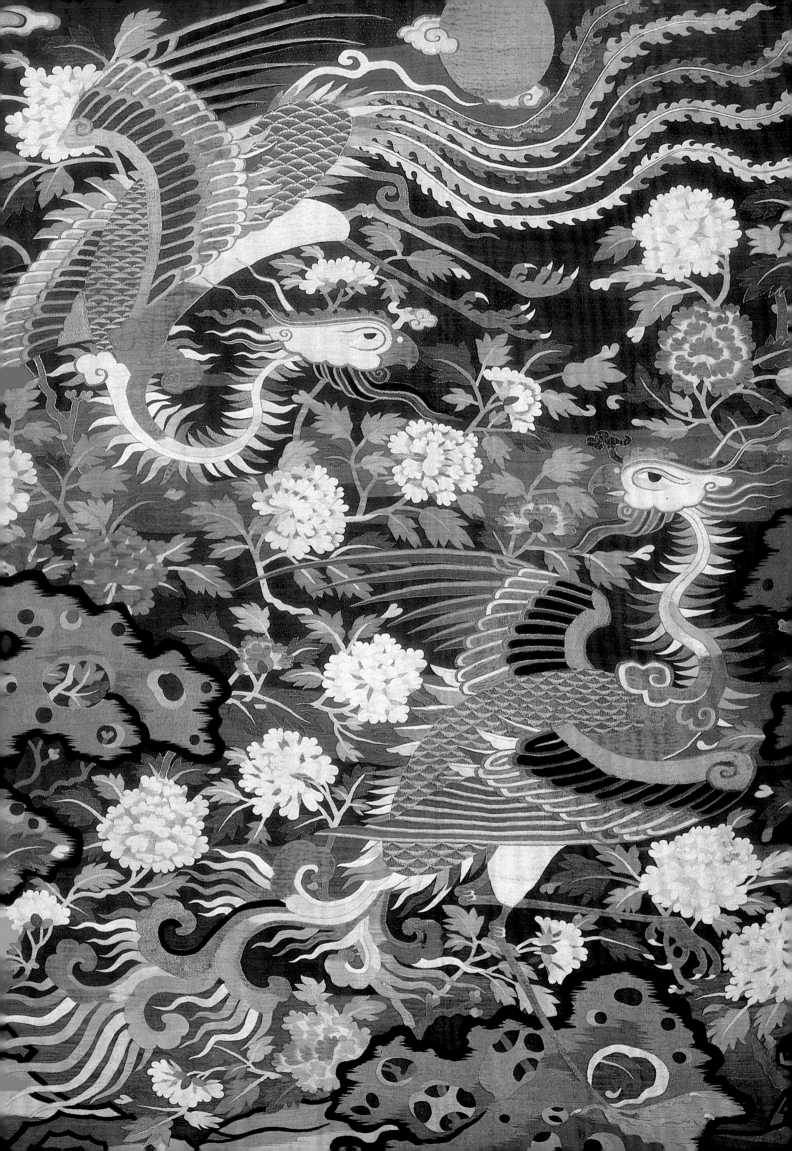

5 FIVE Imported Textiles in *Matsuri*

GLORIA GRANZ GONICK

FOR THE PAST FIVE HUNDRED YEARS, THE FESTIVAL CARTS, FLOATS, AND WAGONS OF a number of *matsuri* have been adorned with imported textiles (figs. 5.1, 5.2). About four hundred examples of foreign textiles used as *matsuri* trappings can still be found in Japan today, preserved by virtue of their having entered the repositories of festival associations. They include clothing and furniture covers retailored into hangings, as well as draperies, tent curtains, and carpets. About three-quarters of the known examples are of Chinese origin, while others are textiles from central Asia, the Middle East, and Europe. These textiles represent a historically important sampling of the textile arts found in a large part of the world from the fourteenth to the nineteenth century. In many cases, they represent types of textiles that have now completely disappeared from their lands of origin due to natural disasters or man-made catastrophes such as political upheavals or warfare.

Imported textiles were paraded through towns draped on carved, gilded, or lacquered vehicles (see figs. 5.2, 1.33). These elaborate moving stages accompanied the *mikoshi* (ark), priests, officials, musicians, and dancers on their promenade down the festival routes. Since Japan has historically been a land where skilled crafts are highly respected, the artworks paraded through the towns received expressions of awe and admiration equal to that today reserved for athletes, actors, or politicians. This attention was augmented by the fact that during the Edo period (1615–1868) Japan was largely sequestered; therefore, anything that arrived from outside the country was greeted with great curiosity. Throughout the era and lingering into the Meiji period, imported objects had near-magical associations for the populace.

When the Portuguese arrived in Japan in the 1540s, they introduced wool carpets from India (see fig. 5.2) and Persia dyed in the deep scarlet hues obtainable from the Indian dye known as lac. This produced rich red colors previously unknown in the textiles available in Japan. The bright crimson wool and the bold patterns of Middle Eastern carpets proved sensational, as they were unrelated to normal Japanese

Detail of fig. 5.3.

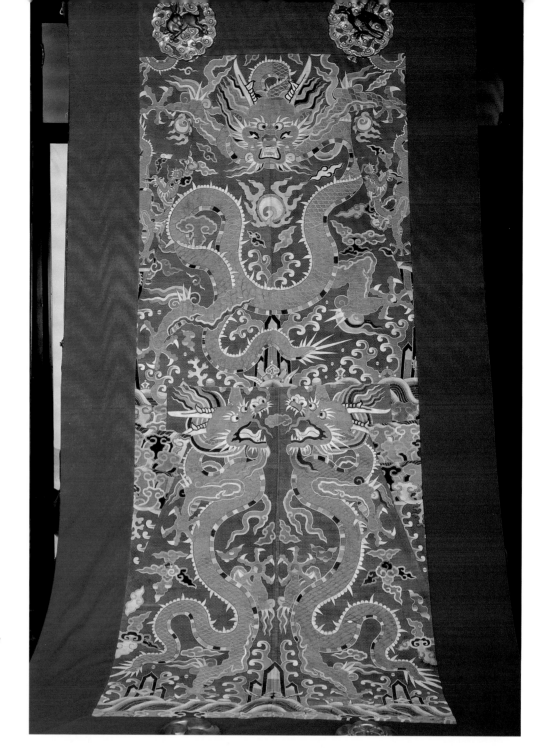

5.1 A seventeenth-century Chinese court robe of silk tapestry (*kesi*) has been retailored into a vertical hanging. Photographed with the permission of Gion Matsuri Yamaboko Rengokai (Gion Festival Neighborhood Float Associations), Kyoto. The Hali Archive, Yuge Sei, 1994.

5.2 An eighteenth-century wool pile carpet from Lahore, India, adorns the Tsuki Boko Float. Photographed with the permission of Gion Matsuri Yamaboko Rengokai (Gion Festival Neighborhood Float Associations), Kyoto. The Hali Archive, 1994.

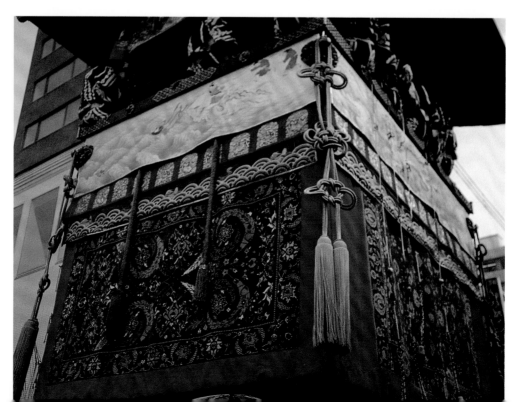

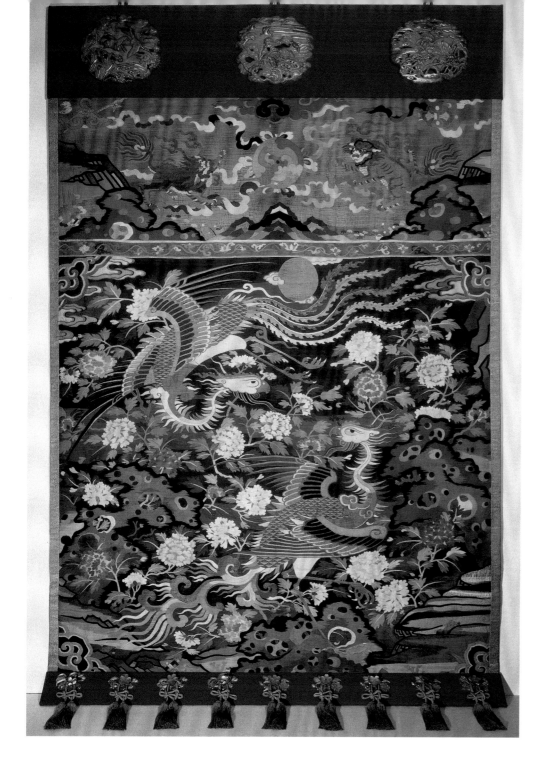

5.3 An eighteenth-century Chinese *kesi* (silk brocade) hanging illustrates paired phoenixes, a symbol of feminine beauty and an homage to fertility, a major theme of the Gion Festival. Photographed with the permission of Gion Matsuri Yamaboko Rengokai (Gion Festival Neighborhood Float Associations), Kyoto. The Hali Archive, Yuge Sei, 1994.

life, architecture, or experience. Although unusable in the homes of the wealthy and powerful to whom they were given, the strange beauty, exotic appearance, and obvious cost of the carpets eventually suggested they be used as festival trappings. Unlike the lightweight silks portrayed fluttering in the wind on early paintings of the *matsuri*, the relatively heavy woolen textiles would stay in place on the sides of festival carts, defining their bulky forms and giving them greater presence as they creaked down the streets.

By the seventeenth century the appearance and activities of *matsuri* increasingly came to reflect the concerns of the rising merchant and artisan classes, which were becoming more numerous, influential, and prosperous as cities grew in size (Yamane 1973, 33). The demonstration of financial success in one's business or craft achieved increased importance as a goal. As a means of attaining this end, increasingly opulent fabrics were sought, especially rare and exotic imports (fig. 5.3). Foreign textiles projected an otherworldly aura, patterned in motifs with meanings that were obscure for a Japanese audience, woven with fibers alien to Japan, and dyed in vibrant hues that contrasted strongly with the sober aesthetics that guided Japanese dyers.

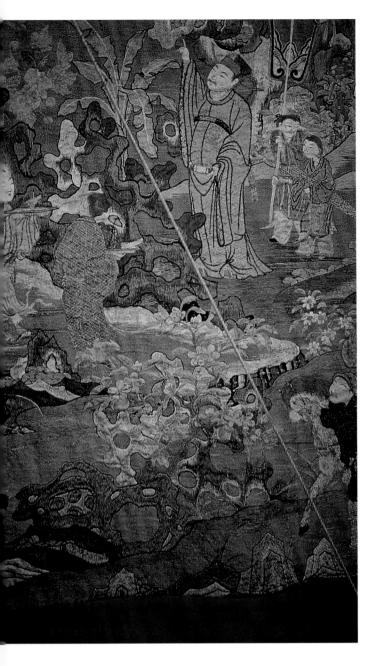

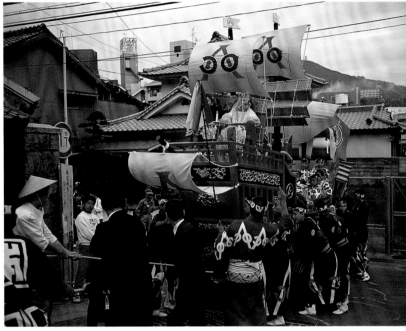

5.4 This Ming dynasty, silk-embroidered hanging (circa 1600–1640) framed in European wool (*rasha*) is paraded at the Tenjin Matsuri, Mie Prefecture. Photograph by GGG, 1991.

5.5 A model of a Dutch trading ship emblazoned "voc" (the V mistakenly placed upside down), the insignia of Dutch East India Company, commemorates seventeenth-century internationl trade at Nagasaki during the Okunchi Matsuri. Photograph by GGG, 1992.

International textiles existed in Japan long before the Tokugawa Laws of Seclusion (circa 1616–1861) were passed. For example, a renowned collection of artwork including foreign textiles and carpets had been stored since the eighth century at the Shōsōin at Tōdai-ji Temple in Nara. It is amazing nonetheless that most of the foreign textiles that came to be included in *matsuri* were documented as having entered Japan precisely during the period of the seclusion (Kajitani and Yoshida 1992, 39). The Tokugawa shoguns had decreed and enforced laws that barred the importation of foreign goods as well as the departure of any Japanese citizens from Japanese territory. Although these rules isolated the Japanese people and prohibited access to foreign technology that might have benefited them, they succeeded in preventing colonization or other forms of foreign penetration. This was in marked contrast to the history of China, India, and Indonesia, all of which came under foreign domination. The regulations also produced a stable government and a homogenous populace with shared values and traditions. Although the Laws of Seclusion were firm, foreign goods managed to slip through formidable barriers at several places.

Many extravagant imported textiles, carpets, and clothing items were given to officials and powerful daimyo, or feudal barons, in and around Edo, Kyoto, and the

port cities of Kyūshū. These were bestowed by foreign traders and clergy because daimyo, as samurai, were strictly prohibited from engaging in trade. The family of the Tokugawa shogun alone received gifts of several seventeenth- and eighteenth-century Persian and Indo-Persian carpets (ten of which remain in the inventory of the Tokugawa Art Museum in Nagoya). Several of the textiles given to daimyo were later presented to temples and some eventually found their way into festival organization storehouses. Secrecy had to be maintained regarding commerce in rare and exotic items, which were especially welcomed by individuals in power (Matsuda 1965, 6, 17, 42).

Foreign textiles were incorporated into many different *matsuri*, the most famous being the Gion Matsuri in Kyoto. These textiles were also found to a smaller extent in nearby cities on Lake Biwa, including Ōtsu and Nagahama. In Ōtsu, there is an example of a painted tapestry from the Buddhist Uighur people of western China, along with several impressive Chinese *kesi* hangings, rare old Persian carpets, and European tapestries. At Ueno-shi in Mie Prefecture, outstanding Chinese Ming-dynasty embroidered hangings are paraded at the Tenjin Matsuri (fig. 5.4). Sakura City in Chiba Prefecture has exhibited opulent gold-thread embroideries from China. The small port city of Sai Mura on the northern coast of Honshū has displayed hangings and a mannequin dressed in an embroidered period costume from China. A number of other rare, old, imported textiles have also been preserved in historical museums and the Museum of the History of Northern Peoples, Hakodate; Tohoku University Museum, Sendai; and the National Museum, Naha, Okinawa Prefecture. In recent decades, examples have also appeared in the wide-ranging international collections of the National Museum of Ethnology in Senri Park, Osaka; in the National Museum of Folk Art, Mingeikan, Tokyo: and in many private collections.

The incorporation of foreign artwork is not the only example of international influence in *matsuri*; indeed, some festivals overtly commemorate specific historic cultural encounters. For example, the importance of the seaport town of Nagasaki to European and Chinese trading ships and their crews was commemorated at Nagasaki Okunchi Matsuri, which showcased a large model of a seventeenth-century Dutch sailing ship (fig. 5.5) and presented dances parodying Dutch and Chinese settlers. An impressive dragon dance also honored Nagasaki's Chinese immigrants. In addition, spectators viewed a parade of oversized parasols (*kasa*) embellished with elaborate silk and gold trapunto, embroidered curtains. In Japan the large parasols, which tradition-ally sheltered Chinese emperors in processions, served as vehicles for the descent of the *kami*, or deities. The Tōjin Matsuri at Tsu-shi in Mie Prefecture celebrates Korean cultural contacts with a Korean officers procession and dance. Sometimes mislabeled as "Chinese," Tōjin costumes may also be seen at Shizuka, Mie Prefecture, and were formerly presented at Ogaki and in Tokyo at Hie Jinja Matsuri. In these festivals, exotic costumes are worn to represent foreign embassies. Although they are constructed of opulent silks and satins created in China, and were actually imported and worn by officials in Korea, they are known in Japan as "Chinese officials' garments"; and in some town theatrical performances and festival processions, as "Korean officials' gar-ments." The tailoring of these Chinese fabrics—originally booty brought back home from Korea by the soldiers of the Japanese military ruler Toyotomi Hideyoshi in the late sixteenth century—is an imaginative interpretation of costumes worn by officials in those countries. At the *matsuri* of the Meiji Shrine in Tokyo, European folk dances are performed to honor the introduction of Western culture during the Meiji period, and at the Tanabata Matsuri in Sendai, Victorian fashions and vintage automobiles appear in a festival procession that was first held during the same era.

5.6 This seventeenth-century Indo-Persian carpet from Lahore is primarily known—apart from a second example in the Gion collection—from similar carpets that appear in European Renaissance paintings. On the day before the procession, a textile conservator checks for stability of the carpet, which is used on a tall festival float (*hoko*) at Gion Matsuri. Photographed with the permission of Gion Matsuri Yamaboko Rengokai (Gion Festival Neighborhood Float Associations), Kyoto. Photograph by GGG, 1994.

5.7 This sketch shows a Gion Matsuri *hoko* dressed for the procession, with musicians seated above framed by wands of sacred *gohei*. Porters in *ha'pi* coats below move the huge wooden wheels slowly forward.

IMPORTED TEXTILES IN THE GION FESTIVAL

Approximately three hundred of some nine hundred textiles maintained for use in the Gion Matsuri are derived from foreign sources. With the exception of their use for a few days during the festival, these textiles are strictly safeguarded in individual owner-association storehouses. It is believed that the number of imports was even greater in earlier centuries, since losses must have occurred due to accidents or natural deterioration.

The city of Kyoto not only possesses the most extensive collection of imports in its treasure houses but has also nurtured the longest-lived interest in exotic trappings (fig. 5.6). On the same early sixteenth-century paintings that illustrate the advent of imported wool textiles in the Gion Matsuri, the viewer sees leopard and tiger skins draped across, over, and even wrapped around the floats. The animal skins reveal the significance of the foreign textiles (see fig. 5.21), which gradually replaced the skins in the procession, as objects of awe, fear, and excitement (Yang 1968, 27). The Japanese associated wild animals with wool fabrics and also with "hairy" peoples from other lands. Awesome tigers and leopards were native to parts of China and Korea, lands that the Japanese considered less civilized than their own. The wild spirits of the beasts were felt to be inherent in hairy or furry fibers, whereas bast fibers (*asa*), cotton, or silk were reflective of Japanese culture. Tiger skins and their substitutes, wool textiles and carpets, entered Japan as exotic trophies offered to those in power and were used to establish an extraordinary environment that would attract and delight the *kami*.

Although the textiles that adorn Gion Matsuri may originally have been intended for rulers or royalty in distant lands, in Kyoto they have been traditionally identified by the name of the neighborhood owning the hanging and by the traditional placement specified on the festival float (e.g., "Minami Kannon Yama Maekake" or "front curtain, South Kannon Neighborhood's float"). In Japan, the textiles were uniformly backed with European red wool yardage called *rasha,* a term derived from the

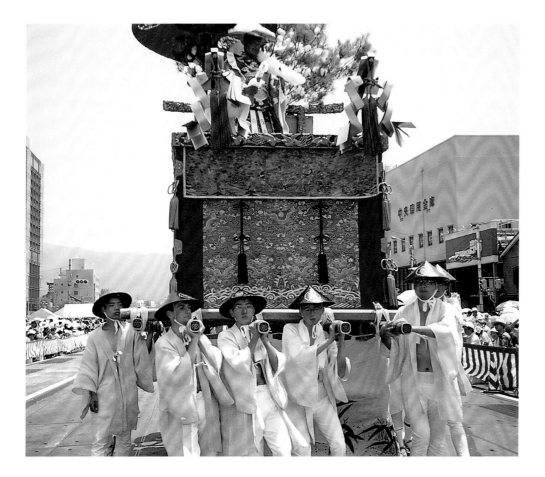

5.8 Golden dragons are a particularly desirable motif as the dragon is the symbol of the Gion Matsuri. This Qing-dynasty Chinese silk hanging decorating one of the tree-topped platforms known as *yama* was originally a robe worn by a courtier. Photographed with the permission of Gion Matsuri Yamaboko Rengokai (Gion Festival Neighborhood Float Associations), Kyoto. Photograph by GGG, 1994.

Portuguese *raxa* (Coats 1996, 278). The backing extends several inches on all four sides, creating a frame for each textile (see figs. 5.1, 5.6, 5.8). The textiles are designated as part of a specific set, each set festooning one of the *yama* or *hoko*, the floats unique to Kyoto's Gion Matsuri. The floats are "dressed" two or three days before the annual procession on July 17. Some artworks are exhibited during this preparation or at an informal spectator promenade of the downtown streets on which the *yamaboko* (festival floats) are parked, held on the eve of the *matsuri* (known as *yoiyama* in Kyoto). These occasions provide an opportunity to have a close-up view of some textiles. July 17—the day of the festival—is the only chance to view all the textiles, but one must fight the crowds to see them even from a distance.[1]

Each float or wagon is draped with a front and a back hanging, as well as one or more hangings on each side sufficient to cover all surfaces (figs. 5.7, 5.8). Around the top hang elaborate valances, sometimes constructed of "retired" full hangings. Another textile—the "farewell hanging"—projects from the rear of the vehicle. There is usually a first-rank set maintained for each float and a second-best set, referred to as the "rainy day draperies." In the float procession, which creaks along slowly in very hot weather, those worshipers who pull the tall *hoko* wear inscribed *ha'pi* (festival jackets). A pair of *yukata*-clad celebrants stand astride the vehicle, calling out a traditional chant and grandly gesturing ahead with oversized fans. A band of musicians similarly attired is charged with "keeping the festival alive" by continuously producing tunes on flutes, gongs, and drums. They perch in their boldly patterned blue-and-white *yukata* on an upper platform of the float while robed officials stride along beside it.

The symbolism that inspired the long-vanished creators of the Gion adornments was derived from varied traditions: Greco-Roman, Judeo-Christian, Islamic, Hindu, and shamanic or animist (Kajitani and Yoshida 1992, 129, 133). Historically, scholars and government officials considered these themes irrelevant to the Kyoto cultural context and largely ignored them. An exception occurred during the seventeenth-century persecution of Christians, when European tapestries with obvious biblical themes

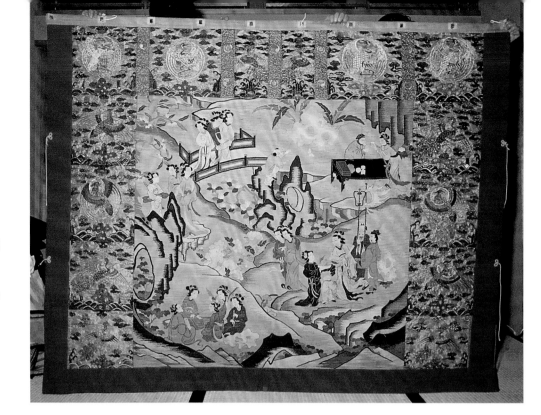

5.9 This Chinese *kesi* (silk brocade) hanging from the Ming dynasty has been framed with joined Qing dynasty embroidered court badges. All the components have been assembled and backed with the imported red wool called *rasha*. Photographed with the permission of Gion Matsuri Yamaboko Rengokai (Gion Festival Neighborhood Float Associations), Kyoto. Photograph by Yuge Sei, 1991.

5.10 Japanese tapestry (*tsutsureori*), middle Edo period. Silk and gold metallic threads. L: 183 cm. Private collection.

When tapestries deteriorated over the centuries, they were salvaged, patched, repaired, and retained in the Gion Matsuri procession, particularly if they illustrated the dragon, a motif of enduring significance to the festival.

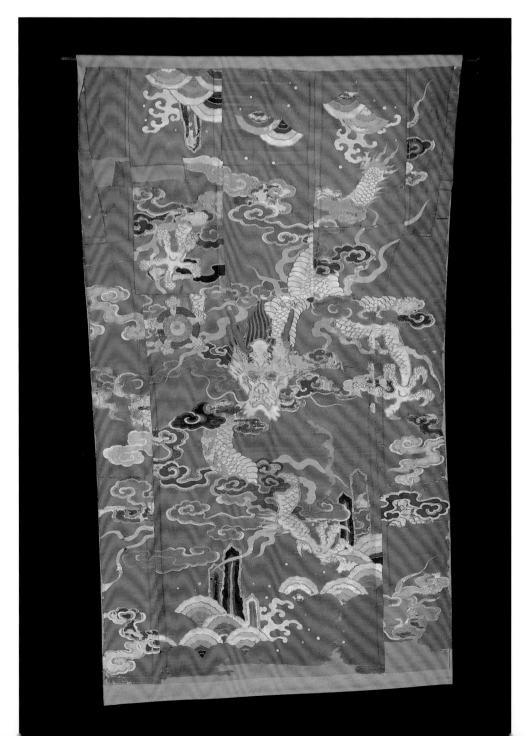

were destroyed (Yoshida Kojiro, personal communication, Kyoto, 1993). Another group of unusual, painted wool tapestries, created by Buddhist Uighur weavers living in western China, were mistakenly assigned a Korean attribution and removed because they were deemed "common and unattractive." This negative appraisal coincided with the worsening of Korean-Japanese relations in the years prior to Japan's annexation of Korea in 1910 (Iriye 1989, 751–69.)

As time wore on, many textiles in the collection achieved "dual citizenship" by virtue of receiving numerous Japanese repairs and patches, as well as overembroidering (fig. 5.9). A striking example of this is found on panels belonging to the En-no-gyoja Yama Float Association, on which appliquéd Ming dynasty dragons, removed from their worn silk backing, were securely overstitched onto a Japanese embroidered ground. *Matsuri* planners in Kyoto were continually concerned that consistency be maintained in the appearance of the festival. Great effort went into salvaging textiles that were considered to be traditional for a particular float. Imported textiles deemed to be beyond repair were replaced by skilled Japanese reproductions. This practice increased as obtaining copies from the original sources became more and more difficult (fig. 5.10).

Despite this, examples created centuries ago in France, Belgium, England, Russia, Iran, India, and China survive today in Kyoto. In their original state, these textiles constituted floor and furniture coverings, wall decorations, clothing, and simple yardage. Some, such as the carpets and flat panels draped on chairs (chair covers), could be used "as is." Others, including robes originally designed for officials of the imperial court of China, were admired sufficiently that festival association members were willing to tolerate the extra expenditure and trouble of disassembling, cutting, and retailoring them. These textiles were eventually converted into sizes and shapes to fit the parameters of the processional vehicles (fig. 5.1).

Members of the Gion Matsuri's Yamaboko Rengokai (Gion Festival Neighborhood Float Associations) donated funds to develop the collections even while recovering from devastating fires and floods, often at great personal sacrifice. They not only overcame the formidable hurdle of the shogunate's edicts but are also presumed to have dealt successfully with the ego and financial needs of local weavers and dyers, who had been the pageant's exclusive suppliers before foreign textiles became available (Kajitani and Yoshida 1992, 38–39). The motivations of the merchants and craftsmen who funded acquisitions and repairs included sincere observance of Shinto-Buddhist religious beliefs, a profound desire to express loyalty to community, keenly felt neighborhood competition, and a deep-seated Kyoto tradition of homage to craftsmanship and beauty especially in the textile arts (the great workshops that produced silk fabrics for the imperial household were founded in Kyoto).

Nineteen neighborhood member associations of the Yamaboko Rengokai currently possess records that date back to 1576; these records document donations made by the members to acquire, repair, rework, and back the textiles. Bills for repairs and replacements—as well as inventories from the seventeenth century on—were all recorded. The Kita Kannon Neighborhood Association's donation lists of 1724 refer to an inventory compiled in 1671, which was unfortunately destroyed by fire (like many other *yamaboko* records). Extant screens, scrolls, and panels painted concurrent with the adoption of the imported textiles, provide graphic details believed to be reliable (Okada 1978, 58–59; Yamane 1973, 112). Over the centuries, the festival has generated sufficient excitement to inspire repeated paintings, sketches and, since the mid-nineteenth century, photographs, including historic photo albums of the

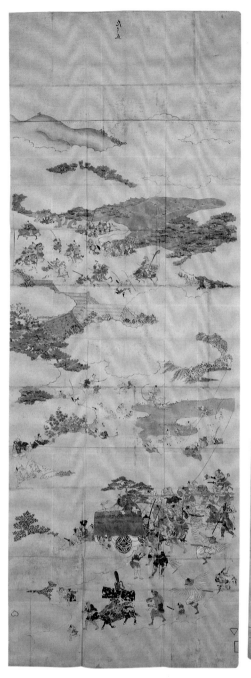
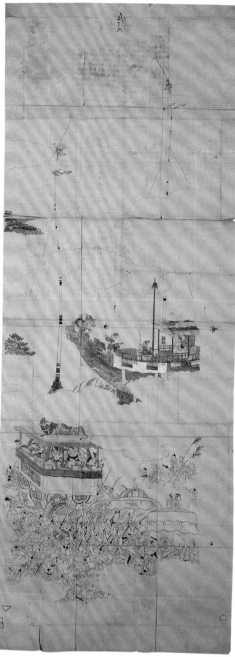

5.11 Tōsa Mitsunobu (1434–1525). Scroll painting, circa 1506. Collection of the Tokyo National Museum.

The *funeboko*, a type of festival float, was traditionally constructed in the shape of a sailing ship. Hung with lanterns, these floats were thought to resemble slow moving ships as they passed through lanes created by the narrow dimly lit streets. Painted wool tapestries (Chinese: *ke-mao*; Japanese: *ke-tsutsureori*) similar to those in figures 5.12–5.22, woven and painted in Gansu, China, hang from the float's railings.

Gion Matsuri (see Takagi 1907, n.p., for example). The screens, dates and descriptions inscribed on old documents, ship's cargo records (Tobankamotsu-cho 1709–1712, 177–78), and a preserved spectator's account from 1757 (Kajitani and Yoshida 1992, 51, 205), have all loosely corroborated one another. The identities of the vendors of the textiles were never documented, however, as marketing and importing foreign artwork was strictly against the law. There are nearly three hundred imported textiles in the Gion Matsuri collections; therefore, the description below is limited to types extant in Kyoto that, have not to my knowledge, been preserved elsewhere.

Painted Wool Tapestries from Buddhist Uighur Communities in Gansu Province, China

An unusual group of thirty-seven wool tapestries was acquired by the Gion Matsuri neighborhood associations and appeared in a festival procession as early as the first decade of the sixteenth century (figs. 5.12–5.15). Many of these wool flat weaves had a lively red-orange signature background color although this gradually faded to a dull

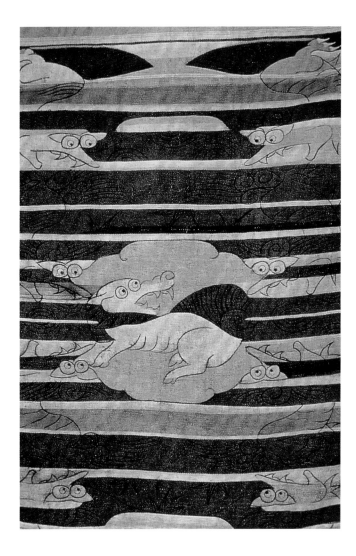

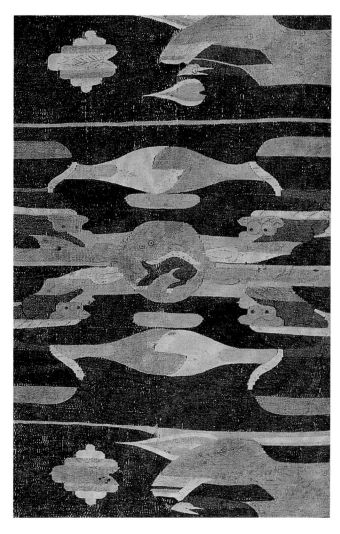

brown on the majority of textiles by the nineteenth century (figs. 5.16). On some, however, the original shade still can be glimpsed in areas that have not been exposed to light, for example, those that were covered by *rasha* borders or joined to another hanging. Newer examples, woven as late as the last half of the eighteenth century, also reveal the red-orange of the older weavings (figs. 5.17–5.20) The tapestry grounds are patterned in broad horizontal swaths of off-white and red-orange, that have been overpainted with designs in black ink. The broad bands of color are bordered by narrower stripes at either end, with some striped areas worn off or missing. The stripes and ink-drawn designs imply a vertical orientation. The width is about one meter and the length about one and one-half meters. In some examples, the end-border stripes enclose a running fret motif, sometimes referred to as "the path of Buddha" (see chapter 7). Variations on these striped borders appear consistently on examples woven as early as 1400 C.E. and as late as 1800 C.E., a span of four hundred years.

A curious characteristic of these textiles is the relationship between the tapestry-woven background and the details painted on the surface with ink. The ink painting serves to elaborate on elements of the tapestry forms, apparently reflecting considerable forethought. Several textiles have backgrounds of horizontal bands of color that evolve midway into the shape of a mountain, surrounded by suggestions of cranes and peonies (figs. 5.21, 5.22). They appear to offer a backdrop for highly unusual ink-painted abstract imagery in a style evocative of that of Pablo Picasso, Georges Braque, or Joan Miró. Images of tigers, peacocks, and lion-dogs with bulging eyes and bared fangs, singly and in pairs, can be discerned. Tall peony plants on stiff stalks and single blossoms flanked by broad, tropical-looking leaves appear and reappear. In four of the paintings a demon emerges (figs. 5.14, 5.15), legs akimbo and facing forward, revealing not only

5.12 This wool tapestry features ink paintings of pairs of guardian dogs (labeled *shishi*, or lion-dogs, in Japan). It served as a tent entry hanging in western China before it was conveyed to Japan and used for a festival hanging in the Gion Matsuri. Today such tapestries have been retired to the Library of Historical documents, Kyoto. Photographed with the permission of Gion Matsuri Yamaboko Rengokai (Gion Festival Neighborhood Float Associations), Kyoto. Photograph by Yuge Sei, 1991.

5.13 Ink painting completes the tapestry-woven forms of peonies, *shishi* dogs, and cranes surrounding a single *shishi* in a central disk on this wool tapestry woven in Gansu Province, China. Photographed with the permission of Gion Matsuri Yamaboko Rengokai (Gion Festival Neighborhood Float Associations), Kyoto. Photograph by Yuge Sei, 1991.

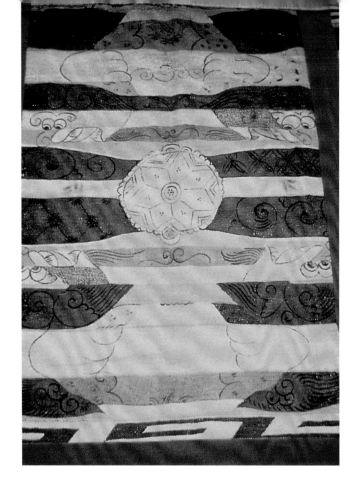

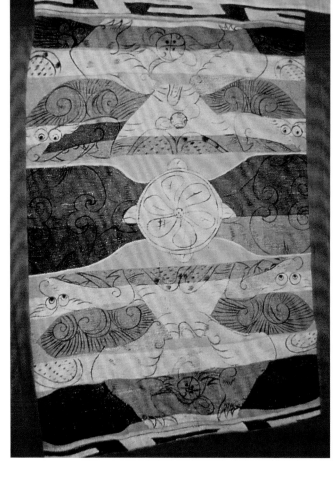

5.14 A demonic twin-bodied guardian figure adorns this wool tapestry. The western Chinese minorities who wove these tapestries as early as the Yuan dynasty, originally practiced shamanism as well as Buddhism. They became increasingly devout Tibetan Buddhists, however, during the Mongol conquests, many having intermarried with Mongol officers. The running fret border is an element that surfaces on intermittent examples over the five-hundred-year history of these tapestries. Photographed with the permission of Gion Matsuri Yamaboko Rengokai (Gion Festival Neighborhood Float Associations), Kyoto. Photograph by Yuge Sei, 1991.

5.15 This ink-painted tapestry of a powerful demonic guardian figure was paraded by the Gion Matsuri Yamaboko Rengokai from the sixteenth through the nineteenth century. The demon faces forward, his single head serving two bodies. The pairs of *shishi* (lion-dogs) on either side also have mirror images of themselves. The tapestries were woven by a Buddhist Uighur minority living in Gansu Province. Imported to Japan, they were installed on the Gion festival floats by around 1500. Photographed with the permission of Gion Matsuri Yamaboko Rengokai (Gion Festival Neighborhood Float Associations), Kyoto. Photograph by Yuge Sei, 1991.

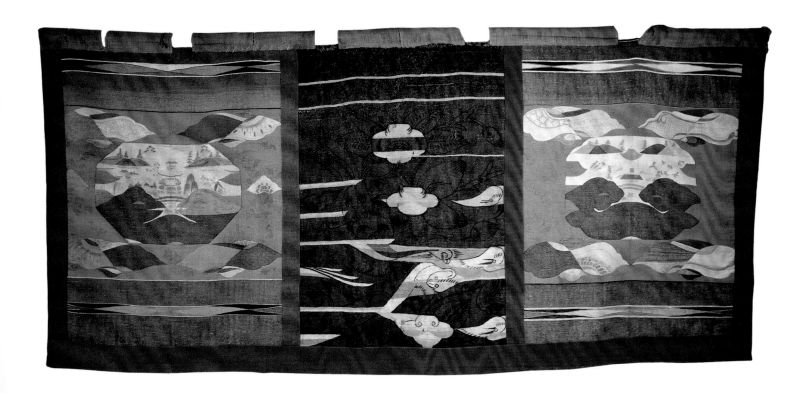

5.17 Tapestry, Gansu Province, Qing dynasty, China. Wool, dye, and ink. L: 329 cm. Collection of the Asian Cultural Arts Trust.

Examples of Gansu wool tapestries found their way to collections outside Kyoto, including institutions in North America, in the eighteenth and nineteenth centuries.

5.16 (OPPOSITE, BOTTOM) Although these rare painted wool tapestries from Gansu Province, China, may occasionally be displayed in exhibitions held by the neighborhood associations that make up the Gion Matsuri Yamaboko Rengokai, they were removed from the procession in the early years of the twentieth century. Their pale coral and brown backgrounds are faded from the original bright red-orange. Photographed with the permission of Gion Matsuri Yamaboko Rengokai (Gion Festival Neighborhood Float Associations), Kyoto. The Hali Archive, Yuge Sei, 1994.

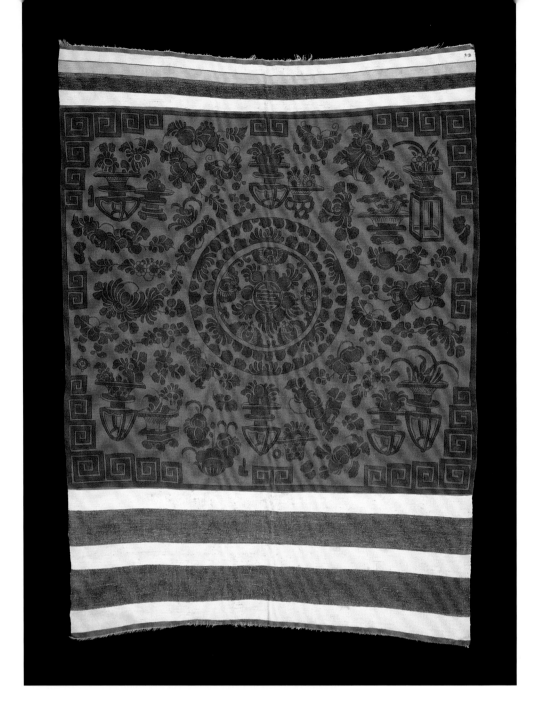

5.18 Tapestry, Gansu Province, China, eighteenth century. Wool, dye, and ink. L: 206 cm. Collection of the Asian Cultural Arts Trust.

This is an example of Gansu painted and printed wool tapestries that found their way to collections outside Japan. It reveals the growing influence of Chinese Taoist imagery on the minority weavers, although the central circle is a form that may be seen in the earliest examples of production.

5.19 This detail of a painted wool tapestry from Gansu or Jiangsu Province, China, dates to the eighteenth century. It continues to appear annually in the Ōtsu Matsuri Procession. Photograph by David Mayo, Ōtsu, 2000.

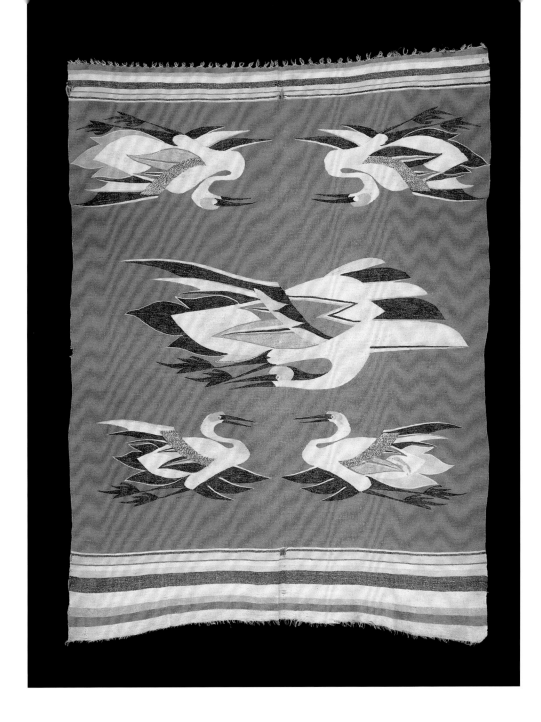

5.20 Detail of a woven tapestry, Gansu or Jiangsu Province, China, eighteenth century. Wool and dye. L: 178 cm. Collection of the Asian Cultural Arts Trust.

It appears that during the Qing dynasty, some Chinese production moved to the seacoast cities near Suchow and Nanjing in Jiangsu Province, where several were acquired by Western traders and missionaries, who used them as floor coverings.

his menacing claws but also his prominent genitalia. The entire scene is animated, whimsical, surreal, and startling. More recent paintings feature themes with familiar Chinese Taoist and Chinese Buddhist imagery. On the six tapestries believed to date from the eighteenth century, the spirited creatures that populate earlier textiles appear suddenly tranquilized. This group is characterized by large central octagonal "windows" framing the legendary Taoist Isles of Immortality and surrounded by floral sprays, pairs of stylized phoenixes, and paired butterflies or fans. *Chia-yen*, a Chinese textile-printing process, replaces most of the hand painting. On these later tapestries, the end border stripes become joined at the center to create an elongated central diamond shape.

Two qualities of wool are used in these imported Chinese tapestries. The earlier examples are coarse, fairly stiff, and abrasive to the touch, probably hardened by centuries of storage. A softer, more pliable hairy wool fiber is found in a few examples that seem to have been woven later in time judging from color retention and stylistic considerations. The Kyoto associations were no longer acquiring this type of weaving after the mid-nineteenth century, however, and as mentioned earlier, the existing collections were withdrawn from the festival procession. Fortunately, the tapestries have been preserved in the municipal research and preservation center and in some of the storehouses of the member associations.

5.22 This detail of a wool tapestry contains ink paintings of peonies, cranes, and other auspicious icons. Photographed with the permission of Gion Matsuri Yamaboko Rengokai (Gion Festival Neighborhood Float Associations), Kyoto. Photograph by Yuge Sei, 1991.

5.21 This detail of an ink-painted wool tapestry from China's Gansu Province reveals the outlines of a white tiger. The tapestry also features *shishi* dogs and auspicious peonies and cranes. Photographed with the permission of Gion Matsuri Yamaboko Rengokai (Gion Festival Neighborhood Float Associations), Kyoto. Photograph by Yuge Sei, 1991.

From 1994 to 1998 I made four trips to Japan and China to investigate the origin of the painted tapestries and an apparently related group described below. My investigation suggests that the tapestries were produced by Buddhist Uighur communities in China who resided in and around the upper Yellow River Valley from the Yuan dynasty (1279–1368) to the last decades of the Qing dynasty (1870–1911). While the Uighurs are a Turkish people, these particular communities maintained Tibetan Buddhist religious traditions rather than converting to Islam and never emigrated to Xinjiang Province with their better-known Uighur kinsmen. The western China provenance was confirmed by Chen Bingying, Director and Researcher, and Zhang Pengchuan, Vice Director, at the Gansu Provincial Museum. They verified that the tapestries are local weavings and showed me an example preserved in the Gansu Museum that was found several decades ago in the town of Qin'an. In addition, they described a second example discovered on another occasion in the same vicinity, now housed in the Palace Museum, Beijing.

Uighurs have been identified with skilled tapestry weaving since at least the ninth century (Watt and Wardwell 1997, 61–63, 101–3). It is thought that the tapestries were originally made for tent doorway drapery; however, there are also reports of their later being converted for use as animal pack covers and as canopies or floor coverings on Chinese riverboats. The many red-orange floor coverings that appear in Japanese paintings of the Momoyama period (1568–1615) may possibly be representations of these carpets. One may speculate that five hundred years ago similar textiles also covered Chinese goods bound for Japan. The Uighur, who originally practiced shamanism, like many other peoples in northern and central Asia, became Buddhists in the early centuries of the common era. By the eighth century, however, they had adopted Manichaeanism, a faith concerned with the ongoing conflict between forces of good

and evil. Painting and calligraphy were considered outstanding attributes of their founder, Mani (third century c.e.), and the Manichaeans particularly valued skillful brushwork (O'Kane 1972, 76, 244).

In the Gion *yamaboko* collections where they were preserved, the painted tapestries were mislabeled as Korean by virtue of the fact that some were transshipped through the port of Tsushima, which was heavily used by Korean traders. It is also possible that some tent furnishings were brought by the Uighurs to Korea when they served the Mongols as scribes and administrators during the Mongol conquest of eastern Asia in the thirteenth century. The port of Tsushima, however, was also used intermittently by Chinese traders. The British East India Company also maintained a factor there for some years in a futile effort to develop markets in Korea for British goods (Farrington 1991 I: 227–28, 239, 551, 567). Evidence has not been uncovered of painted-wool tapestry weaving in Korea, although multiple trips have been conducted by Japanese scholars.

In nineteenth-century Chinese seacoast towns, Western missionaries and traders purchased later editions of the wool tapestries and used them to carpet their residences. Several were brought to their home countries and donated to Western museums in the early twentieth century.[2] In one such collection, the tapestries were identified as Mongol tent doorway curtains.[3] Although tent doorway drapery was likely their original function, the appellation Mongol probably became attached because the Mongol and Monguor tent-dwelling minorities lived in proximity to one another. Mongol tribesmen were contributors to the Monguor communities and shared their religious beliefs. The Monguor absorbed some Buddhist Uighur emigrants in western China (Stuart 1999, 58, 1, 3.).

Pile Carpets Probably from Monguor Communities in Qinghai Province, China

The painted tapestries appear to be linked to an equally unusual group of twenty-one wool pile carpets that are broadly designated "Chinese regional" in the Gion Matsuri collections. The two types of weavings shared some motifs, similar coarse wool fibers, entry dates, and even the same owner associations. There has been speculation that the two types were created by the same or nearby peoples; however, in contrast to the safflower red of the tapestries, a color associated with Turkic tribes, the backgrounds of the pile carpets are all a shade of yellow-gold.

The motifs on the pile carpets are nearly as mystifying as those on the flat-woven painted tapestries, as they appear to be identified with a number of different cultures. The paired lion-dogs, blossoming plum branches, peonies, and running fret borders are evocative of China. The roundels with compartments and rosettes are associated with Khotan in central Asia. The lattice grids enclosing dot motifs are said to derive from Tibetan tie-dye designs. (Bidder 1979, 38–41). The images of stalking tigers suggest Korean paintings (fig. 5.23). Corner elements resemble those on a "nomad" carpet that appears in Chinese paintings of the Southern Sung dynasty (1127–1279), illustrating the tale of Lady Ts'ai Wen-Chi (Rorex and Fong 1974). Turkoman gul and designs resembling Kufic, which would normally be associated with Islam, add to the confusion.

Tibetan Buddhist symbols, however, are prevalent. They include prayer wheels, a "jewel" pulled by a unique Tibeto-Mongol style dog with bulging eyes, *manji* (a swastika-shaped motif), and running fret borders. There is a notable absence of images often seen on other Chinese carpets, such as dragons, waves, or clouds, as well as the absence of colors commonly used in Middle Eastern or central Asian carpets. The brown, black, and white elements in the designs might have been worked in the

5.23 This knotted pile carpet was woven in China in Qinghai Province (part of Gansu until 1926) and depicts the regional talisman, the white tiger. The weavers were likely Monguor peoples, local Uighurs who had married the Mongol officers of Chinggis Khan and settled in Yellow River communities, where some of their descendants still reside. Photographed with the permission of Gion Matsuri Yamaboko Rengokai (Gion Festival Neighborhood Float Associations), Kyoto. The Hali Archive, Yuge Sei, 1994.

5.24 This knotted pile carpet woven in China in Qinghai Province (part of Gansu until 1926) is said to be a style reserved for use by a Living Buddha. Although the carpet's border resembles Kufic script, it is probably derived from Turkish tribal motifs (the Uighurs are a Turkic people). The design of the inner border is commonly seen on embroideries created by Monguor (Buddhist Uighur-Mongols) women in Qinghai Province. Photographed with the permission of Gion Matsuri Yamaboko Rengokai (Gion Festival Neighborhood Float Associations), Kyoto. The Hali Archive, Yuge Sei, 1994.

natural colors of sheep wool, but the centuries-old technique of dyeing all backgrounds yellow-gold implied a cultural or aesthetic mandate. In fact, the carpets were likely dyed in shades of yellow at the request of Lamaist (Tibetan) Buddhist monasteries.

These diverse elements suggest that the carpets probably originated in Lamaist communities that were exposed to Chinese influence and had assimilated Turkic and Mongol imagery. My search for the source of the carpets, therefore, necessitated identifying a people who practiced Tibetan Buddhism, were experienced with pile-weaving traditions, and lived near the central Asian trade routes. The most likely locations seemed to be Gansu or Qinghai Provinces along the Silk Route, areas renowned for the production of hairy and resilient wool yarn considered ideal for carpet weaving (Rostov and Jia 1983, 172–73, 177, 198–99). I consulted with Chinese scholars, visited ruined architectural sites, and investigated costume history texts, paying particular attention to costume details, as these often retain design elements that have been dropped from other forms of artistic expression.

My investigations led me to focus on the people known as the Monguor, who also call themselves Mongghull or Mangghuer, and were known to the Chinese as Tu, meaning "natives" (Stuart 1999, 58, 1, 3). The Monguor are devout Tibetan Buddhists descended from Mongol, Tibetan, Uighur Turk, and other Turkic tribal forebears, and they have further intermarried with Tibetans in some places. They live in the Yellow River Valley, along the great river that served as one of China's main commercial highways during the centuries that the carpets were exported to Japan. This region is famed for its Lamaist temples—Kunbun, (Chinese: Taer Si), and Jouning (formerly Erh-ku-lung)—most active in the seventeenth through the nineteenth centuries Schram 1957, 2, 28–29). Their abundant powers and their rites were first significantly curtailed with the establishment of the Chinese Republic in 1912, then nearly totally restrained during the most repressive years of communist rule. Activities have only resumed to a modest degree since the 1970s with the gradual growth of religious freedom in China (Gaubatz 1996, 196–208, 298).

I found that indigenous costumes were still worn in at least one community, Huzhu, located a short distance north of the city of Xining. These costumes retained, albeit in degraded form, motifs that occur on the Gion carpets with a frequency that seems more than coincidental. When I showed photographs of the Kyoto carpets to a Monguor whose great-uncle had served as a High Lama in the community, he responded, "Carpets like these were strictly intended for use by our Hutuktu [Living Buddhas]." Living Buddhas are individuals who are recognized, usually at an early age, as the reincarnation of a former enlightened being or bodhisattva (fig. 5.24). Having attained the highest degree of holiness, they have the potential to become Buddhas at death. On the death of a prominent Living Buddha, the current Dalai Lama is invited to cast the horoscope indicating the place of his rebirth. Two or three boys are recognized as his potential incarnation, and one of them is ultimately decided to be genuine. The discovered boy is brought to a lamasery where he resides and receives very extensive training in the Lamaist scriptures and rites, in a special apartment, where he is accorded great deference, elegant robes, and fine furnishings including carpets, banners, and draperies. His family usually benefits substantially as well, enjoying an elevated rank and material advantages. As an adult the Living Buddha continues to enjoy rank and privileges as he assumes the role of a religious leader in one or more Lamaist congregations (Schram 1957, 2, 66–69; Haslund 1935, 34–42). Ashencaen has observed that the motif known as "cooperating lion-dogs" was reserved for Living Buddhas (1990, 44), a fact reiterated to me by local residents.

At factories located near temples serving local villages, I observed carpets being woven for ecclesiastical purposes, for example, pillar covers or sitting mats. Most of the carpet weaving, however, was commercial production for the domestic market. Many of the motifs familiar to me from the Gion textiles were still in evidence, but here they were repeated endlessly in hot pink and bright lime green. In another Monguor community a few hours from Kunbun in Guanting County, I was informed that weaving had flourished until the 1950s. The cornerstones and doorway lintels of the few ecclesiastical structures left standing in this community showed repeated design elements familiar from the pile carpets in the Gion Matsuri Float Associations' collection (figs. 5.25, 5.26). In the Monguor community in Minhe County weaving seemed to have totally disappeared, although it was reported that pile carpets were produced there until the 1950s. By contrast, among the Monguor of Guanting County, weaving traditions were still retained by a few families. I viewed some fine wool brocades, interestingly all dyed red, but no pile carpet weaving was in evidence.

All of this evidence suggests that the Gion pile carpets were quite plausibly woven in Monguor communities, and pile weaving remains viable in some of these communities today. Regarding the Gion tapestry-woven textiles, I found no specific evidence for a tradition of Monguor tapestry weaving, although this, too, may well have been practiced in the past.

The wool weavings currently preserved in the Gion collections include thirty-six ink-painted tapestries and twenty-one "Chinese regional" pile carpets. In 1994 Alan Marcusson and Nicholas Purdon, both at that time employees of *Hali Magazine,* and I were given permission to remove fibers from four examples for purposes of carbon dating. A yarn from a tapestry that seemed to come from about the middle of the design spectrum was carbon dated to 1398–1527 C.E. Yarn taken from a pile carpet yielded dates of 1293–1437. The remaining two samples yielded dates of 1293–1447 and 1387–1511. The probability rating for all of the tests was 95 percent (University of Oxford Laboratories 1995).

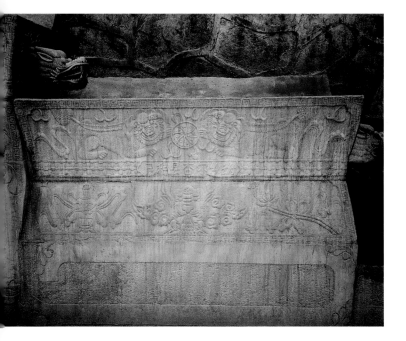

5.25 A stone bench on the grounds of Taer si (Kunbun) Temple is incised with paired *shishi* dogs chasing or rolling a jewel, similar to the motif on several of the Gion Festival Collections pile carpets (see fig. 5.24). Photograph by GGG, Qinghai Province, China, 1997.

5.26 This cornerstone appears on the remaining ruins of a Monguor Tibetan Buddhist temple. The balance of the temple was recently reconstructed on this site. The cross-in-the-circle motif, said to repel evil spirits, is seen also on the "jewel" being rolled by the lion-dogs on the carpet in figure 5.24. Photograph by GGG, Guanting County, Qinghai Province, China, 1997.

Carpets or Fragments Known through Chinese Sung-Dynasty Paintings

Fragments of discarded carpets used as bindings or patches at times provide clues to the designs of earlier periods. One pile carpet that entered the Gion Matsuri collection around 1500 C.E., believed to have been woven one hundred and fifty years earlier (Kajitani and Yoshida 1992, 76), was assembled from fragments of carpets that appear to have been woven still earlier. The designs on one of the fragments bear a marked resemblance to those seen on the carpets appearing in the Sung-dynasty illustrations of the tale of Lady Ts'ai Wen-Chi, painted in approximately 1140 C.E. by an unknown artist (Rorex and Fong 1974; von Erdmann 1978, 1: 3, 230–31).

An additional carpet in the Gion collections also resembles another carpet illustrated in paintings of the tale of Lady Ts'ai Wen-Chi. According to festival authorities in Kyoto, this carpet is among the most ancient in the collection. Its designs and coloration seem to link it to Turkic peoples. The compartmentalized design is described as "Mamluk" in Kyoto, although because of this carpet's distinctive weave structure, it is unlikely that it was woven in Egypt (Purdon 1994, 25, 77, 92). Some textile scholars think that compartmentalized designs on carpets are a type of Buddhist mandala.

European Tapestries Joined to Chinese Embroideries

Nine hangings in the Gion collections incorporate European tapestries. Members of the owner associations seem to take particular pride in these hangings, perhaps because they are the most exotic and bear no relationship to Japanese experience. The tapestries were made in Belgium and France, and were brought to Japan by the Dutch in the seventeenth century. In their current form, some have been joined to textiles from other cultures (primarily China), a practice perceived as a visual "resolving of differences," a primary goal of the *matsuri* period.

Court Robes from China

Chinese court robes are found in museum collections worldwide. Only in Kyoto, however, have the silk robes worn by the Chinese emperor and his family been disassembled and retailored into rectangular hangings. The robes included examples made by three different techniques—silk tapestry weave (*kesi*), Chinese brocade, and embroidery. The *kesi* examples are the most numerous, with eleven dating from the Ming dynasty (1368–1644) and nine from the early to mid-Qing dynasty (1644–1820). This is in contrast to other major collections of Chinese imperial robes, where Qing examples far outnumber their Ming counterparts. In addition to the robes, ninety-five

early Qing rank badges have also been preserved in Kyoto. These have been joined into vertical or horizontal strips to serve as borders or valences. The robes and badges were acquired in their original form by fourteen of the associations.

In Kyoto the brilliantly patterned silk-and-gold Chinese court textiles were acknowledged as supreme examples of the textile arts, deemed especially appropriate for a city of expert weavers and dyers. Their imagery was familiar to the Japanese and widely understood, linked over the centuries to shared symbols derived from Taoist and Buddhist sources. The strongest appeal of the robes, however, resided in their primary motif, the dragon, which was linked to the earliest history of the community. Before Kyoto was established as the capital in 794 C.E., the area was a modest agricultural settlement that held a "water festival" to celebrate the existence of a nearby spring and to appease the water deity, thus ensuring rainfall crucial to the rice crop. Later, concern developed that unsanctified or impure water was a source of pestilence and disease, a recurrent danger in midsummer. In Japan, as in China, the dragon was regarded the powerful bringer of rain and controller of the water supply, and it thus served as the main symbol of the ancient festival. This image was carried forward and incorporated as the primary icon of the Gion Matsuri. Court robes of the dragon throne, with their tapestried, brocaded, and embroidered dragons, were therefore, ideal decorations. The large-scale Ming dragons were particularly appealing because they could easily be seen from the streets. Relatively few Qing dynasty robes were acquired, perhaps because their smaller dragon designs were relatively inconspicuous (Kajitani and Yoshida 1992, 152–60).

ROUTES OF IMPORTATION

Three different trade routes seem to have been involved in the importation of textiles to Kyoto, particularly during periods when Japan was ostensibly closed to international trade. The best known is via Nagasaki on Japan's southern island of Kyūshū where trade with foreigners was permitted when controlled by the local daimyo or the shogunate. A second route reached Japan via the Ryukyu Kingdom (present-day Okinawa Prefecture). The final route, sometimes called the "Northern Silk Route," passed through the lands of the Ainu people in northern Japan (see map, p. 208).

The port of Nagasaki was primarily manned by foreign traders, first serving the Portuguese from 1571 to 1639, then the Dutch (Niwa 1980, 2–3). Goods entered Nagasaki only with the costly cooperation of the daimyo. Although no records exist of *chōnai* members negotiating directly with foreigners, Kyoto merchants visited Nagasaki to conduct business with the Portuguese and later with the Dutch (Niwa 1980, 9), both of whom dealt in Chinese silks and decorated textiles from India. In 1559 Jesuit priests established a church in Kyoto (Matsuda 1965, 87). The Jesuits may have brought Chinese court robes, since they were commonly worn by Catholic priests serving missions in China (Fairbank, Reischauer, and Craig 1965, 2: 21, 42–44, 47, Blunden and Elvin 1983, 145). Luxury textiles from China and elsewhere were given as presents by Christian missionaries to the daimyo, their retinues, and various officials (Matsuda 1965, 6, 17, 42). On at least one occasion, in 1591, Portuguese adventurers also visited Kyoto.

Although there is little written documentation, Japanese encounters with the Portuguese have been recorded in amazing detail on painted screens. The screens are called *namban*, a term that refers to goods or persons from the southern seas. The Japanese believed the startling intruders came from Southeast Asia, since this was then the furthermost extent of their known world. The Portuguese themselves were called "*namban* from India" (Okamoto 1972, 71).

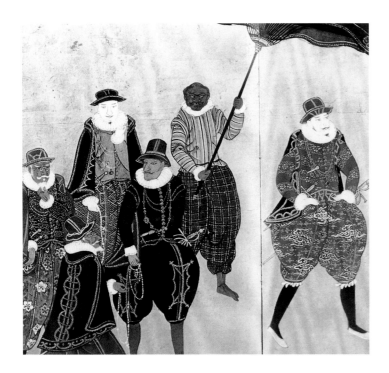

5.27 Kanō Naizen, detail of *Nanban Byobu* (southern barbarian screens), early seventeenth century. Color on gold paper (part of a six-fold screen). The Portuguese have been depicted here as if they had visited European tailors in China. They wear European styles created with Chinese tapestry woven silks. Collection of the Kobe City Museum.

5.28 The foreigners' habit of wearing Chinese silks may have caught the imagination of actors. To the present day in the Kabuki theater, actors playing foreigners are costumed with Chinese silks. Courtesy of Prof. M. Gunji.

The early Portuguese explorers evidently obtained Chinese court brocades en route to Nagasaki, and they had these tailored in contemporary and familiar European styles (fig. 5.27). Portuguese traders have been documented in seventeenth-century screen paintings on the wharves of Nagasaki Harbor wearing these garments. This may have contributed to the subsequent practice of costuming Kabuki actors playing "foreigners" in Chinese silk brocade fabrics (fig. 5.28).[4] The screen paintings were created during the time the Portuguese were in Japan (1543–1639) and after. Later, Ukiyo-e woodblock portraits representing Kabuki actors portraying foreigners also recorded the phenomenon (Laforet Museum 1982, 55, 59, 56). It is possible this was simply a vagary of the artists' imagination in both forms of artistry, but several other fabric and clothing details portrayed in screen paintings and in woodblock prints are thought to be realistic (Okamoto 1972, 60–61).

The proselytizing of the daimyo and their subjects by the Portuguese missionaries eventually threatened the Tokugawa shogun to such an extent that the Portuguese were expelled from Japan in 1639. Dutch merchants eager to replace the Portuguese were willing to acquiesce to all Japanese stipulations and were awarded the sole right to conduct foreign trade in Japan in 1641 (Keene 1952, 2). Dutch traders had to accept supervision of all commerce by the shogun's government and were sequestered on the tiny island of Deshima in Nagasaki Harbor, where all other aspects of their lives could be controlled as well. From the middle of the seventeenth century on, numerous Chinese goods were brought to Nagasaki on Dutch cargo ships (Niwa 1980, 3, 6; Tobankamotsu-cho 1709–1712). A few smaller Chinese and Japanese ships were also licensed to participate in the silk trade conducted through Nagasaki.

Evidence for the Ryukyu route is provided by a hanging in the Gion collections, which was tailored from a Ming *kesi* robe (fig. 5.29). The robe was transported from Ryukyu in 1605 by Fukuchujōnin, a Buddhist monk who had journeyed there three years earlier (Kajitani and Yoshida 1992, 147–50). A gift from the Ryukyuan king, the robe was donated to a Kyoto temple. There is no further documentation of this robe

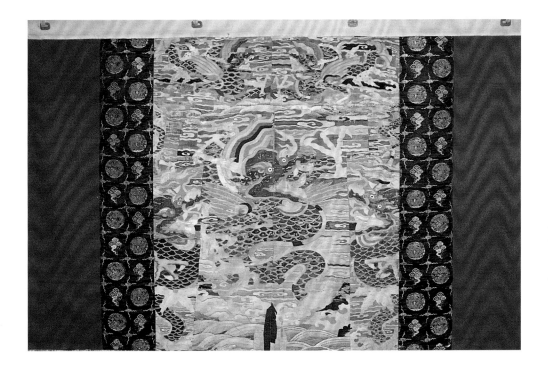

5.29 This Ming-dynasty Chinese silk tapestry (*kesi*) court robe, gifted by the king of the Ryukyu Kingdom to a Japanese Buddhist monk, was in turn given to a temple and eventually came into the collection of the Gion Matsuri Festival Association. It was annually paraded as a hanging throughout the twentieth century. Photographed with the permission of Gion Matsuri Yamaboko Rengokai (Gion Festival Neighborhood Float Associations), Kyoto. Photograph by Yuge Sei, 1991.

until 1817, when it was recorded as a donation to the Kuronushi Neighborhood Association upon whose *hoko* it is proudly paraded (in an altered form) to this day. Ryukyu had a tributary relationship with China, entitling it to a profitable international trade, and the Ryukyuan ruler and his courtiers wore Chinese court robes for official duties. Ryukyu was ideally located between China and Japan, nations that mutually prohibited direct commerce with each other. At the beginning of the seventeenth century, the Ryukyuan king was under great military pressure from the daimyo of Satsuma in Kyūshū, who coveted the lucrative Ryukyuan sea trade. He made several gestures of appeasement to the Japanese during these years, including abundant gifts.

In 1609 the Japanese from Satsuma invaded the Ryukyuan capital, sacking and looting Shuri Castle and the nearby princely houses. This was yet another opportunity to gather exotic textiles. Confiscated Ryukyuan goods—as well as all future Ryukyuan imports from China—were from this point on channeled through Satsuma and labeled as local products (Kerr 1958, 195–96, 246).

A significant number of Chinese textiles were probably imported along the third path, the "Northern Silk Route" through the lands of the Ainu (map, p. 208). The curious label "Ezo Kazari" (Ainu decorations) appears in association with Chinese court robes in the records of the Kyoto Festival Associations (Kajitani and Yoshida 1992, 147–60). "Ezo" is the old name for Hokkaidō, the northernmost of the Japanese Islands, as well as for the Ainu, Hokkaidō's indigenous people. Curiosity propelled me northward in 1994 to follow a trail of Chinese silks in northern Honshū and Hokkaidō. Sai Mura, a quiet coastal village near the northern tip of Honshū, served as a lively port for Japanese merchant boats sailing to and from Hokkaidō prior to the development of the current Aomori route (Tanaka 1992, 17-18). The Sai Mura Port Historical Museum displays Chinese court garments and fragments discovered in that area, designated "Ezo Nishiki," or Ainu brocade. Evidently, one early Qing robe was paraded on a mannequin in the local *matsuri* (Tanaka 1992, 49-53). In Sai Mura the robes are perceived as costumes linked to the Ainu people and worn by them.

The Ainu Portraits

A set of twelve portraits (Ishū-Retsuzō) of eighteenth-century Ainu inhabitants of Hokkaidō exists in Japan. Matsuura Historical Museum has a copy of the series, and a nearly complete second copy resides in the collection of the Musée d'Ethnographie et d'Histoire Naturelle in Besançon, France.[5] The portraits were painted by the artist Kakizaki Hakyō (1764–1826), circa 1790 (figs. 5.30, 5.31). Reproductions of these paintings have been published and are currently exhibited in several Japanese museums. The subjects are intriguing, attired in Chinese imperial and Russian aristocratic garments. The richness of the detail and the skillful painting initially appear aimed at describing Ainu life, clothing, and furnishings of the time.

The portraits, however, which depict members of one extended family, had quite a different rhetorical intent. They were created to promote the local assets of the Matsumae family, the dominant Japanese clan in the area. The Matsumae daimyo, his family, and vassals—empowered by the shogunate—were at this time in the process of consolidating their political power and establishing an economic monopoly in the Ainu lands. The paintings were made to advertise their own lucrative foreign trade with the Asian mainland and to impress the Ainu with the cultural superiority of the Japanese.

The Ainu had long engaged in trade along the "Northern Silk Route." This northern trade in Asian luxury fabrics included the castoffs of defeated Chinese dynasties—from the Yuan through the early Qing—and of the Mongols, including their Buddhist Uighur officials and scribes. The silk trappings used in Kyoto's Gion Matsuri through the present are constructed from the clothing of the Chinese imperial family and courtiers that was traded north. The Ainu offered in exchange for these goods the much-prized kelp harvested in the local seas as well as

highly profitable furs. The latter were trapped by the Ainu and their mainland cousins (in the Amur region called Santan by the Japanese and Heilongjiang by the Chinese). Luxury Chinese silk and gold brocade (Ezo Nishiki; "Ezo" being the Japanese name for the Ainu) can still be seen in the trimmings of nineteenth-century Ainu robes preserved in northern Japanese museums. With the ascendance of the Japanese, the Ainu were subjugated politically, and all their possessions, resources, labor, and lands were heavily taxed by the designates of the shogun, completely impoverishing them. The desperate condition of the Ainu led to the untimely death of thousands over the next two centuries.

At the period when the portraits were painted, the Ainu were divided into two camps: those who resigned themselves to accepting Japanese domination in the form of the Matsumae daimyo and those who resisted and strove to remain independent and retain their control of the area trade with related Ainu peoples on Sakhalin Island and on the northeast coastal areas of Manchuria. It should be noted that a small number of Japanese sympathized with the plight of the Ainu.

The individuals portrayed in the Kakizaki portraits cooperated with the Matsumae daimyo. The portraits displayed furnishings and clothing selected by the daimyo's representatives from trade goods. The artist himself, who had assumed the name Kakizaki, was a member of the daimyo's family, and his uncle (Matsumae Hironaga) served at the Matsumae Court.

Many in Tohoku (northern Japan) see the portraits as humiliating documents and those who served as models for them as traitors to the Ainu cause. The portraits are, however, defended by those who feel the willingness of some Ainu to cooperate is understandable in light of their difficult circumstances. Most agree that the portraits succeed in

Across the sea on the island of Hokkaidō, where the Ainu were driven by the Japanese centuries ago, lies the port of Hakodate. In Hakodate's Museum of the History of Northern Peoples, beside fine examples of indigenous Ainu robes made of elm bark appliquéed with cotton, two impressive early Qing-dynasty Chinese robes greeted me with yet a new designation, "Santan Nishiki" (Santan brocade). A series of copies of late eighteenth-century portraits of one family of Ainu chieftains was also on display. The chieftains in the portraits are dressed in Chinese silk court robes, and even more surprisingly, some are sitting on red wool tapestries painted with ink, apparently of Buddhist Uighur origin (see fig. 5.31).

illuminating the lively commerce with the Asian mainland and that the clothes and carpets, though not an accurate portrayal of Ainu dress, have merit in their ability to reveal the extent of that historic trade. Although the portraits are misleading as indications of authentic Ainu culture and taste, they remain the sole portraits of eighteenth-century Ainu available to us.

5.30 Kojima Sessei after an original by Kakizaki Hakyō, portrait of an Ainu chieftain's son from the Ishū-Retsuzō series, 1843 (original 1790). Painting on paper. Collection of Kitao Michi. In this painting a young chieftain (purportedly the son of the woman portrayed in fig. 5.31) wears a red Russian wool coat on top a Chinese silk court robe. Courtesy of Kitao Michi and Prof. Inoue Kenichiro, Miyagi University.

5.31 Kojima Sessei after an original by Kakizaki Hakyō, portrait of an Ainu chieftain's wife from the Ishū-Retsuzō series, 1843 (original 1790). Painting on paper. Collection of Kitao Michi. One port of entry for the painted wool tapestries was through the Ainu lands in Hokkaidō. In this painting, an Ainu chieftain's wife wears a Chinese court robe and sits on a fur rug placed on top of a Gansu Chinese wool tapestry carpet. Courtesy of Kitao Michi and Prof. Inoue Kenichiro, Miyagi University.

Santan is the old name for the area of coastal Siberia surrounding the Amur River, and the name for members of the Urichi tribes who live there. Both traditional and local variations on Chinese court robes were worn in Santan, which was a tributary region of China. Just south in the town of Deren (a site presently flooded over), the Qing government maintained a provincial office (Fairbank, Reischauer, and Craig 1965, 2: 21, 42–44, 47). Santan tribespeople brought furs, such as marten and wolf, to the Qing officials. These were highly sought after by the Chinese who used them for the tribute owed or traded them for silk. In return, the Santan leaders acquired and wore court robes at these official trading negotiations. The Chinese court robes

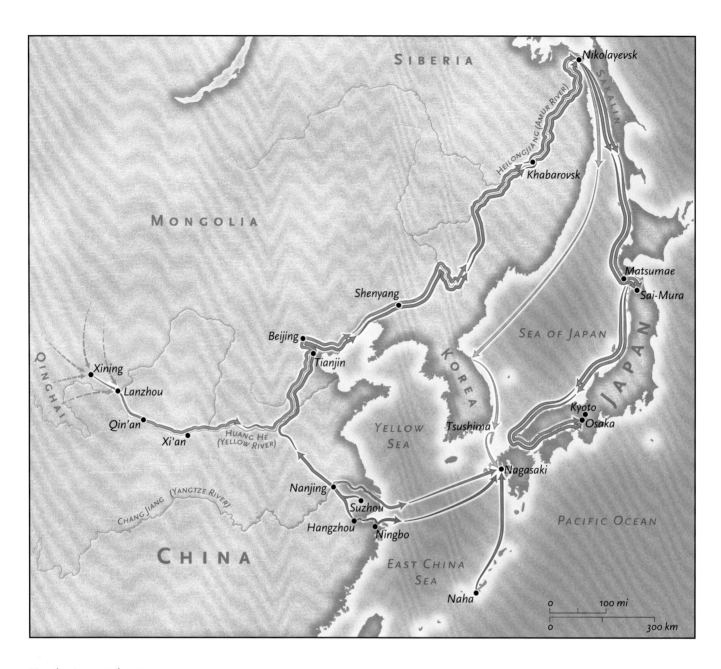

Map showing several routes
through which foreign textiles
and other goods were imported
into Japan.

belonging to Urichi families are still worn for ceremonial occasions in Santan today (Hokkaidō Shinbun-sha 1991, 44–46).

Japanese merchants traded with the Ainu, who lived inland and further north, along the coast of Hokkaidō for about three hundred years (1500–1800 C.E.). The Hokkaidō Ainu made courageous sailing voyages northward to their tribal cousins, the Ainu of the southern part of Sakhalin Island. The northernmost tip of Sakhalin lies close to the mouth of the Amur River on the Siberian mainland. Sakhalin Island Ainu and Santan people from the Asian mainland maintained a lively trade in furs and in kelp (*konbu*), a Japanese food prized if harvested in the north.[6] The chieftains of the Sakhalin Ainu received Chinese court robes as gifts or traded for them with Santan tribespeople (Hokkaidō Shinbun-sha 1991, 6–10; Ohtsuka 1993, 22–31).

It may be speculated that many illegal or outdated robes were sent by the agents of the Qing dynasty from Beijing via the northern river routes and seas since this was the least costly way to ship them. Moreover, in the early years of the Qing, while their assumption of rule in China was still shaky, shipment of robes through the ancestral Manchu homelands might have meant greater control over their permanent disposal abroad. Outdated robes were likely sent as well from the Chinese coast to the Japanese port on Tsushima Island and then on to Nagasaki. Korean ships, some of which were licensed to trade with Japan, docked at Tsushima, where they brought Chinese and Korean goods. The trade in court robes via the Hokkaidō route diminished significantly at the beginning of the nineteenth century. The highly profitable and unregulated commerce enjoyed by the Ainu eventually came to the attention of the local Japanese ruler, the Matsumae daimyo, who took control in 1806 as an official of the shogunate (Serizawa, et al. 1990, 65). The robes were labeled Ezo Nishiki by Matsumae government officials, possibly with the intention of suggesting they were indigenous relics of Hokkaidō.

Although the international textiles used for *matsuri* have had primarily local significance for the residents of Kyoto, who have valued them as rare festival adornments, outside Kyoto, they are appreciated as precious relics of largely lost traditions. Their survival in Kyoto was occasioned by ardent devotion to maintaining those objects that were thought pleasing to the *kami*. Finding and utilizing the exotic was a means of creating the extraordinary environment required by *matsuri*. This was possible in Kyoto, home of the emperor and the former capital of Japan, as its inhabitants had been the recipients of treasures gifted to powerful persons by traders, adventurers, and the clergy, especially during the centuries of oceanic exploration. The high status and connections of the merchants of Kyoto, enabled their festival organizers to overcome the importation restrictions of the Edo-period shogunate. ●

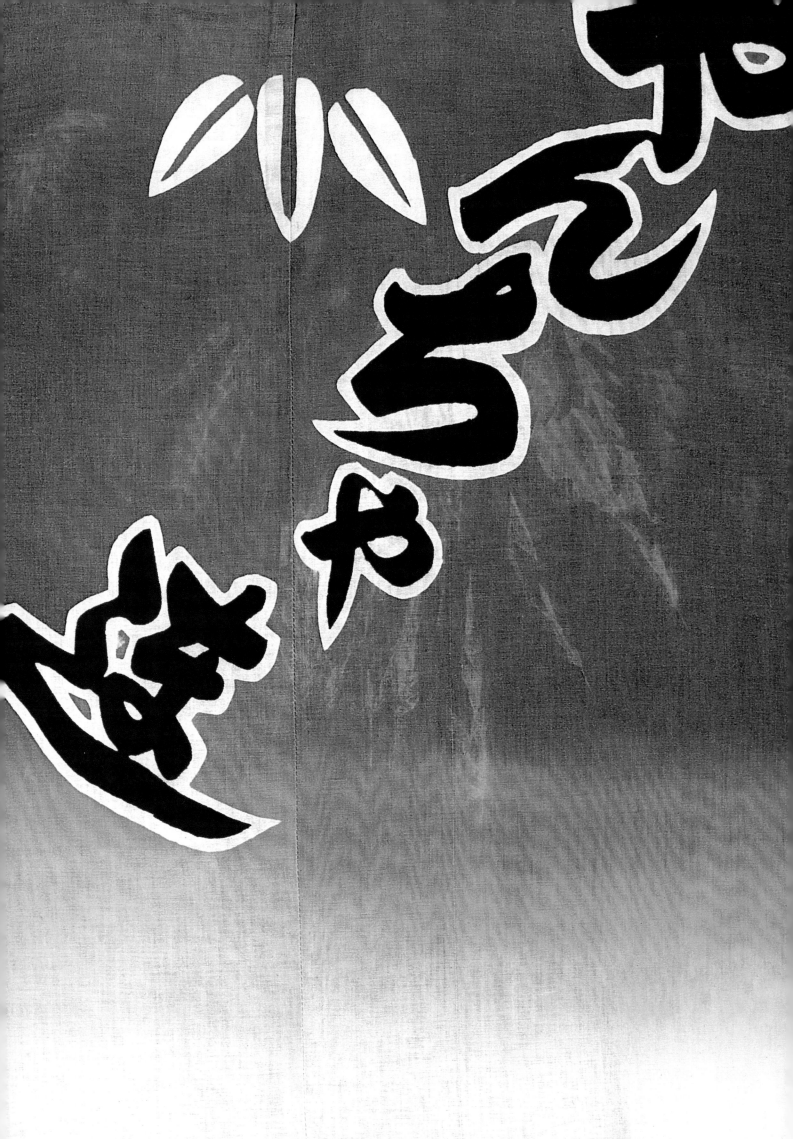

SIX

The Symbolic Meaning of the Inscriptions on Japanese Festival Jackets

HIROYUKI NAGAHARA

NUMEROUS SYMBOLIC ELEMENTS AND MOTIFS APPEAR IN MANY FESTIVAL CLOTHING designs. These have been created, maintained, and modified throughout centuries by artists and artisans following the social and cultural norms of their community and their own artistic flair. Most of these design elements are traditional motifs (such as cranes, tigers, or dragons) and those that are based on myths and legends or are of religious importance (figs. 6.1a–c). Of these design elements, the most important are the letterings inscribed on the lapels and the backs of *ha'pi* (festival jackets). Those inscriptions usually identify the group in the community to which the wearer of the jacket belongs, so that other group members can identify their group-mates and distinguish themselves from outsiders. These letterings on festival jackets do not, however, merely serve as identification tags. They also have to be artistically blended into the total design of the jacket and must express the individuality of the group to which its wearer belongs, hence the individuality of the wearer himself. The clothes one wears are a matter of personal choice and aesthetics, while putting on a *ha'pi* jacket in a festival setting is a social act, an act to identify oneself, to know who one really is, and to be born again (fig. 6.3a,b). Inscribed *matsuri* garments worn by group members at the time of festival sanction a community to periodically call attention to its existence, to confirm its importance to the members, and to celebrate its rebirth at once.

Detail of fig. 6.3a.

THE JAPANESE WRITING SYSTEM

Prior to the seventh century, the Japanese language was strictly a spoken one without any writing system. By the eighth century, the Japanese started to make use of what they call *kanji* (Han Chinese characters) to write, first completely in Chinese, then in their own language (fig. 6.2a,b). They also developed two syllabary systems (called *kana* syllabaries) by graphically modifying *kanji* characters, to represent the inflectional endings of verbs and adjectives, that cannot be represented by *kanji* characters (which are used only to represent names and concepts). Like the Egyptian hieroglyphics, the

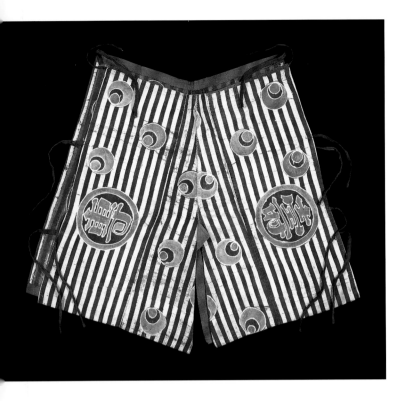

6.1a Trousers, early twentieth century. Cotton, stencil-dyed. L: 88 cm. FMCH X2000.40.1a; Gift of Dr. Brenda Buller Focht.

These striped trousers for a member of a troop of festival performers are decorated with the Buddhist jewel motif bestowing riches. The *kanji* (Han Chinese) character on the right says *kotobuki*, or blessings (fig. 6.1b), and that on the left, *sen*, or dedicated (fig. 6.1c). The trousers were probably worn by a *shishi*, or lion, dancer at a festival in the northeastern region.

6.1b The *kanji* for *kotobuki* (blessings).

6.1c The *kanji* for *sen* (dedicated).

6.2a Fireman's coat, late Edo-Meiji period. Cotton, *sashiko*-quilted. L: 117 cm. FMCH X82.1385a; Gift of Keigi Higashi.

Brigade coats worn by firemen are often inscribed, as in this example from Tokyo dating from the late nineteenth century. The *kanji* character here is *tetsu*, or iron, likely to be part of the name of the group (fig. 6.2b). The *kanji* is surrounded by billowing clouds suggesting rainfall, a frequent motif chosen by firemen.

6.2b The *kanji* for *tetsu* (iron).

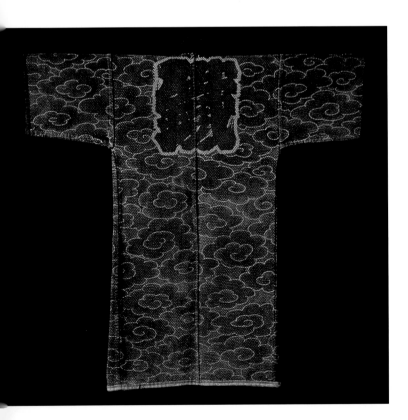

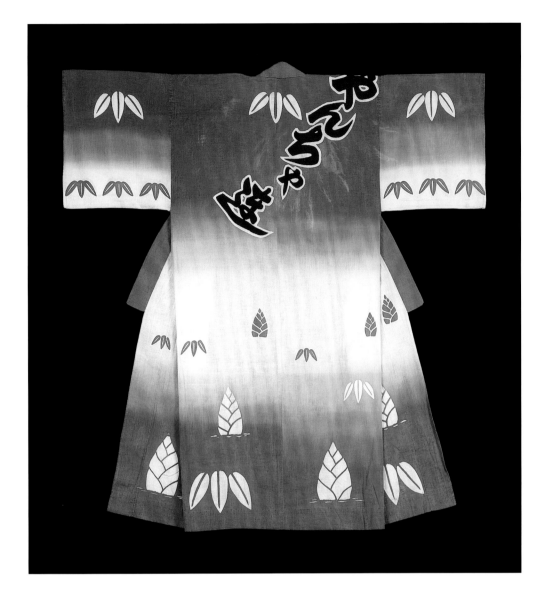

6.3a *Yukata* (summer kimono), circa 1989. Cotton. L: 133 cm. Collection of the Asian Cultural Arts Trust.

This *yukata* is inscribed impudently on the back with the name Yancha Ren, a combination of the word *yancha* (rascals; rambunctious, mischievous boys) in syllabary script (*hiragana*) and *ren* (association) in a single *kanji* character (fig. 6.3b). Bamboo shoots are a common motif symbolizing the wish of parents that their boys may grow tall, strong, resilient, and fair, like the shoots themselves. The motif is very fitting for this group of young men, who call themselves "rascals." The *yukata* is dyed shades of green (often described by the Japanese term *ao* [blue-green, emerald]). The *yukata* was worn at Awa Odori Festival, Tokushima Prefecture.

6.3b The name Yancha Ren, a combination of the word *yancha* (rascals) in syllabary script (*hiragana*) and *ren* (association) in a single *kanji* character.

earliest *kanji* characters used in Chinese were pictographic and diagrammatic; however, in later years, they became increasingly abstract in form as well as in what they symbolize.

The characters from which *kanji* ultimately derived originated in China between 2000 and 1500 B.C.E. The term *kanji* is used by the Japanese to represent the characters introduced during China's Han dynasty (207 B.C.E.–220 C.E.). The same term is still used to refer to those members of Chinese society regarded as indigenous people, who form the majority of the population in the traditional core of Chinese cultural territory, the eastern and southeastern provinces surrounding the Yellow and Yantse Rivers.

Originally, markings were usually inscribed on bones and tortoiseshells and were often connected with divination rites. At first they were mostly simple pictographs

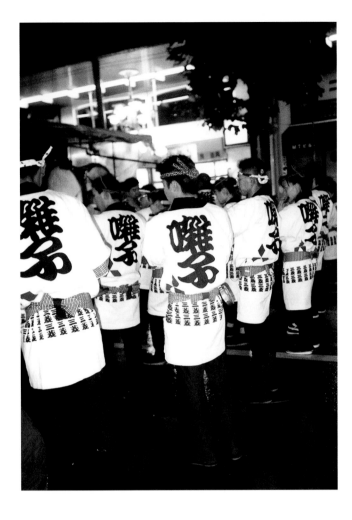

6.4b The *kanji* for *hayashi* (festival musicians).

6.4a The white *ha'pi* worn at Neputa Matsuri, Aomori Prefecture, are inscribed with the characters for *hayashi* (festival musicians or troop; see fig. 6.4b).

(e.g., the character for eye being a pictorial representation of the eyes) and diagrammatic representations (the characters for the numbers one, two, and three, being written as one, two, and three tallying bars, respectively). With the passage of time these pictographs became increasingly complicated and abstract in meaning and in graphical forms. For example, one pictograph was combined with another to form new characters representing new names and concepts. Although *kanji* characters represent names and concepts, because those names and concepts are actual words in Chinese, *kanji* characters were also associated with the phonetic sounds corresponding to those Chinese words. For example, the character for *fire* represents the concept of fire, which is *huo* in Chinese, and the character became associated with the sequence of sounds *huo* (or read as *huo*). In terms of character forms, there were many different versions of the same character forms, which were later standardized. Today's characters have been standardized to one of the squared-off versions used in ancient times. The early characters numbered as many as fifty thousand around 200 C.E.

By the third or fourth century C.E., *kanji* characters were introduced to Japan by Chinese and Korean monks. In order to read and transmit the Buddhist scriptures (or sutras), one had to be literate in Chinese, as the scriptures were Chinese translations of the original Buddhist texts written in Sanskrit in India. To be enlightened in Buddhism, one had to be enlightened in Chinese. Since the earliest role of *kanji* was as the transmitter of scriptures, the characters themselves became infused with an aura of sanctity and erudition.

In the early centuries of the present era, the Japanese language existed only in spoken form; beginning in the fourth century, the Japanese started to adopt the Han Chinese characters in order to write texts in their own language. While Chinese characters represent meanings, they are also associated with the sounds of the spoken words for those meanings in Chinese (figs. 6.4a,b). The Japanese language has its

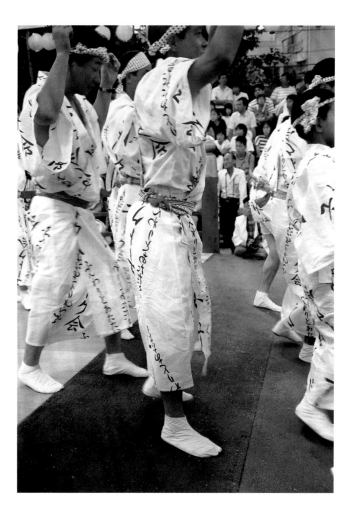

6.5a The *kanji* character for shadow or lunar, which is *yin* in Chinese, and *in* and *kage* in Japanese *on* and *kun* readings.

6.5b The *kanji* character for sun or solar, which is *yang* in Chinese and *yoo* and *hi* in Japanese *on* and *kun* readings.

own spoken words for those meanings, however, so the same characters became associated with the sounds of the spoken words for the same meanings in Japanese as well. In other words, when Chinese characters were adopted by the Japanese, they represented both Chinese and Japanese words for the same meanings. It is exactly like the case of many Latin words that have multiple readings. For example, the Latin abbreviation *cf.* can be read as "confer" (the Latin word) or "compare" (its English equivalent), but the symbol itself means the same thing. The Chinese word associated with a character is called the *on* reading, and the Japanese word is the *kun* reading of the character. For example, the character for shadow or lunar and the one for sun or solar are the same in Chinese and Japanese, but Chinese read them as *yin* and *yang*, whereas Japanese read them as *in* and *yoo* (the *on* readings) and as *kage* and *hi* (the *kun* readings). The meanings of these characters themselves remain the same as in Chinese, however (figs. 6.5a,b). This is why the Japanese who cannot speak Chinese are able to interpret Chinese newspapers to some extent.

Since there are fundamental differences between monosyllabic classical Chinese and polysyllabic early Japanese, the Chinese system was inadequate to represent Japanese words in writing, particularly verbs and adjectives, which have inflectional endings in Japanese but not in Chinese. Those inflectional endings are grammatical, sometimes referring to the present or past tense, or the status of the speaker. (They are exactly like the *-ed* endings for many English verbs in the past tense.) To solve this problem, two phonetic syllabaries called *kana,* were created by graphically simplifying those *kanji* characters, which when read aloud sounded like the basic syllables of the language (figs. 6.6–6.8). *Hiragana*—flowing and curvilinear in appearance— was created from the cursive forms of full characters, whereas *katakana*—angular or geometric in appearance—was created from one segment of the full character. It is easy to distinguish *kanji* characters from *kana* letters because the graphical shapes

6.6 Scattered diagonal inscriptions of *kanji* characters mixed with *kana* provide the pattern on this *yukata* from Awa Odori Festival, Tokushima Prefecture. The *yukata* is white with deep blue and red inscriptions and is worn by dancers wearing white *tabi* (split-toed socks) and *hachimaki* (headbands). Photograph by GGG, 1989.

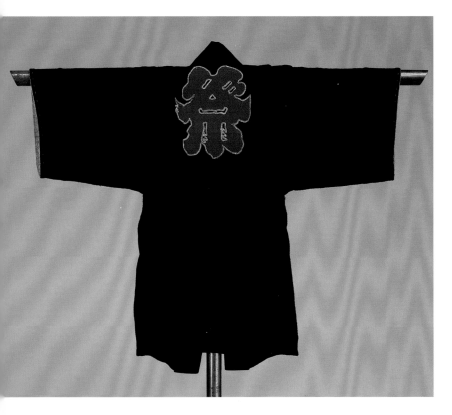

6.9 The *hiragana* letter "ii" creates a crest design on the back of this blue-and-white festival jacket. Photograph by GGG, Otanjōbi Matsuri, Kyoto, 1994.

of *kana* letters consist of just a few brushstrokes (fig. 6.9), whereas those of *kanji* characters are much more complex and have as many as twenty or more strokes.

There are no linguistic-functional differences between the two syllabary systems; therefore, any word can be written in either *hiragana* or *katakana*. There was, however, a difference in how they were used in the early centuries in Japan. Learned men used *kanji* almost exclusively to write documents, following the Chinese grammar. This is analogous to Latin having been used exclusively in religious contexts in the Christian world. On the one hand, *hiragana* was called *onna-moji* (women's letters) and was used mostly by women including Murasaki Shikibu, the author of the *Tale of Genji* in the eleventh century. On the other hand, *katakana* was used to annotate Chinese texts. In modern days, *katakana* is used to write mostly loanwords from Western and other foreign languages, which do not have any meaning in the lexicon of the Japanese language and, therefore, cannot be expressed by essentially ideographic *kanji*. For example, there is no word or concept denoted by the English word *computer*, so it must be phonetically written by *kana* in Japanese since there is no *kanji* character representing that concept. There are many such words in any language. For example, the English term *tsunami* is a loanword from Japanese. Likewise, foreign personal and place names do not have any corresponding *kanji* characters so they must be written in *kana*.

Personal, group, and place names written in Japanese texts are usually given in *kanji* (fig. 6.10). Since *kanji* characters represent meanings, a name written in *kanji* is not just a sequence of sounds but a sequence of meanings as well. This is in stark contrast with foreign names written in *katakana*, since they are just sequences of sounds and mean nothing in Japanese. The foreign names written in *kana* are just for identification, whereas Japanese names mean something to them and are written in *kanji*. Since anything written in *kanji* means something, names that are written in *kanji* are often identified as the persons and groups themselves and become their "signatures." Furthermore, not only the names written in *kanji* but the *kanji* characters themselves have become regarded as personal and sacred to those who write their names and group names in *kanji*. Writing someone's name using the wrong characters is a blunder of social significance.

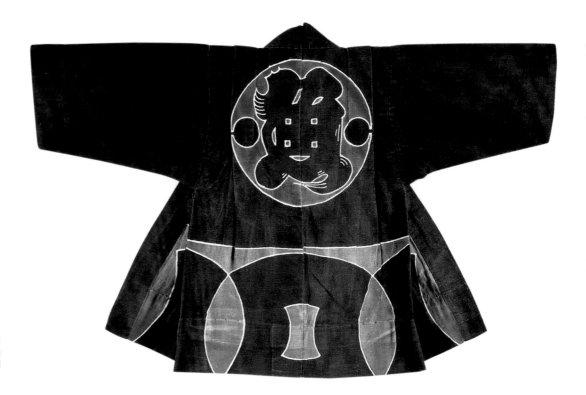

6.7 (OPPOSITE, LEFT) Child's *ha'pi* (festival jacket). Collection of Iwao Nagasaki

Some *ha'pi* are simply inscribed with the generic character for *matsuri*, or festival.

6.8 (OPPOSITE, RIGHT) Infants and toddlers may wear a stenciled *matsuri* character on their stomach warmers. Collection of the National Museum of Ethnology, Senri Expo Park, Suita, Osaka, no. H25840.

THE MAGICAL POWER OF LANGUAGE

It is true that names, particularly personal names, have a great social, cultural, and personal import in the Western world as well as in Japan. People give their children special, beautiful names and names with biblical or cultural references hoping to ensure the best for them. We know the importance of one's signature, which is symbolic of a person's essence. There is a difference, however, between personal names in the West and Japanese names. The latter are written mostly in *kanji*, which always means something, whereas the former are written in the same alphabet used for any word, sacred or vulgar. *Kanji*, in particular, are felt to be special because of their social, cultural, and spiritual transcendence beyond mere signs in Japanese and other Asian cultures. (Even in Korea, people still use Chinese characters to write their names, despite the fact that they have a very efficient writing system of their own and there is no need for Chinese characters.) This is the very reason why calligraphy became an art, one used in soul-searching in Zen Buddhism during the medieval period in Japan (fig. 6.11).

Language is believed to possess a certain magical power in many cultures; therefore, the use of certain words could be considered sacrilegious. One can cast a spell on somebody by incantation alone. There is also a belief in some "primitive" societies that taking a photograph of someone will take his soul. They believe that the picture taken of him becomes his "pictograph," which, with its magical power, robs that person of his soul. The act of wearing a *ha'pi* jacket with an inscribed crest and letterings on the back in a festival setting is a transcendental act for self-assertion and self-transformation.

There is a strange Japanese tale told of Hooichi, a blind *biwa* (lute) player and reciter. He was famed for his skill, and he was particularly good at reciting the story of the battle at Danno-ura, where the Heike clan—including their imperial infant— perished in the sea at the battle. As dead spirits the Heike clan heard of Hooichi's skill as a reciter and duped him to their cemetery to have him recite the story of Danno-ura. He was superb, so they told him to come back next day. Hooichi, unaware that they were the dead spirits of the Heike clan, was bewitched. The next night, some of his friends realized this, and a priest who was sympathetic toward Hooichi bade

6.10 *Ha'pi* (festival jacket), early Showa period. Cotton, *tsutsugaki*-painted. L: 62.2 cm. FMCH x86.4426; Anonymous Gift.

This festival *ha'pi* from the Tsukiji neighborhood of Tokyo—the fish market district—is inscribed with the character for fish read as *sakana*, in this case in a pictographic style. The background of the crest is formed from the shape of a weight used on a scale for weighing fish.

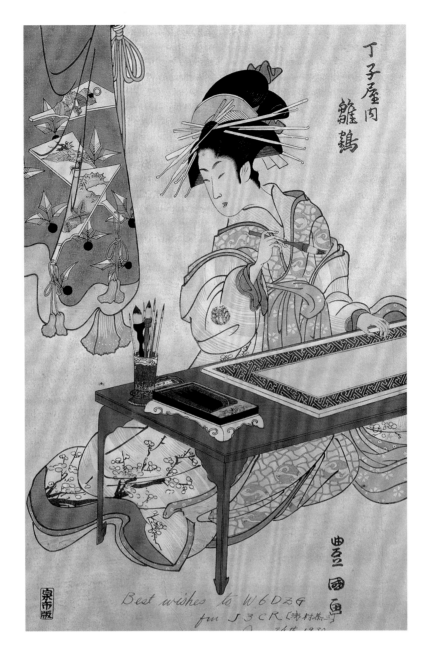

6.11 Toyokuni. *Chōji Yanai Sukaku*, eighteenth century Woodblock print. Inscribed in English: "Best Wishes August 24, 1930." Collection of the Asian Cultural Arts Trust.

Kakizome (lit., "calligraphy first in the year") is the inscribing of one's New Year's resolution. A young courtesan tests her skill in inscribing the first characters of the New Year, expecting that an admirable result will portend a successful year. Her kimono is decorated with an auspicious New Year's message called *shoo-chiku-bai* and consisting of the pine (longevity), bamboo (resilience), and plum (happiness). Above her the draperies are stencil-resist painted with designs of the *hagoita* (a decorative badminton paddle) used in a traditional game played at New Year's.

him not to answer their call when they returned to visit him at night. The priest then stripped him and wrote the text of a holy sutra carefully all over his body, except his ears, which the priest's acolyte overlooked. Hooichi, covered and protected by holy text, was invisible to the spirits and was therefore, safe except for his ears. There was no writing on the ears to make them invisible, and the spirits saw them and tore them off.

His story spread far and wide, and Hooichi became known by the appellation of Miminashi Hooichi (Hooichi the Earless). Someone wearing a *ha'pi* jacket with an inscribed crest and letterings on the back in a festival setting is a Hooichi, clad with the text of the sutra *Transcendent Wisdom,* and can wade through evil spirits in the twilight zone, to be blissfully born again. This is truly a religious experience.

THE LETTERINGS ON *HA'PI* JACKETS

Both *kanji* and *hiragana* appear on festival coats, but *kanji* is used more frequently as a form connected with tradition, erudition, and thus social status. Knowledge of around nine-hundred *kanji* characters is deemed necessary by Japan's Ministry of Education and Science for graduation from elementary school, and literacy in around two thousand characters is required for graduation from high school. Facility with *kanji* reading and writing is considered the mark of a truly educated man. This last

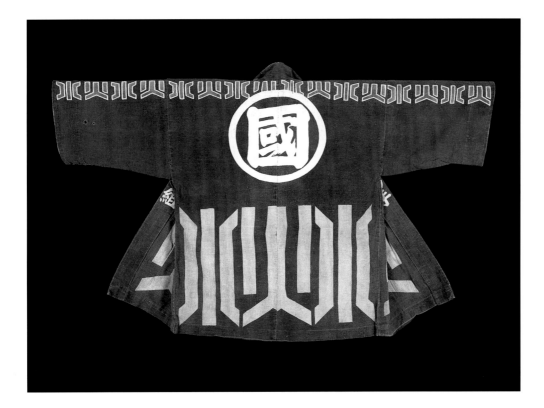

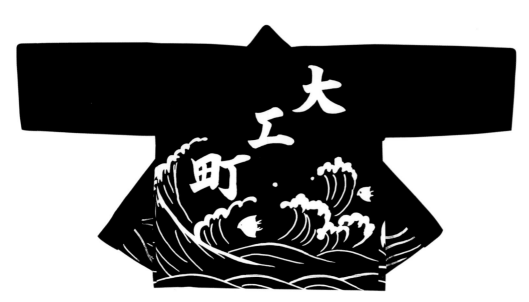

6.12a (ABOVE, TOP LEFT) Fireman's coat, Meiji period Cotton, *katazome*-stenciled. L: 77 cm. FMCH x86.4411; Anonymous Gift.

Coats worn by rank-and-file firemen are also worn in firemen's festival processions, each inscribed with a *kanji* or *hiragana* letter, identifying the men's fire company. The background pattern is a geometric repeat design, communicating the same information. Together, they enable the company's identification from some distance away. On this fireman's coat the two characters representing fire (*hi*) and water (*mizu*) have been stylized and repeated to form a visual rhythm (see figs. 6.12b,c)

6.12b (ABOVE, TOP RIGHT) The *kanji* for *hi* (fire).

6.12c (ABOVE) The *kanji* for *mizu* (water).

6.13 (ABOVE, LEFT) Child's *ha'pi* (festival jacket), mid-twentieth century. Rayon and cotton. L: 60 cm. Collection of the Asian Cultural Arts Trust.

This child's *ha'pi* is inscribed "Daiku machi" and "Kodomo Naka" meaning "Carpenter town children extend their friendship." The jacket's design incorporates waves and spray. At first glance it looks like expensive *tsutsugaki* hand painting, but it is actually a stenciled (*katazome*) design with the stencil cut to resemble hand painting.

remark referred specifically to the male gender until recent decades, since in practice *kanji* study was undertaken primarily by men, and *hiragana* was the written form associated with the writing of women. The use of *kanji* on festival clothing, on the one hand, implies strength, masculinity, rank, and seriousness of purpose (fig. 6.12a–c). *Hiragana*, on the other hand, suggests a playful, informal attitude, and its curvilinear appearance often dances across garments in an irregular fashion, at once emulating the swaying movements of dancers, and suggesting jocularity and irreverence. Even the "rascals" referred to in figure 6.3 should know that, as they are dancers.

The difference between *kanji* and *hiragana* is like the difference between the moon and the sun, yin and yang, geometric and curvilinear. Festival clothing designers recognize this fact and take advantage of the connotations and characteristics of different scripts when creating motifs by employing them either as a main design element or as a background repeat pattern (fig. 6.13).

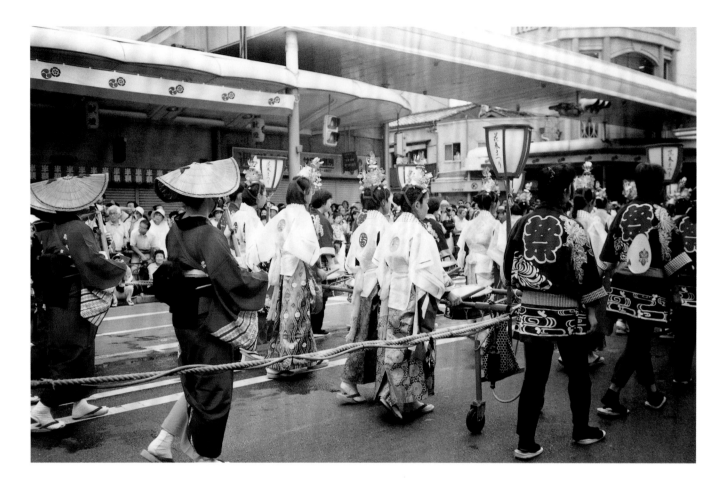

6.14 Visiting troupes of festival musicians and dancers. Photograph by GGG, Otanjōbi Matsuri, Kyoto, 1994.

6.15 (OPPOSITE) Fireman's coat, Meiji period. Cotton, *sashiko*-quilted, *tsutsugaki*-painted, and *katazome*-stenciled. L: 101 cm. Collection of the Asian Cultural Arts Trust.

The design elements of this fireman's coat, the sleeves of which are missing, include a crest encircling a *kanji* character, broken in two at the garment's closure to provoke a slightly jarring sensation to viewers.

THE LINK BETWEEN ART AND CALLIGRAPHY

In Japan, art and calligraphy have traditionally been intricately linked. Calligraphy itself became an art, one that has been closely associated not only with erudition but also with the activities of the tearoom and its hangings. In the hushed elegance of the indoor tea ceremony space or in the contemplative corner of the household *tokonoma* (alcove), inscribed scrolls are hung for purposes of contemplation, communication, and focus. Just as the *tokonoma* itself, its scrolls, and its flower arrangements receive abundant attention as to their aesthetic appropriateness, the style and drawing of calligraphy on festival textiles is the subject of careful decision making. Nevertheless, in the crowded outdoor festival arena or during the boisterous *ha'pi*-coated street procession, the carefully planned and brashly inscribed festival coats must also command attention and excite speculation among festival-goers. Throughout the buzzing crowd, opinions are commonly offered and the most outstanding graphics, which deftly capture the essence of the group or the festival, are noted (fig. 6.14).

Individual examples of calligraphy on scrolls or paintings have been traditionally accepted as revelations of the character, emotion, and nonverbal qualities of the writer; similarly, calligraphic inscriptions on festival coats are assumed to express the spirit, energy, talent, skill, and intentions of a group (fig. 6.15). By means of the style of calligraphy—its position, shape, color, and strength—inscriptions also attempt to convey the character of the group they garb—its public character. Calligraphic designs identify while they offer revelations of a group's desired self-image, commitment, traditions, and goals—all of which are at the essence of the festival's meaning to the

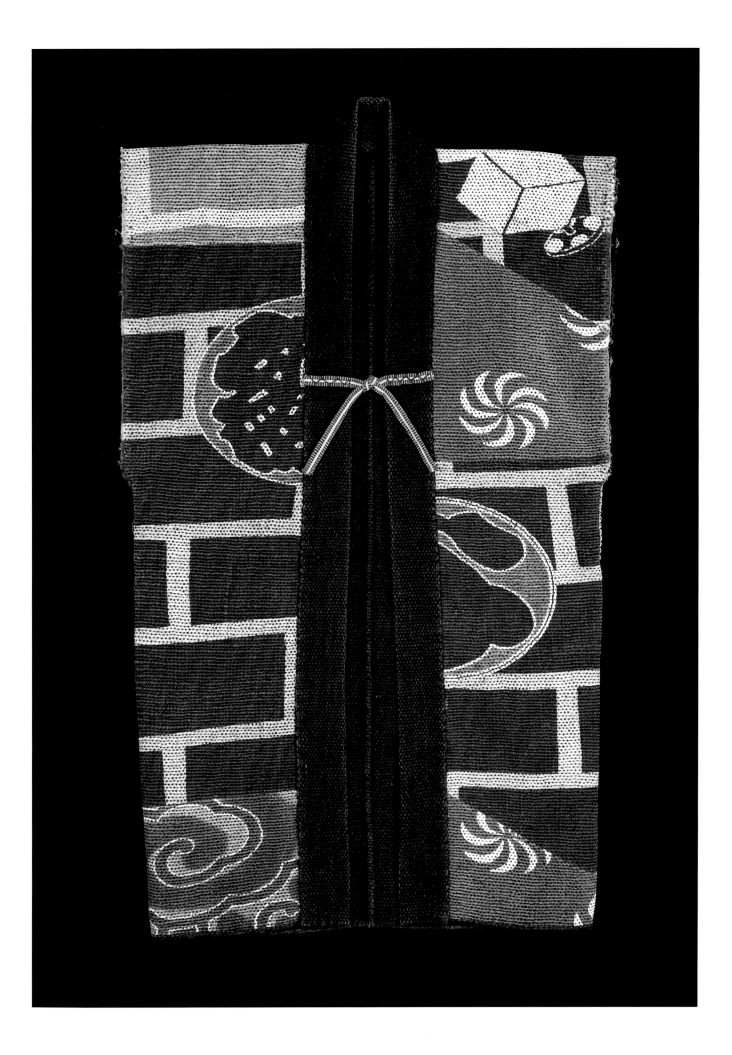

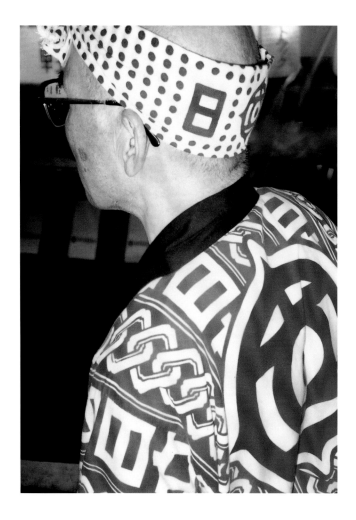

6.16b (ABOVE) The *kanji* for *hi* (sun) and *tachi* (stand).

6.16c (LEFT) The characters *hi* and *tachi* (see fig. 6.16b) combined to form the logo for Hitachi.

6.16a The two characters *hi* (sun) and *tachi* (stand) on this headband (*tachi* is not visible in this picture) are combined and encircled to form a crest as the company logo for Hitachi. The same crest is also visible on the back of the man's jacket. The wearer, most likely a proud employee of Hitachi, marches with his comrades in the procession at Kurama Fire Festival. Photograph by GGG, Kurama, 1991.

group. The means of accomplishing this is through the choice of characters, auxiliary inscriptions, related pictorial motifs, styles, and sizes of the relevant parts. Another example of a neighborhood group's gesture for attention is that of gang members in American cities who cover walls and billboards in large scrawls of graffiti. The gang must also include skilled graphic designers intent on securing recognition for their group. On Japanese festival coats, the thought that goes into the calligraphy and the planning of an entire garment, as well as the skill with which it is executed, are not only heavily weighed by the members but also spontaneously evaluated by spectators once they are publicly displayed.

The garments, along with their inscriptions and designs are repeatedly observed during *matsuri* by one's colleagues, friends, and neighbors, when they are extensively exhibited however short the *matsuri* may be. Graphic designs and calligraphic touches are compared informally but publicly, with past versions paraded by that neighborhood, as well as judged with those of competing groups. In Japanese towns, the goal of such recognition is to affirm the group's devotion to the *matsuri* and its aim of community renewal and revitalization.

LABELING THE BODY: THE TATTOO

Today's Japanese tattoo art is a residual product of the Edo Period (1615–1868). By the end of the seventeenth century there were several literary references to the practice of tattooing. In *The Life of an Amorous Man* (*Kōshoku ichidai otoko*) by Ihara Saikaku (1642–1693), for example, the main character had a word in the form of a *kanji* character tattooed on his hand.

The standard term for tattoo in modern Japanese is *irezumi* (insertion of pigment, *zumi* (sumi), or charcoal ink). One of the Ukiyo-e prints by Kitagawa Utamaro (1753?–1806) shows a woman tattooing her lover. At that time, tattooing was definitely

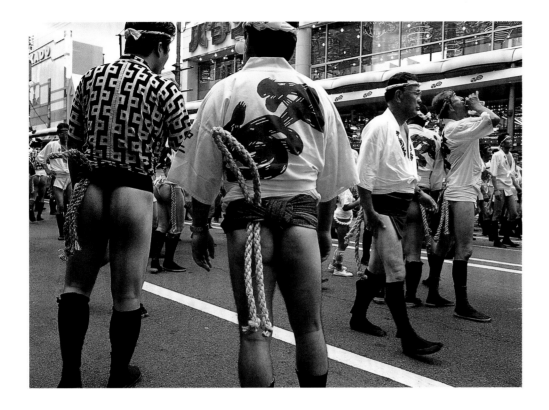

6.17 In place of *ha'pi*, lightweight cotton shirts are inscribed with the names for the festival groups at Hakata Matsuri on Kyūshū Island, a sunny southern locale. Photograph by Yuge Sei, Otanjōbi Matsuri, Kyoto, 1994.

outside the law and the ideologies of polite society. In that world of outcasts, which included Kabuki actors and Ukiyo-e printmakers, the tattoo became a popular means of those who rejected the oppressive and numerous rules of the Edo society. Within the groups mentioned above, it appears that firemen in particular adopted the practice of having their bodies elaborately tattooed. Evidently, bearers of palanquins used tattoos to attract customers, and tattoos were very popular with carpenters and construction workers—groups characterized by their boisterous and unapologetically brash behavior and speech. Construction workers and carpenters, accustomed to the skills required for building and climbing scaffolds, often filled the ranks of volunteer firemen. The graphics that adorned their bodies may have inspired transfer of similar themes to firemen's parade coats.

CRESTS

Ha'pi festival jackets were not the only type of jackets worn. In premodern periods, *hanten* (work jackets) were worn by merchants and servants, in addition to firemen and other professionals. The work jacket for a merchant, for example, had his shop name written on the lapels and either the crest of the merchant family or the whole name (or a character or two from the name) written prominently on the back. The crests of many merchant families were often artistic renditions of a *kanji* character or two taken from their names. These work jackets were probably medieval versions of modern-day work shirts and jackets with company names and logos on the back (figs. 6.16a–c), or the uniforms of athletes with their team names noted on the back.

The letterings on the lapels and backs of jackets (particularly those on *ha'pi* festival jackets) developed into more than mere identification marks. They became more artistically rendered as part of the total design of the jacket (see fig. 4.73). The inscriptions on some jacket designs are so artistically distorted that at times they are

unrecognizable as anything resembling *kanji* or *kana* letters and look more like a form of abstract calligraphy or brush painting (fig. 6.17). Moreover, the letterings on the backs of jackets (particularly *ha'pi* jackets) became a sort of a symbol for group membership solidarity among those who wear the jackets of the same design, because the letterings (or their artistic renditions) on the backs are the only distinct symbol used to identify other group members who wear the jackets of the same design. They are very distinct from other design motifs such as dragons, which are quite common across many different types of festival garments and on the *ha'pi* jackets of many different groups.

As a result, these festival jackets have become strikingly more and more emblematic of the tattoos worn by the members belonging to the same fire brigade in premodern days or the members of the same gang group in modern times in terms of both artistic expressiveness and group membership identity. That is, they are both artistically expressive and identify the group to which the wearer belongs or with which the wearer wants to be identified. These similarities aside, there is an important difference between the design on the back of a festival jacket and the tattoos on a human body. Festival jackets are outerwear, whereas tattoos are worn directly on the body and usually hidden by everyday outerwear. Such difference between tattoos and festival jacket designs with inscriptions reveals the true meaning and function of festivals themselves—code sharing and code breaking.

CODE SHARING AND CODE BREAKING

Cultural symbolism is a system of symbols and representations in the domain of social and cultural events specific to the community that shares the same unwritten codes of social and cultural norms. Dress codes, in various forms and functions and in different cultures, are one example of cultural symbolism. For a man to wear a suit in his workplace, for example, is expected in many business firms and situations. It is true that some individuals and individual firms might not follow the same suit-wearing norm; but such code-breaking exceptions, in fact, prove the existence of the code itself. Code breaking is effective because there is an underlying code shared by the whole community.

Not all instances of code breaking are cultural, however. For example, wearing long hair in a ponytail for a man working for a Fortune 500 company is probably against the dress code of the company; but it is not necessarily cultural in its code-breaking nature because such an act is not necessarily shared and embraced by the whole community. Rather, it is more like an act of self-assertion of the individuality of the person who wears his hair in that style. Code sharing and breaking as cultural symbolism, however, are different from these cases of individualistic, self-assertive code breaking in that it is a system in which code breaking itself is shared and embraced by the whole community. Thus, the exceptionality of code breaking itself is an accepted and encouraged part of the game. Festivals, in almost all cultures, are the prime example of such a code-sharing and code-breaking system sanctioned by the whole community sharing the same social and cultural norms. Accepted and shared code breaking is the essential function of a festival, where the social norms governing everyday life can be relaxed and broken to allow the release of the inner tensions within the individuals living under the strict social codes of the community. That is, the festival is a socially controlled outburst and catharsis mechanism for code sharing and breaking. Everything revolves (including life itself), but the turns are cyclical through sharing and breaking of the social and cultural norms of the community.

For individual participants, the festival provides the opportunity to transform themselves by means of the ways in which they present themselves (using masks, makeup, and body painting, and costumes) and by how they act in ways appropriate to how they look. In this sense, the way a person looks and dresses during festivals is symbolic of a staged outburst, which is the essence of the festival. Wearing clothes is a matter of necessity and personal choice most of the time in our daily life while putting on a costume at the festival time is nothing short of a social act sanctioned, sanctified, embraced, and encouraged by the cultural norms of the whole community. During these cathartic times, wearing a jacket with one's group name in *kanji* lettering forming a crest can be thought of as the symbolic act of revealing one's tattooed skin to the public. In other words, the tattooed skin, which is inner-wear, symbolically becomes an outerwear in the form of *kanji* crests and lettering on the backs of *ha'pi* jackets. Observe the same outburst/catharsis dramaturgy working in the performances of the rock star Madonna, who creates the cleverly calculated risqué—therefore, outburst, outcast, cathartic—images of the Madonna, by wearing an under[inner]-wear as an outerwear on stage. Festival truly is showtime. ●

Imagery and Symbolism
in Festival Textiles

GLORIA GRANZ GONICK

FESTIVAL COSTUMES AND TEXTILES ARE FREQUENTLY DECORATED WITH EMBLEMS THAT reflect the blessings of the Japanese deities. The goodwill of these deities is deemed crucial to success in all endeavors, including the production of works of art. Nature and its seasons are thought to be primary inspirations for artistic endeavor (fig. 7.1). A deeply felt obligation to reflect the ways of nature is considered responsible for the long-standing Japanese preference for asymmetry in design, consistently seen in examples produced as early as the Nara period (645–794 C.E.; Agency for Cultural Affairs 1981, 79). The physical environment, which is considered awesome and unpredictable, is evoked by the irregular and unexpected. The need to reflect the inclinations of materials is responsible for the focus on surface textures and natural hues. Raw, unadorned artworks that strive for harmony with the basic attributes of their materials are valued for being direct, honest, simple in form, clean in line, and in tune with the environment. Purity and simplicity are Shinto ideals embodied in every-day objects designed for utilitarian purposes (Lee 1981, 11–15; Yanagi 1972, 109–29).

At festival time however, in contrast with the everyday, these ideals are purposefully reversed (fig. 7.2). Contrived shapes, embellished surfaces, and startling color combinations assert themselves. Bold and even flamboyant objects and textiles appear that display little regard for reflecting nature, even though it may be the original source of inspiration. Playful forms are created. Play (*asobi*) is a quality the deities themselves demonstrate in the contradictions and surprises of the weather and seasonal changes, and this extends to the ironies evident in mortal behavior. The motifs that predominate on festival textiles frequently consist of whimsical images of fortuitous plants and trees, birds, animals, and fish, as well as highly stylized images of waves and clouds. Graphic symbols are requests for happiness, wealth, and long life from the *kami*, and they seek to attract their continuing attention.

Detail of fig. 7.2.

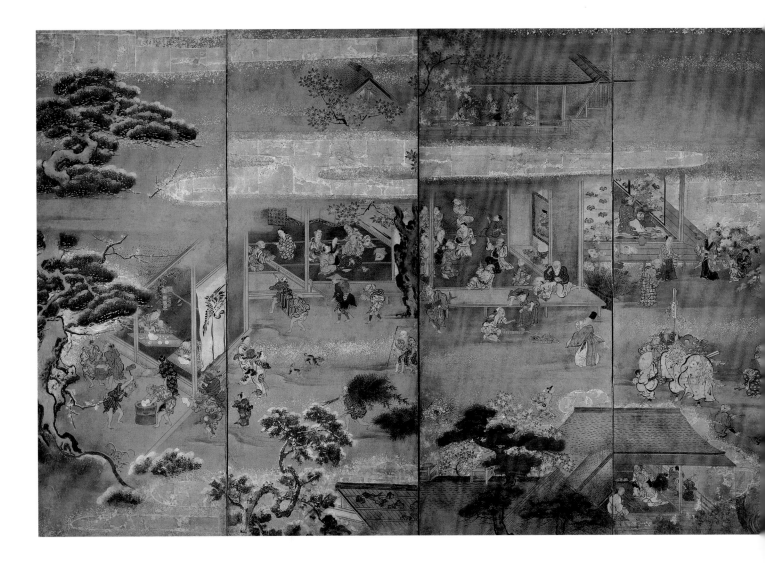

SHINTO AND FESTIVAL IMAGERY

A multitude of references to dress are contained in the *Kojiki*, the annals completed in 712 C.E. In particular allusions are made to the prestige obtained from wearing certain colors and fibers, particularly crimson and silk, which were evidently restricted to persons of rank (Phillipi 1968, 40, 108–9, 288, 371). Red was considered the color of rebirth, the primary goal of *matsuri* rites. When it could be afforded—red dyes were expensive—splashes of the color accented festival decor and dress. At the Gion Matsuri in Kyoto, procession hangings dyed with substantial amounts of red appear to have been preferred for at least the last five hundred years (fig. 7.3).

Shinto Constructions

References to sacred Shinto constructions are portrayed on festival textiles. Frequently employed motifs from shrine surroundings include the gateway, or *torii* (see fig. 4.89), the stone and bronze lanterns often placed before a shrine, and the sacred thick twisted rope (*shimenawa*) that is strung across *torii* or across the shrine entry to mark sanctified space and prevent penetration by evil spirits (see fig. 1.12).

Gift Offerings

Allusions are made on textiles to the offerings or gifts presented at *matsuri* time to the deities, or *kami*, the shrine, as well as family or friends. These include sake bottles and cups; gourds, which were used as sake vessels; bales or cakes of rice (*mochi*); fish; and fruits or vegetables. Rolls of fabric, jewels, and money are also offered as tribute and are popular as motifs. The *mikan*, or *tachibana* (tangerine) is placed on offering platforms particularly at New Year's. The round shape and bright

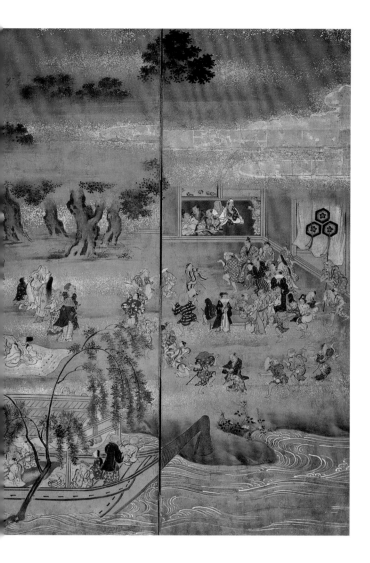

7.1 Artist unknown. Screen painting, circa 1700. Gold leaf and color on paper. 124 x 279 cm. Collection of Joe and Etsuko Price.

The artist of this painting is unknown, but it is thought to be in the style of Hanabucho Icho. The screen reads from right to left, appearing to portray summer and fall and then moving on to anticipate the New Year. Cooling watery scenes and activities of midsummer—including boating, picnics, and Bon dancing—give way to autumn's vibrant hues accompanied by *shishi* dancing and drumming, which are related to hopes for the harvest. Meanwhile, indoors sake parties and games are underway. As winter snows appear on pine branches, the pounding of *mochi* for New Year's celebratory cakes is joyfully pursued.

7.2 Detail of the theater coat illustrated in figures 1.14, 2.16. Depicted here is the flaming jewel, or "foxfire," which is thought to indicate the presence of foxes and thus fields heavy with rice.

7.3 Detail of a printed wool tapestry, Gansu Province, China, late nineteenth—early twentieth century. *Ke-tsutsureori* (wool tapestry) technique. L. 79 cm. Private collection.

Painted and printed tapestries like the one illustrated here were used as festival wagon draperies in Kyoto, red finding favor with festival planners for over five centuries.

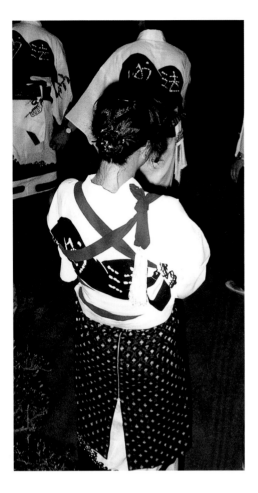

7.4 Obon dancers at Daimonji Matsuri in Matsugasaki, near Kyoto, wear *tasuki* shoulder braces that emulate the style worn by rice harvesters. Photograph by GGG, 1990.

7.5 Detail of a sleeve showing a tortoiseshell motif. Photograph by GGG, Tenjin Matsuri, Ueno-shi, Mie Prefecture, 1993.

orange color of the fruit is thought to suggest both the sun and the brightness of fire (Casals 1967, 11).

Since ancient times lobster and shrimp have been placed on offering platforms, particularly at New Year's festivals. These symbolized a person bent with age and thus represented wishes for long life. Painted or stenciled images of shellfish on textiles (see fig. 4.73) functioned in the same manner (Dower 1971, 98). In festivals in fishing villages, these motifs also had the special significance of expressing hope for a bountiful catch (Yamanobe 1983, 34).

Cords, Ropes, and Ribbons

In the eighth-century Shinto annals, the *Kojiki* and the *Nihongi*, cords, which were important in binding off sacred territory, persons, or objects, were frequently described (Philippi 1968; Aston 1972). Cords and tassels became a part of many textile designs, likely implying sanctification as well as felicitations (see figs. 4.63, 4.64, 4.66). Cord, tassel, and ribbon motifs were also brought to Japan with Indian Buddhist artworks in the sixth century. Actual cords and tassels have long been a feature of Japanese festival dress *(haregi)*; see figure 4.41d. Although they appear to be decorative fasteners and drawstrings, their prominent placement on costume suggests that they may have had a sacred function as well.

The *tasuki* (cords that crisscross the back and go under the shoulders; fig. 7.4), seen on the costumes of farm women during rice planting festivals *(otaue)*, are said to derive from cords that originally braced trays holding offerings proffered the deities. The shoulder braces can be seen on Haniwa figurines (circa 200 C.E.; The Asia Society 1960, 40, 42). In the Heian period (794–1185) *tasuki* were used by priests, to prevent their wide flapping sleeves from contaminating sacred offerings. During the past century *tasuki* were adapted to everyday dress, and city housewives as well as farm women hung them nearby to bind off loose sleeves while performing household tasks.

Animals

Shintoists considered certain animals to be the companions or messengers of the *kami,* and these sometimes appeared on textiles. In Japan the shadows on the face of the moon were said to be created by rabbits who were busy pounding rice to make *mochi* cake for the New Year (see fig. 4.44a). The rabbit was thus regarded as an auspicious animal, believed to embody the spirit of the moon (Dower 1971, 97). The *Kojiki* recounts the story of a rabbit who, stranded in the ocean, rode across the waves to the safety of the islands on the back of a crocodile. Elaborate themes involving animals could be rendered as textile designs using the freehand paste-resist painting technique known as *tsutsugaki* (see fig. 4.17).

The tortoise and the design of its shell were prominent symbols of long life imported from China (fig. 7.5). At the festivals at Matsuo and Izumo Shrines, the motifs played an especially important role, as the tortoise was sacred to those shrines. The tortoise was often portrayed with a mound of moss extending from his shell like a hairy tail, which the animal was thought to have accumulated from centuries of life along the riverbanks.

Plants

The motif of the plum blossom (see fig. 4.12a) suggests the bittersweet tale of the renowned statesman and scholar Sugawara no Michizane (845–903), who in his deified form is known as Tenjin. The plum motif, however, was popular even before his time (Dower 1971, 74). The pine functioned in Shinto symbology very early, although it was not used as an art motif until the Heian period (794–1185) after which it was inspired by imagery imported from China. The pine's thick knarled branches and evergreen foliage stood for longevity, and it frequently appeared on festival costumes of all types and in numerous interpretations over the centuries (see fig. 2.6).

The large raddish, or *daikon,* is used as a humorous fertility symbol due to its resemblance to an oversized male organ. This has given rise to the popular belief in the motif's powers of fecundity. The *daikon* is associated with both Shinto and esoteric Buddhism, as it is linked with the forked elephant head of the deity Shoten, whose blessings are believed to bring prosperity and success.

BUDDHISM AND FESTIVAL IMAGERY

Buddhist designs often appear simultaneously with those derived from Shinto as talismans and lucky symbols for the wearer. The Buddhist belief in the transitory nature of being is suggested by clusters of drifting clouds, floating mists, and partial images that disappear into negative space (see figs. 4.125a, 4.134, 6.3a).

Vine (Karakusa)

Buddhist motifs imported from the Asian mainland also include the scrolling leafy vine known as *karakusa,* which appears as an undulating line. This design was believed to have evolved from statuary depicting a halo of fire surrounding the head of the Buddha. The flame tips, which were paradoxically thought to be protective against fire, evolved into an arabesque form that became a slender and graceful honeysuckle vine. Later that design became the familiar bold spandrels and leaves of strong curvilinear lines and patterns (Mizoguchi 1973, 20–29). The *karakusa* design was produced in myriad variations (Earhart 1974, 48).

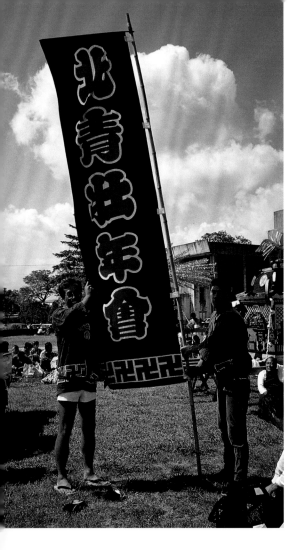

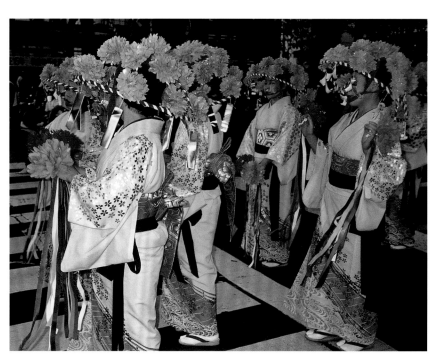

7.6 Festival banner inscribed with name of a *chōnai-kai* (neighborhood festival association) and at the bottom a horizontal *manji* bestowing multiple blessings. Photograph by GGG, Hitoyoshi Okunchi Matsuri, Kyūshū, 1993.

7.7 Peony-topped sunbonnets adorn a dance troop in procession. Photograph by GGG, Tanabata Matsuri, Sendai, 1989.

Fret and Running Fret (Sayagata)

The fret known as the *sayagata* design (fig. 7.6) was sometimes called the "path toward Buddha." *Saya* means "pattern" and the suffix *gata* is used to suggest that a particular pattern looks like or "takes the shape" of something else (Japan Textile Color Design Center 1980, 2: 24, 26). Often interpreted diagonally, the motif was made up of sequential clusters of geometric mazes based on segments of the key fret design (a left-facing repeat swastika). The motif, called *manji* in Japan, has stood for lightning or thunder in China since the Chou dynasty (eleventh–fifth century B.C.E.; Williams 1974, 120). In Japan *manji* stood for the number ten thousand (*man*), connoting infinite blessings (Tanahashi, 15, 68, figs. 24, 84). It is used on theater costumes to suggest a character's religious devotion. In its meandering whimsical interpretation it is often associated with inebriated characters. Auspicious symbols on stage costumes help define an actor's role, and they are also thought to transmit their beneficent aura to members of the audience.

The Wheel of the Law (Rimbo)

The Wheel of the Law is a widely portrayed Buddhist symbol that appears in many versions on festival coats and jackets. The wheel, originally a weapon with small swords as spokes (Shaver 1966, 227, fig. 87), originated in India and traveled to Japan with members of the esoteric Buddhist Shingon and Tendai Sects. The wheel was thought useful in smoothing the rocky road to Buddhahood and was also said to be capable of rolling over the enemies of Buddha's law.

Jewel (Tama)

Also known as a flaming jewel, this graceful rounded motif signifies the fulfillment of one's wishes and is a signal of fine harvests and prosperity. Extremely popular on all sorts of costumes and textiles, it particularly appeared on festival textiles and gifts presented at New Year's time.

Peony *(Botan)*

The peony was called the sovereign of flowers because its lush blossoms suggested abundance (fig. 7.7). Its Chinese origins, its appearance in conjunction with other Buddhist emblems such as the *tama* and *shishi* dogs, as well as its adoption by several famous temples, have caused it to be associated with Buddhism. Its luxuriant beauty and positive connotation garnered great popularity. The peony was also believed to project feminine energy and was often seen balancing the masculine force of a pair of frolicking Chinese lion-dogs (*shishi*). The dogs were depicted as playful or ferocious and sometimes both.

CONFUCIANISM AND FESTIVAL IMAGERY

During the Edo period the male ideal was exemplified by the warrior. In the subsequent Meiji period, festivals were founded to commemorate warrior traditions and remember the great military clans of Edo. Outlawed swords, helmets, and armor became infused with a supernatural aura. Long columns of nostalgic men dressed in heavy armor marched through several towns. Horse racing, which has been an uninterrupted court tradition since ancient times at Wakamiya Matsuri held at Kasuga Shrine in Nara, is also preserved. Each year a wild horse round-up is held on Hibarigaoka Moor in Fukushima Prefecture. Tall vertical banners, dyed in brilliant hues and emblazoned with white crests swirling high on bamboo poles, lead competing teams into games that simulate battles of an earlier era.

The wearing of fabricated as well as vintage clothing pays homage to the past as well as to ancestral deities. Famed for its authentic historic costumes, Jidai Matsuri (Festivals of the Eras) began to be celebrated during the Meiji period, the most elaborate of these is held in Kyoto. Such pageants celebrate entire historic eras. Although there are no actual origins in religious tradition, these festivals have become imbued with an aura of sanctity. As Jidai Matsuri became established, Shinto priests have been called upon to bless the events with prayers of purification and resurrection.

Crests

Perhaps nowhere else in the world is clan and regional loyalty so universally and enthusiastically displayed as in Japan. Identifying crests (*mon*) are emblazoned on clothing, banners, flags, and drapery. The jackets of those in procession feature crests, and banners bear the host shrine's name in Chinese characters (*kanji*) or a crest related to the festival celebrated. Sometimes groups wear crests announcing the name of their employer or a sponsoring company.

Crests had flourished as a heraldic military device in medieval battles, although they had actually originated earlier with Heian period courtiers. Samurai adopted crests, which were codified in the mid-1600s, to signify their elevated status and emblazoned them on all of their possessions. In the beginning, they identified the family possessions of one's daimyo (lord). Eventually, retainers were given the right to use the daimyo's crest on their own family wardrobe and objects. The lines of crest inheritance became clouded as insignia were borrowed, changed by wars, or altered by marriage.

The practice of wearing crests was also assumed by audacious Kabuki actors and courtesans, whose enormous fashion influence was similar to that of movie stars of the present. Ardent fans, including townspeople, wealthy merchants, and artisans, copied the fashionable crests for their own clothing and possessions.

7.8 Detail of the *yukata* illustrated in figure 4.102. The fragile blossoms of the wisteria form a soft curvilinear repeat motif on this summer kimono. They are thought to reflect feminity.

NATIONWIDE FESTIVALS INSPIRED BY CONFUCIAN IDEALS

Girls' Day Festival *(*Hinamatsuri): Decorations and Imagery

On the third day of the third month, female expectations are reaffirmed annually to young girls through the nationwide festival called Hinamatsuri (Festival of the Dolls or Girls' Day). Hinamatsuri is also referred to as the Momo no Sekku (Peach-Blossom Festival)—the peach and its blossoms stand for spring, marriage, fertility, and longevity (Casals 1967, 57; Williams 1974, 316–317). During this annual holiday female children are exposed to Confucian ideals pertaining to women; high priority is placed on appearance, social grace, personal grooming, and wardrobe selection.

The obligation of each little girl—said to be enthusiastically performed—is to decorate her family home at this time with a display of several dolls attired in the garments of the upper class of the Heian period. Once the dolls are set up, they are never played with and only minimally touched. A doll might be purchased for the occasion, but most are retained from generation to generation and passed down as heirlooms. The dolls, male and female, wear expensive silks brocaded with auspicious motifs that include pine, wisteria (fig. 7.8), and chrysanthemum. The upright spreading pine in this context not only represents long life but also strength and protection. These are regarded as attributes offered by the male sex. The delicate blossoms of wisteria communicate the feminine, fragile, and clinging. The two motifs represent complementary aspects of an ideal union according to Confucianist beliefs (Casals 1967, 52–60).

On staggered platforms denoting their social status, the dolls also serve as imaginary actors in a drama about the etiquette of visiting and paying proper respects. During the weeks of preparation, as well as on the day of the festival, the young girl of the household enjoys unique prestige as set designer, director, and producer of the montage. To prepare for the event, dolls and artifacts are retrieved from storage and removed from boxes by the youngster. They are unwrapped very carefully, as handling precious objects with care is another lesson to be learned at this time. The arrangement of exactly replicated furniture and accessories, including miniature *tonsu* chests, lacquered tables, and tea sets is always set upon a platform or stairway covered with a red carpet, symbol of fecundity (Joya 1960, 114–15).

Central to the display a prince *(odairisama)* and a princess *(himesama)* are placed on the top shelf as a reminder to girls that a good marriage should be their

Memories of Hinamatsuri (Girls' Day)

Nobuko Nabeshima

When I remember Hinamatsuri I think of pink. It seems as if everywhere one looked one saw pink on that day. Light pink *bonbori* were set out in our home. *Bonbori* look like pink ping-pong balls and stand for the light pink blossoms of peach trees, the peach fruit being a symbol of fertility. The *bonbori* are like small lanterns that are supposed to light the way.

March third was very much looked forward to in our home and especially by me. Although I was an only child and had no brothers, I was still unused to a great fuss made solely on my account and the attention both parents bestowed upon me on this day. Preparation was the most exciting part. My parents and I together carefully unpacked and unwrapped the dolls and the paraphernalia that had been stored all year. Most were heirloom dolls passed down to me by my female ancestors. Seeing the dolls appear was a genuine delight—like seeing dear friends again after a long absence. We kept the lights on day and night throughout March third, then very quickly took the entire display down on March fourth, carefully repacking everything. It was explained to us when we were very little girls at our first Hinamatsuri that if everything were not taken down promptly, in the future no man would marry us.

When finished the display included, a prince and princess, their courtiers, and musicians. These were placed on a stepped platform draped in a red velvet cloth and were carefully staggered on the steps according to their status. At the top, the prince and princess in billowing Heian-period costumes were seated. At that time their costumes were mostly handmade and very beautiful. By comparison todays' displays look very commercial and artificial.

When I was a young girl, I felt this holiday celebrated femininity and I enjoyed that thoroughly. In my family the holiday did not require special dress, and we didn't wear kimono or exchange gifts. However, we ate delicious *hishi mochi*, diamond-shaped rice cakes in pink, white, and green, consumed during the day along with *shirozake* (sweet white sake).

highest goal (Casals 1967, 55). The princess is dressed in the *juni hitoe*, the Heian period court costume composed of twelve layers of unlined silk kimono, each of a different color. Thus knowledge of Japanese historical dress is also imparted during this festival. The prince is clad in a purple or black figured silk damask formal robe of the same period and an archaic tall hat (*eboshi*). He carries a sword and scepter. On the next level down are placed three maids of honor wearing long-sleeved white silk damask kimono and wide trailing red *hakama* culottes. On the next step appear five court musicians with their instruments. Other dolls, such as guards and servants, may enhance and expand the retinue according to the girl's whim and the family's resources (Casals 1967, 46–60). During February of each year, impressive arrays of the magnificently costumed dolls and their paraphernalia are set up in department stores. These doll bazaars function much like Christmas windows in the West, providing family entertainment and motivating viewers to indulge in shopping.

Boys' Day Festival (Tango no Sekku)

Along with Hinamatsuri, one of the most important transmitters of Confucian values is *Tango no Sekku* (Boys' Day Festival), celebrated on May fifth of each year. Traditions inherited from the Samurai era dictate that boys be inspired by the careers of legendary warriors. Until recently the goals of samurai culture were emulated by most ordinary Japanese eager for their sons to acquire those virtues considered manly, such as unfailing loyalty to superiors and to family and the will to overcome difficult obstacles. Boys' Day *nobori* are brilliantly painted banners that are extremely long and narrow (limited to single or double loom widths) and sometimes reach three

7.9 Indoor Boys' Day banner, Taisho period. Chirimen (silk crepe), *yūzen*-painted. Small banners hang in homes often over displays of miniature samurai paraphernalia. These often include a model horse decked out in red trappings.

7.10 Festival Curtain. Cotton, hand-painted.

Kintaro, a sort of Japanese baby Hercules capable of all sorts of amazing physical feats, is frequently portrayed on Boys' Day trappings. This legendary "superboy" used his extraordinary strength to protect his family and garner riches for them.

hundred feet in length. The colorful banners are created by hand painting with mineral pigment directly on cotton fabric after pictorial areas are outlined with rice paste squeezed from a tube (*tsutsu*). Most of the backgrounds are left white but some are brush-dyed indigo blue.

Shoki the Demon Queller

A popular portrait painted on the Boys' Day banners, Shoki is supposed to inspire dread and scatter lurking *oni* (goblins). Shoki is depicted as tall and muscular with piercing eyes and bushy brows. Dressed in full samurai costume, he carries a sword and a shield to protect families and their sons from evil. On Boys' Day sons accompany their parents to shrines where prayers are offered for the boys' prosperity and health. The boys wear taffeta *hakama* trousers and black silk formal kimono decorated with irises or with portraits of brave samurai in action.

Iris

Boys' Day is symbolized primarily by a horticultural motif, the iris (*shobu*). The plant's swordlike leaves rise from a voluptuous rounded bulb that yields elongated blossoms, suggesting at once fertility and upward movement (fig. 7.9). The fresh green leaves that appear each spring are believed to infuse vigor into all male children, as well as the coming growing season. Iris leaves are placed in a boy's bath water, and the petals are floated in ritual sake consumed during this time. Boys fight mock battles with iris-leaf swords. *Shobu* competitions are held in which two groups armed with thick bundles of irises vigorously beat the ground with the plants, intending to destroy the *oni* (goblins) hovering just under the soil. The winners are those who make the most racket.

Oak leaves (*Kashi*)

The broad leaf of the Mongolian Oak Tree (*kashi*) is also featured on Boys' Day trappings. *Kashi* leaves are used at Shinto rituals as an emblem of force, endurance, and manliness. *Kashi* sounds like *kashikoi*, the Japanese word for *clever*. Holiday food includes rice balls wrapped in the leaves of the *kashi* and called *kashiwa*.

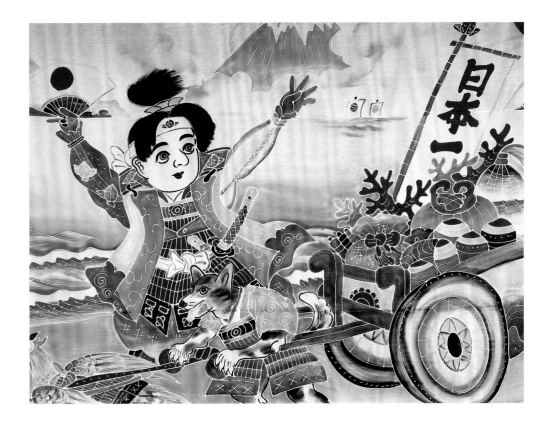

7.11 Detail of a festival curtain, Cotton, hand-painted. L. 429 cm. Collection of the Asian Cultural Arts Trust.

This festival curtain features a portrait of the legendary peach boy Momotaro, whose extreme devotion to his aged parents and his overcoming of enormous challenges led him to become a hero.

Bamboo grass (*Sasa*)

Another plant symbolic of Boys' Day is bamboo grass (*sasa*). *Sasa* was considered a weed, but its fronds were tenaciously rooted. Thus it came to symbolize loyalty. Often the three plants—iris, oak leaves, and bamboo grass—were used together in seasonal flower arrangements and appeared as combined motifs on clothing and banners.

Koi (Carp)

Flying *koi-nobori*, or carp banners, on Boys' Day was a practice of samurai families during the Edo period. Since the Meiji Reformation in 1868, the practice has been popularized. Sets of painted carp (*koi*) banners are strung outdoors on bamboo poles, each fish representing a son in the family (see fig. 4.16). The largest carp stands for the eldest son with his brothers represented by fish of descending sizes. The cotton carp streamers, usually painted in clear primary colors and black on a white ground, are normally anywhere from three feet to thirty feet in length. They are often three dimensional, being fitted with a metal aperture that keeps the carp's mouth open to capture the wind and produce swerving motions that resemble a fish swimming (Joya 1960, 107–8; Casals 1967, 61–78).

The set often includes *fukinagashi,* a tubular cotton structure ending in long fringes that also blows easily in the wind (see fig. 4.4). *Fukinagashi* are believed to discourage evil spirits, dispersing them with their flutterings and crossings. Simultaneously the *fukinagashi* streamers are believed to spread good vapors and protect the growing crops from insects. *Fukinagashi* are also hung in abundance at the midsummer festival called Tanabata, held on July 7, the largest celebration taking place annually in Sendai, Miyagi Prefecture.

Before the late twentieth century, when some Japanese parents began to doubt or even deny their benefits, Boys' Day and Girls' Day served to integrate and perpetuate firmly established gender-related expectations. Males aspired to success in their work and approached it with warlike ferocity and perseverance (figs. 7.10, 7.11). A girl's ideal femininity was thought best directed toward decorating herself and her home, acting as a hostess, preparing and presenting food, and, most of all, achieving a successful marriage in which she would seek to identify with her husband's goals.

7.12 Detail of the *yukata* illustrated in figure 6.3a. This *yukata*, which features a motif of bamboo shoots was worn at Awa Odori Matsuri in Tokushima Prefecture.

TAOISM AND FESTIVAL IMAGERY

In China, where Taoist beliefs originated early in the past millennium, works of art were to serve as vehicles for bringing people into harmony with the vibrations of nature. While seeking to capture the primordial flow of the earth's atmosphere, artists strove to become one with that flow, eliciting from it works devoid of artifice or stress. Taoists believe that those who come into contact with successful artwork will absorb its beneficent energies and hold the conviction that an individual's fate is influenced by the colors, motifs, and textures that surround him or her. In Taoist thought, the demonstration of visual harmony between the dual essences of *yang* and *yin* is considered crucial. *Yang* and *yin* should be shown in proximity visibly affecting one another. The balance of their proportions induces balance in the viewer or wearer while at the same time stimulating his or her *yang* and *yin* potencies. Certain hues and motifs are linked with feminine attributes; others are considered masculine. Dark grounds are used with light or bright motifs in thoughtfully calculated proportions (Rawson and Legesa 1973, 24–25).

Taoist emblems originally entered Japan on engraved metalwork and as patterns on opulent brocades imported by the ruling class from China (Mizoguchi 1973, 18). Dragons, tortoises, phoenixes, and "triple comma" (*mitsu-tomoe*) motifs inspired by Taoist convictions had originally been reserved for ornamenting the possessions of the warrior class. In the form of castoffs, these were adopted by the lower ranks of samurai. By the Edo period, the once-restricted motifs were enjoyed by townspeople emboldened by their new wealth. Taoist designs were thought to inspire auspicious prophecies. Their connotations of vigor, long life, abundance, and fertility were reiterated at *matsuri*.

Immortality

By the Muromachi period (1392–1568), the worthy attributes of those who were reputed to have achieved immortality, the so-called Taoist Immortals, became popular subjects in Japanese painting (Murase, 208). On Mount Horai in the Islands of Immortality—the legendary abode of the Immortals—pine, bamboo, peach, and magic fungus grew in profusion. Cranes flew overhead, tortoises filled the rivers, and stags leapt about the slopes.

The Pine, Bamboo, and Plum

The vegetation of Mount Horai, the pine, bamboo, and plum, became festival motifs in every corner of Japan. As separate motifs, and grouped as a trio, and sometimes in combination with the long-lived tortoise and the crane, this design enjoyed the greatest popularity throughout the Edo and Meiji periods.

Pine

The idea of endurance associated with the pine was furthered by the Chinese belief that pine sap turned into amber after one thousand years. The trunk of the pine, which often grew in unexpected shapes and curves, seemed to suggest the supernatural. The trees, their cones, their needles, the cluster of their branches, and the texture of their trunks, were all used as festival motifs (see fig. 2.6).

Bamboo

Chinese legend told that bamboo shoots were the food eaten by the phoenix (*ho-o*). Bamboo appeared with the phoenix and paulownia and alone in numerous stages of

7.13 At the Tenjin Matsuri *oni* (goblin) procession a dignitary (shown at the left) wears a "Chinese" brocade vest (*jimbaori*) with the fortuitous tortoiseshell design (*kikko*). Photograph by GGG, Ueno-shi, Mie Prefecture, 1993.

growth (fig. 7.12). The roots of bamboo were particularly appealing as they were widely enjoyed as a delicacy. Bamboo trunks are very strong but bend without breaking, therefore the trunk came to symbolize resilience. Bamboo is often specified in the construction of ritual objects for *matsuri*.

Plum

White or pink blossoms of the Japanese plum tree blooming in the dim light of February inspired hope. The plum came to signify courage, as it is the first tree to bloom in winter. The three trees together, the pine, bamboo, and plum, are commonly called "the three friends of winter." The plum joined the pine and bamboo, early arrivals from China, during the Muromachi period, and by the Edo period all three were used in combination with the tortoise and crane motifs—and sometimes the peach as well—which augmented their power to sustain life and happiness (see fig. 4.12a).

Tortoise

Chinese legend explains that the entire world and the heavens rest on the back of a huge tortoise. Depictions of Mount Horai portray the tortoise as a symbol of stability, a trusted carrier of precious cargo and a messenger of the deities. Tortoises are thought to live ten thousand years. Strength, masculinity, stability, and longevity are suggested by the hexagonal design on the tortoise' shell (*kikko*). The ability of tortoises to protect themselves as well as their association with water made them particularly popular subjects (fig. 7.13).

Cranes

The Taoist immortals reportedly flew through the air on the backs of cranes (see fig. 4.104). Just as the tortoise is believed to live ten thousand years, the crane is believed to live one thousand years (see fig. 2.6). The shapes of the two animals provide complementary forms in many designs. In fishing villages a crane is often pictured on the backs of festival coats (*maiwai*) worn by celebrating fishermen. The bird often carries a banner in his mouth inscribed with characters celebrating a big catch.

7.14 Votive plaque (*ema*), Meiji period. Wood and paint. 25 x 32 cm. FMCH x89.863; Gift of Dr. Daniel C. Holtom.

The old couple of Takasago, Jo and his wife, Uba, are portrayed enjoying a healthy and useful old age under the shelter of the longevity-inducing pine tree.

The Old Couple of Takasago

Although legends concerning immortality exist in many cultures, in this motif, the pair illustrated are not eternally young. The elderly were admired for their longevity, revered as being closer to the deities, and suspected of already being in communication with them. The Taoist paradise portrayed in this motif derived from a Noh play called *Takasago*. The couple, Jo and Uba, sometimes garbed in gorgeous robes suggesting affluence, are always depicted as vigorous and usefully occupied with rake and broom (fig. 7.14). Jo and Uba are often accompanied by the tortoise and crane. Sometimes the couple are just suggested by their tools or by their symbolic animal companions.

Phoenix and Paulownia

The link of the mythical phoenix (*ho-o*) to Taoist origins is demonstrated by its coloration, the five shades representing the five virtues of Taoist philosophy, including red, blue (referring to green as well), yellow, black, and white. The phoenix alights only on the branches of the paulownia tree and feeds only on the seeds of bamboo. The auspicious bird is usually portrayed nested among paulownia branches and leaves. Although originally the phoenix's head resembled that of a peacock (see fig. 4.49), by the end of the Edo period it was depicted as that of a rooster (figs. 7.15, 7.16).

The phoenix was said to be seen only at times of a momentous event, such as the appearance of a truly virtuous ruler. As the bird would only dwell in kingdoms enjoying peace and prosperity, it heralded the advent of good fortune. By the Muromachi period the sculpture of a phoenix in gold or brass often adorned the top of the sacred palanquin (*mikoshi*) used to transport the deity during *matsuri*. The phoenix atop the *mikoshi* is said to signify the status of the deity within and to signal a fortuitous period to come.

Dragon

The dragon represents the *yang*, or male, principle, which complements the *yin*, or female principle, suggested by the phoenix when the two are portrayed in proximity. On festival coats, single dragons were usually partly hidden in swirling clouds as it was considered dangerous to gaze upon their entire bodies. The dragon is believed

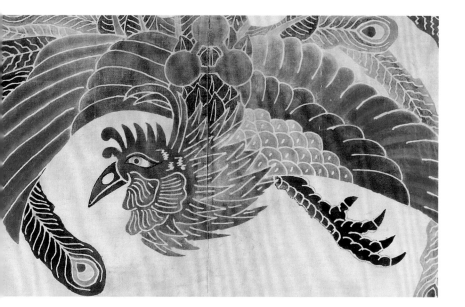

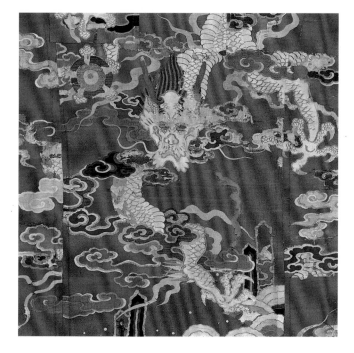

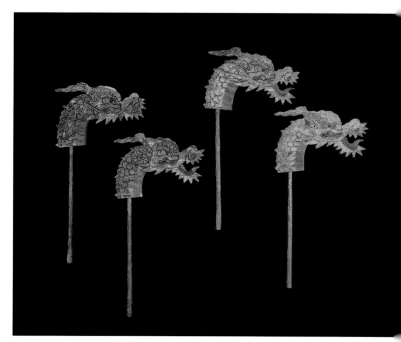

7.15 (UPPER LEFT) Detail of a festival coat, Gifu Prefecture, Meiji period. Cotton, *tsutsugaki-* and stencil-painted. L: 135 cm. FMCH X2000.44.1; Gift of Dr. Jean Krag.

7.16 (UPPER RIGHT) Photo of phoenix atop a *mikoshi*. Photograph by GGG, Hitoyoshi, 1992.

7.17 (LOWER LEFT) Detail of Japanese silk tapestry (*tsutsureori*) illustrated in figure 5.10. The dragon is the main icon of the Gion Matsuri, and this tapestry may have been custom ordered with bright safflower red ground (now faded to orange) for a participating festival group.

7.18 (LOWER RIGHT) Dragon wands, Showa period. Carved wood, paint. L (of longest): 53 cm. Collection of the Asian Cultural Arts Trust.

These wands from the Tohoku area were likely props for a dragon or shi shi dance or may have adorned a float structure.

7.19 Detail of the *yukata* illustrated in figure 4.99c. This summer kimono is decorated with chrysanthemums to suggest the coming autumn and a respite from the heat of summer.

capable of rising into the heavens and causing cloudbursts and descending into the sea to control the tides (figs. 7.17, 7.18). Dragon dances are thus performed at festivals to affect rainfall. The dragon is believed to be the embodiment of all the earth's energies. In China its's image came to represent the emperor and assumed regal significance.

Chrysanthemum

The chrysanthemum became associated with long life because Chinese legend told of venerable Taoist sages who had survived by subsisting on a diet of these flowers (fig. 7.19). Another Chinese tale told of a mountain village so covered with chrysanthemums that they floated on the rivers nearby. The rivers provided the water supply for the village, and the inhabitants who drank from them reputedly lived for one hundred years. A festival originated in China to celebrate the flower's miraculous life-extending powers, and the beauty of its numerous varieties. It was also celebrated in Japan each September. Although the chrysanthemum was originally reserved for royalty, various samurai retainers were eventually permitted to adopt the design, and by the middle of the Edo period, it was commonly used in multiple forms by all classes. The designation of the sixteen-petaled chrysanthemum as unique to the Imperial Family has only enjoyed formal status since the Meiji period.

Tomoe

In its tripartite form (*mitsu-tomoe*), the *tomoe* emblem is said to represent three swirling currents of water and is often described as representative of an eddy visible at times of thunderstorms (see fig. 4.54). Thunder precedes lightning and is sometimes believed to be the vengeful weapon of the deities as well as the signal of the rainfall crucial to the crops. Motifs related to thunder were perceived as especially powerful.

The *tomoe* seems to be linked to the similar *yin* and the *yang* motif. The *mitsu-tomoe* is a ubiquitous presence in festival proceedings, appearing as the central motif on the large festival drums *(taiko)*. The *taiko* signal the deities and the populace to assemble, while driving away any evil spirits. A belief exists that the boom of drums produces rainfall as well as torrents of good fortune.

Drum and Cock

Related to the *tomoe* motif is the cock perched on a drum. This is believed to have originated in China, where a large drum was kept on the main gate of the palace to assemble the troops. As the practice fell into disuse, the drum became a roosting place for fowl but was still used by the regent to summon officials to settle grievances. The emperor Kotoku Tenno was reported to have introduced this custom to Japan in 645 C.E., decreeing that a drum should be provided for petitioners. The shoguns of the Kamakura period (1185–1333) continued this practice (Joly 1960, 113, 346). The cock motif appears to have absorbed the authority. At some point in the late Edo period the cock became mingled with the image of the phoenix, the head of the cock eventually replacing the head of the peacock that had appeared in earlier depictions of the phoenix (see figs. 7.15 and 4.49).

Gourds (Hyotan)

The *hyotan* is one of three types of gourds grown in Japan. It has a unique shape, a slender neck projecting from a double, rounded, divided bulb. The gourds were used for carrying sake, the rice wine that is abundantly available at nearly all *matsuri*. Gourds symbolizing sake were frequently hung from the obi that secured summer festival *yukata* and *hanten*. As symbols of good times and camaraderie, gourds were also stenciled on festival garments implying *matsuri* spirit. Their shape drawn on textiles may also have served as a humorous reference to the male genitalia, thus a fertile period ahead.

FOLK RELIGION AND FESTIVAL IMAGERY

In the long span before recorded history, beliefs in certain icons felt to be infused with supernatural powers were shared by several East Asian peoples. Numerous plants, animals, elements of the natural landscape—particularly mountains—as well as natural phenomenon such as thunder, were portrayed on objects and endowed them with sacred significance. Spiritual ideas were dominated by animistic and shamanistic beliefs developed to gain success in the hunt and protection from the threat of dangerous animals. The earliest migrants to the Japanese Islands carried with them icons that helped strengthen their will to enable them to cope with a fearsome world (Hori 1968 5, 8, 9).

With the introduction of agriculture to Japan around 200 B.C.E., symbols related to the cultivation of rice appeared. Artifacts from this period (200 B.C.E.–200 C.E.) include large bronze bell-shaped objects known as *dōtaku*. The surfaces of bells, which ranged in size from less than a foot to four feet, were segmented into rectangles enclosing line-drawn birds and animals and hunting and farming scenes (Mizoguchi 1973, 15–17; Smith and Wang 1979, 22, 23, 15).

It is thought that these bells played a significant role in ritual festivals that were aimed at securing the water crucial to wet-rice agriculture. Watery motifs such as whirlpools, arcs, and wavy lines were frequently engraved on the bells. Tortoises, frogs, lizards, and waterfowl, such as the heron, appeared prominently (Japan 1980, 1: 37, pl.1). Other motifs believed related to the size of the rice harvest were helpful insects, including the dragonfly and praying mantis. Snakes, dangerous to farm workers, appeared on the bells, possibly to appease their spirits.

7.20 Detail of fig 4.129.

Water

The motifs used on the bells may have decorated festival garments as well, but no examples of clothing have survived from these early times. Prehistoric pottery and ceramic Haniwa figures from the subsequent Kofun period (300–552), however, show costumes decorated with spirals and with overlapping waves that appear as multiple arc designs. The dynamic quality of waves (fig. 7.20 and see fig. 4.63), the power of the oceans, the importance of irrigation to wet-rice agriculture, as well as the refreshing implications of water, have made watery motifs a favored choice for festival dress and drapery continuously over the ages, particularly in summer (Japan 1980, 1: 37, pl.1).

Snake and Snake Scales

The linked triangles traditionally referred to as snake scales *(uroko)* were frequently incised on the representations of costumes worn by the prehistoric Haniwa figurines of the Kofun period. On these images of ancient textiles, every other triangle was seemingly painted red. The design appeared so consistently in this positive/negative format on coats and pantaloons, hats, crowns, obi, and even on the braided cords passed diagonally across the back *(tasuki)*, that it has been speculated that it may have had a totemic significance (see fig. 1.5). The design became popular for theater costumes of strong male characters (Noh and Kabuki) and in ritual dance (Kagura). It also decorated the costumes worn by female characters who were portrayed as so consumed with venomous jealousy that they developed the appearance of serpents. The linked repeat has been used continuously on Japanese theater costume to communicate animal energy. It was worn at *matsuri* as a stenciled overall design on *ha'pi* and *hanten* (Japan Textile Color Center, 2: 22).

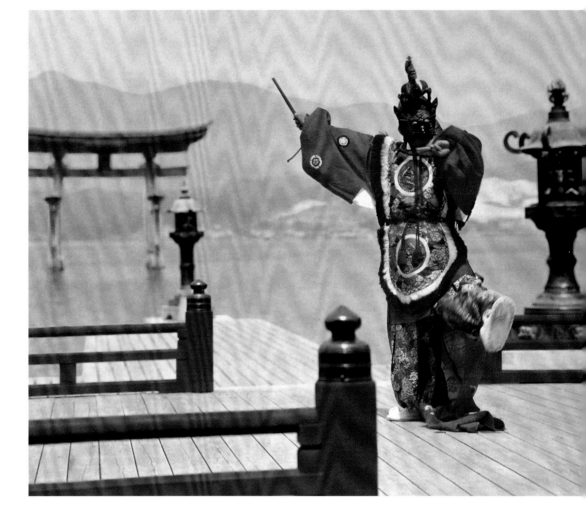

7.20 Bugaku, a classic dance form, has been revered in Japan since its introduction from China in the mid-fifth century. At the Kasuga Shrine in Nara, this costume is used for Ranryo Oh, one of the most representative Bukagu dances. The dance tells the story of an exceedingly handsome ruler in northern China, King Ranryo, who was forced to don a fierce mask when he departed for the battlefield to face his adversaries. Led by a general with such a ferocious visage, his men were able to route the enemy decisively. The mask is topped with a dragon, considered the most powerful of all creatures, and the costume is patterned with dragons floating in the clouds.

Appeased Animal Spirits

Deer and wild boar, trophies of the hunt, may have been portrayed on bronze bells because these animals fed on the rice stalks growing in the field, significantly diminishing the yield (Saito 1982).[1] Portrayals on artworks honoring animals in order to appease them have been a part of Japanese festivals over the centuries. Deer and wild boar, often transformed later into the more dramatic lion-dogs, have been continuously represented in costume and dance. Although also referred to as *shishi odori* (lion dances), they began as *shika odori*, or deer dances, and were performed in deer masks crowned with tall antlers (see figs. 4.59a,b, 4.60). The lion dances were performed with lion masks, flowing manes, and elongated decorated cloth panels covering two dancers. Although lions have never existed in Japan, *shishi odori* have been embraced throughout the Japanese islands and are thought to dispel evil and bring rain (see figs. 4.52–4.57).

Heron

Along with the "honored animals" described above, the heron, frequently observed in flooded rice fields, was traditionally represented in costume and dance at several *matsuri* (see fig. 4.70). The slow and graceful heron dance was performed by two dancers costumed as tall white herons. These dances have been frequently referred to as "crane" dances in English, but the crane may be differentiated from the heron by its "bustle." It was the heron motif, which was linked to the success of the planting of the rice crop, that was resist painted and embroidered on textiles. The crane was associated with Taoism and longevity. Ritual dance and theater costumes used in performances of the heron dance during the Muromachi period (1392–1568) are stored in Japanese shrine and museum collections. ●

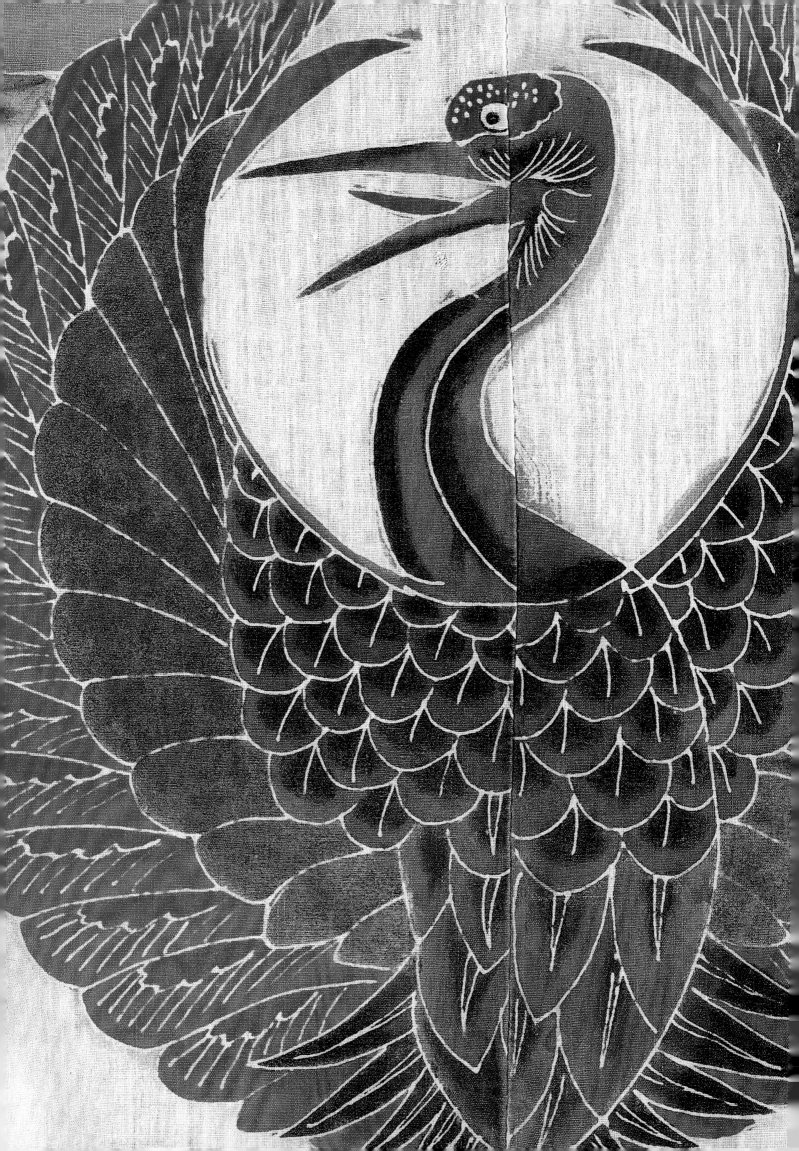

APPENDIX A: MATSURI AT SPECIFIED SITES *Prepared by Ono Saori*

Town (Prefecture)	Matsuri Name	Town (Prefecture)	Matsuri Name
Hokkaidō		Sakai (Osaka)	Sakai Matsuri
Abashiri	Orochon-no-Himatsuri	Sakata (Yamagata)	Sakata Matsuri
Kushiro	Kushiro Kotan Matsuri	Sendai (Miyagi)	Sendai Tanabata Matsuri
Sapporo	Yuki Matsuri	Shiogama (Miyagi)	Hode Matsuri
		Shirakawa-mura (Gifu)	Shirakawa-mura Doburoku Matsuri
Honshū		Shirakawa (Fukushima)	Shirakawa Chōchin Matsuri
Aizu-wakamatsu (Fukushima)	Aizu Byakko Matsuri	Sōma (Fukushima)	Sōma Nomaoi
Aomori (Aomori)	Aomori Nebuta	Suwa (Nagano)	Onhashira Matsuri
Chichibu (Saitama)	Chichibu Yomatsuri	Takaoka (Toyama)	Mikurumayama Matsuri
Ena (Gifu)	Soharajinja Matsuri	Takayama (Gifu)	Takayama Matsuri
Fujisawa (Kanagawa)	Tennōsai	Tokyo	Kanda Matsuri, Sanja Matsuri, Fukagawa Matsuri
Gifu (Gifu)	Mieji Matsuri		
Hachinohe (Aomori)	Enburi	Tōno (Iwate)	Tōno Matsuri
Hamamatsu (Shizuoka)	Tako-age	Tsu (Mie)	Tsu-no-Aki Matsuri, Tōjin Odori
Hanamaki (Iwate)	Shishi Odori	Tsuruga (Fukui)	Shishi-mai, Tsuruga Matsuri
Himeji (Hyogo)	Mega Kenka Matsuri	Ueno-shi (Mie)	Ueno Tenjin Matsuri
Hirosaki (Aomori)	Hirosaki Neputa	Utsonomiya (Tochigi)	Furusato Miya Matsuri
Inuyama (Aichi)	Inuyama Matsuri	Wakayama (Wakayama)	Nagashi-bina
Ise (Mie)	Kanko Odori	Yamagata (Yamagata)	Hanagasa Matsuri
Izumo (Shimane)	Izumo-taisha Jinzaisai	Yatsuo (Osaka)	Yatsuo Kauchiondo Matsuri
Kamakura (Kanagawa)	Yabusame (Tsurugaoka-hachimangū Reitaisai)	Yokosuka (Kanagawa)	Uraga-no-Toraodori
		Yokote (Akita)	Bonden
Kanazawa (Ishikawa)	Hyakumangoku Matsuri	Yonezawa (Yamagata)	Uesugi Matsuri
Katsuura (Chiba)	Ubara-no-Daimyōgyōretsu		
Kawagoe (Saitama)	Kawagoe Hikawa Matsuri	**Shikoku**	
Kōbe (Hyogo)	Tsuina shiki	Kōchi (Kochi)	Yosakoi matsuri
Kōfu (Yamanashi)	Takeda Shingen sai	Kotohira (Kagawa)	Konpiragū taisai
Kumano Taisha (Yamagata)	Kumanotaisha Reidaisai	Takamatsu (Kagawa)	Takamatsu Odori
Kyoto	Gion matsuri, Aoi Matsuri, Daimonji-yamayaki (Daimonji Okuribi), Ushi Matsuri, Jidai Matsuri	Tokushima (Tokushima)	Awa Odori
		Uwajima (Ehime)	Warei Taisai
Miyajima-cho (Hiroshima)	Kangensai	**Kyūshū**	
Mizusawa (Iwate)	Hidaka Hibuse Matsuri	Ariake-cho (Saga)	Men Fūryū Matsuri
Mutsu (Aomori)	Osorezan Taisai	Hakata (Fukuoka)	Hakata Dontaku, Hakata Gion Yamagasa
Nagahama (Shiga)	Hikiyama Matsuri	Hitoyoshi (Kumamoto)	Okunchi
Nagoya (Aichi)	Nagoya Matsuri	Kagoshima (Kagoshima)	Ohara Matsuri
Nara	Wakamiya Matsuri, Kasuga Matsuri	Karatsu (Saga)	Okunchi
Narita (Chiba)	Narita Gion-e	Kitakyūshū (Fukuoka)	Kokura Gion Daiko
Nikkō (Tochigi)	Tōshōgū Sennin Gyōretsu	Nagasaki (Nagasaki)	Okunchi
Ōda-shi (Mie)	Tenjin Matsuri	Saga (Saga)	Sakae-no-kuni Matsuri
Ojiya (Niigata)	Sai-no-Kami		
Okayama (Okayama)	Otaue Matsuri	**Okinawa**	
Osaka	Tenjin Matsuri	Naha	Naha Tsunahiki
Ōtsu (Shiga)	Otsu Hon Matsuri		

APPENDIX B: JAPANESE HISTORICAL PERIODS

Paleolithic Period
circa 50,000–11,000 B.C.E.

Jomon Period
11,000–300 B.C.E.

Yayoi Period
300 B.C.E.–300 C.E.

Kofun Period
300–552

Asuka Period
552–645

Early Nara Period
645–710

Late Nara Period
710–794

Early Heian Period
794–897

Late Heian Period
897–1185

Kamakura Period
1185–1333

Nambokucho Period
1333–1392

Muromachi Period
1392–1568

Momoyama Period
1568–1615

Edo Period
1615–1868

Meiji Period
1868–1912

Taisho Period
1912–1926

Showa Period
1926–1989

Heisei Period
1989–present

NOTES TO THE TEXT

Preface
1. The term "close arts" was first mentioned to me by Professor Robert Haas.
2. *Atane* is traditionally identified with *akane*, or madder, a European herb whose roots produce a red dye (Philippi 1968, 466)

Chapter 1
1. Even today in several towns, women may not ascend *matsuri* wagons (*hikiyama*) of the most conservative associations. This is so they do not compromise the purity of the wagons or that of the setting. A Japanese female textile conservator documenting artworks while in the employ of a festival association reportedly was not permitted to enter the association storage facilities (Kajitani Nobuko, personnal communication, New York, 1995).
2. Weaving may be seen as another form of order under assault.
3. This information was kindly provided by William M. Bodiford, Associate Professor, Department of East Asian Languages and Literatures, UCLA.
4. Priests, physicians, and educators were considered outside these categories.
5. Private conversations with Professor Yoneyama Toshinao, Kyoto, October 1993 and July and August 1994.
6. Professor Alan Graphard of the University of California, Santa Barbara, described this theory in a lecture delivered at UCLA in 1999 for the Center for Japanese Studies, UCLA.
7. Professor Tomoyuki Yamanobe, personal communication, Warabi-shi, Saitama-ken, September 4, 1997.
8. Not every town holds a procession, however; in some towns, the shrine rituals and their auxiliary performances are deemed sufficient to attract the attention of the deities and to convey their spirits into the community. In these festivals, the main events center around the shrine or sites nearby. At temporary stages trained theatrical troops offer Kagura dance, Noh plays, Kyogen skits, Kabuki performances, and Bunraku puppet shows, as well as solo concerts by admired professional singers and musicians (see chapter 2).

Chapter 4
1. This opinion was expressed to me by Fukukawa Yoshifumi, a priest in Hitoyoshi who is a graduate of Kokugakuin University (Shinto Ecumenical University), October 10, 2000.
2. As foreign tourists misinterpreted this gesture and perceived the *yukata* to be complementary souvenirs, this practice has somewhat diminished.
3. Although the winds died down as the rainy season began, the end of the fire season marked the onset of new threats. Not only were floods feared, but warm weather meant the arrival of pestilence, which endangered human health as well as the newly planted rice crop in the surrounding farmlands.
4. It was only after the Meiji Reformation (1868) that people from different social strata were permitted to dwell in the same area.

Chapter 5
1. An exhibition hall in downtown Kyoto is maintained by the Gion Matsuri Yamaboko Rengokai; the artworks belonging to the float associations are exhibited there in rotation.
2. They appear in the collections of the Museum of International Folk Art, Santa Fe; the Royal Ontario Museum, Toronto; the Textile Museum, Washington, D.C.; and the Honolulu Academy of Arts.
3. John Vollmer, personal communication, 1996.
4. The equation of foreigners with Chinese may have also resulted from the fact that the Chinese were the only foreigners that the Japanese had ever previously encountered.
5. Background material for this caption was provided by Professor Inoue Kenichirō of Miyagi Gakuin Women's University (personal communication May 15, 2002). I first became aware of the Northern Silk Route through books, articles, and conversations held in 1994 with Professor Ohtsuka Kazuyoshi at the Minpaku (National Museum of Ethnology), Senri Park, Osaka. The Minpaku's catalog of its exhibition *Ainu Moshir* (June 1993) proved especially illuminating. Conversations with Serisawa Chōsuke, Hamada Shukuko, and Watabe Akiko were also enlightening, as was their catalog *Ainu Folk Culture* (Tohoku University Museum 1990).

 Ms. Kitao Michi of Sapporo, Hokkaidō, has the finest and only complete collection of Ishū-Retsuzō portraits. Matsuura Historical Museum has a copy of the series, as does the Musée d'Ethnographie et d'Histoire Naturelle in Besançon (missing one portrait). There are two portraits of the original series in the library of the Museum of the History of Northern Peoples, Hakodate (reproductions of the entire series are exhibited).
6. Although primarily known as a food, kelp was also used as an ingredient in medicines.

Chapter 7
1. On similar bells found in China, linear decorations designated tones and indicated where festival musicians should strike their mallets (Von Falkenhausen, personal communication 1992). It is possible that designs on *dōtaku* served a similar function.

GLOSSARY

Asa Term used for bast fibers and cloth. It refers not only to hemp and ramie but also to a host of other plant fibers, including wisteria, mulberry, and the core of the banana plant, or *bashō*.

Bon Festival to honor the ancestors, particularly those recently deceased.

Bugaku Classical dance-drama imported to Japan from the Asian continent during the sixth and seventh centuries.

Chō Neighborhood (*machi* is an alternative reading).

Chochin Small, round paper lantern.

Chōnai-kai Neighborhood association.

Chōnin Townsmen (merchants and craftsmen in the Edo period).

Daimyo Autonomous lord during the Edo period with income guaranteed by the shogunate.

Eboshi Tall, brimless, black gauze hat worn by priests during rituals.

Fuda Slip of paper printed with the name of a *kami*, usually placed on the *kamidana*, or shelf containing offerings for the *kami*.

Furusato One's place of birth or original residence.

Gohei Zigzag-shaped strips of folded paper suspended atop an upright wand that are representative of *kami*-spirit and capable of sanctifying objects, places, and persons.

Gūji Chief priest of a shrine.

Hachimaki Headband.

Hakama Culottes worn as part of formal Japanese costume by both sexes.

Ha' pi A short, inscribed coat worn during festivals.

Harae Segment of ritual in which a priest or officiate waves a *haraigushi* over participants to purify them.

Haraigushi Wand or branch to which paper streamers and flax threads are attached; it is waved over precincts and participants to purify them.

Hata Flag, sometimes a suspended banner.

Hikeshi Firemen's coats.

Hitogami Deified human being.

Ishō Performer's costume.

Jimbaori Campaign vests worn over armor. Early examples were designed to afford the greatest protection against cold or inclement weather during actual campaigns, but by the Edo period *jimbaori* were largely decorative overgarments worn on outdoor occasions. In the Meiji period, they became festival procession garments.

Jinja Shinto shrine.

Juni hitoe Heian-period formal woman's costume consisting of twelve layers of unlined kimono, worn by high-ranking ladies of the imperial court.

Kagura Dance performed for the entertainment of *kami* during a ritual or festival.

Kami Shinto deity; object of veneration.

Kamidana Shelf in a house furnished with a small shrine for ancestral and household *kami*.

Kamishimo Literally, "upper and lower." A man's garment of two parts (*kataginu* and *hakama*) designed to be worn together.

Kanmuri Hat worn by head priest during rituals.

Kannushi Priest trained to officiate at rituals.

Kariginu Loose overgarment of brocade silk worn with *hakama* by a priest.

Katagami Japanese stencil papers made of two to four layers of hand-made paper laminated together with persimmon juice. The tannin in the juice strengthens and waterproofs the paper.

Kataginu Broad-shouldered sleeveless upper part of *kamishimo* outfit, worn as outer garment over formal kimono.

Katazome Term derived from *kata* for "stencil" and *zome* for "dyeing." It is also known as *aizome*, named for Aizen Myōou, the Buddhist deity worshiped by dyers. The term also connotes love of dyeing as *ai* means "love" and *zen* means "dyeing." If a design is relatively simple, it is likely that a paper stencil will be cut for the crest and characters. The *katazome* method of decorating cloth permits numerous identical jackets to be produced at reasonable cost. In *katazome* technique a paper stencil is placed on the cotton cloth, the cut-out design traced on with rice paste. Accent colors are applied, fixed with a coat of soybean liquid, and then covered with rice paste. The panels are then brushed with indigo or dipped in a vat of natural indigo dye. At first the background color of the cloth appears unaffected and remains white. Indigo dye requires oxidation to turn blue. After the cloth receives the indigo dye, it is rinsed in clear water and allowed to oxidize by drying slowly in the open air. This gradually changes the color to blue. To achieve the deep blue that is usually considered most desirable, the process of dipping and air exposure is repeated

several times. When the desired shade is reached, the paste is washed off revealing the designs.

With years of use and successive washings, these colors remain permanent and in many opinions, even increase in beauty as they mellow with use and age. Around 1880 chemical dyes began to be used widely. Since chemical dyes were more expensive than natural dyes, particularly for homemakers who dyed their own family's garments, ordinary people continued to use natural dyes. Therefore it was possible to find examples of handwoven and natural indigo textiles well into the twentieth century.

Kazari Decoration.

Kegare Impure, polluted; pollution.

Ke-tsutsureori Wool tapestry (Chinese: *ke mao*).

Kitamaesen Northern sea trading route.

Kosode Kimono with narrow hand openings. First used as an outer garment during the Momoyama period, a version with large, more markedly rectangular sleeves was popularly worn during the Edo period. Although usually wrapped tightly about the body and secured with an obi, long-trained *kosode* were also worn as loose, flowing outer robes.

Kyahan Leggings.

Machi Neighborhood (*chō* is another reading).

Matsuri To worship, serve, offer up; festival.

Miki Consecrated sake.

Miko Shrine maiden.

Mikoshi Palanquin of a deity to be transported through a town during a festival.

Mingei Handwoven and hand-decorated fabrics and other artworks created by anonymous artisans for the use of ordinary people, particularly for everyday use. However, textiles decorated broadly in bright colors for the holy days were also usually categorized as *mingei*, since they were used by ordinary people.

Mochi Pounded glutinous rice.

Momen Cotton, widely grown from the eighteenth century onward. Cotton replaced bast fibers for the working clothes and festival garments of ordinary people. By the beginning of the twentieth century, cotton, either handwoven at home or workshop produced, was the usual fabric for festival textiles.

Montsuki Formal Japanese outer garment with the owner's crests on sleeves and center back.

Naorai Feast at the end of a ritual; also, sharing of wine and food from the altar.

Nishiki Silk brocade.

Nobori Long banner.

Obi Belt.

O-bon See *bon*.

O-shō-gatsu New Year's celebration.

(O)tera (Also *ji* as part of a proper noun) Buddhist temple.

Ro Gauze weave.

Sakaki Evergreen used in Shinto rituals (*Cleyera ochmacea* or *Cleyera japonica*).

Sanbō Raised tray used for offerings in Shinto rites.

Sankin kōtai The system by which daimyo were required to reside in Edo every other year during the Edo period.

Santan Japanese term for coastal Manchuria or its inhabitants.

Sashiko A type of quilting. *Sashiko* for firemen's coats and other work coats is created with three layers of cotton stitched together in a running stitch. The stitches are placed in vertical parallel rows, approximately one centimeter apart. The thread is of two strands of cotton and is visible, producing an intriguing striated surface. Dense *sashiko* quilting gave ordinary cotton variety, substance, and texture. During the Edo period *sashiko* quilting was primarily done by family members. At the end of that period and subsequently, production was gradually turned over to workshops.

Shi Administrative municipality (city).

Shibori Yukata and individual *ha' pi* and *hanten* are sometimes dyed by means of *shibori*, a resist textile decoration technique utilizing tie-dye. Cotton is especially responsive to *shibori*, the cloth is decorated by tying off sections that will not receive the dye. The sections to reject the dye can also be prevented from accepting the dye by tying them tightly over another object, such as rice grains, spools, stones, or pins. Cotton is flexible and fairly easy to twist or tie in order to reserve the fabric where desired. After sections are tied off to obtain the predetermined design,

the fabric is dip dyed in vats of indigo. Large blocks of color can be created by dipping the fabric in a bucket of dye after tying off the desired design.

Shichi-go-san Annual festival for three- and seven-year-old girls and five-year-old boys.

Shimenawa A rope of braided rice straw marking boundries of a consecrated area.

Shintai A material object in which the *kami's* spirit is believed to reside.

Shishū Embroidery.

Shitamachi Working-class neighborhood.

Shōbō Term for firemen's coats after the Edo period.

shōgun Feudal military ruler of Japan.

Shugendō A syncretic and ascetic mountain-worship religious sect.

Tabi Split-toed socks.

Taiko Drum.

Tasuki Sash / cord.

Tekiya Itinerant festival marketplace vendor.

Tenugui Towel.

Torii Open gateway marking the approach to a Shinto shrine.

Tsutsugaki This term comes from the word *tsutsu*, meaning tube. The technique, used on cotton or bast fiber, came into use around 350 to 400 years after *katazome*. *Tsutsugaki* requires a skilled painter, which makes it a more elaborate and more costly technique. The painter produces an image that is presented on paper for approval before it is placed on fabric. Then a *tsutsu*, or paper cone holding the rice paste (very much like a pastry tube used to decorate cakes), is used to apply the outlines of the drawing on the fabric. Sometimes a portion of the design, the *kanji* character naming the group, for example, is given precedence by being hand painted in *tsutsugaki* technique, while the balance of the pattern is *katazome* stenciled. In this case the stencil portion is established first and then covered with rice paste. The hand-painted section is then drawn on with liquified rice paste and covered with a further coat of rice paste before being brushed with indigo or dip dyed in a vat of indigo dye. The aesthetics associated with Taoism are especially reflected in the work of *tsutsugaki* artisans. Typical designs reflect Taoist concerns with maintaining harmony with the natural world and drawing on yin-yang principles of balancing light and dark, active and passive, feminine and masculine. These principles appear to have guided the artists, whether consciously or unconsciously. In deft and fluid brushstrokes, *tsutsugaki* artisans hand painted not only the auspicious symbols of Taoism but also of Buddhism and Shinto, their vision producing a sensation of ease and joy for both wearer and observer.

Toward the end of the Meiji period, with the growth of urbanization and industrialization, fewer apprentices acquired the skill of *tsutsugaki* painting. Stencil resist-painting (*katazome*) was increasingly adopted as a less expensive and faster method of creating decorated *ha' pi* and *hanten*. Although, during the Edo and Meiji periods, some of the stencil designs, extremely skillfully cut, approached the freehand painted *tsutsugaki* examples in their deftly drawn images, by the mid-twentieth century, even these were difficult for festival committees to acquire. Stencil cutting too, was increasingly abandoned for faster and less expensive machine-printed fabrics. Mass production and oversimplification of designs gradually lessened the vitality of the early *tsutsugaki* textiles.

Tsutsureori Silk tapestry (Chinese: *kesi*).

Ujigami The tutelary deity of a family or clan.

Wakamono-kai Young men's association of a neighborhood.

Waraji Straw sandals.

Yoimatsuri The eve of a festival (*yoiyama, yoimiya*).

Yukata Light summer robe (usually cotton).

Yūzen This is a technique used for decorating silk. The designs are drawn on plain white silk with the juice of the *aobana* plant. Aferward, a line of *nori* starch (glue made from sea kelp) is squeezed from a *tsutsu*, or tube, along the design borders. The *nori* prevents the colors from seeping into one another. When the *nori* is dry, juice of mashed soybeans is brushed over the design. After the colors for the designs are brushed on, the silk fabric is steamed, heat setting the colors in the fabric. After steaming, the dyed sections are coated with *nori* starch, and dye is applied to the background silk. The pasted-over pictorial or patterned sections resist the dye. The fabric is then rinsed thoroughly with water. Lastly, the wrinkles of the fabric are smoothed out with steam.

Yūzen is regarded as a prestigious means of pattern or pictorial dyeing, a technique formerly reserved only for fine silks such as elegant kimono. It was also employed on the theatrical fabrics that costumed some of the solo performers and festival parade mannequins and on the extravagant silks that garbed geisha and *maiko*.

Yūzen is said to have been invented by the artist Miyazaki Yūzen in the middle of the Edo period, and it remained very popular until the end of the Edo period. With this dyeing method, the colors are reserved and remain bright no matter how often the fabric is cleaned. Moreover, silk dyed with this method never loses its soft texture. One reason given for its popularity over the centuries is that it is judged to appear archaic and refined, suggesting the aesthetics of the Heian period court. In addition, it is felt that embroidery or *shibori* techniques are limited to simple forms, while *yūzen* may express complex designs filled with people, scenery, or furnishings in great detail, the final product resembling fine paintings.

At the end of the nineteenth century *chō-nai-kai* members enjoyed the services of the elite *yūzen* artists who had decorated silk fabrics for the aristocracy during the Edo period. When the samurai class lost its power and economic base, many of those whose artistry had embellished their finery suffered severe economic hardships. The situation was aggravated by the fact that affluent people, who wanted to appear fashionable, were slowly rejecting Japanese traditional dress and turning to Western attire. The formerly exclusive textile painters became willing and eager to place their skills at the service of merchants and other townspeople who engaged them to decorate cotton *ha' pi*, *hanten*, and decorative hangings and banners for festival use. They also began to be employed drawing the models of the designs that would be copied onto stencil paper (*katagami*), as well as those that would become the one-of-a-kind resist paintings (*tsutsugaki*). The original sketches and drawings for Ukiyo-e (woodblock prints) were also frequently the work of former *yūzen* artists.

REFERENCES CITED

Agency for Cultural Affairs
1981 *Treasures of the Shōsō-in*. Tokyo: Imperial Household Agency, Agency for Cultural Affairs.

Ashencaen, Deborah
1990 "Tibet: The Rug Weaver's Art." *Octagon* 27, no. 1 (spring): 44. (A catalogue by Spink and Son, Ltd., London.)

Ashkenazi, Michael
1993 *Matsuri: Festivals of a Japanese Town*. Honolulu: University of Hawai'i Press.

Aston, W. G., trans.
1972 *Nihongi: Chronicles of Japan from the Earliest Times to A.D. 697*. Rutland, Vt., and Tokyo: Charles E. Tuttle Company.

Averbach, Irit
1995 *The Gods Come Dancing: A Study of the Japanese Ritual Dance of Yamabushi Kagura*. Ithaca: Cornell University Press.

Bauer, Helen, and Sherwin Carlquist
1965 *Japanese Festivals*. New York: Doubleday.

Bidder, Hans
1979 *Carpets from Eastern Turkestan: Known as Khotan, Samarkand, and Kansu Carpets*. Accokeek, Md.: Washington International Associates.

Blunden, Caroline, and Mark Elvin
1983 *Cultural Atlas of China*. New York: Facts on File.

Brandon, Reiko Mochinaga
1986 *Country Textiles of Japan: The Art of Tsutsugaki*. New York: Weatherhill, Inc.

Casal, U. A.
1967 *The Five Sacred Festivals of Ancient Japan: Their Symbolism and Historical Development*. Tokyo: Sophia University.

Coats, Bruce A.
1996 *Arms and Armor in Japan's Golden Age: Momoyama*. Edited by Money L. Hickman. New Haven: Yale University Press.

Dower, John
1971 *The Elements of Japanese Design*. New York: Weatherhill, Inc.

Earhart, H. Byron
1974 *Religion in the Japanese Experience*. Encino: Dickenson Publishing Company.
1984 *Religions of Japan: Many Traditions within One Sacred Way*. New York: Harper & Row.

Embree, John F.
1939 *Suye Mura: A Japanese Village*. Chicago: The University of Chicago Press.

Fairbank, John King, Edwin O. Reischauer, and Albert M. Craig
1965 *East Asia: The Modern Transformation*. Vol. 2 of *A History of East Asian Civilization*. Boston: Houghton Mifflin Co.

Farrington, Anthony
1991 *The English Factory in Japan, 1613–1623*. 2 vols. London: British Library.

Fetchko, Peter, and Money L. Hickman
1977 *Japan Day by Day: An Exhibition in Honor of Edward Sylvester Morse*. Salem, Mass.: Peabody Museum of Salem.

Friedman, Mildred, ed.
1986 *Tokyo: Form and Spirit*. Minneapolis: Walker Art Center; New York: Harry N. Abrams, Inc.

Gaubatz, Piper Rae
1996 *Beyond the Great Wall*. Stanford: Stanford University Press.

Graphard, Allan
1993 "Review of *Hōsōgami, ou la petite véreole aisément: Matériaux pour l'étude des épidemies dans le Japon des XVIIIe, XIXe siécles*." *Asian Folklore Studies* 52, no. 1: 219–21.

Grim, John, and Mary Evelyn Grim
1982 "Viewing the Hana Matsuri at Shimoawashiro, Aichi Prefecture." *Asian Folklore Studies* 41, no. 2: 142.

Guth, Christine
1996 "Textiles." In *Japan's Golden Age: Momoyama*, edited by Money L. Hickman et al., 275–90. New Haven: Yale University Press.

Haga, Hideo
1970 *Japanese Folk Festivals Illustrated*. Translated by Fanny Hagin Mayer. Tokyo: Miura Printing Co.

Hane, Mikiso
1982 *Peasants, Rebels, and Outcasts: The Underside of Modern Japan*. New York: Pantheon Books.

Haslund, Henning
1935 *Men and Gods in Mongolia*. 2d ed. Translated by Elizabeth Sprigge and Claude Napier. Stelle, Ill.: Adventures Unlimited Press.

Hayashi, Junshin
1983 *Edo mikoshi shunjū: Aki no maki*. Tokyo: Taishō Shuppan.

Hearn, Lafcadio
1976 *Glimpses of Unfamiliar Japan*. Tokyo: Charles E. Tuttle Company.

Herbert, Jean
1967 *Shinto: The Fountainhead of Japan*. New York: Stein and Day.

Hirai, Naofusa
1987 "Shinto." In *The Encyclopedia of Religion*, vol. 13, edited by Mircea Eliade, 280–94. New York: Macmillan Publishing Company.

Hoff, Frank
1978 *Song, Dance, Storytelling: Aspects of the Performing Arts in Japan*. Cornell China Japan Program. Ithaca: Cornell University Press.

Hokkaidō Shinbun-sha
1991 *Ezo Nishiki no kita michi* (Ainu Silk Brocade and the Northern Route). Sapporo: Hokkaidō Shinbun-sha.

Honda, Yasushi
1986 *Dentō geinō no keifu*. Tokyo: Menseisha.

Hori, Ichiro
1968 *Folk Religion in Japan: Continuity and Change*. Chicago: The University of Chicago Press.

Horiuchi, Noriko
1980 "Maiwai to Tairyōki." *Senshoku no Bi* 8 (autumn): 89–95.

Inagaki, Shinichi
1985 "Edo meisho kajiba meguri." In *Hikeshi fūzoku date sugata*. Edited by Suzuki Hitoshi, Miya Tugio, and Tokyo Rengo Bōka Kyōkai, 120–25. Tokyo: Haga Akira, Haga Shoten.

Inoue, Mitsuo
1985 *Space in Japanese Architecture*. Translated by Hiroshi Watanabe. New York: Weatherhill, Inc..

Iriye, Akira
1989 "Domestic Politics and Overseas Expansion." In *The Nineteenth Century*. Vol. 5 of *The Cambridge History of Japan*, edited by Marius B. Jansen, 747–65. Cambridge: Cambridge University Press.

Itō, Mikiharu
1983 "Festivals." In *Kodansha Encyclopedia of Japan*, 252–70. Tokyo: Kodansha

Jansen, Marius B., ed.
1989 *The Nineteenth Century*. Vol. 5 of *The Cambridge History of Japan*. Cambridge: Cambridge University Press.

Japan Textile Color Design Center
1980 *Textile Designs of Japan*. Vol. 1. Tokyo: Kodansha International, Ltd.

Japan Travel Bureau
1985 *Illustrated Festivals of Japan*. Translated by John Loftus. Tokyo: Japan Travel Bureau.

Jeremy, Michael, and M. E. Robinson
1989 *Ceremony and Symbolism in the Japanese Home*. Manchester: Manchester University Press.

Joly, Henri L.
1967 *Legend in Japanese Art*. Tokyo: Charles E. Tuttle Company.

Joya, Mock
1960 *Things Japanese*. Tokyo: Tokyo News Service, Ltd.

Kajitani, Nobuko, and Yoshida Kojiro
1992 *Gion Matsuri Yamaboko kensohin chosa hokokusho: Torai senshokuhin no bu* (Catalog of the Gion Festival float decorations: The imported hangings). Kyoto: Gion Matsuri Yamaboko Rengokai.

Kaneko, Kenji
1983 "Nihon no kawa kōgei." *Senshoku no Bi* 24 (summer): 73–80.

Keene, Donald
1952 *The Japanese Discovery of Europe, 1720–1830*. Rev. ed. Stanford: Stanford University Press.

Kerr, Charles
1958 *Okinawa: The History of an Island People*. Berkeley: University of California Press.

Kitagawa, Joseph M.
1966 *Religion in Japanese History*. New York and London: Columbia University Press.

Kitao, Yoshikazu
1993 *Shōzōgashū Ishūretsuzō*. Hokkaidō: Kitao Yoshikazu.

Komatsu, Kazuhiko
1999 "Supernatural Apparitions and Domestic Life in Japan." *The Japan Foundation Newsletter* 27, no. 1 (June): 1–5.

Laforet Museum
1982 *Dragon Robes of China: Catalogue of the Exhibition, Sept. 14–26, 1982*. Tokyo: The Japan Foundation.

Lee, Sherman
1981 *The Genius of Japanese Design*. New York: Harper & Row.

Leupp, Gary P.
1992 *Servants, Shophands, and Laborers in the Cities of Tokugawa Japan*. Princeton: Princeton University Press.

Maraini, Fosco
1959 *Meeting with Japan*. New York: The Viking Press.

Masaharu, Akemi
2000 "Jingasa" (Soldier's hats). *Daruma* 7, no. 3 (summer): 32–43.

Masuda, Takefumi
1986 *Za foto Gion Matsuri: The Photograph of the Gion Festival*. Kyoto: Kyoto Shoin.

Matsuda, Kiichi
1965 *The Relations between Portugal and Japan*. Lisbon: Junta de Investigaçoes do Ultramar and Centro de Estudos Historicos Ultramarinos.

Matsumoto, Kaneo
1984 *Jodai-gire*. Translated by Shigetaka Kaneko and Richard Mellott. Kyoto: Shiko-sha Publishing Co., Ltd.

Mitani, Kazuma
1987 *Fukagawa Edo Museum*. Tokyo: Fukagawa Edo Shiryōkan.

Miyao, Shigeo
1968 *Nihon no minzoku geinō* (Japanese folk art). Tokyo: Kashima Kenkyūjo Shuppankai.

Mizoguchi, Saburo
1973 *Design Motifs*. Translated and adapted by Louise Cort. Arts of Japan Series 1. New York and Tokyo: Weatherhill/Shabundo.

Moes, Robert
1985 *Mingei: Japanese Folk Craft*. New York: Universe Books.

Moriarity, Elizabeth
1972 "The Communitarian Aspect of Shirato Matsuri (Festivals)." *Asian Folklore Studies* 31, no. 2: 94–95, 134–36.

Moriya, Takeshi.
1985 *Chusei geinō no genzo*. Kyoto: Tankosha.

Murase, Miyeko
1986 *Tales of Japan: Scrolls and Prints from the New York Public Library*. New York: Oxford University Press.

Niwa, Kankichi
1980 *The Dutch Settlement at Dejima: A Guide to the Past and Present*. Translated by Lane Earns. Nagasaki: The Committee to Promote the Restoration of Dejima.

Notehelfer, F. G., ed.
1992 "Japan through American Eyes." In *The Journal of Francis Hall: Kanagawa and Yokohama, 1859–1866*. Princeton: Princeton University Press.

Nouët, Noele
1990 *The Shogun's City: A History of Tokyo*. Translated by John and Michele Mills. Sandgate, England: Paul Norbury Publications.

Ohtsuka, Kazuyoshi, ed.
1993 *Ainu moshiri: Minzoku moyo kara mita Ainu no sekai* (The world of the Ainu through their design motifs). Osaka: Kokuritsu Minzoku Hakubutsukan.

Okada, Jō
1978 *Genre Screens from the Suntory Museum of Art*. Translated by Emily J. Sano. New York: Japan Society.

Okamoto, Yoshitomo
1972 *The Nanban Art of Japan*. Translated by Ronald K. Jones. Tokyo: Heibonsha Survey of Japanese Art.

O'Kane, John
1972 *The Ship of Sulaiman*. Persian Heritage Series, no. 11. London: Routledge & Kegan Paul

Ono, Sokyo
1962 *Shinto: The Kami Way*. 19th ed. Tokyo: Charles E. Tuttle Company.

Ozawa, Hiroyuki
1999 *Spectacle and Spirit: The Great Festivals of Japan*. New York: Kodansha America.

Pearson, Richard J.
1992 *Ancient Japan*. New York: George Braziller; Washington, D.C.:
 Smithsonian Institution.

Philippi, Donald L., trans.
1968 *The Kojiki*. Tokyo: University of Tokyo Press.

Plutschow, Herbert
1990 *Chaos and Cosmos: Ritual in Early and Medieval Japanese
 Literature*. Leiden: E. J. Brill..
1996 *Matsuri: The Festivals of Japan*. Surrey: Japan Library

Purdon, Nicholas
1994 "Gion Matsuri." *Hali: The International Magazine of Antique Carpet
 and Textile Art* 16, no. 5, issue 77 (October/November): 88–95.

Rawson, Philip, and Laszlo Legeza
1973 *Tao: The Eastern Philosophy of Time and Change*. London: Thames
 and Hudson, Ltd.

Rorex, Robert A., and Wen Fong
1974 *Eighteen Songs of a Nomad Flute: The Story of Lady Wen-Chi, a
 Fourteenth-Century Handscroll in the Metropolitan Museum of Art*.
 New York: Metropolitan Museum of Art.

Rostov, Charles I., and Jia Guanyan
1983 *Chinese Carpets*. New York: Harry N. Abrams, Inc.

Sadler, A. W.
1972 "Carrying the Mikoshi: Further Field Notes on the Shrine
 Festival in Modern Tokyo." *Asian Folklore Studies* 31: 92–109.
1974 "At the Sanctuary: Further Field Notes on the Shrine Festival in
 Modern Tokyo." *Asian Folklore Studies* 33: 22–23
1975 "The Shrine: Notes towards a Study of Neighborhood Festivals
 in Tokyo." *Asian Folklore Studies* 34: 1–38.

Sakata, Ikuko
1979 "Ikki/Chōsan." In *Shinōkōshō Nōmin* (Classes of warriors, farmers,
 artisans, and tradesmen: People's lives in the Edo and Meiji peri-
 ods). The Sun Collection, no. 10, edited by Kozaburo Nishimaki,
 88–89. Tokyo: Heibonsha.

Sasama, Yoshihiko
1982 *Nihon budō jiten* (Dictionary of Japanese military arts). Tokyo:
 Kashiwa Shobō.

Schnell, Scott
1999 *The Rousing Drum: Ritual Practice in a Japanese Community*.
 Honolulu: University of Hawai'i Press.

Schram, Louis M. J.
1957 *The Monguors of the Kansu-Tibetan Frontier, Part 2: Their Religious
 Life*. Transactions of the American Philosophical Society, n.s.,
 vol. 47. Philadelphia: American Philosophical Society.

Serizawa, Chosuke, Hamada Shukuko, and Akiko Watabe
1990 *Ainu bunkaten* (Exhibition of Ainu culture). Sendai: Tōhoku
 Fukushi Daigaku Serizawa Keisuke Bijutsu Kōgei-kan

Shaver, Ruth M.
1966 *Kabuki Costume*. Tokyo: Charles E. Tuttle Company.

Shibusawa, Keizo
1958 *Japanese Culture in the Meiji Era, Life and Culture*. Vol. 5.
 Translated by Charles S. Terry. Tokyo: Ōbunsha.

Shimazaki, Tōson
1987 *Before the Dawn*. Translated by William E. Naff. Honolulu:
 University of Hawai'i Press

Smith, Bradley, and Wen-go Weng
1979 *China: A History in Art*. New York: Doubleday.

Sonoda, Minoru
1988 "Festival and Sacred Transgression." In *Matsuri: Festival and Rite
 in Japanese Life*, edited by N. Inoue, K. Ueda, and N. Havens,
 33–77. Tokyo: Institute for Japanese Culture and Classics,
 Kokugakuin University.

Stuart, Kevin
1999 "Folklore in Northwest China." *Asian Folklore Studies* 58, no. 1: 1–4.

Takagi, Tejiro
1907 *The Great Gion Matsuri: The Annual Festival of the Gion Shrine at
 Kyoto*. Kobe: Tamamura Publishing Co.

Takahashi, Haruko
1968 "Structure of Dance Costumes in the Miyakawa Flower Region."
 Folk Culture (November): 13–28.

Tanahashi, Kazuaki
1968 *Japanese Design Motifs*. Tokyo: Hozansha Publishing Co., Ltd.

Tanaka, Chizaburo
1992 *Honshū Hokugen no Mūjiamu Sai Mura Kaikyō Mūjiamu*.
 (Museums of northernmost Honshū the Sai Mura Channel
 Museum). Aomori: Sai Mura Kaikyō Mūjiamu.

Teikoku Gunjin Kyōikukai
1914 *Kinjō heika Gosokui shiki shashin chō* (The photographs of Taisho
 emperor's enthronement ceremony). *Junbi no maki* (Volume of
 preparation). Tokyo: Teikoku Gunjin Kyōikukai.

Thompson, Fred S.
1986 "Manifestation of the Japanese Sense of Space in Matsuri." In
 Fudo: An Introduction, edited by Anthony V. Liman and Fred S.
 Thompson, 19–32. Waterloo, Canada: University of Waterloo Press.

Thornton, Richard S.
1989 "The Continuity of Tradition." In *Shirushi Banten: The
 Traditional Japanese Dyeing of Happi and Handtowels*, edited by
 Akira Iwata, 10–15. Tokyo: Shinshindo Shuppan Co., Ltd.

Tobankamotsu-cho
1709–1712 An official Edo government document listing of goods
 imported through Nagasaki between 1709 and 1712 (pp. 177–78).

Togi, Masataro
1973 *Bugaku: Ancient Japanese Music and Dance*. Tokyo: Otsuka
 Kogeisha Co. Ltd.

Tokyo Fire Museum
2000 A leaflet documenting an exhibition at the Tokyo Fire
 Department, Fire Museum (Shōbō Hakubutsukan).

Tsunoda, Ryusaku, Wm. Theodore De Bary, and Donald Keene
1958 *Sources of Japanese Tradition*. Vol. 1. New York: Columbia
 University Press.

Ueda, Kenji, Sonoda Minoru, Inoue Nobutaka, and Jaycee Takai, eds.
1985 *Terms of Shinto*. Tokyo: Kokugakuin University.

Varley, Paul H.
1973 *Japanese Culture: A Short History*. Tokyo: Charles E. Tuttle Company.

Vlastos, Stephen
1989 "The Meiji Land Tax and Village Protests." In *The Nineteenth
 Century*. Vol. 5 of *The Cambridge History of Japan*, edited by Marius
 B. Jansen, 372–82. Cambridge: Cambridge University Press.

Von Erdmann, Hanna
1978 "Die Beziehung der vorosmanischen Teppichmuster zu den
 gleichzeitigen Ornamenten." *Hali: The International Magazine
 of Antique Carpet and Textile Art* 1, no. 3 (autumn): 228–33.

Watt, J. C. Y., and A. E. Wardwell
1997 *When Silk Was Gold: Central Asian and Chinese Textiles*, New
 York: Metropolitan Museum of Art.

Williams, C. A. S.
1974 *Outlines of Chinese Symbolism and Art Motives*. Rutland, Vt.:
 Charles E. Tuttle Company.

Yamaguchi, Masao
1988 *Poetics of Exhibition in Japanese Culture*. Unpublished paper pre-
 pared for the symposium *Poetics and Politics of Representation*,
 September 26–29, Washington, D.C.

Yamane, Yuzo
1973 *Momoyama Genre Painting*. Translated by John M. Shields.
 Tokyo: Weatherhill/Heibonsha.

Yamanobe, Tomoyuki
1985 *Textiles of the Common People (Folk Textiles): The Tomoyuki
 Yamanobe Collection*. Tokyo: Genryusha.

Yanagawa, Keiichi
1988 "The Sensation of Matsuri." In *Matsuri: Festival and Rite in
 Japanese Life*, edited by N. Inoue, K. Ueda, and N. Havens, 3–31.
 Tokyo: Institute for Japanese Culture and Classics, Kokugakuin
 University.

Yanagi, Soetsu
1972 *The Unknown Craftsman: A Japanese Insight into Beauty*. New
 York: Kodansha/Harper & Row.

Yang, Lien-sheng
1968 "Historical Notes on the Chinese World Order." In *The Chinese
 World Order*, edited by John King Fairbank, 20–33. Cambridge:
 Harvard University Press.

Yoshida, Mitsukuni, Tanaka Ikko, and Sesoko Tsune, eds.
1985 *The Culture of Anima: Supernature in Japanese Life*. Tokyo: Cosmo
 Public Relations Corp. Mazda Motor Corp.
1987 *Asobi: The Sensibilities at Play*. Tokyo: The Mazda Motor
 Company, Cosmo.

Gloria Granz Gonick received her master's degree from the Department of Art History at UCLA, concentrating her studies on Japanese design, language, and culture. Her long-standing interest in Japanese textiles led her to the study of *matsuri*.

Yo-ichiro Hakomori is an adjunct assistant professor in the School of Architecture at the University of Southern California. Dr. Hakomori received a master of architecture degree from UCLA and a doctor of engineering and architecture degree from the University of Tokyo. He has taught and worked as an architect in Japan and the United States. Currently he maintains an architectural practice in Venice, California.

Hiroyuki Nagahara is an assistant professor of Japanese in the Department of East Asian Languages and Literatures at the University of Hawai'i at Manoa. He received his doctorate in linguistics from UCLA. He is presently pursuing research on phonological phrasing in Japanese.

Herbert Plutschow is a professor in the Department of East Asian Languages and Cultures at UCLA. He received his doctorate in Japanese literature from Columbia University. Dr. Plutschow's research emphasizes classical Japanese literature and cultural history. His publications include *Matsuri: The Festivals of Japan* (1996), *Japan's Name Culture: The Significance of Names in a Religious, Political, and Social Context* (1995), *Chaos and Cosmos: Ritual in Early and Medieval Japanese Literature* (1990), and *The Japanese Travelers: A Study of Medieval Japanese Travel Diary Literature* (in Japanese; 1983).